"I'd like to turn people
on to the fact
that the world is form,
not just function
and money."

Claes Oldenburg[1]

ARTFORMS

Second edition of *Man Creates Art Creates Man*

by Duane Preble

with Sarah Preble

HARPER & ROW, PUBLISHERS
New York Philadelphia San Francisco London

Text and cover design by James Stockton.
Cover photograph © by Wolfgang Volz. Page layout by
Donna Davis. Copy editing by Carol Dondrea. Technical
line art by Boardworks. Typesetting, page make-up and
black-and-white photographic preparation by
Continental Graphics. 4/color separations by Focus 4.
Printing and binding by Kingsport Press.

Production Manager: Laura Argento.

Project coordination by Thomas Dorsaneo.

Sponsoring Editor: Ann Ludwig.

ARTFORMS © 1978 by Harper & Row, Publishers, Inc.
MAN CREATES ART CREATES MAN © 1973
by Harper & Row, Publishers, Inc.

Library of Congress Cataloging in Publication Data

Preble, Duane.
 Artforms.

 First ed. published in 1973 under title: Man creates art
creates man.
 Bibliography: p. 419
 Includes index.
 1. Composition (Art) 2. Art—Psychology.
3. Art and society. I. Title.
N7430.P69 1978 700 77-21989
ISBN 0-06-386828-8

82 83 84 85 16 15 14 13 12 11 10 9

**To my students,
whose interest and ideas
helped create this book**

CONTENTS

CONTENTS WITH ARTISTS

A note
about the cover

In October 1976, Christo directed the installation of an eighteen-foot, 24½-mile long, white nylon fence that ran through the coastal hills of California, north of San Francisco. Though temporary, this *Running Fence* was both a work of art itself and the starting point for a much larger work that included the landscape, light, and wind. It also included the experiences of thousands of people who were involved in the process of its construction, who perceived it as a physical object, and who are aware of it as an idea.

In this way, Christo's work has been a springboard for increased awareness. The *Running Fence* takes art away from the frames and pedestals of museums and puts it directly into the environment and into people's lives. In its challenge to our preconceptions about the nature of art and its role in life, it makes a fitting cover for this new Second Edition of ARTFORMS.

PREFACE

ARTFORMS is primarily a visual experience. The careful selection, ordering, and combining of images are designed to entice you into greater interest in and understanding of the visual arts. In this sense *ARTFORMS* is a portfolio with commentary, bringing together quality reproductions of art from around the world.

ARTFORMS is the second edition of *MAN CREATES ART CREATES MAN*. The concluding sentences in the draft of the first edition were "Man creates art. Art creates man." This concept was so central to the book that it became the title. The world has changed since 1972, and now the root word *man*, meaning humanity, is more commonly taken to refer to the male of the species. Therefore *MAN CREATES ART CREATES MAN* became *ARTFORMS*, which still contains the basic theme—condensed in one word. As we create forms, we are in turn shaped by that which we have formed.

Our purpose, as before, is to meet the need for a clear, concise, visually exciting and logically organized book that brings together art theory, practice, and history in a single volume. We feel there is a great need to present not only the communication and beautification potential offered by art, but also its roles in increasing awareness and guiding environmental decisions on all levels.

ARTFORMS retains the concern for art in daily life, yet increases depth and breadth of coverage in the "fine arts" as well as the "applied arts." Considerable new material has been added to that contained in earlier editions. For example there are an extensively revised and expanded discussion of creativity, new treatment

of evaluation, a new section on the performing arts, a new color wheel, and new material on the art of the Seventies. More than one-third of the reproductions are new to this edition. The revision provided an opportunity to update the content throughout, but especially in areas of considerable contemporary activity such as the camera arts, urban planning, and environmental design.

This edition is reorganized and largely rewritten. The visual elements precede the media, which are followed by chapters on history. Organized chronologically, the expanded coverage of art history in *ARTFORMS* introduces additional comparative material from non-Western traditions though retaining a basically Western perspective. Within each chapter a great deal of attention was given to the order of presentation and to providing logical connections among topics. The progression of material has been made even more accessible by the addition of headings and subheadings. As before we have reproduced only works that are discussed in the text and have not discussed works without reproducing them, usually on the same page. We have retained the informative reference material in the back and condensed its page length with improved typography. A comprehensive glossary has been added.

The coverage of art history is more extensive in *ARTFORMS* than in the abridged edition, WE CREATE ART CREATE US. In the abridged edition emphasis is placed on the nature of art and visual experience and on the visual arts themselves. Coverage of history prior to this century is greatly abbreviated and presented in a comparative thematic rather than chronological manner.

We hope that *ARTFORMS* will help readers become independent in their enjoyment and continuing experience of the arts and their context in life. If we have conveyed some portion of our excitement with these works and concepts, it has been worth the effort.

My thanks to the people who have made this book possible—to the artists whose works are presented here, to my colleagues who shared their ideas and knowledge, and especially to those closest to the actual production of the book: Sarah Preble, my wife, who co-authored this edition; and two fellow faculty members at the University of Hawaii, Jeanne Wiig, researcher and consultant, and Carol Richmond Langner, reviewer and consultant. I am also grateful to Douglas M. Brown, Chadron State College; Elaine Foster, Jersey City State College; Susan R. Kattas, Inner Hills Community College; and Robert J. Myers, Ellsworth Community College for their reviews of the manuscript and for their many helpful suggestions. All of our work was brought to final form by the careful management, generous and creative spirit of the staff at Canfield Press.

As in most books, the ideas come from many sources, and are brought together by the experiences of the authors. Those readers who have responded to personal and written inquiries regarding the first edition have contributed generously to this volume. We welcome your comments and suggestions regarding *ARTFORMS* and invite you to send them directly to me at the Department of Art, University of Hawaii, Honolulu, Hawaii 96822.

Duane Preble.
Honolulu, Hawaii.

INTRODUCTION

1 Saul Steinberg.

The goal of this book is to help you, the reader and viewer find or extend your inherent artistic capacities, and to help enrich your life with an expanded awareness of art —its potential as a concept and its actualization in the vast field of human expression called the visual arts.

A technologically explosive society needs the humanizing rewards of art experience. Science and the arts work for humanity in different ways. Science seeks and finds factual answers to questions related to our physical world. The arts help meet our emotional and spiritual needs, and help shape our physical environment as well. Art is created by fusing skill, knowledge, intuition, and emotion with materials. Although works of art are facts because of their physical existence, they also possess inner life or spirit. Works of art are a unity of spirit and matter, and remain alive regardless of when or where created. This is why art always lives in the present, evoking human responses from those who perceive it.

Appreciation of art is sometimes difficult. Art can seem vague and indefinite, unrelated to essential things. And to some people the creation of art is itself an insignificant process. The necessity for hard labor and frugality that accompanied the settlement of North America and the later development of industrial technology strengthened an emphasis on efficiency, utility, and production at the expense of the natural environment and the aesthetic aspects of life. The belief that the young nation had no time for art remains with us today. Calvin Coolidge revealed the priorities when he said in 1925,

"The chief business of America is business."[1] But must other life-enriching values be overlooked?

Although art museums have record attendance, sales of artworks increase, and much space is devoted to the arts in magazines, today's artists often find themselves and their work isolated from everyday life and alienated from the dominant values of their culture. Or their work may be borrowed and modified to serve other ends.

Grant Wood's AMERICAN GOTHIC, painted in 1930, touches America's foundations. Yet Wood's visual statement has since been adapted to sell potato chips. Here is art used and distorted, atop a pile of urban chaos—while we continue business as usual.

Popularized versions of the work of today's leading artists become part of the commercial world of buying, and consuming almost overnight, but these images do little to reveal the true nature of art as a vital, ongoing life-enhancing process. By increasing our visual awareness we will become less tolerant of the visual pollution of today's man-made environment. We will come to grasp the importance of art today, and hopefully, begin to close the gap between art and everyday life.

The domain of the visual arts is extensive. It ranges from drawing to urban design, from making pots to making films. Although written to give an understanding of the visual arts as unique forms of human experience, this book is intended to go beyond the usual art appreciation approach. It includes works and concepts that reveal art as one of the interdependent factors that determine the quality of our life on Earth.

All of the visual arts are environmental; they exist in and help define human living spaces. Thus, artistic awareness can help us deal with environmental problems. Art can help us understand and avert potential disaster, and make human survival worthwhile.

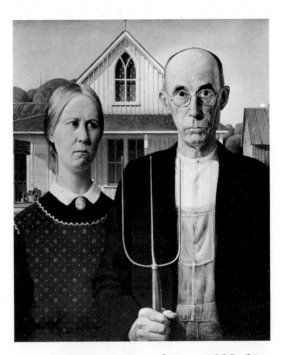

2 Grant Wood. AMERICAN GOTHIC. 1930. Oil on beaver board. 29⅞ x 24⅞". The Art Institute of Chicago.

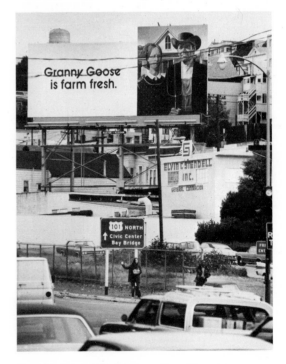

3 HIGHWAY 101 NORTH. San Francisco. 1971. Photograph.

1 WHY ART?

To evoke in oneself a feeling one has experienced, and having evoked it in oneself, then by means of movement, line, color, sounds or forms expressed in words, so to transmit that feeling that others experience the same feeling—this is the activity of art.

Leo Tolstoy[1]

THE CONCEPT "ART"

Art, like life itself, does not have to be defined or understood to be enjoyed. It must simply be experienced.

Art is not something apart from us. It grows from capacities that we all possess. If you have ever experienced something intensely and wanted to share that experience with others, you have been where art begins.

To many people *art* means something created by an artist, and an *artist* is generally thought of as a painter or sculptor. This concept of art is limited. In a very general way, almost anything we do can be art. Art is something done so well that it takes on more than ordinary significance.

art (ärt), n. 1. the quality, production, or expression of what is beautiful, appealing, or of more than ordinary significance.[2]

A *work of art* is the expression of an idea, formed with human skills through the use of a medium. A *medium*

is the physical material from which art is made—for example, clay, oil paint, steel, or film. Depending on the way it is used, a medium can either limit or expand experience. When a medium is used so well that it expands our experience beyond ordinary consciousness, that particular use of the medium can be considered art.

When people speak of "the arts" in our culture, they are usually referring to dance, drama, music, literature, and the visual arts. These arts are unique types of human activity. Each produces forms perceived by our senses in different ways. Yet each grows from a common urge to give physical form to ideas, feelings, and experiences. This urge, shared by all artists, goes beyond ordinary functions, facts, and explanations. The arts can be thought of as a means to extend our consciousness beyond the measurable world we know to that larger universe whose presence we feel but cannot comprehend through ordinary consciousness or awareness.

Art has a magical quality. It can relieve our doubts by merging the known and the unknown in beneficial harmony. In this way, art can help us interact in a positive way with the mysteries of life.

Above all, art reflects us and our relationship with our environment. This reflection can be inspiring or depressing. An art experience can give us great joy; it can create a feeling similar to what might be described as a "religious experience." An art experience can also lead us to discover many dimensions of ourselves that are disturbing. In the ugliness and distortion of some images, we may begin to see and recognize negative and destructive aspects of ourselves. Yet, this very recognition can be an impetus for positive growth and change.

There are no absolute standards for appraising the quality of a work of art. If it contributes to *your* experience at a particular time in your life, then it is probably art for you. You must ultimately determine the quality of any work for yourself. Your ability to do this is refined through the continued assessment of experience and involvement with art.

It is best to approach art openly, without bias. Give yourself time to react. Ask yourself questions such as: How does this work of art make me feel? Why does it make me feel this way? Did the artist have something particular in mind to which I can respond? How was it made? How does it relate to my life in the universe? Meaningful reactions to works of art require personal participation. The experience and words of others can help increase understanding, but the contact itself must be of your own making. Each of us must re-create the life of a work of art.

No teachers or critics can determine your likes and dislikes in art. They can, however, offer the results of their experience and involvement with art, perhaps adding new dimensions of perception and knowledge to your own consideration of it. Works of art that add to the experience of many people over a long period of time, and make a lasting contribution to human life, are considered masterpieces.

Cartoonist James Thurber has turned around the old saw "I don't know anything about art, but I know what I like." (See next page.) Knowing what you like is the beginning; knowing why you respond favorably to certain forms takes you that much further. Ultimately, the dialogue between the viewer and works of art goes far beyond likes and dislikes.

The focus of this book is the visual arts. Since there is much common ground among the arts, the word *art* as used in this book can be taken to mean either the arts in general or the visual arts in particular, depending on the context in which it is found. Or it may be used to refer to the most important art of all—the art of living.

"*He knows all about art, but he doesn't know what he likes.*"

In a sense, art has become separated from life in the modern world. We have a notion of a separate "High Art," produced by a few gifted people, most of whom are no longer living. This attitude is commonly seen in relation to the art of museums, which is put on a pedestal and approached self-consciously, with little empathy or identity with the life experiences of the person(s) who created it.

The concept that art is created only by inspired geniuses has been with us since the Renaissance. By the eighteenth century, this concept had resulted in distinctions between "fine" and "applied" arts, between artist and craftsman. Thus, we had "High Art" on the one side, and hand-made functional objects on the other.

The Industrial Revolution and the invention of photography and lithography, however, led to the proliferation of mass-produced objects and images characteristic of modern society. More recent technology has brought us an even greater abundance of manufactured materials and objects that have become both media and subject for today's artists. And with all these changes, the roles of artist and craftsman are merging again. Once more there is less distinction between what is and what isn't art.

In today's urban technological cultures, we are frequently bombarded with stereotyped or "canned" images. The effects of mass media are often deadening because we block out perception when we experience sensory overload. Some people, however, feel that the glut of commercial images that surrounds us *is* the art of today.

Whether we accept this view or not, the concept of art is changing. The twentieth century has seen artists aggressively questioning and pushing back what we understood were the traditional limits of art. Art, in this new sense, seems to be making its way back into everyday life. In each case, on the most imme-

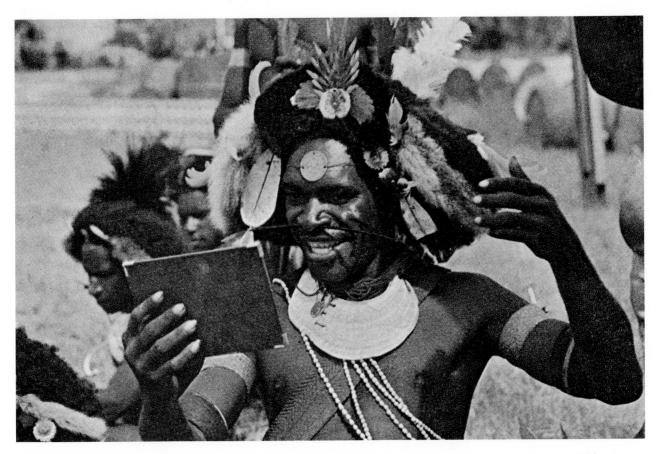

5　A New Guinea tribesman admires the result of hours of primping. Photograph by Jack Fields, 1969.

diate level, art extends our innate expressiveness as well as our general awareness.

While the meaning of the word *art* is debated and the forms and functions of art change, the fact remains that humanity continues to delight in using perception and manual skill to produce and enjoy an infinite variety of forms that express human experience.

THE NECESSITY FOR ART

Is it necessary for us to give physical form to things we feel, think, and imagine? Must we gesture, dance, draw, speak, sing, write, carve, paint, and build? To be human, it seems we must.

Sharing experience is something we all must do. Studies have shown that an infant will not survive and develop as a healthy human being if denied interaction with another human, even though it is provided with every other necessity of life. We know how important it is to communicate an idea to someone else. If the idea is important to us and we succeed in making it known to another person, we feel strengthened by the success. If we fail to get the idea across, we are frustrated and diminished. As with other forms of communication, art is a means of sharing human experience.

Most cultures, particularly those of the past, have produced objects to meet their physical and spiritual needs. Such objects, from simple tools to temple complexes, were often designed to satisfy both needs simultaneously. There was, and in some cultures still is, no distinction between the practical function of an object and its spiritual and aesthetic significance.

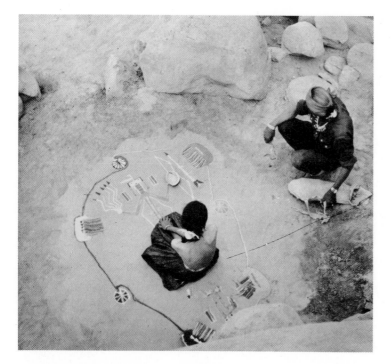

6 Navajo Sand Painting.

NAVAJO SAND PAINTING

From between the fingers of the
 medicine man
Colored sand flows steadily,
Out of the hand of the Singer, tirelessly
 chanting,
Flows blue and white and brown, flows
 yellow and black and red,
Covering the hogan floor with patterns,
Meaningless to unbelievers,
While the sick girl, surrounded by silent
 watchers,
Sits facing toward the East,
Awaiting, with quiet confidence, the
 Sing's sure end.
"There will be dancing to-night." she
 tells herself,
"And I shall dance with the others!"
"There will be feasting to-night." she
 says in her heart,
"And laughter and talk around the fires
 of my people;
And I shall be a part of it!"

 Elizabeth-Ellen Long[3]

Many sophisticated artistic cultures have no word for art. For these people "art" is not a finished product valued for its own sake; it is simply part of the process of living, and therefore no more or less important than anything else that results from or expresses life. The Balinese say: "We have no art; we do everything as well as we can."

In contemporary technological cultures few of us conceive of art as an integral part of our lives. We need to bring art back into everyday life.

AWARENESS

Of all our planet's resources, the most precious is human awareness; each new device, instrument or technique that increases our receptivity to the stimuli of our natural environment also creates new avenues for the solution of ancient problems whose solution under the pressure of growing population cannot much longer be delayed. What we mine is the mind of man; what we extract are new dimensions of human experience.

 Don Fabun[4]

How we "see" determines how we live. Developing awareness and becoming personally involved in shaping our surroundings can lead us to an improved quality of life.

As children, we are conditioned by our culture. We are taught what is "good" and "bad," taught to accept some things and reject others—taught thereby to limit our perception.

In learning to cope with the world, we learn to conceptualize almost everything that we perceive. (The process is brought to a final crescendo by higher education.) We place the unique elements of our experience into general classes or categories, and give names to such categories in order to think about them and communicate our ideas about them to others.

The system built up by this process of classification is called a "cognitive system." Such a system provides a framework for our perception, which includes our basic values. We all have our own cognitive system, yet we share a common, more general cognitive system with others in our society. We could not get along without such classification, yet labeling and categorizing ignore the unique qualities of objects and events and emphasize those qualities believed to be held in common. If they are not balanced by direct perception, these generalized categories form the basis for prejudice of all kinds. It is important to recognize that each of us has developed "a distinctive way of looking at the world *that is not the way the world actually is* but simply the way our group conventionally looks at our world."[5]

Since we are guided in our perceptions by the people we emulate, we may become aware only to the degree that we are stimulated to become aware by these people—our parents, teachers, and friends—and by the relative pleasantness or unpleasantness of our surroundings. We have to learn to use our senses. The eyes are blind to what the mind cannot see. As we mentally discover new ways of seeing, we increase our perception of the world.

Joey, a New York City boy with blind parents, had cerebral palsy as a baby. Because of his own and his parents' disabilities, Joey was largely confined to his family's apartment. As he grew older he learned to get around the apartment in a walker. His mother thought he seemed to have normal intelligence, yet clinical tests showed him to be blind and mentally retarded. At age five Joey was admitted to a school for children with a variety of disabilities. This was his first real contact with people who could see. Although he bumped into things in his walker and felt for almost everything, as a blind person does, it soon became apparent that he was not blind. Joey simply had never learned to use his eyes. After a year

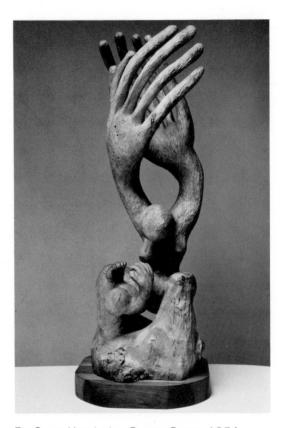

7 Steve Handschu. FOREST BIRTH. 1974. Wood. Height 42″. Collection of the artist.

of working with specialists, and playing with sighted children, his visual responses were normal. Those who worked with him concluded that Joey was a bright and alert child. The combined disabilities of Joey and his parents had prevented normal visual awareness from developing.

People who are actually blind often have a highly developed tactile sense that enables them to create forms that can be enjoyed by both sighted and blind people. Blind artist Steve Handschu studied art at Cornell University School of Fine Arts and elsewhere. His carved sculpture FOREST BIRTH is a powerful evocation of the primal origins of life. Handschu's ability to "see" with his hands has produced expressive statements of superior tactile sensitivity, including award-winning playground sculpture.

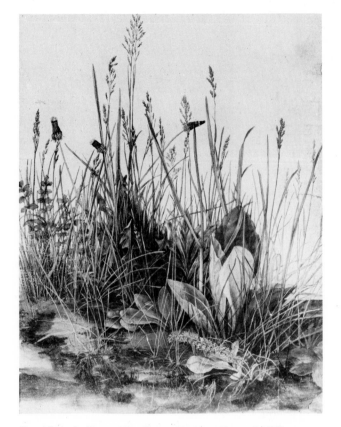

8 Albrecht Dürer. THE GREAT PIECE OF TURF. 1503. Watercolor. 16¼ x 12⅜''. Albertina Collection, Vienna. *See color plate 1, opposite page 18.*

To see is itself a creative operation, requiring an effort. Everything that we see in our daily life is more or less distorted by acquired habits, and this is perhaps more evident in an age like ours when the cinema, posters, and magazines present us every day with a flood of ready-made images which are to the eye what prejudices are to the mind. The effort needed to see things without distortion takes something very like courage.

Henri Matisse[6]

"Looking" implies opening our eyes in a purely mechanical way, taking in what is before us in order to move about. "Seeing" is an extension of looking which leads to perceiving. In the world of function, a doorknob is something to be looked at in order to grasp and turn it, not something to be seen for itself. When we get excited about the shape and finish of a doorknob, the bright clear quality of a winter day, or the rich color of a sunset, we have gone beyond what we *need* to perceive and have enjoyed the perception itself.

Albrecht Dürer's watercolor painting of an ordinary patch of small wild plants is appropriately call THE GREAT PIECE OF TURF. (See color plate 1.) This commonplace subject is seen as if for the first time.

Enjoyment of visual art, and of life, can be enhanced by an understanding of the nature of seeing. We generally think of "vision" as the means by which we see either the physical environment outside ourselves or inner images such as memories and dreams. Recent research shows, however, that the difference between "outer" and "inner" vision is not distinct. Images from both outer and inner worlds are real, and the brain uses similar processes of *visualization* in becoming aware of them.[7]

Studies indicate that vision is about one-tenth physical and nine-tenths mental. The eye receives light patterns, but it is the brain that transforms this input into meaningful images based on the preconditioned or learned perception of the viewer. The brain's two hemispheres evidently have unique but mutually dependent functions. The left side is primarily concerned with rational verbal analysis, and the right side with metaphorical, intuitive cognition. It is the right side of the brain that is concerned with aesthetic relationships, symbol making, art endeavors, intuition, and other forms of nonlinear thought. The process of visualization enables a person to bring inner and outer realities into a single experience and therefore provides the means by which ideas and images can be expressed creatively.

9 Visual metaphor.

A horticulturalist says: "Before you can have beautiful roses on your lawn or in your greenhouse, you have to have beautiful roses in your mind." This is true of many other things. Before a stately building is built it must live in the architect's mind. Before a beautiful picture is painted it must live in the artist's mind. The controlling power of life comes from within."

Rev. Paul S. Osumi[8]

As we become aware of our own sensory-related decisions—aesthetic decisions—we then begin to open up an entirely new world of sensory awareness. Ordinary things become extraordinary when seen in a new way.

The word *aesthetic* refers to a sense of the beautiful and sense perception in general. (The opposite of aesthetic is anesthetic.) Most of us have preconceived and therefore limited ideas of what is beautiful. So-called "good taste" can be a limitation because it may cause one to bypass direct personal perception. We judge what is beautiful not so much by what we feel, but by what is commonly accepted by the culture in which we live. Our perception of flowers, sunsets, waterfalls, and human forms are defined by attitudes and values. We often reject things that other cultures consider beautiful because they do not fit our mold.

We sometimes use the word *beauty* to refer to things that are simply pretty. "Pretty" means pleasant or attractive to the eye, whereas "beautiful" means having qualities of a high order, being capable of delighting the eye or engaging the intellectual and moral sense, or doing both these things simultaneously. "Beautiful doesn't necessarily mean good looking."[9] When something moves us so much that we lose ourselves in the total experience, our reaction is often referred to as an aesthetic experience. The experience is the result of intense perception and accompanying reactions.

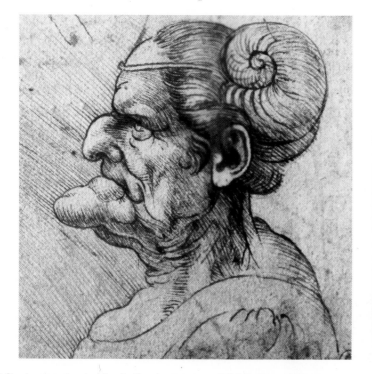

10 Leonardo da Vinci. CARICATURE. c. 1490. Pen and ink over red chalk. Royal Library. Windsor Castle. Copyright reserved.

11 Basil Wolverton and Al Capp. PANEL FROM LI'L ABNER, UGLY WOMEN CONTEST. 1946.

12 CARICATURE FROM CEILING OF HORYU-JI TEMPLE, Nara, Japan. Eighth century.

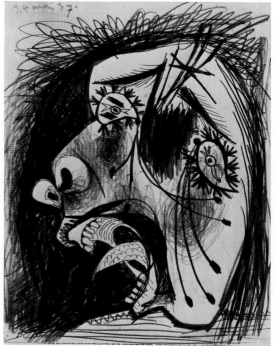

13 Pablo Picasso. HEAD (study for GUERNICA). *See illustration 414.* 1937. Pencil and gouache. 11⅜ x 9¼″. On extended loan to the Museum of Modern Art, New York, from the artist's estate.

An important dimension of awareness is the ability to open ourselves to possibilities beyond the usual limits of beauty and ugliness. Many people assume that the primary function of art is to please the senses. If this were so, ugliness would have no place in art.

Four artists from different times and places chose to explore dimensions of human "ugliness." Although the works are similar in many ways, their similarities emphasize their differences. Each work is a unique expression, created from a particular point of view.

The main concern in bringing together the works of art in this book is to let them act on the viewer as guideposts, pointing to the process that brought them into being. The art process, the creative or form making process, is itself the priceless element in the story of art.

CREATIVITY

_. . . a first-rate soup is more creative
than a second-rate painting._
 Abraham Maslow[10]
_Imagination is more important than
knowledge._

 Albert Einstein[11]

The process of visualization, especially that part involving imagination, is the source of creativity. Imagining is the forming and combining in one's mind images that are not actually present to the senses, and thus creating new images not known by experience. Since art is involved with making of actual images or forms, these mental images become visible in the visual arts, audible in music, and verbal in literature.

We all have the potential to be creative. Even though most of us have never been given the opportunity to develop this potential, we can do so by deliberately seeking new relationships between ourselves and life around us. Creativity is not limited to those with "inborn talent."

An artist (or creative person) must be a dreamer, a realist, and a skilled worker. The creative process requires the ideas of a dreaming and imaginative mind. It also requires the ability to play, to manipulate freely and consciously the elements of perceptual experience—the ability to look at one thing and see another.

There are as many ways to create as there are creative people, but creative processes generally have certain sequential characteristics in common. Dr. G. Wallis' thorough study of creativity led to his four-stage theory of the creative process.[12]

The need or desire for a thing or condition not yet existing is certainly where the creative process begins. During _preparation,_ the first stage, a person enthusiastically collects data and selects tools and media. Excitement, questioning, study, and perplexity often affect one's mood at this stage.

Incubation is the second stage. There is a shift from the conscious to the unconscious; a person may relax and turn to other things. During this period the metaphorical mind takes over and visual images realign themselves. Incubation is considered to be the most important phase. A person may have sudden incomplete insights.

Wallis calls the third stage _illumination._ During this stage, the solution suddenly appears, often unexpectedly. The person "knows" this is the inspiration for which he or she has been waiting. A feeling of certainty and joy pervades the person's entire being. The visual artist may quickly sketch the design (see Picasso, page 121), the composer may record a few bars of music, and the poet may write the central lines of a new poem.

During _verification_ or _revision,_ the fourth stage, the artist works out the design and completes the final form. A scientist completes his or her experiments and presents the proven theory. This stage culminates in the presentation of the newly created form.

To be creative is to be able to put known things together in original ways, thus producing a new thing, image, or idea. Simply making things is not enough. Nor is it enough to make something that is merely unique. The process must lead to new forms or experiences of significance.

Studies of creativity have produced various descriptions of the major characteristics of creative people. These include the abilities to:

- wonder, be curious
- be enthusiastic, spontaneous, and flexible
- be willing to approach new experience with an open mind and able to see the familiar from an unfamiliar point of view
- confront complexity and ambiguity with interest

- take advantage of accidental events in order to make desirable but unsought discoveries (called serendipity)
- make one thing out of another by shifting its functions
- generalize in order to see universal applications of ideas
- synthesize and integrate, find order in disorder

- be in touch with unconscious sources yet be intensely conscious
- visualize or imagine new possibilities
- be analytical and critical
- know oneself, and have the courage to be oneself in the face of opposition
- be willing to "lose" oneself in one's work
- be persistent, working for long periods in pursuit of a goal, without guaranteed results.

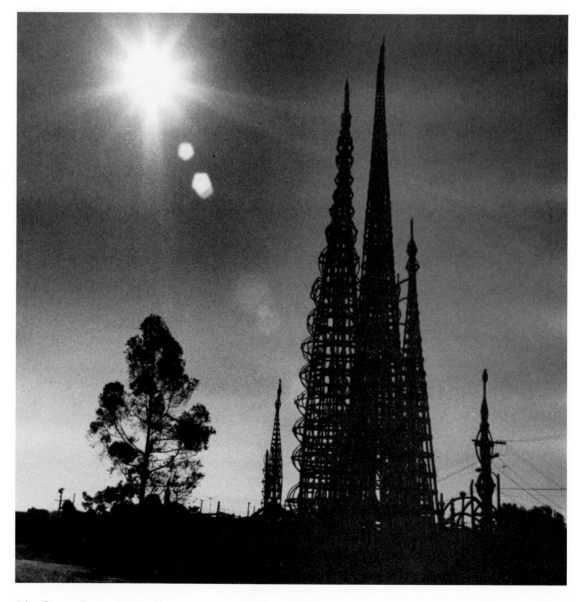

14 Simon Rodia. WATTS TOWERS. 1921-1954. Height 105'.

The Watts Towers of California are the creative work of an Italian tile-setter named Simon Rodia. He worked for 33 years creating fantastic towers out of steel rods, mesh, and mortar. They grew from his tiny triangular backyard like Gothic spires. He lovingly covered their surfaces with bits and pieces of broken tile, melted bottle glass, shells, and other colorful junk that he gathered from the vacant lots of the neighborhood where he lived. Rodia's towers and thoughts are a testimony to the creative process. His statement of purpose reads as follows:

I no have anybody help me out.
I was a poor man.
Had to do a little at a time.
Nobody helped me.
I think if I hire a man
he don't know what to do.
A million times
I don't know what to do myself.
I never had a single helper.
Some of the people say
what was he doing . . . some of the
 people
think I was crazy
and some people said
I was going to do something.
I wanted to do something
in the United States
because I was raised here you
 understand?
I wanted to do something for the
 United States
because there are nice people
in this country.

Simon Rodia[13]

Children naturally reach out to the world around them from birth. They taste, touch, hear, see, and smell their environment, becoming part of it through their senses.

Most of the abilities listed as being characteristic of creative people are found in all children during the first few years of life. What happens to this extraordinary capacity? John Holt, author of *How Children Fail*, answers:

. . . We destroy this capacity above all by making them afraid—afraid of not doing what other people want, of not pleasing, or of making mistakes, of failing, of being wrong. Thus we make them afraid to gamble, afraid to experiment, afraid to try the difficult and unknown.[14]

Many people, including some parents and teachers, ignore and may even attack evidence of creative imagination in children. This destructiveness can be traced to their own underdeveloped imaginations and to a cycle of ignorance and anxiety regarding creativity that has been passed on for generations. The tendency is to discourage in others what has been discouraged in oneself. Yet, to ignore or to criticize expressive work negatively is like saying, "Your experience is not valid, therefore you are not valid."

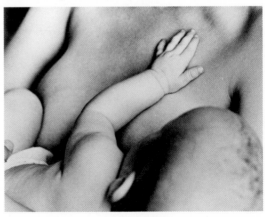

15 Wayne Miller. MOTHER AND BABY. 1948. Photograph.

16 a. This bird shows one child's expression before exposure to coloring books.

seven birds

Color seven birds blue.

16 b. Then the child colored a workbook illustration.

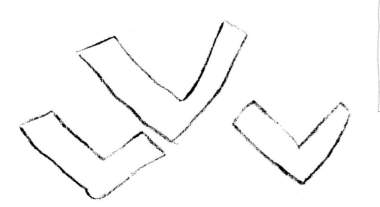

16 c. After coloring the workbook birds, the child lost creative sensitivity and self-reliance.

For all of us, especially the very young, mental and emotional growth depends on our ability to bring together experience of the world outside and experience of the world within. For this reason, opportunities for creative expression are extremely important to us. The art process helps us discover our world and helps us relate to it in positive ways.

When we were young, many of us were made to doubt the validity of our expressions. Thus we grew out of touch with our own feelings and with our natural abilities to express those feelings. Personal expression is very fragile. It is easily crushed by what may seem like a conspiracy of outside forces. These overlapping, inhibiting pressures include: being forced to follow certain views of how things should look; being embarrassed by the negative comments and criticism of others, including parents, teachers, siblings, peers; and being forced to conform to particular kinds of so-called "education."

It has long been recognized by researchers in art education that most children who have been given coloring books, workbooks, and predrawn printed single sheets at home and in school become totally dependent on such stereotyped impersonal props. They lose the urge to invent unique images relevant to their own experience, as well as individual modes of expression for those images. Such devices may even block the development of discipline and skills. Without opportunities for relevant personal expression, the urge to achieve or excel can be lost.

17 Malia, age four. SELF PORTRAIT.

It is important that children be given the opportunity to give honest, tangible expression to their ideas and emotions. Children and adults, especially adults, need a great deal of encouragement to be able to express themselves without fear or hesitation.[15]

A four-year-old girl did this self-portrait. A line drawn around the edge of her paper shows an awareness of the whole space. One hand with radiating fingers reaches out, giving strong asymmetrical balance to the composition. This was accomplished spontaneously after considerable drawing experience, but without any adult guidance or conscious knowledge of design.

At age four or five children begin drawing things they have seen. This series of drawings shows a four-year-old's struggle to draw an elephant soon after seeing a circus for the first time. He began with the most characteristic part of the elephant—the trunk. The child tried several times. Angrily he crossed out all but one of his first drawings. He not only wanted to draw an elephant, he wanted the elephant to be placed so that his entire vision of the circus could be expressed. When he was satisfied with his elephant, he turned the drawing over and drew the full circus with an elephant, lion, juggler, and tight-rope walker in action. This scene was so real for him that he asked his father to write down the story while he told about his picture.

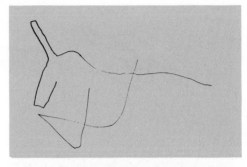

18 Jeff, age four. CIRCUS.

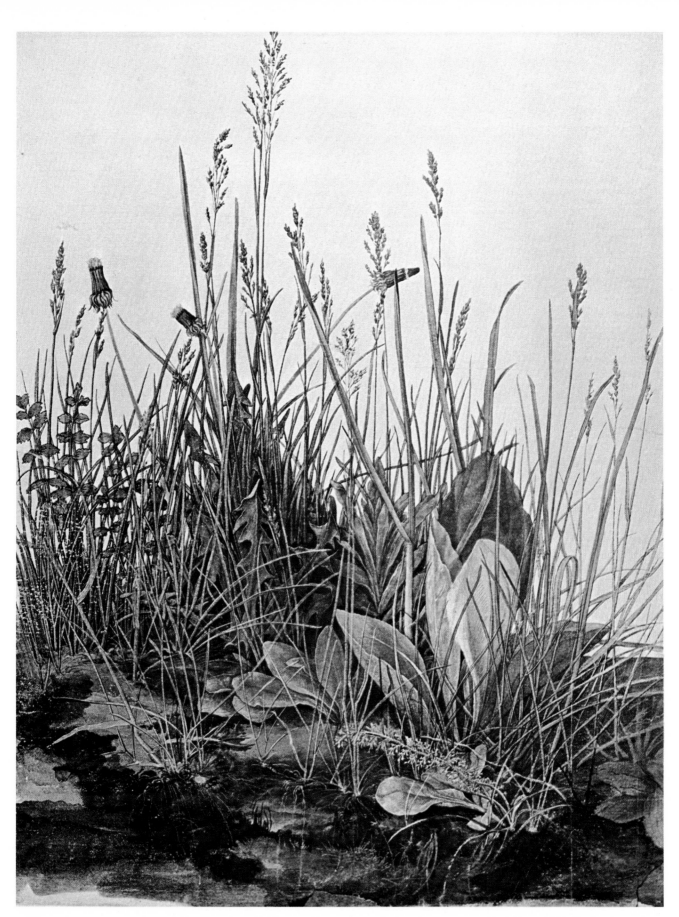

Color plate 1 Albrecht Dürer. THE GREAT PIECE OF TURF. 1503. Watercolor. 16¼ x 12⅜''. Albertina Collection, Vienna.

Color plate 2 Christopher Parfitt, age four. CHILD'S PAINTING OF A TREE. Gouache.
14 5/16 x 9¼''.

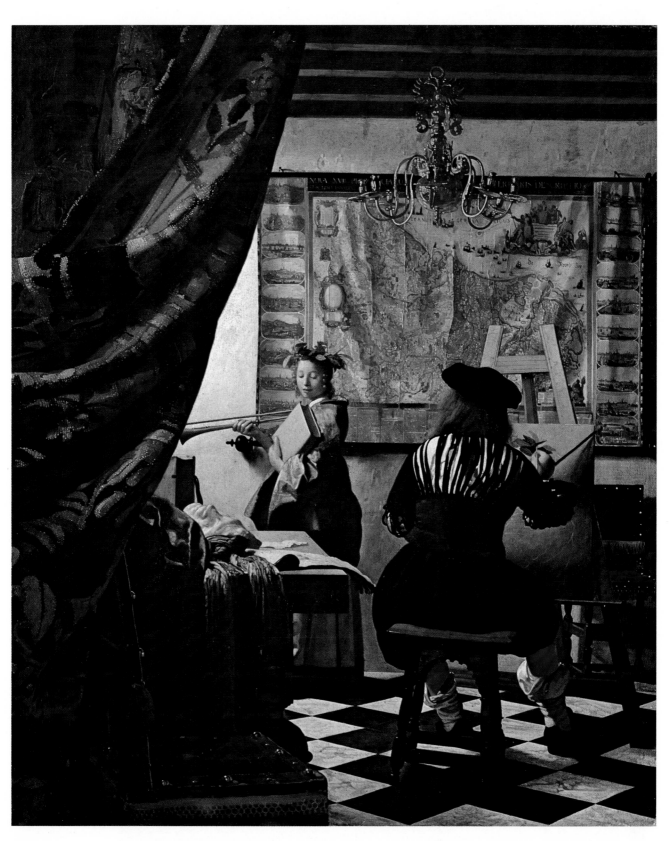

Color plate 3 Jan Vermeer. THE ARTIST IN HIS STUDIO. c. 1665. Oil on canvas. 31⅜ x 26″. Kunsthistorisches Museum, Vienna.

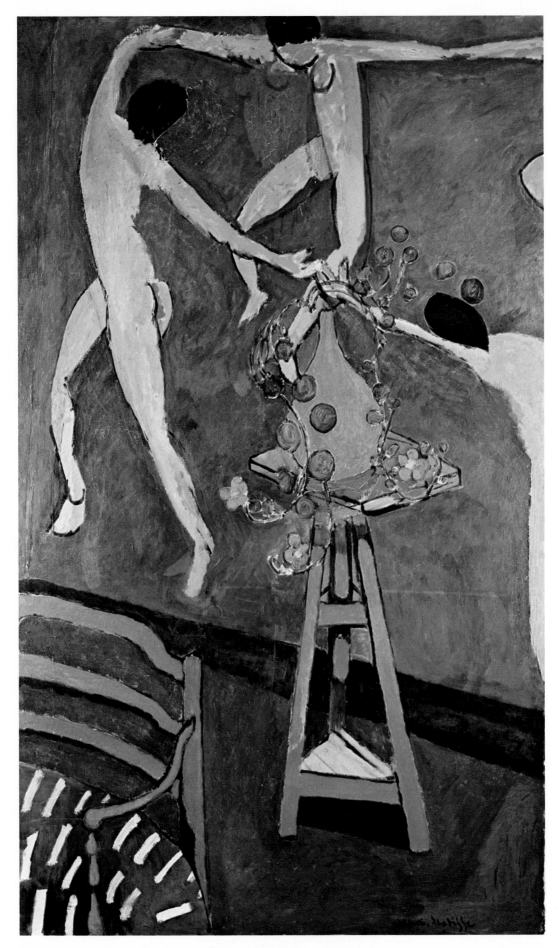

Color plate 4 Henri Matisse. NASTURTIUMS AND THE DANCE. 1912. Oil on canvas.
75¾ x 45''. Pushkin Museum of Fine Arts, Moscow.

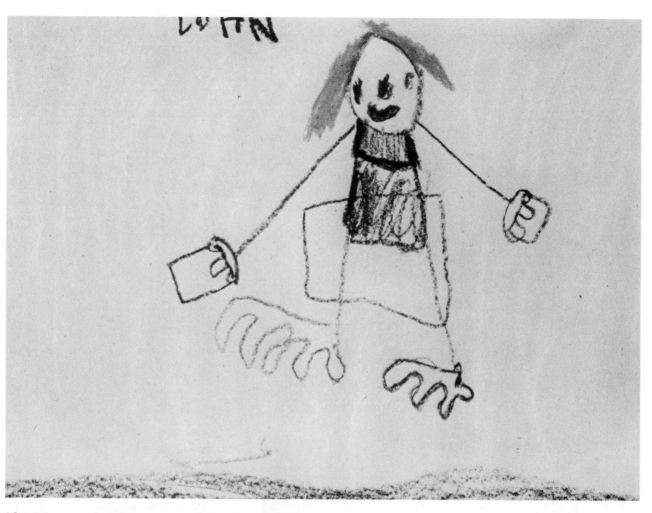

19 John, age six. WALKING IN THE GRASS AFTER THE RAIN.

The visual expression of children satisfies a crucial part of the universal human need to share things felt, thought, and imagined. How does it feel to go walking in wet grass just after it rains? John expresses the feeling eloquently.

Bali

Switzerland

India

Indonesia

Ceylon

United States

20 Children's art from around the world.

There is an international and timeless language of human expression in the work of children. The same basic visual vocabulary appears in children's pictures all over the world. Although typical motifs recur, their uses and personal variations are infinite.

With bold colors, a four-year-old child painted his feelings about a tree, color, the sun, and life itself. (See color plate 2.)

It is important to recognize that the ten-year-old boy who made this painting was working with a familiar subject, and that he had gained enough self-confidence to give visual expression to his own experience.

21 Christopher, age four. CHILD'S PAINTING OF A TREE. Gouache. 9¼ x 14⅚''. *See color plate 2, near page 18.*

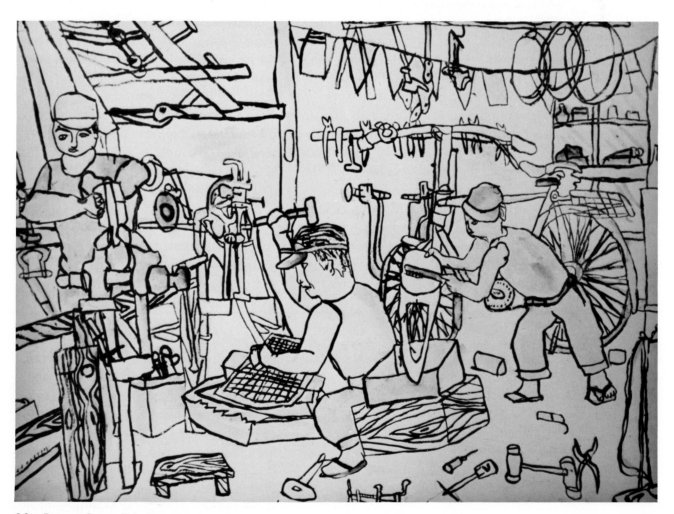

22 BICYCLE SHOP. Painting.

FUNCTIONS OF ART

Art reveals, clarifies, and extends experience by providing ways of perceiving things directly and intensely, as well as giving form to such experiences. Through these processes, the artist makes personal vision accessible and emphasizes our shared concerns. Art, science, philosophy, and religion are all ways in which we search for and demonstrate human concepts of reality. They are means employed in our continuous search for Ultimate Reality.

Art is a form of communication between the work and its maker and between the artist and the audience or viewer. It is a means of sharing the vital aspects of human life. Art can advertise, celebrate, clarify, decorate, educate, enhance, entice, express, heal, inspire, integrate, intensify, interpret, narrate, record, reveal, and transform, among other things. It can also arouse, attack, deceive, humiliate, incense, obscure, and terrorize.

Many of our everyday actions involve art-related decisions, such as choosing our hairstyles, the clothing we wear, the dishes from which we eat, the pictures we hang, and the car we drive. These objects are, in a sense, visual statements of what we are and of the kind of world we like to see around us.

Art reflects and reveals the people and values of the culture which produced it. It is not the artist alone, but our collective selves that we see in the mirror of art, both past and present.

SELF-IMAGE TO UNIVERSAL SYMBOL

In essence, a work of art is the product and expression of the artist, the culture from which it comes, and the material from which it is made. The artist's purpose is not to imitate nature, but to do what nature does, that is to create "life"—to invent something that "works"—to express an inner reality discovered beneath the shifting impressions of everyday life. A work of art is a unique object or event fashioned out of the personal experience of the individual who creates it. This is true even when the style of art is strictly controlled by forces of the society within which the artist works.

Style refers to a characteristic way of designing or shaping form that makes it identifiable as the work of a particular person, group, period, or place. Many styles are described in detail in Chapters 4 and 5. Artists choose to work in a particular way according to what they intend to express. This intention forms their style. Of course, an individual artist may also work in a variety of styles. See the works of Picasso (pages 317–324) and Kandinsky (pages 315–316).

Subject or subject matter refers to recognizable and nameable objects or themes represented in a work of art. Subject matter is the factual imagery to which the viewer responds, after relying on personal associations related to his or her particular culture. Such interpretations of the subject may be relevant. However, understanding the full significance of a work of art involves more than simply recognizing the objects portrayed.

To understand a work of art, we must be aware of its various levels of meaning, including those represented by conventional symbols and those represented by private symbols of the artist. The form itself is designed to communicate the various meanings. In this

sense works of art are symbolic when they are intended to imply something more than their obvious and immediate meaning.[16]

Representational art (also called *naturalistic*, *realistic*, and *figurative*) depicts the appearance of things. Objects in the everyday world are presented again or re-presented.

Abstract art is based on pre-existing objects, in which the natural image of the subject is changed or distorted in order to emphasize or reveal certain qualities not otherwise apparent. As a verb, "to abstract" means to take from, to extract the essence of a thing or idea. In one sense, of course, all art is abstract because it is not possible for an artist to reproduce exactly what is seen.

Nonrepresentational art (also called *nonobjective* and *nonfigurative*) rejects the representation of appearances. It presents a visual form with no specific reference to anything outside itself.

Pieter Brueghel's drawing of THE PAINTER AND THE CONNOISSEUR begins here a series of self-portraits done by different artists over several centuries. These works, and those that follow them, show the representational, abstract, and nonrepresentational modes of expression defined above and offer a visual means of getting acquainted with approaches to visual expression from the artist's point of view. All of these works show clearly each artist's involvement with the relationships among himself, his materials, and the world at large. With each work in the series—as with all works of art—viewers are asked to see through the eyes of the artist as well as their own.

We are looking over the artist's shoulder in Brueghel's drawing. Or are we? Maybe we do not wish to be identified with the connoisseur. Of course, since Brueghel and not the connoisseur did the drawing, he gives us the whole story from the artist's point of view. The drawing has been done in such a way that if we identify with anyone, it is Brueghel.

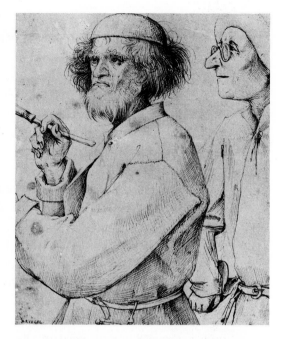

23 Pieter Brueghel. THE PAINTER AND THE CONNOISSEUR. c. 1568. Pen and bistre. 10 x 8⅜". Albertina Collection, Vienna.

Rembrandt van Rijn's tiny etching, SELF PORTRAIT IN A CAP, OPEN MOUTHED AND STARING, which he did when he was 24 years old, is reproduced here in the actual size of the original print. It captures a fleeting expression of intense surprise. Rembrandt faced his mirror directly in order to study the expressive qualities of the human face.

During his artistic career, Rembrandt produced many self-portraits. Most of the time he seemed to look upon himself as a stranger or actor, but he did so with the same penetrating insight and depth of feeling that he brought to all his human subjects. For the painting done 28 years later, Rembrandt dressed himself as a wealthy merchant. The work is brought to life by the eyes, which reveal a man of great insight and sincerity.

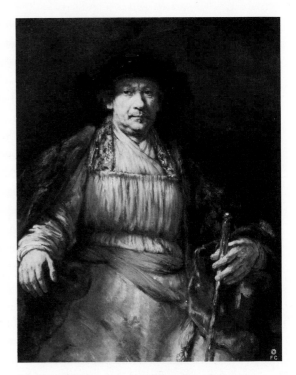

25 a. Rembrandt van Rijn. SELF-PORTRAIT. 1658. Oil on canvas. 33¼ x 26″. Copyright The Frick Collection, New York.

24 Rembrandt van Rijn. SELF-PORTRAIT IN A CAP, OPEN MOUTHED AND STARING. 1630. Etching. 2 x 1⅞″. The British Museum, London.

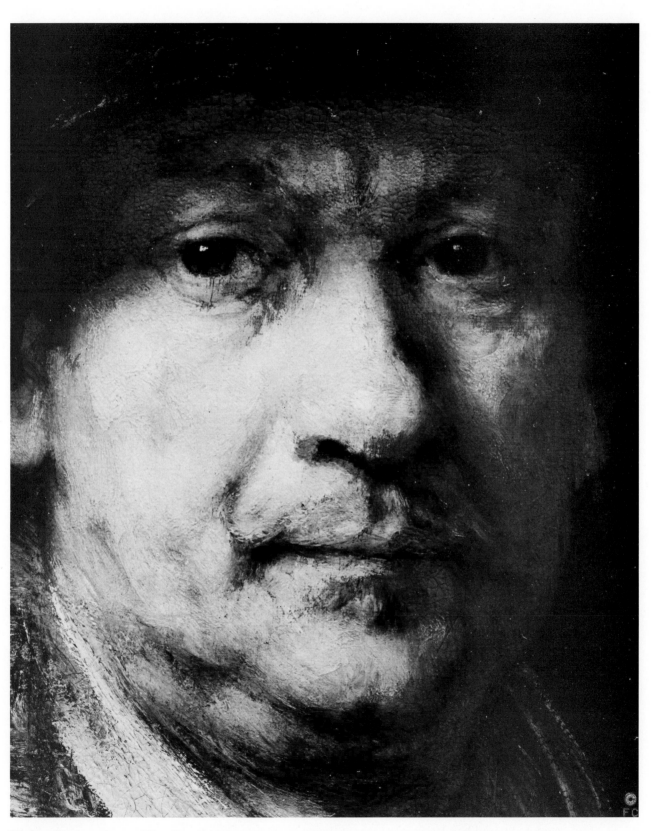

25 b. Rembrandt van Rijn. Detail of SELF-PORTRAIT.

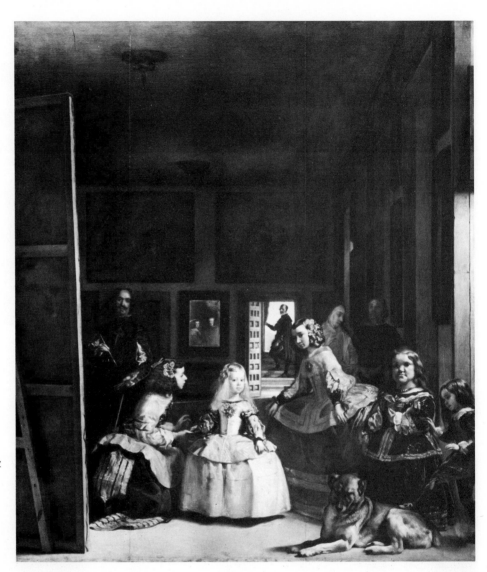

26 Diego Rodriguez de Silva y Velázquez. THE MAIDS OF HONOR. 1656. 18 x 15¾'. The Prado Museum, Madrid.

The great seventeenth century Spanish painter, Diego Rodríguez de Silva y Velázquez, painted himself at work on the large canvas originally called THE ROYAL FAMILY, now known as THE MAIDS OF HONOR or LAS MENINAS. This was the painter's last major work. The Infanta Marguerita, the blond daughter of the king, is easily seen as the center of interest. Velázquez emphasized her by making her figure the clearest and lightest shape and by placing her near the foreground close to the center. Around her, Velázquez created the appearance of his large studio, in which a complex group of life-size figures interact with the princess and the viewer. The interaction between ourselves and the image of this fascinating group sustains our interest. As the king and queen viewed this work, they saw themselves as painted reflections in the mirror on the far wall. Although obscure, these two mirrored figures are a pivotal point for the entire composition. As we view the work today, we see it as if we were reflected in the mirror ourselves.

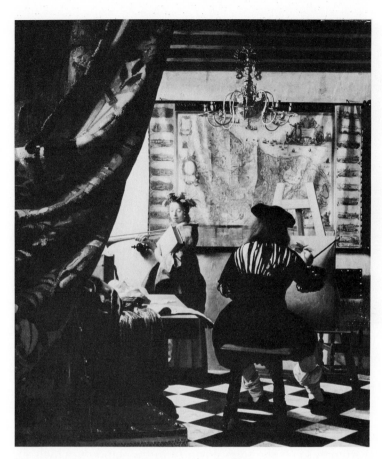

27 Jan Vermeer. THE ARTIST IN HIS STUDIO.
c. 1665. Oil on canvas. 31⅜ x 26″.
Kunsthistorisches Museum, Vienna.
See color plate 3, near page 18.

By masterfully controlling the light, color, and placement in space of everything in the room, Velázquez has led us through a very intricate composition, designed in such a way that it reveals not only the artist's view of the court of Philip IV, but his view of the veils of illusion inherent in life itself. Velázquez placed himself directly in semishadow, brush in hand, where his image acts as a kind of signature to the work. The realities of flat, painted illusion and the actual three-dimensional world are masterfully joined in this mind-teasing image of vast proportions and rich complexity.

Another seventeenth century self-portrait reveals the artist's world and concerns, though we do not see the artist's face. In THE ARTIST IN HIS STUDIO, Jan Vermeer painted himself at work, as did Velázquez. (See color plate 3.) Our eyes move immediately past the heavy curtain to the strong black-and-white stripes on the back of the artist's shirt. We find ourselves looking with him at his painting on the easel and beyond that to the model posing as an allegorical figure who may represent fame. She is only mildly interesting; she seems like a prop and acts as a neutral focal point. Vermeer is showing us himself in his studio, but more important than the physical appearance of his studio is the way in which he presents it—his way. Although it looks as though we came upon the situation by chance, every relationship in this painting was carefully selected by the artist. As in the work of Velázquez, light and placement play very important roles. For Vermeer, directional light was a major element defining the precise character of each thing he observed.

In Rembrandt's work, we saw the artist *as* model; in the works of Velázquez and Vermeer, the artist *and* his models. The following two paintings are not self-portraits, but they do deal with the relationship between artist and model.

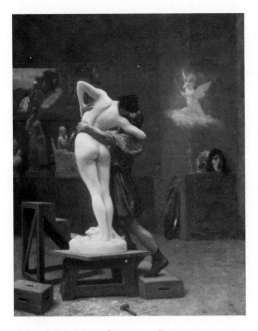

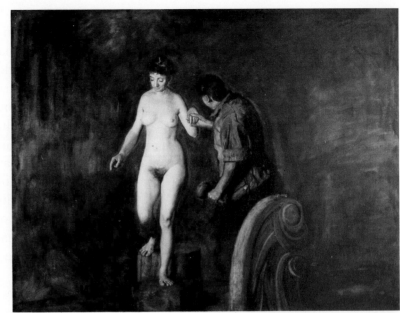

28 Jean Léon Gérôme. PYGMALION AND GALATEA. c. 1860. Oil on canvas. 35 x 27''. The Metropolitan Museum of Art, New York. Gift of Louis C. Raegner, 1927.

29 Thomas Eakins. WILLIAM RUSH AND HIS MODEL. 1907-1908. Oil on canvas. 35¼ x 47¼''. Honolulu Academy of Arts.

The Greek myth of Pygmalion tells of a sculptor who created a statue of a woman so beautiful he fell in love with it. Aphrodite, goddess of love, responding to the artist's prayer, made the figure actually come to life, and the pair lived happily ever after. In PYGMALION AND GALATEA, a painting illustrating this myth, the French painter Jean Léon Gérôme places the woman on a pedestal, both literally and figuratively.

In Thomas Eakins' painting of WILLIAM RUSH AND HIS MODEL, the woman comes down off the pedestal and takes her place in the real world. Eakins painted his friend, the sculptor William Rush, helping his model as she steps down from the stand on which she has been posing. Although the artist depicted is not Eakins, it is clear that he identified so strongly with his friend that it could easily have been he.

Eakins' painting shows us a man of considerable physical strength as well as tenderness. Rush has his mallot firmly in one hand and his model's hand gently in the other. The model is not a "raving beauty," yet she descends from the stump as if she were a queen being helped from her royal carriage.

The model is the main subject here. Eakins has demonstrated an attitude that he asks us to share. It is an attitude of great respect and admiration for what is real as opposed to the artificialities of what had become a stereotyped ideal. What Eakins asks us to confront is the beauty of the ordinary human figure and perhaps, by extension, the importance of really seeing all so-called ordinary things.

If we look at more than one work of a given artist, we soon begin to discover the point of view that is the basis of that artist's personal expression. Of course this can change and often does. As point of view changes, style changes.

Each one of us has a particular point of view that determines how we experience the world around us, and also what we experience.

In every work of art, the artist creates form out of his or her own experience. In doing this, the artist is saying, "Here I am. I exist. This is what is important to me. This is how I see life." In this sense, every work of art is a self-portrait. In another sense, even a representational self-portrait is not merely a self-image, but is also an attempt to give universal significance to a personal experience. As art contributes to the expanding consciousness of the artist and the viewer, it creates humanity.

The works of the following five artists demonstrate this. Although they lived during approximately the same time, they come from different countries and hold very different attitudes. The first three, Henri Matisse, Käthe Kollwitz and Werner Bischof, were primarily interested in people and, therefore, the human figure is their most frequent subject.

In 1908, Henri Matisse wrote the following statement about his work:

The purpose of a painter must not be conceived as separate from his pictorial means, and these pictorial means must be the more complete (I do not mean complicated) the deeper is his thought. I am unable to distinguish between the feeling I have for life and my way of expressing it.[17]

Matisse wrote these words a few years before he painted NASTURTIUMS AND THE DANCE. (See color plate 4.) The work illustrates his point. In this painting of a corner of his studio, he shows a chair, a sculpture stand topped by a vase of flowers, and against the wall a section of his large painting called THE DANCE. Here Matisse expresses what the French call *la joie de vivre* or "the joy of life." Every line, shape, and color radiates with it. And this is true of most of his work.

The human figure had a particular importance for Matisse. He said:

What interests me most is neither still life nor landscape but the human figure. It is through it that I best succeed in expressing the nearly religious feeling that I have towards life.[18]

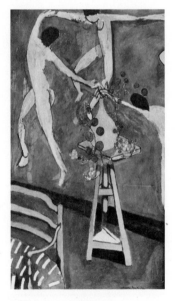

30 Henri Matisse.
NASTURTIUMS AND THE
DANCE.
1912. Oil on canvas.
75¾ x 45".
Pushkin Museum of
Fine Arts, Moscow.
*See color plate 4, opposite
page 19.*

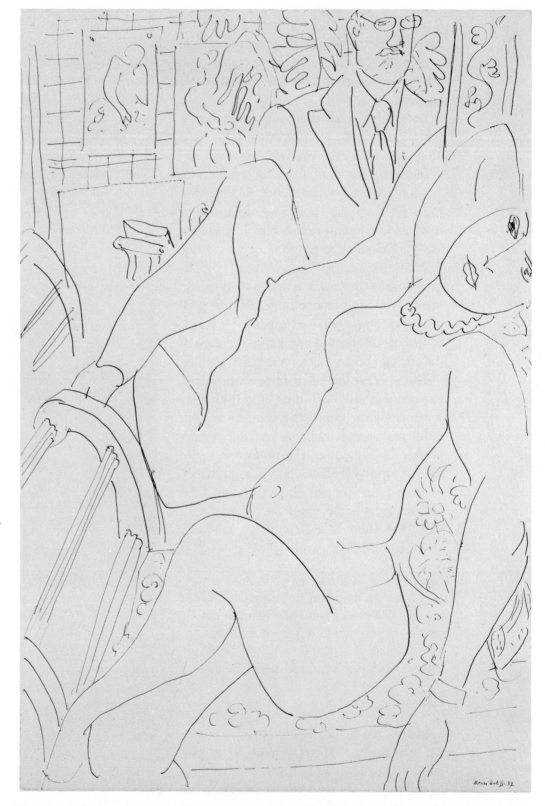

31 Henri Matisse. ARTIST AND MODEL REFLECTED IN A MIRROR. 1937. Pen and ink. 24⅛ x 16⅙''.
The Baltimore Museum of Art, The Cone Collection.

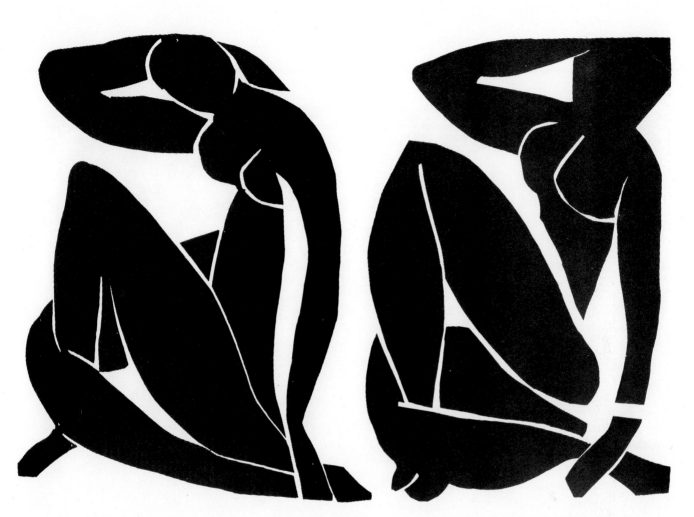

32 Henri Matisse. BLUE NUDE III and BLUE NUDE IV. 1952. Gouache cutout. 105 x 85 cm., 109 x 74 cm. Private collection, Paris.

Matisse was a great master of the first half of our century. Although during his lifetime (1869–1954) there was much suffering in the world, he chose to emphasize happier themes.

In the article quoted above, which was published on Christmas Day in 1908, Matisse states his purpose as a painter:

What I dream of is an art of balance, of purity and serenity, devoid of troubling or depressing subject matter, an art which might be for every mental worker, be he businessman or writer, like an appeasing influence, like a mental soother, something like a good armchair in which to rest from physical fatigue.[19]

In this free and sensuous drawing (opposite page), Matisse appears in a mirror along with the reflected back view of his model. His formal business-like image acts as an effective point of contrast to the model, and appears, as in other works that we have seen, to remind us that the expressive lines exist because of him. There is no chance that we might confuse this with an anonymous reflection of reality. It is an extension of Matisse.

THE BLUE NUDES by Matisse were cut from paper when he was an invalid two years before his death. His feeling for life comes across as strongly as ever. These late works are some of his most joyous.

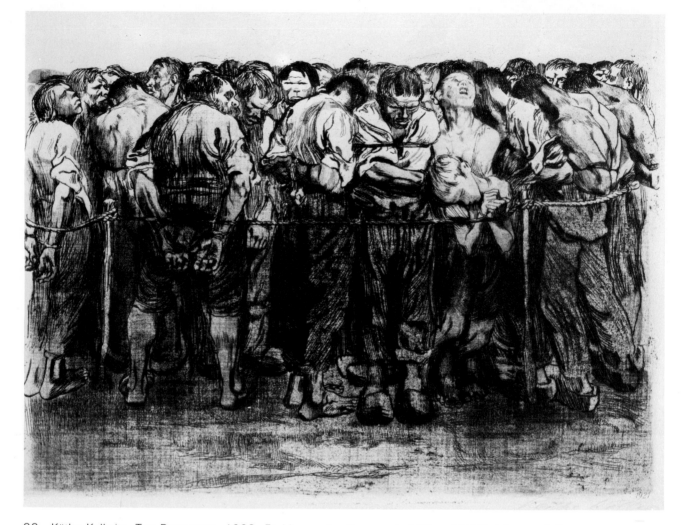

33 Käthe Kollwitz. THE PRISONERS. 1908. Etching and soft-ground. 12⅞ x 16⅝". Library of Congress, Washington, D. C.

In contrast, the work of Käthe Kollwitz expresses a completely different attitude toward life. Throughout her life, she identified with the sufferings of the poor and the oppressed who were often her neighbors. She lived in Germany during the first half of this century and was aware that many around her were experiencing extreme anguish and pain. She and her husband, a physician, acted as social workers, welcoming those with grief and problems into their home. Her strong identity with the suffering of others is revealed in her prints and drawings, many of which appear to be self-portraits. She lost a son in the First World War, and a grandson in the Second, but her personal grief was secondary to her deep concern for humanity. Käthe Kollwitz dreamed of a united mankind that would elevate human life above the misery she saw so clearly.

The three prints reproduced here were made over a period of 26 years, yet they are remarkably consistent in mood and graphic quality. THE PRISONERS, done in 1908, was one of a series of prints inspired by Kollwitz's interest in a violent peasant revolution that occurred in southern Germany in 1525.

The lithograph DEATH SEIZING A WOMAN was completed in 1935 although the original drawing expressing this idea was done in 1924. The impact of this print was achieved by reducing the idea to its essentials. The mother holding her child in a protective grasp stares ahead in terror as the symbolic figure of death presses down on her from behind. Dramatic lines focus attention on the mother's expression of fear.

The self-portrait done in 1934 reveals a kindly, yet monumental face—a powerful image of a woman who knew great personal grief and felt deep concern for humanity.

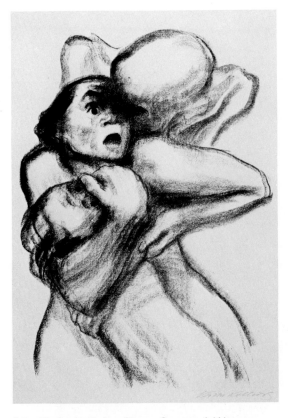

34 Käthe Kollwitz. DEATH SEIZING A WOMAN. 1935 Lithograph. 20 x 14⁷⁄₁₆''. The Museum of Modern Art, New York.

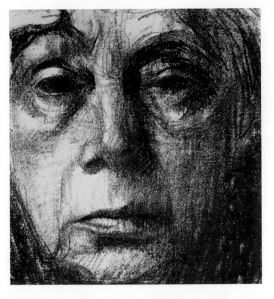

35 Käthe Kollwitz. SELF-PORTRAIT. 1934. Lithograph. 8¹⁄₁₆ x 7³⁄₁₆''. Philadelphia Museum of Art, given by Dr. and Mrs. William Wolgin.

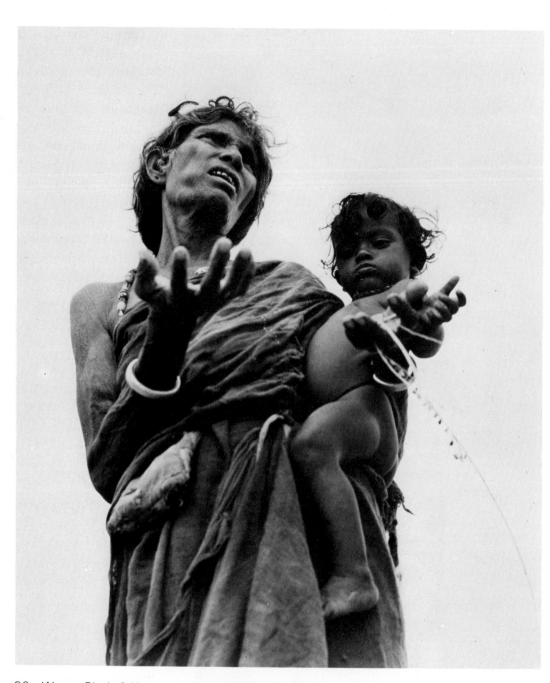

36 Werner Bischof. HUNGER IN INDIA. 1951. Photograph.

From his photographs, we can see that photographer Werner Bischof also had compassion for all he saw of human suffering. His photograph of a starving mother and her child, HUNGER IN INDIA, taken in 1951, is one of the most heartrending ever made. By coming close to his subject at a low angle, he was able to bring together the pleading hand and face of the mother. The gaze of the child brings the composition back to us. In this image Bischof calls our attention to a major problem of humanity and asks for our help in solving it. The

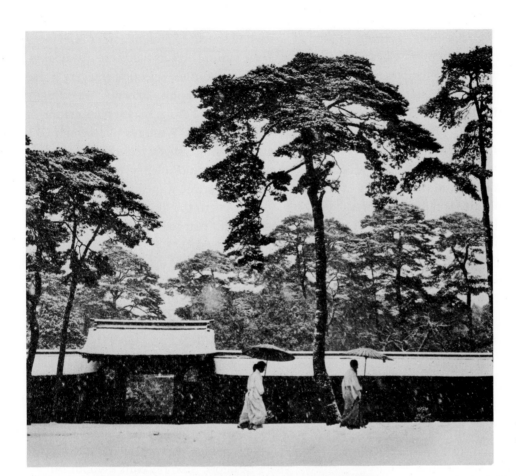

37 Werner Bischof. SHINTO PRIESTS IN TEMPLE GARDEN. Meiji Temple, Tokyo, 1951. Photograph.

38 Werner Bischof. LONE FLUTE PLAYER. Peru, 1954. Photograph.

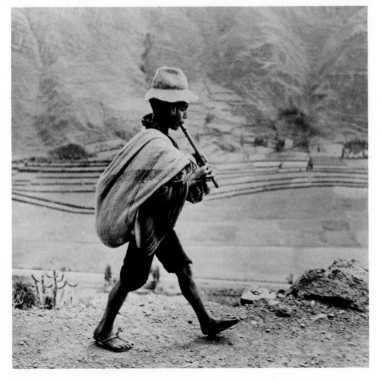

visual statement of the artist alerts us to the need for social change.

In the same year, Bischof photographed SHINTO PRIESTS IN TEMPLE GARDEN. By carefully selecting his distance from the figures, he shows their relationship to the trees, and thus records a classic image of a basic Asian attitude toward man in nature.

One of Bischof's last photographs was LONE FLUTE PLAYER, taken in Peru. The lilting steps of the boy with his flute are captured with lyric charm. A feeling for form, as well as a deep human understanding, enabled him to protest or affirm aspects of the human condition by visually saying NO! or YES!

By discovering their own responses to life, artists are able to give of themselves so deeply that it is no longer just themselves they are giving. The expressions of their experience become universal and therefore valuable and accessible to all.

Bischof's work recorded transitory moments that reveal the essential qualities of the human condition. Edward Weston was a photographer with a different focus. He wanted to record his feelings for life as he saw it in the "sheer aesthetic form" of his subjects. In doing so, he revealed with clarity and intensity the universality of the many natural objects with which he was working.

Clouds, torsos, shells, peppers, trees, rock, smokestacks are but interdependent, interrelated parts of a whole, which is life.—Life rhythms felt in no matter what, become symbols of the whole.

Edward Weston, April 24, 1930[20]

Weston sought to present, rather than interpret, the natural objects that were his subjects. By exercising critical selection in every phase of the photographic process, he finally achieved his goal of significant presentation of the thing itself. Is Weston's photograph of a green pepper meaningful to us because we like peppers so much? Probably not. Weston has been able to create a meaningful image on a flat surface with the help of a pepper. It is his sense of form that tells us how he has experienced this pepper.

August 8, 1930

I could wait no longer to print them—my new peppers, so I put aside several orders, and yesterday afternoon had an exciting time with seven new negatives.

First I printed my favorite, the one made last Saturday, August 2, just as the light was failing—quickly made, but with a week's previous effort back my immediate, unhesitating decision. A week? —yes, on this certain pepper—but twenty years of effort, starting with a youth on a farm in Michigan, armed with a No. 2 Bull's Eye Kodak, 3½ x 3½, have gone into the making of this pepper, which I consider a peak of achievement.

It is classic, completely satisfying,—a pepper—but more than a pepper . . .[21]

Our aim is to help you arrive at the point where you do not need subject matter or verbal interpretation to recognize your responses to visual form.

Having looked at a collection of works in which human forms dominate as subject matter, it is important to realize that visual forms, like audible sounds, evoke responses in us whether they represent subjects, or not. Many people are concerned more with subject than form. Representational works seem easier to identify with and therefore less demanding than non-representational works. But subject is a minor element in many of the arts. Without significant form, subject is irrelevant.

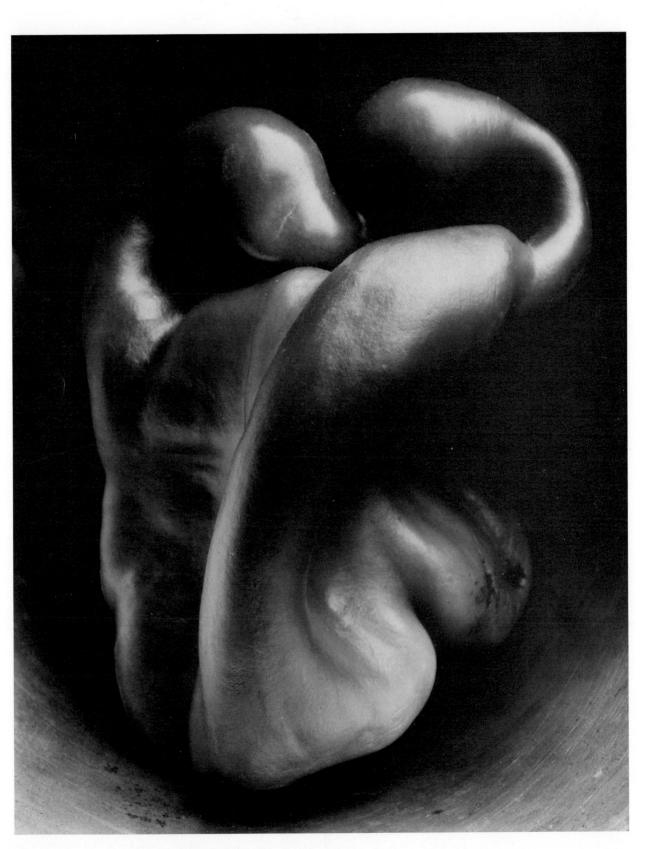

39 Edward Weston, PEPPER #30. 1930. Photograph.

40 Piet Mondrian. RED TREE. 1908. Oil on canvas. 27½ x 39''. Gemeentemuseum, The Hague.

41 Piet Mondrian. TREES IN BLOOM. 1912. Oil on canvas. 25⅝ x 33½''. The Solomon R. Guggenheim Museum, New York.

42 Piet Mondrian. COMPOSITION WITH RED, YELLOW AND BLUE. 1930. Oil on canvas. 19 x 19''. Private collection. _See color plate 36, near page 322._

Piet Mondrian's 1910 painting RED TREE shows the artist's early concern with the visual pattern or structure created by the tree's branches and the spaces between them. At that time Mondrian was beginning his long quest for the purest means by which art can express universal truth. Through what he saw as the "essential plastic means of art"—line and color freed from any particular subject matter—he sought to emphasize the expressive qualities of pure nonrepresentational form.

[Non-figurative art] shows that "art" is not the expression of the appearance of reality such as we see it, nor of the life which we live, but that it is the expression of true reality and true life. . . .[22]

Mondrian worked to free painting from the depiction of nameable objects and even from the expression of personal feelings. He wanted to lead the way toward an art that was objective, impersonal, and universal in its implications. His progression from representation to nonrepresentation placed greater and greater emphasis on the fundamental qualities of proportion, balance, and rhythm. Within the strict limitations that he set for himself, he was able to achieve a rich variety of formal images expressive of life's essential nature.

Artists manipulate visual form in order to express their ideas and feelings, regardless of whether or not these ideas and feelings refer to the appearance of things in the everyday world. The expressive potential of the various aspects of visual form is the subject of the next chapter.

2 WHAT DO WE RESPOND TO IN A WORK OF ART?

Art is "defined by context and completed by the spectator's response"
Marcel Duchamp[1]

VISUAL COMMUNICATION

Verbal language consists of certain sounds with agreed-upon meanings that are learned through continuous repetition. Verbal language is highly abstract; it is not visually representational. Except for a learned association, word symbols have little or no connection with the things to which they refer. Therefore, when repetition stops, verbal language is soon forgotten.

The world we know through our senses has meaning for us apart from verbal language. When we speak of a "language of sound" or a "language of vision," we are referring to the elements and groupings of audible or visual phenomena to which humans react in generally similar ways. That is, there are common human responses to much sensory experience. However, there are no auditory or visual languages based on specific, agreed-upon meanings that are independent of verbal languages. With the help of words, we can analyze and therefore better understand the ways in which artists work with the elements of visual form to communicate certain meanings.

Although we live at a time when there is emphasis on visual images, many of us are still visually illiterate. The first step toward becoming visually literate is to open ourselves up enough to realize what our senses are telling us; to become increasingly aware of what we see and how we feel about what we see. Enjoying the visual arts requires this ability to see, yet, as we have observed, few of us are given the chance to develop it.

Art is a form of communication. The artist interacts with the audience through the form he or she gives to the work. The artist is the source or sender. The work is the medium carrying the message. We, as viewers, must receive and experience the work if the communication is to be complete.

Clearly, it requires effort to put a work of art together. What is not so clear is that responding to a work of art also requires effort. Contemporary American composer John Cage calls this to our attention:

Most people mistakenly think that when they hear a piece of music, that they're not doing anything, but that something is being done to them. Now this is not true, and we must arrange our music and our art so that people realize that they themselves are doing it, and not something is being done to them.[2]

FORM AND CONTENT

We guide our actions by reading the form and content of the people, things, and events that make up our environment. We have an amazing ability to remember certain visual forms. We read content based on our previous experiences with the forms. A stranger who looks like someone we know may cause feelings of like or dislike depending on how we feel about the acquaintance. When we see faces and figures of people whom we have seen before, they are familiar.

Form in its broadest meaning refers to the combination of all perceivable characteristics of any given thing. In art, form is the total structure of the visual elements working together in a design. _Content_ is the cause, the meaning, the life within the outer form. Content determines the form and is expressed by it. The two are inseparable. All form has some content and any content must have some form. The basic content of works of art is usually spiritual, emotional, or experiential. When perceiving any physical form, we see and respond to the character of the form. Artists manipulate form in order to express certain content. In the visual arts, form is what we see, and content is what we interpret as the meaning of what we see. As form changes, content changes.

If we take an agreed-upon symbol for a subject, we can change its form in such a way that its generally accepted content is completely changed. For example, the valentine ♥ heart, an abstraction of the human heart, is a symbol of love. If someone were to give you a huge, beautifully made red velvet valentine, so large it had to be pulled on a cart, you would probably be overwhelmed by this gesture of love. The content would be—LOVE! But if you were to receive a faded mimeographed outline of a heart on a sheet of cheap paper, you might read the content as: love—sort of—a very impersonal kind. Or, if you were to receive a shriveled, greenish-brown, slightly moldy image of the heart symbol, the content might be considered: UGH, HATE!

To understand how art contributes to experience, it is revealing to examine a series of works with the same subject, varying in form and content. In those presented here, the universal relationship between mother and child is symbolized by artists far apart in time and location. These contrasting images of the same subject are all valid expressions of the ideals, intentions, and experiences of individual artists from different cultures.

It is possible that the most important event related to the mother and child theme is birth itself. However, our culture has long avoided presenting visual images of this event. It is only recently that photography and film have recorded the birth of a child for public viewing.

The Aztec sculptor who carved this image of childbirth gave powerful abstract form to the essential aspects of birth as it was practiced by that culture. The figure of the mother, TLA-ZOLTÉOTL, Aztec goddess of childbirth, has been simplified and strengthened by exaggerating some parts and underplaying or omitting others. By so doing, the artist has created a symbol of great impact based on a consistently bold abstraction of human anatomy. A rare contemporary depiction of birth can be seen in Steve Handshu's FOREST BIRTH on page 9.

The African Ashanti carving is part of a drum stand. The original work includes two animals supporting a large drum and a father as well as this nursing mother. This detail is a direct, abstract, geometrically clear portrayal of a nursing mother.

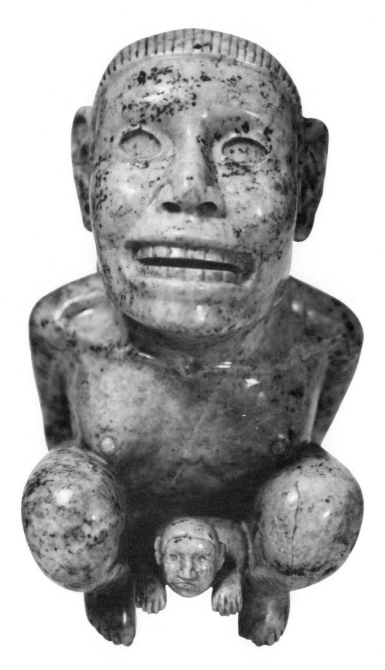

43 TLAZOLTÉOTL. Aztec Goddess of Childbirth. c. 1500. Aplite. Height 8⅛″. Dumbarton Oaks, Washington, D.C.

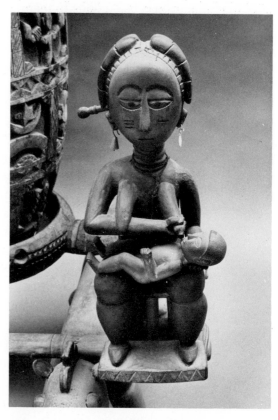

44 Detail of DRUM STAND. Ashanti, Ghana. c. 19th century. Height 31″. Ghana Museum. Photograph: Eliott Elisofon.

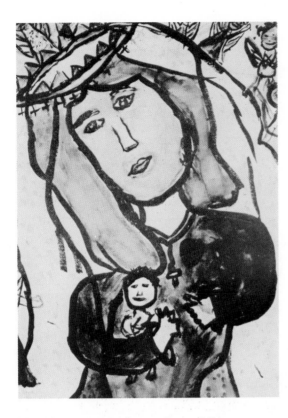

45 MADONNA AND CHILD. By a child.

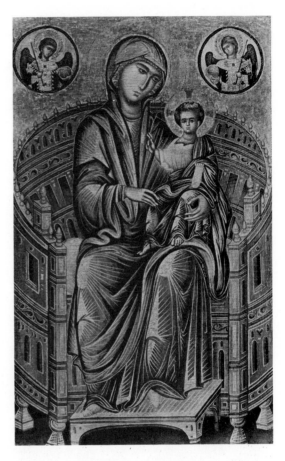

46 ENTHRONED MADONNA AND CHILD. 1200.
Byzantine School. Tempera on wood.
32⅛ x 19⅜". National Gallery of Art,
Washington, D.C. Andrew Mellon Collection.

The art of tribal cultures is based on sophisticated traditions and is therefore quite different from the naive simplicity of children's art. Without an artistic tradition to guide her expression, the shy girl who made this picture of Mary holding the Christ Child was able to give form to her personal feelings. She seems to have identified with both the tiny secure child and the large protective mother. In this sense it is a self-portrait. The free, flowing lines, curving shapes, and size of the image in relation to the size of the paper contribute to the symbolic power of this painting.

The abstract Byzantine ENTHRONED MADONNA AND CHILD, painted in Constantinople about 1200, is as highly stylized and removed from natural appearance as the Ashanti figure. As a depiction of mother and child, it seems more remote than the preceding child's painting. The Byzantine style, still followed by artists working within the tradition of the Eastern Orthodox Church, resolves both the desire to avoid idolatry and the need to educate the illiterate through pictures.

The figures of Mary and Christ are seated on a throne that seems to symbolize the Roman Colosseum where the early Christians met death for their beliefs. In order to emphasize the spiritual content, the artist abstracted the form. The draped robes covering the figures are indicated by linear patterns that give scarcely a hint of a body underneath. The gold background surrounding the throne symbolizes heaven and the Colosseum represents the earthly Christian setting. This is not the image of an ordinary mother and child. Christ appears as a wise little man, supported on the lap of a heavenly, supernatural mother.

43

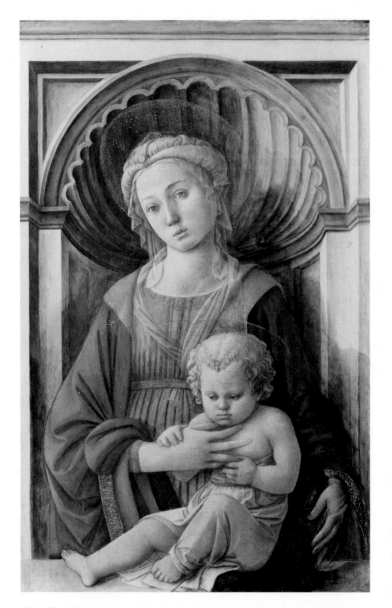

47 Fra Filippo Lippi. MADONNA AND CHILD. c. 1440–1445. Tempera on wood. 31⅜ x 20⅛″. National Gallery of Art. Washington, D.C. Samuel H. Kress Collection.

Approximately 250 years later, the Italian Renaissance painter, Fra Filippo Lippi, painted a very different MADONNA AND CHILD. Many abstract refinements handed down from the Byzantine tradition are visible, yet the image is now essentially representational in style. The mother is still enthroned and her child is still both child and wise man. Yet the figures and the niche behind them now appear more earthly or natural, in keeping with the Renaissance desire to humanize medieval Christianity. Both Mary and Christ appear quite three-dimensional. Light and shade are effectively employed to give the figures and their setting a solid sculptural quality. Behind the appearance of naturalism, Lippi has given the figures quiet grandeur by placing them carefully within the simple shape of the niche.

At about the same time, Andrea Mantegna painted an even more representational picture

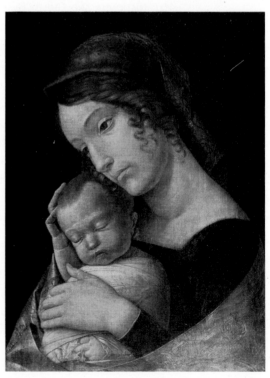

48 Andrea Mantegna. THE MADONNA AND CHILD. c. 1445. Tempera. Staatliche Museum. Berlin.

of the Madonna that must have been a surprise to his contemporaries. Here is a natural looking image of a mother and child. If it were not for the title, THE MADONNA AND CHILD, we would have no clue that this tender scene is meant to be Christ and his Mother.

In keeping with the humanist ideals of the Renaissance, the Madonna is now a humble, accessible woman, no longer enthroned. Christ is a sleeping infant with no suggestion of his future. Only Mary's introspective gaze suggests that there is more to come. The painting is a universal statement of the mother-child relationship seen as Christian subject matter.

Pablo Picasso's conté crayon drawing has much in common with the tempera painting by Mantegna. The drawing, A MOTHER HOLDING A CHILD, was done as a study for a painting of a circus family. Picasso tried several times to capture the right gesture of tenderness in the hands of the mother as she holds her baby. The relationship of love between the mother and child is emphasized by the child's upreaching arm and by the mother's inclining head and fallen lock of hair.

The elegant calm of the mother and child in the drawing contrasts sharply with the brutal anguish of a mother holding her dead child in a detail of Picasso's painting GUERNICA. (See also a reproduction of the full painting on pages 344 and 345.) Not only does the breadth of Picasso's visual expression become evident, but we see the way in which the visual form is changed as the content expressed by it is changed. Picasso consciously modified the visual depiction of anatomy in order to increase the impact of his imagery.

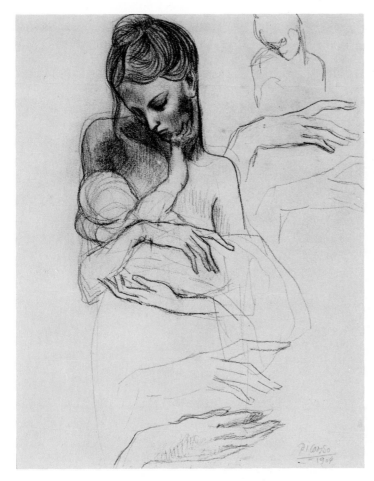

49 Pablo Picasso. A MOTHER HOLDING A CHILD AND FOUR STUDIES OF HER RIGHT HAND. 1904. Conté crayon. 13½ x 10½". Fogg Art Museum, Harvard University. Bequest of Meta and Paul J. Sachs.

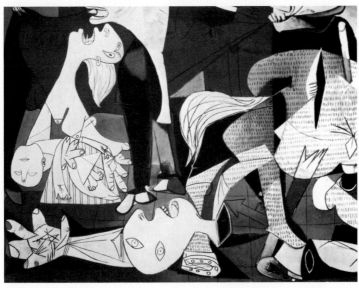

50 Pablo Picasso. Detail of GUERNICA. 1937. Oil on canvas. On extended loan to the Museum of Modern Art, New York, from the artist's estate. See pages 344–345.

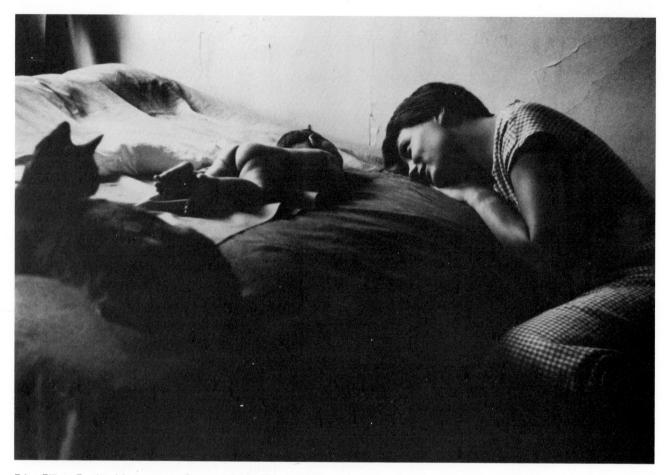

51 Elliott Erwitt. MOTHER AND CHILD. 1956. Photograph.

Elliot Erwitt's photograph of his family reveals the intimate involvement of a husband-father with the mother and child theme. Erwitt managed to capture a lasting image of motherly love. His compassion mixed with awe comes through to the viewer. Strong directional lighting and the low angle of vision convince us that we are there, a part of this private scene. The resulting naturalness of MOTHER AND CHILD suggests a spontaneous and effortless endeavor, yet these very qualities reveal the skill and intuitive abilities of the artist. Erwitt has created a photograph that shares the special bond of the family unit.

The preceding illustrations show diverse treatments of the mother and child theme. These different images, and our own responses to them, result from the way each individual artist has manipulated the various elements of visual form. We will begin to explore the "language" of visual form by developing an understanding of the expressive potential of each of these elements.

VISUAL ELEMENTS

Visual experience is one continuous flow of complex interrelationships. However, in order to discuss visual form, it is necessary to recognize the expressive potential of the various elements and their interactions within the form. The number of elements and the terms used to identify them vary considerably among artists and teachers. All of these elements can be discussed separately, but they are largely inseparable.

Analyzing works of art may sometimes seem like killing the art itself. Dissection of a "living" thing usually kills it. The frog cut open in biology class, for example, will never hop again. But works of art are not biologically alive, so there is a good chance they will go back together again visually. And hopefully they will be freshly perceived and enjoyed even more than before they were "taken apart" and verbally analyzed. Much of what is learned during analysis of one work can be applied to others.

In our discussion, the words used to designate visual elements are merely tools for discussing the various aspects of line, shape, light, color, texture, mass, space, time, and motion. They represent an attempt to translate visual form into verbal symbols. In the last section of this chapter, we discuss the design principles involved in the process of structuring or composing visual elements into significant whole forms.

As we said, all visual elements are simply aspects of total form and are usually experienced simultaneously. Separating them to present them one at a time in a sequence can be misleading. However, we will see that the sequence itself is relevant to our study.

Line is presented first because it is one of the easiest elements to understand and use. It grows out of the smallest visible unit or event: a point or dot. As a point moves, it creates or implies a line. When a line turns back on itself, it defines a shape. Shapes also appear because of changes in light, color, and texture. Light reveals color and texture. Color is an aspect of light as well as a surface quality. Texture is a tactile surface quality. The three-dimensional qualities of mass are revealed by light, but they can also be experienced through the textural qualities of surfaces.

Mass is always within space and interacting with it, both enclosed by it and enclosing it in infinite ways. The full dimensions of space are experienced through motion occurring in time as well as space. The process of structuring these aspects of form into works of art is design. When we know something about the expressive potential of the visual elements and how they interrelate according to the principles of design, we can evaluate the results with a greater sense of knowing why we respond the way we do.

52 Saul Steinberg

Line

Line is the path left by a moving point. It is a visual path of action. Its character is determined by the quality of the motion that created it. A line may vary in length, width, density, and direction.

Line is a basic element in defining visual form. Line, like the other visual elements, is a human way of symbolizing what is seen, felt, or imagined. Lines are marks with length on a two-dimensional surface, or they are the perceived edges of things in two- or three-dimensional space. Lines can appear smooth and flowing or nervous and erratic. They can be angry or happy, harsh or gentle. Saul Steinberg shows what happens to a highly irregular line when it is transformed as the result of a certain experience.

The element of line is basic to writing, drawing, and most painting. Pictographs or picture writing were the earliest forms of written language.

Calligraphy, or writing, has been an important art form for countless generations. The quality of line created by the heart, hand, and writing tool working together expresses the depth of character, sincerity, and feeling of the person who is writing and painting.

In China and Japan, writing and painting have long been interrelated. Similar brushes and brush strokes are employed in both, as seen in Gibon Sengai's THE CRAB.

The crab, not moving back and forth between good and evil as humans do, only moves sideways.[3]

Lettering was a highly developed art in Europe before the invention of the printing press. In fact, "to take pen in hand" is still an important expressive act even though the ball-point pen has removed the dimension of thick and thin line variation. Each person's writing has its own unique line quality, thus

53　Gibon Sengai. THE CRAB. c. 1800. Ink on paper. Idemitsu Art Gallery, Tokyo.

54　Unknown Chinese artist. A WAVE UNDER THE MOON. 12th century. Ink on silk, detail of a scroll. National Palace Museum, Taiwan.

55　Bridget Riley. CREST. 1964. Emulsion on board. 65½ x 65½″. Private Collection.

making one's signature an important identifying mark.

Lines on a flat surface can act as independent elements, define shapes, imply volumes, or suggest solid mass. Lines can be grouped to make patterns or portray shadows.

An unknown Chinese artist of the twelfth century painted A WAVE UNDER THE MOON as part of a scroll. The small moon sets off a large area of rhythmically vibrating lines. The work is very close in feeling to that of contemporary painter, Bridget Riley.

56 Marc Chagall. I AND MY
VILLAGE. 1911. Oil on canvas.
75⅝ x 59⅝". The Museum
of Modern Art, New York.
Mrs. Simon Guggenheim Fund.

Shape

Shape refers to that aspect of form seen as a flat two-dimensional area or plane, as in a silhouette or shadow. Shapes become visible when a line encloses an area or when an apparent change in value, color, or texture sets an area apart from its surroundings.

The infinite variety of shapes can be approached through two general categories: organic and geometric, although there is no clear-cut division between the two. The most common shapes in nature are organic—soft, relaxed, curvilinear and irregular. The most common shapes in the man-made world are geometric—hard, rigid, and regular and most often rectangular.

Marc Chagall's I AND MY VILLAGE is a subtle blend of organic and geometric shapes. Chagall has simplified and abstracted the forms of the natural objects he portrays in order to strengthen their visual impact. The major shapes implied in the resulting composition are triangles and circles. The diagram of the design makes this clear. Yet Chagall has softened the geometric severity so that there is a natural visual flow between the various sections of the painting.

The famous Rorschach inkblot test takes advantage of the evocative potential of nonrepresentational shapes in order to stimulate a personal flow of psychologically significant imagery.

57 Hermann Rorschach.
INK BLOT TEST, card III.

58 Jean Arp. DANCER II. 1955. Oil on Canvas. 57⅝ x 42⅞''. Museum of Modern Art. Strasbourg, France.

60 Paul Gauguin. FATATA TE MITI. 1892. Oil on canvas. 26¾ x 36''. National Gallery of Art, Washington, D.C. Chester Dale Collection.

The ambiguous *composite shape* or combined shapes of the figure in Jean Arp's DANCER II engages the viewer's imagination as does the inkblot test, yet Arp's beguiling image offers a few clues as to subject matter.

Most artists have personal styles that include preferences for certain types of visual form. Paul Gauguin's mature style emphasized flat curvilinear shapes. He was one of many Europeans influenced by the bold flat shapes found in Japanese color prints, which first came into Europe during the 1860s. (See page 301.) He evidently liked the unique shape that he used for the tree trunk and massive root in his painting WORDS OF THE DEVIL because he used it again in FATATA TE MITI.

59 Paul Gauguin. WORDS OF THE DEVIL. 1892. Oil on canvas. 37 x 27''. National Gallery of Art, Washington, D.C. Gift of the W. Averell Harriman Foundation in memory of Marie N. Harriman.

51

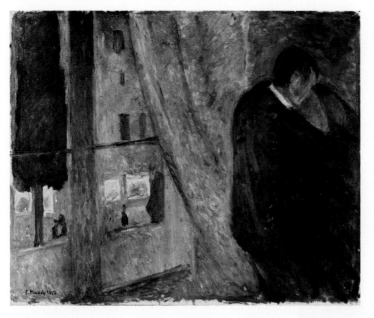

61 Edvard Munch. KISS BY THE WINDOW. 1892. Oil on canvas. 72.3 x 90.7 cm. National Gallery, Oslo.

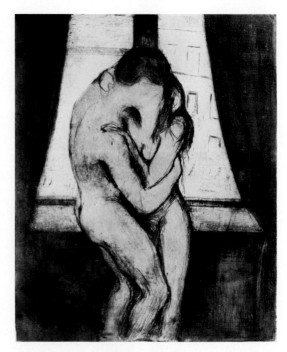

62 Edvard Munch. THE KISS. 1895. Dry point and aquatint. 343 x 278 mm. Albertina Collection, Vienna.

Under the influence of Gauguin, the Norwegian painter Edvard Munch produced images with similar bold curvilinear shapes. During the same decade that Gauguin was doing much of his best work in Tahiti, Munch produced several works whose subject was an embracing couple.

The first is a painting, KISS BY THE WINDOW, in 1892. The couple stands to the side of a window, their figures joined in a composite shape balanced by the tree visible through the window.

The second work is a drypoint and aquatint print, THE KISS, completed three years later. Here the couple stands unclothed before the window. Munch has boldly emphasized the outlines of the figures and made them into one relatively simple shape. By removing the line that would normally indicate the division between their faces, he has emphasized their unity.

The third work is a woodcut print, THE

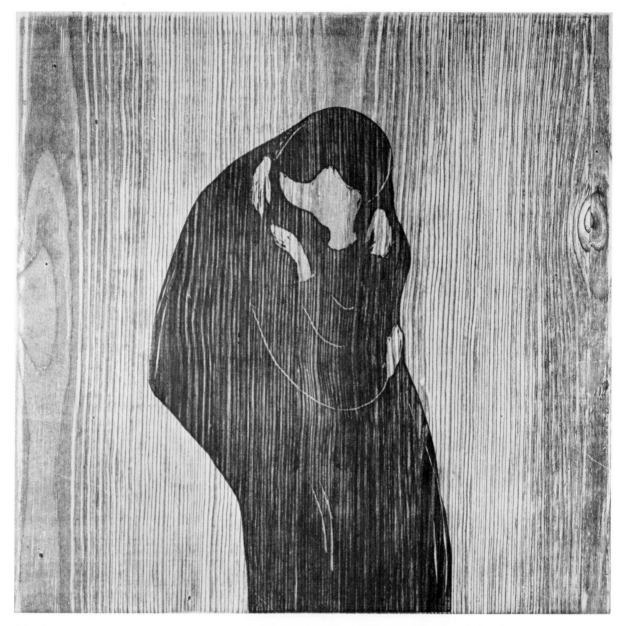

63 Edvard Munch. THE KISS. 1897–1898. Woodcut. 467 x 465 mm. Albertina Collection, Vienna.

KISS, done in 1897, five years after the initial painting. He used two blocks of wood, one of which was uncut. He wiped the uncut block with just enough ink to bring out the grain of the wood; this serves as background. The second block of wood was cut with the design. Here Munch has simplified his basic concept to its essence. He did not achieve this result all at once; it evolved from one work to the next. The woodcut is the most abstract of the three works, utilizing a flat, bold organic shape. Of the three versions, the woodcut is the best known because it so effectively symbolizes the basic concept.

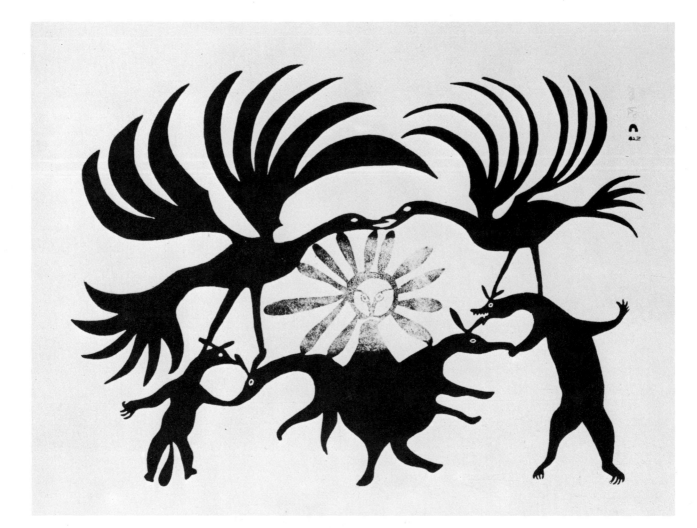

64 Kenoujuak. THE RETURN OF THE SUN. c. 1965. Relief print.

Our discussion of shape in the preceding works has focused on foreground shapes. This is only half the picture, however, because any shape appearing on a picture plane simultaneously creates a second shape out of the background area. The first shape may be referred to as a *positive shape* and the neutral or passive background as a *negative shape*. The artist must consider both positive and negative shapes simultaneously and as equally important to the total effectiveness of an image. Positive shapes are called *figure* shapes, whether or not they portray human figures or objects. Negative shapes are called *ground* shapes, and are part of the background. Figure shapes create ground shapes. Interactions between figure and ground shapes are discussed as figure-ground relationships. Because we are conditioned to see only objects, and not the spaces between and around them, it takes a shift in awareness to see the shapes of spaces.

In this print, THE RETURN OF THE SUN, by Kenoujuak, a contemporary Eskimo artist, the white negative shapes are not recognizable as subject matter, yet they contribute to the vitality of the work as a whole. By keeping the white negative and the black positive shapes similar in size and configuration, the artist has

achieved a balance and interaction between them. The flat black positive shapes derive from shadows seen against the snowy white environment. Inspired by the rich mythological tradition of her people, Kenoujuak fills her prints with shapes symbolic of the interacting forces of nature.

While both are important, figure and ground in Kenoujuak's work retain their clear distinction. In contrast, this woodcut by M. C. Escher, SKY AND WATER I, depends on the interchangeability of figure and ground. With shifts in awareness, these shapes trade places or pop back and forth, a phenomenon appropriately called *figure-ground reversal*.

Creating your own images in which you put equal emphasis on positive and negative shape is a good way to learn to see figure-ground relationships.

66 FIGURE GROUND REVERSAL.
Student design problem.

65 M.C. Escher.
SKY AND WATER I.
1938.
Woodcut.
17⅛ x 17¼".
Vorpal Galleries,
San Francisco,
New York,
Chicago, and
Laguna Beach.

67 Daniel Chester French. Detail of ABRAHAM LINCOLN.
1916–1922. Marble. Lincoln Memorial, Washington, D.C.

Light

Light is a form of radiant energy. The visual world is revealed by light. Sunlight, which is white light, contains all the light colors that make up the visible spectrum of the electromagnetic field. (See chart, page 61.) The source, color, intensity, and direction of light determine the way things appear. Light reveals three-dimensional surfaces. As light changes, things that are illuminated by it appear to change. Light can be reflected, bent, diffracted, or diffused, as well as directed. Various types of man-made light include incandescent, fluorescent, neon, and laser.

A simple change in the direction of light makes a dramatic change in the way we see the sculpture of ABRAHAM LINCOLN. When the monumental figure was first installed in the Lincoln Memorial in Washington, D.C., the sculptor, Daniel Chester French, was disturbed by the lighting. The entire character of his figure was different from his original conception because the dominant light falling on the figure came at a low angle through the open doorway of the building. This was cor-

rected by placing artificial lights in the ceiling above the figure that were stronger than the natural light coming through the doorway. Light had changed the appearance of the form, and therefore had changed the content expressed by French in the sculpted features of Lincoln.

Light coming from a source directly in front of or behind objects seems to flatten three-dimensional form and emphasize shape. Light from above or from the side, slightly in front, most clearly reveals three-dimensional objects in space as we are accustomed to seeing them. Natural and artificial light sources are nearly all above us.

Value refers to the relative lightness and darkness of surfaces. The amount of light reflected from a surface determines its luminosity. The value range extends from white to black and may be seen as a property of color or independent of color. Subtle relationships between light and dark areas determine how things look. In a picture, value relates one area to another. Gradations of value can make flat areas appear to have three-dimensional form.

The value scale shows that we perceive *relationships*, not isolated forms. The middle gray circles are identical in value, yet their value appears quite different when the value of their background is changed.

This drawing of light falling on a sphere illustrates how a curved surface is suggested by a value gradation or gradual shifting from light to dark. The technique that uses gradations of light and shade rather than sharp outlines in pictorial representation is called *chiaroscuro*. This technique makes it possible to create the illusion that objects depicted on a flat surface are rounded and three-dimensional.

Pierre-Paul Prud'hon gives the illusion of roundness to his figure in STUDY OF A FEMALE NUDE, by using black and white chalk on a middle-value blue-gray paper. Because the paper is a value halfway between white and

68 VALUE SCALE

69 VALUE GRADATION GIVING
THE ILLUSION OF THE
CURVING SURFACE OF A SPHERE.

black, he is able to let it act as a connective value between the highlights and shadows. If you follow the form of this figure you will see how it appears first as a light against a darker background (as in the right shoulder) and then as a dark against a lighter area (as in the under-part of the breast on the same side). The background stays the same, appearing first dark, then light.

Look around you and you will see that all objects become visible in this way. Sometimes, as in the area between the shoulder and the breast on this figure, the edge of an object will disppear when its value at that point becomes the same as the value behind it, and the two surfaces merge into one. Usually we do not see this, however, because our minds fill in the blanks from experience. We *know* the form is continuous, so we see it as continuous.

In the "real" world, values are always seen along with other color properties and textures of surfaces. Artists can minimize or eliminate various surface qualities in order to concentrate attention on certain elements. In Zen Buddhist painting, black ink (sumie) is traditionally employed on white surfaces because black and white best express the desired content. See Sengai's THE CRAB on page 49.

70 Pierre-Paul Prud'hon. STUDY OF A FEMALE NUDE. c. 1814. Black-and-white chalk on blue-gray paper. 28 x 22 cm. Collection Henry P. McIlhenny, Philadelphia.

71 Francisco de Zurbarán. ST. SERAPION. 1628. Oil on canvas. 47½ x 40¾″. Wadsworth Athenium, Hartford.

Works of art in which color is an important element obviously suffer when reproduced only in black and white. Most drawings and many prints are originally in black and white. Photography was possible only in brown or black and white, from its inception in the 1830s until 1906 when the first plates sensitive to all the colors of the spectrum were developed. Many photographers now limit their work to black and white by choice. They feel that the graphic clarity of black and white fits better with the kind of visual statements they want to make.

Value alone can clearly express various moods and feelings. When gradations of value are eliminated, images take on a more forceful appearance. If no gray values are present, and black areas and white areas adjoin one another directly, the strong contrast between light and dark gives impact to the work that may be essential to its content.

Strong value contrast emphasizes the dramatic content of Francisco de Zurbarán's ST. SERAPION. In simple compositional terms, the major visual element is a light rectangular shape against a dark background. Light and dark qualities are powerful elements in any design.

Minimal value contrast is seen in Kasimir Malevich's WHITE ON WHITE. The simplicity of this unique painting is enhanced by the closely keyed value relationship of one white square placed on top of another.

If a two-dimensional image with minimal value contrast utilizes light or high values exclusively, it is said to be *high key* in value; if only low values are employed, the work is *low key*. Such controlled use of value range creates particular moods within the work that are uniquely different from the more usual mood created by a balance of light and dark values. The terms *high key* and *low key* can also be used in referring to the combined effect achieved by limiting the values of wall and

72 Kasimir Malevich. SUPERMATIST COMPOSITION: WHITE ON WHITE. c. 1918. Oil on canvas. 31¼ x 31¼". The Museum of Modern Art, New York.

Light has been an important element in art since prehistoric times. Early cave paintings were painted and viewed by flickering torchlight. The sun's changing rays illuminate the stained glass walls of Gothic cathedrals, filling their interiors with colored light. In the twentieth century we have a variety of ways to produce and control light. Some artists use manmade light as their medium.

Light is a key element in photography, cinematography, television, stage design, architecture, and interior design. As our awareness of light's potential has increased, light artists have become more important. At first, lighting designers were primarily technicians or engineers. Now, that is not enough. The light artist uses his or her material with the same subtlety as the painter.

One of the early light artists was Thomas Wilfred, who began experimenting in 1905 with the relationship between moving colored lights and music, and created one of the first light organs. In his later automated constructions, images of changing light move across a translucent screen in a continuous sequence. Wilfred's term for light art is _lumia_. (See page 367 and color plate 39.)

Light used in combination with other media has become of increasing interest to contemporary artist-technicians, who, working with other technicians, have created new art forms. Light art is often combined with music and dance. Light shows, influenced by Wilfred's early work, were presented with rock and other forms of contemporary popular music beginning in the mid 1960s.

floor covering, furniture, and room illumination in interior design. For example, hospitals tend to be high key; bars tend to be low key.

We are beginning to pay more attention to the kind of interior and exterior environmental light that we live with daily. Color, direction, quantity, and intensity of light have a major effect on our moods. California architect Vincent Palmer has experimented with the effect that changes in the color and intensity of interior light have on people. He has found that he can modify the behavior of his guests by changing the light around them. Light quality affects people's emotions and physical comfort, thus changing the volume and intensity of their conversation and even the length of their visit.

Color

Color affects our emotions directly, modifying our thoughts, moods, actions, and even our health. Some painters of the past found color so dominating that they avoided pure colors to enable viewers to see the essence of the subject without being distracted. Early in the twentieth century, pure bright colors were used very little in everyday life in the United States. The French Impressionist painters and their followers led the way to the free use of color we enjoy today.

The Hindus, Greeks, Chinese, and certain American Indian tribes are known to have assigned colors to the elements symbolically. Each culture makes these associations in their own way. Italian Leonardo da Vinci wrote, "We shall set down white for the representative of light, without which no color can be seen; yellow for earth; green for water; blue for air; red for fire; and black for total darkness."[4]

Such symbolic color associations were disputed following the Renaissance when the spiritual and physical were separated. In recent years, however, artists as well as scientists have begun to study such human responses to color as visual, psychological, biological, cultural, historical, and metaphysical.

The psychic healer Edgar Cayce experienced a metaphysical response to color—particularly regarding colors related to *auras*. An aura is thought to indicate the outer limits of a person's life energy force. It can be seen most strongly by a sensitive eye in the form of colored light emanating from the entire body. Such a phenomenon is particularly visible around the head and shoulders. The tradition of halos in both Western and Eastern art lends credence to the universal existence of auras for those who have not seen them. Spiritual or religious leaders would be expected to have strong auras. From his experience with auras Cayce generalized about his response to certain colors. The following are examples:

Red: force, vigor, energy, nervousness, egotism, the color of life
Yellow: health, well-being, friendliness
Blue: the color of the spirit, artistic, selfless, melancholy
Green: the color of healing, helpful, strong, friendly[5]

Our favorite colors may be those that complement our aura. Unknowingly, we may change our favorite color when our aura changes.

Evidently the human ability to see color continues to expand. Some scholars believe humans have only recently developed the ability to see hues with the shortest wavelengths, like blue, indigo, and violet. The ancient Greek philosopher Aristotle named only three colors in the rainbow: red, yellow, and green.

When we look at a color we may disagree about what we see or, more specifically, how we name what we see. Each color and variation of that color has its own character. Yet we see a color only in relationship to other colors. Even the color of a single surface is affected by the color of the light illuminating it. We all respond in our own way to color. To many people yellow seems to be a happy, free color, while to others the same yellow seems soft and quiet. The quality can change, however, depending on the kind of yellow, its association with other colors, and the mood of the person seeing it. The painter Wassily Kandinsky felt that bright yellow can be shrill, and he pointed out that "the sour-tasting lemon and the shrill-singing canary are both yellow."[6]

That part of the electromagnetic spectrum visible to the human eye includes wavelengths of violet through red, but does not include the shorter ultraviolet wavelengths that are visible to ants and honeybees, or the longer infrared wavelengths visible to rattlesnakes. Most other mammals see no color.

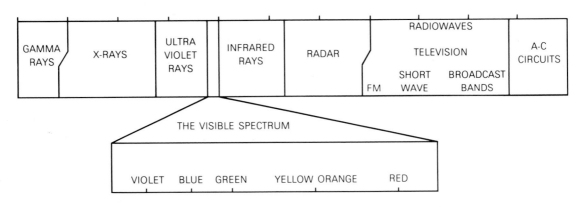

73 THE ELECTROMAGNETIC SPECTRUM.

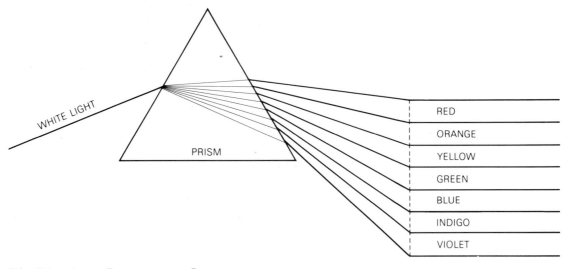

74 WHITE LIGHT REFRACTED BY A PRISM.

Specific colors on the electromagnetic spectrum are called hues. *Hue* designates a color in its pure form according to its specific wavelength. Spectrum-intensity red is spoken of as the hue red, as distinguished from the hue orange, its neighbor on the spectrum.

When white light is separated into its visible components by a prism, the hues of the spectrum appear as in a rainbow.

When the opposite is done, colored lights are combined and can eventually add up to full white light. Therefore, light mixture is called *additive* color mixture. Each hue that is added to a light mixture brings the mixture closer to pure white light. When the three *light primaries*—red, green, and blue—are combined,

the result is white light. Red and green light when mixed make yellow light. A working knowledge of the character and mixing properties of light colors is essential to anyone working with light as an art form.

Our common experience with color is provided by reflective surfaces, not by prismatic light. Therefore the emphasis in this book is on color in terms of reflective surfaces and the changes on these surfaces caused by pigments and the light that illuminates them.

A red surface absorbs most of the spectrum except red, which it reflects. A green surface absorbs most of the spectrum except green, which it reflects, and so on with all the hues of the spectrum.

Mixing *pigment colors* is quite different from mixing light colors. If the complementary colors red and green are mixed together in equal amounts in pigment form as paint or dye, the result is a gray because almost all of the light of the spectrum is absorbed; little is reflected.

The more pigments of different hues are mixed together, the duller and darker the mixture appears because the pigments absorb more and more light as their absorptive qualities combine. For this reason, pigment mixture is called *subtractive* color mixture. Mixing red, blue, and yellow will produce a dark gray, almost black, depending on the proportions of the pigments involved.

There are several major pigment color systems in use today, each with its own basic hues. The *color wheel* (opposite page 66) is one of several contemporary versions of the wheel concept first developed by Sir Isaac Newton. After Newton discovered the spectrum, he found that both ends could be combined into the hue red-violet, making the color wheel possible. Numerous color systems have followed since that time. The color system presented here is based on twelve pure hues.

The color wheel is divided into:

- *Primaries:* red, yellow, and blue. These are the pigment hues that cannot be produced by an intermixing of other hues. They are also referred to as primary colors. (See 1 on the color wheel, color plate 5.)

- *Secondaries:* orange, green, and violet. The mixture of two primaries produces a secondary hue. Secondaries are midway between the two primaries of which they are composed. (See 2 on the color wheel.) In practice, the secondaries mixed from primaries do not have the pure brilliance of oranges, greens, and violets manufactured to achieve those pure hues.

- *Intermediates:* red-orange, yellow-orange, yellow-green, blue-green, blue-violet, and red-violet. Their names indicate their components. Intermediates are located between the primaries and the secondaries of which they are composed. (See 3 on the color wheel.)

Black and white may be thought of as colors, but they are not hues. Pigment black is the presence of all colors and pigment white is the absence of all colors. With light it is just the reverse: black is the absence of light and therefore the absence of color. White light is the presence of all color. White, black, and their combination, gray, are *achromatic*, or *neutral* colors, referred to as neutrals.

The basic properties of color—hue, value, and saturation—are demonstrated in color plate 5.

- *Hue:* the particular wavelength of spectrum color to which we give a name. (See also prism diagram, page 61.)

- *Value:* the range from white through the grays to black, either independent of color or within hues and mixtures of hues. (See also value scale, page 57.)

Black and white as pigments can be important ingredients in changing color values. Black added to a hue produces *shades* of that hue. For example, when black is added to orange, the result is a brown; and when black is mixed with yellow, an olive green results. The brown is a shade of orange and the olive green is a shade of yellow. White added to a hue produces a *tint*. Lavender is a tint of violet.

Hues at their purest saturation are also at their normal value. For example, the value of pure yellow is much lighter than the value of pure violet. Pure yellow is the lightest of hues and violet is the darkest. Red and green are middle value hues.

■ *Saturation* or *intensity:* the purity of a hue, or color. A pure hue is the most intense form of a given color; it is the hue at its highest saturation, in its brightest form. If white, black, gray, or another hue is added to a pure hue, saturation diminishes and intensity drops. The color is dulled. Highly effective intensity changes can be made by mixing varying amounts of two complementary hues together. Complementary hues are opposite each other on the color wheel (opposite page 66).

The blue-green side of the wheel is cool in visual temperature, and the red-orange side, warm. Yellow-green and red-violet are the poles dividing the color wheel into *warm* and *cool* hues. The difference between warm and cool colors is based on association. Relative warm and cool qualities can be seen in any combination of hues. A room painted a warm color becomes warm psychologically. Color affects our feelings about size as well as temperature. Cool colors appear to recede and warm colors appear to advance.

Color groupings that provide certain kinds of color harmonies are called *color schemes.* The most common of these are:

■ *Monochromatic:* variations on one hue only. In this color scheme a pure hue is used alone with black and/or white or mixed with black and/or white. The hue can be combined with varying amounts of white (tints) or varying amounts of black (shades). The result is a monochromatic scheme based on that hue. For example, a scheme based on red (pure hue) with pink (tint of red) and maroon (shade of red) would be called monochromatic. (Monochromatic color is used in color plate 15.)

■ *Analogous:* hues adjacent to one another on the color wheel, each containing the same hue—for example, yellow-green, green, and blue-green, which all contain the hue green. (Analogous color is used in plate 41.) Tints and shades of each analogous hue may be used to add variations to this color scheme.

■ *Complementary:* two hues directly opposite one another on the color wheel. When mixed together, complementary hues form neutrals or grays, but when placed side by side as pure hues, they contrast strongly, often appearing to vibrate. Because they are almost identical in value, the complementary hues red and green tend to "vibrate" more than other complements when placed next to each other. The complements yellow and violet provide the strongest value contrast possible with pure hues. The complement of a primary is the opposite secondary, obtained by mixing the other two primaries. For example, the complement of yellow is violet, which is obtained by mixing red and blue. (Complementary color is used in color plate 2.)

■ *Polychromatic:* random use of hues and their variations. When painters choose their palettes, they visualize color schemes in terms of their familiarity with certain available pigment colors. Most artists work intuitively when determining a color scheme. (See color plate 10.)

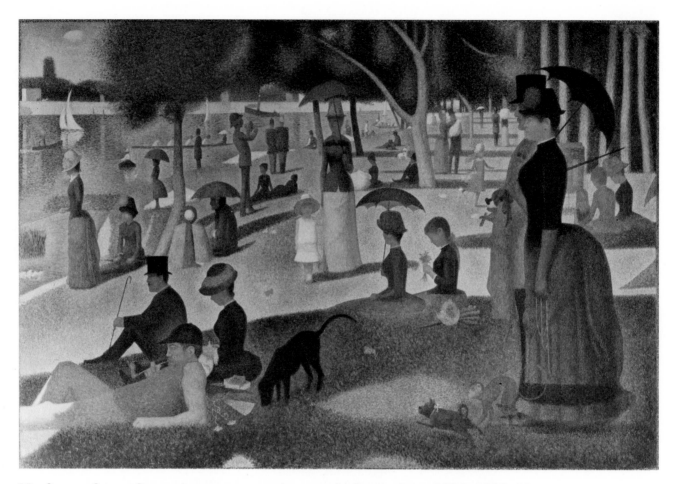

75 Georges Seurat. SUNDAY AFTERNOON ON THE ISLAND OF LA GRANDE JATTE. 1884–1886. Oil on canvas.
81 x 120⅜''. The Art Institute of Chicago. *See color plate 27, opposite page 291.*

Color sensations more vibrant or lively than those achieved with actual pigment mixture are obtained when dots of pure color are placed together so that they blend in the eye, creating the appearance of other hues. This is called *optical color mixture*. For example, rich greens appear when many tiny dots or particles of pure blue and yellow are placed with dots of green and even small amounts of green's complement, red.

This concept was developed in the 1880s by the painter Georges Seurat as a result of his studies of Impressionist painting and scientific theories of light and color. His method,

called *pointillism*, influenced the development of modern four-color printing in which tiny dots of printers' primaries—magenta (a red), yellow, and cyan (a blue)—are printed together in various amounts with black on white paper to achieve the effect of full color. Seurat used no black. Compare the enlarged detail of Seurat's SUNDAY AFTERNOON ON THE ISLAND OF LA GRANDE JATTE with the color separations and the greatly enlarged detail of the reproduction of Botticelli's BIRTH OF VENUS. (See color plate 6.)

An *afterimage* appears to the eye when prolonged exposure to a visual form causes excita-

tion and subsequent fatigue of the retina. Such an image appears most commonly when you look at a bright object against a dark background and then the object becomes darkened. For example, it appears at night if you look at and then turn off a reading lamp when all other lights are out. If you close your eyes immediately, the original image of light against dark lasts a few seconds. This is followed by a negative (dark against light) afterimage. If the original image is in color, the afterimage is seen in the complementary color. The afterimage exists only in the eye, and therefore shifts as the viewer moves his or her eyes. Afterimages are common, but most people don't see them until their existence is pointed out.

Color afterimages are caused by partial color blindness temporarily induced in the normal eye by desensitizing one or two of its three red, green, and blue color receptors. For example, staring at a red spot for thirty seconds under a bright white light will tire the red receptors in that segment of the retina on which the red spot is focused and make them less sensitive to red light, or partially red-blind. Thus, when the red spot is removed, a blue-green spot appears to the eye on a white surface because the tired red receptors react weakly to the red light reflected by that area of the surface. The blue and green receptors, meanwhile, respond strongly to the reflected blue and green light, producing an apparent blue-green dot that is not actually present on the surface. On a neutral surface, therefore, the hue of the afterimage is complementary to the hue of the image or stimulus.

A more complex example of this phenomenon can be experienced by staring for about thirty seconds at the white dot in the center of the flag at the top of Jasper Johns's painting FLAGS, then looking down at the black dot in the gray flag below. (See color plate 7.)

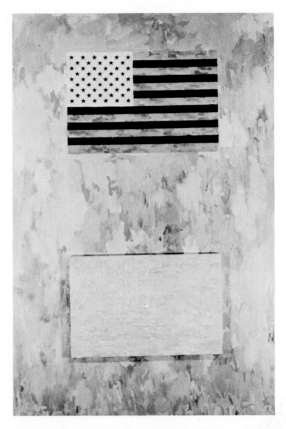

76 Jasper Johns. FLAGS. 1965. Oil on canvas with raised canvas. 72 x 48''. Private Collection. *See color plate 7, near page 66.*

We have difficulty distinguishing the actual colors in our environment because our awareness of color is conditioned by preconceptions. The idea that the sky is blue, for example, can get in the way of our direct perception of a violet or yellow-orange sky. Words identify concepts and in turn play their part in determining color perception.

The appearance of a given color in things around us is always relative to adjacent colors and conditions. A hue can appear to change radically according to such relationships. In INJURED BY GREEN, Richard Anuszkiewicz painted a uniform pattern of dots in two sizes. (See color plate 8.) Behind these, the red-orange ground appears to change, but it does not. Intensity builds from the outer edges of the painting toward the center where we are "injured" by an area of yellow-green dots, which seems to pulse because it is almost identical to the background in value, yet almost opposite or complementary in hue. The blue tint of the dots in the outer border is slightly lighter in value than the background. The blue-green dots in the four triangular areas are slightly darker in value. If Anuszkiewicz had used straight blue-green, the complement of red-orange, rather than yellow-green in the center, he would not have achieved the startling subtle power that the painting now has, because value is as important as hue and saturation in the total effect of this painting.

My work is of an experimental nature and has centered on an investigation into the effects of complementary colors of full intensity when juxtaposed and the optical changes that occur as a result.

Anuszkiewicz[7]

The actual pigment color of specific surfaces is called *local color*. It is modified by its association with surrounding colors and by such factors as the intensity, temperature, and angle of the light. As light decreases, individual colors become less distinct. In bright light, colors reflect on one another, causing changes in the appearance of local color. In his painting

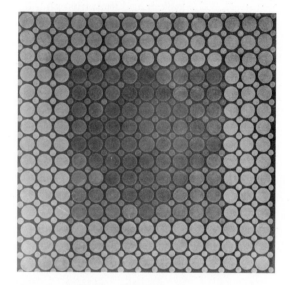

77 Richard Anuszkiewicz. INJURED BY GREEN. 1963. Acrylic on board. 36 x 36''. Collection Janet S. Fleisher, Philadelphia. *See color plate 8, near page 67.*

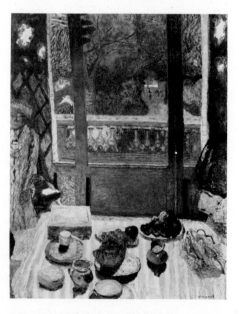

78 Pierre Bonnard. THE BREAKFAST ROOM. c. 1930–1931. Oil on canvas. 62⅞ x 44⅞''. The Museum of Modern Art, New York. *See color plate 10, near page 67.*

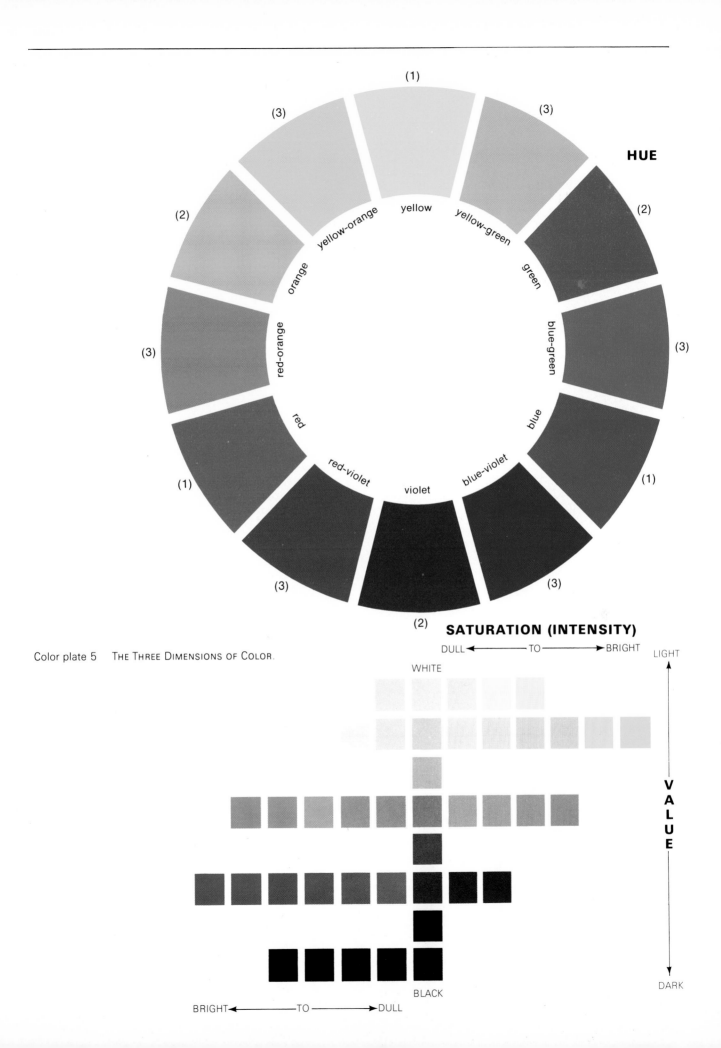

Color plate 5 THE THREE DIMENSIONS OF COLOR.

a. Yellow

b. Magenta

c. Yellow and Magenta

d. Cyan

e. Yellow, Magenta, and Cyan

f. Black

g. Yellow, Magenta, Cyan, and Black

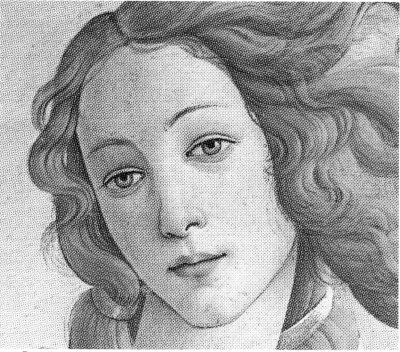

h. Detail showing mechanical dot pattern of offset photo-lithography.

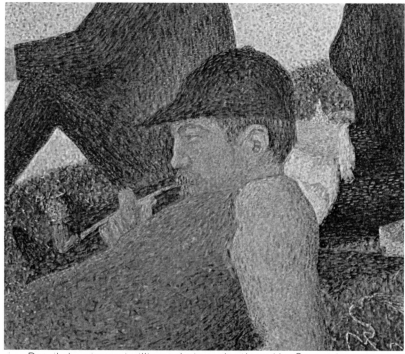

i. Detail showing pointillist technique developed by Seurat (as well as pattern mentioned above).

Color plate 6 OPTICAL COLOR MIXTURE AND COLOR PRINTING.

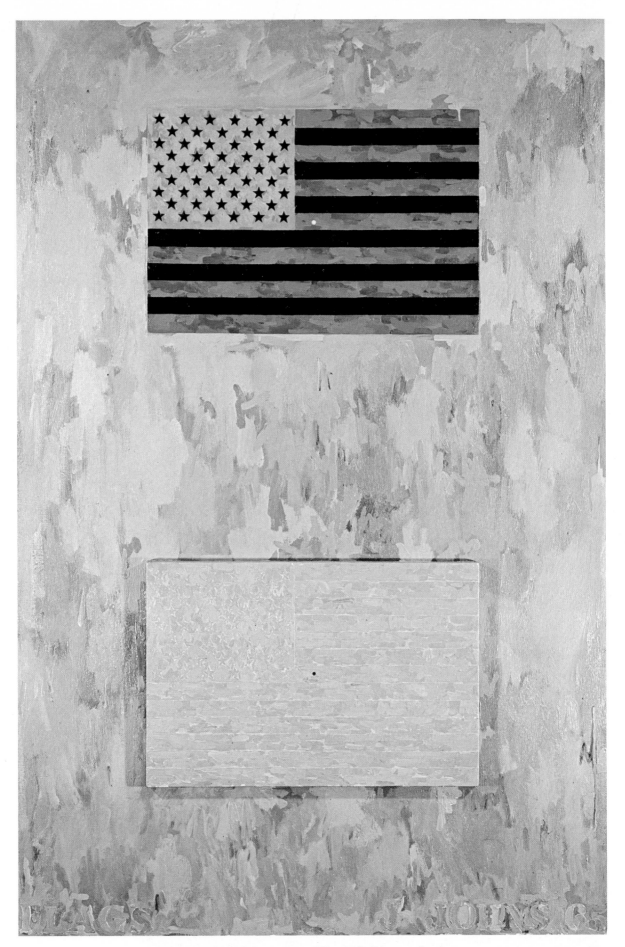

Color plate 7 . Jasper Johns. FLAGS. 1965. Oil on canvas. 72 x 48''. Private collection.

Color plate 8 Richard Anuszkiewicz. INJURED BY GREEN. 1963. Acrylic on board. 36 x 36''. Collection Janet S. Fleisher, Philadelphia.

Color plate 9 Detail of a peacock feather.

Color plate 10 Pierre Bonnard. THE BREAKFAST ROOM. c. 1930–1931. Oil on canvas.
62⅞ x 44⅞'' The Museum of Modern Art, New York.

Color plate 11 Shaykh
Zadeh. INCIDENT IN A
MOSQUE. Persian
miniature painting.
c. 1520. 28.9 x 17.8 cm.
Private collection.

THE BREAKFAST ROOM (see color plate 10), Pierre Bonnard has emphasized these shifts in local color and added many personal poetic color relationships of his own invention.

Color is central to Bonnard's art. He took a somewhat ordinary scene and intensified its effect on us by concentrating on the magical qualities of light and color on a sunny day. The painting portrays Bonnard's feelings about the mood of that day, using color that could not have been recorded with a camera.

Bonnard's color is the result of a personal search. During the 1890s he worked with limited color. About 1900 he began to use more color in what he described as a personal version of Impressionism. As his color sense matured, his paintings became filled with rich harmonies of warm and cool colors, subtly played off against each other. In these paintings his surfaces seem to shimmer with a light of their own.

Texture

Texture refers to the tactile qualities of surfaces. It can be actual or implied. *Actual texture* is revealed through the sense of touch. Wayne Miller's photograph of a baby being breast-fed shows the beginning of experience with actual texture. (See page 15.) Such tactile experience is essential to growing infants. The sense of touch develops before the sense of vision. It isn't until much later that we learn to "feel" texture with our eyes.

The notorious fur-lined teacup was constructed in 1935 by Meret Oppenheim. She presented the viewer with an intentionally revolting object. The refined tactile experience associated with a teacup is reversed here. The actual texture of fur is pleasant, and so is the smooth texture of a teacup, but the combination makes the tongue "crawl." The work was designed to evoke a strong response. Social and psychological implications are abundant and intended.

79 Meret Oppenheim. OBJECT. 1936. Fur-covered cup,
4⅜'' diameter; saucer, 9⅜'' diameter; spoon, 8'' long. The Museum of Modern Art, New York.

80 Alberto Giacometti. Detail of MAN POINTING. 1947. Bronze. Height of full figure 70½". The Museum of Modern Art, New York. Gift of Mrs. John D. Rockefeller. *See page 73.*

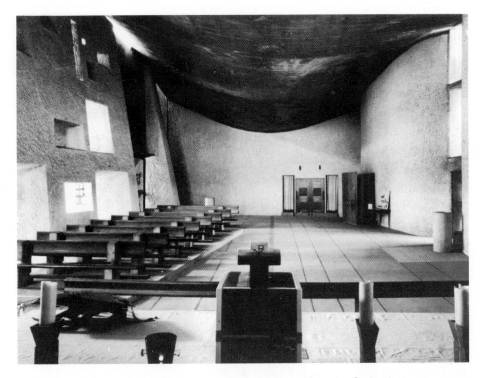

81 Le Corbusier.
Notre-Dame-du-Haut at
Ronchamp, France.
1950–1955. Interior.

Used expressively, texture communicates emotion and content, adding an important dimension to our sensory experience. Some textures are inviting, making us want to run our hands over them. Others repel us. Compare the eroding surfaces of Alberto Giacometti's figure with the youthful skinlike textures of the figures in Rodin's The Kiss, a work which in itself has strong textural contrast. (See page 311.) Each artist used texture to heighten emotional impact.

In Le Corbusier's chapel at Ronchamp, Notre-Dame-du-Haut, rough and smooth concrete and wooden furnishings are contrasted to produce textural variations. (See also page 351.) In contrast, buildings like Lever House (see page 198) offer a subtle interplay of smooth textures of glass and metal, producing crisp, hard surfaces.

Implied texture, as in a photograph or painting, is purely visual and must be seen to be experienced. In his woodblock print, The Kiss, Munch used the actual texture of the wood to create implied texture (see page 53.)

A variety of textures, such as the softness of fur and velvet, are implied with paint in Hans Holbein's portrait of SIR THOMAS MORE. Holbein has observed the variety of textures with great care. Notice how carefully he has portrayed the textures of the face alone.

A painting may have a rich tactile surface as well as implied texture, as in Rembrandt's HEAD OF SAINT MATTHEW. Rembrandt applied oil paint in thick strokes, creating both actual and implied texture. There is only a hint here of the textural difference between skin and hair, but there is a great deal of feeling demonstrated for the tactile possibilities of paint. When paint the consistency of thick paste is applied directly to a surface, it is called *impasto*. In THE GOLDEN WALL, Hans Hofmann built up a thick impasto creating actual texture. (See color plate 12.) Many contemporary painters use even thicker paint to invent exciting textural surfaces.

82 a. Hans Holbein. SIR THOMAS MORE. 1527. Oil on wood. 29½ x 23¾''. Copyright The Frick Collection, New York.
b. Hans Holbein. Detail of SIR THOMAS MORE.

83 Rembrandt van Rijn. HEAD OF SAINT MATHEW. c. 1661. Oil on wood. 9⅞ x 7¾''. National Gallery of Art, Washington, D.C. Widener Collection.

Mass

A two-dimensional area is referred to as a shape; a three-dimensional area is a mass. *Mass* refers to the physical bulk of a solid body of material. Actual mass is a major element in sculpture; in painting, mass is implied. Like other visual elements, mass is an aspect of total form, not a separate entity. The term *mass* may also be used when referring to solid or flat areas that take on visual weight because they contrast with the background on which they are placed. Actual mass and space are, of course, inseparable, since three-dimensional objects always exist within space.

A few contrasting pieces of sculpture demonstrate the expressive possibilities of actual mass in three-dimensional works.

Great control was exercised over Egyptian artists during the long period in which this ancient culture lasted. One of the dominant characteristics of their architecture and sculpture was its massiveness. They sought this quality and perfected it because it fit their desire to make their works everlasting. Egyptian art that we know today is largely funerary, designed to accompany the dead. A common function of their portrait sculpture was to act as a symbolic container for the soul of some important person, helping the soul to live forever.

The figure of QENNEFER, STEWARD OF THE PALACE, carved from hard black granite, retains the cubic, blocklike appearance of the quarried stone. None of the limbs project out into the surrounding space. The figure is shown in a sitting position, knees drawn up, arms folded, and the neck reinforced by a ceremonial headdress. The body is abstracted and implied with minimal suggestion. This piece is a prime example of *closed form*, which exists in space, but does not interact with it. It is a solid, massive sculpture, and a strong symbol of permanence.

84 QENNEFER, STEWARD OF THE PALACE. c. 1450 B.C. Black granite. Height 2'9''. British Museum, London.

Figures by the contemporary sculptor, Alberto Giacometti, evoke no such feelings of permanence. MAN POINTING is a notable example of his work. The tall, thin figure appears eroded by time—barely existing. The amount of solid material utilized to construct the figure is minimal. We are more aware of space than mass. The *open form* figure reaches out and interacts with the surrounding space, which seems to envelop him. The content seems to imply the tentative or impermanent nature of man caught between birth and death and eaten away by the void that surrounds him, threatened by non-being.

Existential philosophy developed in the nineteenth and twentieth centuries around a new consciousness of the fragile and unexplainable nature of human existence and the importance of coming to terms with *now* as the only facet of existence that we can know. One of the key thinkers in existentialism, Jean-Paul Sartre, found Giacometti's work a major expression of this attitude. On a metal armature, Giacometti built up, then chipped away, the plaster of his original pieces before they were cast in bronze. The artist saw the process as an almost hopeless struggle to create something that satisfied him. His struggle was rooted in an intense awareness of the human predicament in modern times.

85 Alberto Giacometti. MAN POINTING. 1947. Bronze. Height 70½''. The Museum of Modern Art, New York. Gift of Mrs. John D. Rockefeller.

86 Constantin Brancusi. BIRD IN SPACE. 1928. Bronze, Unique cast. Height 54". The Museum of Modern Art, New York.

In Constantin Brancusi's BIRD IN SPACE, mass is drawn out in a dramatic spatial thrust. The "bird" is highly abstract, almost totally nonrepresentational. It is the essence of an idea about flight as a particular kind of movement through space. Brancusi started working on this concept about a decade after the Wright brothers began the history of man's rapid movement in space, and long before the world was filled with streamlined aircraft, cars, and pens.

Henry Moore's RECUMBENT FIGURE is massive in quite a different way from Egyptian solidity and seems to have nothing in common with Giacometti's work. Moore's abstract figure reflects the windworn stone and bone forms that have impressed him since his youth. Moore made his figure compact in its mass and at the same time opened up holes in the figure that allow space to flow around and through the mass. An active relationship exists between mass and space.

In Paula Modersohn-Becker's painting MOTHER AND CHILD, the sculptural simplicity of the implied mass gives a feeling of earthiness and stability. The artist's strong personal expression has an element of truth based on her own observation and experience.

Compare the monumental quality of these painted figures with the actual three-dimensional form of Henry Moore's RECUMBENT FIGURE. Modersohn-Becker's figures appear solid because of the way she used gradual shifts from light to dark, giving the appearance of light from above falling on the curving surfaces. The texture of the thick paint emphasizes the solid sculptural qualities of the figures.

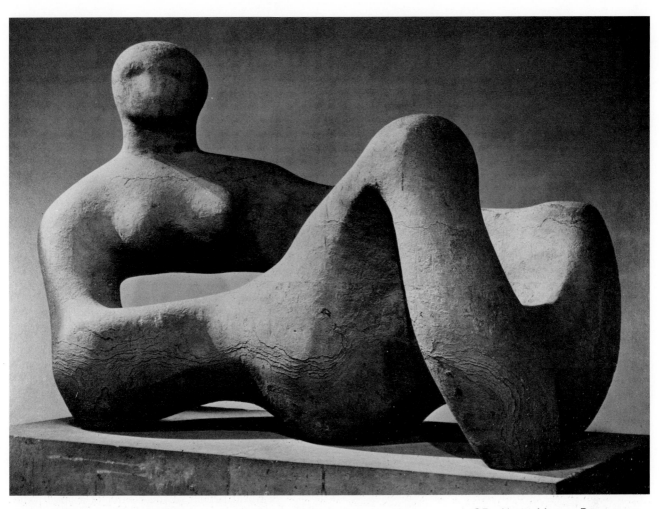

87 Henry Moore. RECUMBENT
FIGURE. 1938. Green
hornton stone. Length 54''.
The Tate Gallery, London.

88 Paula Modersohn-Becker.
MOTHER AND CHILD. 1907.
Oil on canvas. 18 x 24 cm.
Ludwig-Roselius Collection,
Bottcherstrasse, Bremen.

Space

To help us understand the importance of space to each of us, it makes sense to begin with personal space—that area surrounding our bodies which others may not enter unless invited. The dimensions of this space do not extend equally in all directions. Strangers are tolerated more closely at our sides than directly in front of us. The distances of these invisible boundaries vary only slightly from person to person, but from culture to culture there are major differences. Italians stand physically closer to each other than Americans, for example.

Our personal space, or "breathing room," is violated in places such as crowded buses and elevators. In these situations we "keep our distance" by escaping with our eyes, looking out the windows of the bus or at the changing numbers above the door in the elevator. It is useful to develop an understanding of how we use our sense of personal space in expressive ways, and how in turn we are affected by the spatial qualities of our surroundings. A timid drawing in the corner of a piece of paper and a timid person in the corner of a large room have an expressive affinity.

The visual arts are sometimes referred to as spatial arts because visual form is organized in space. Music is a temporal art because in music, elements are organized in time. *Space* is the indefinable, great, general receptacle of things. It is continuous and infinite and ever present. It cannot exist by itself because it is part of everything.

The most physically apparent organization of space is found in architecture. One of the first considerations about any building is the relationship it will have to the site and its climate. Rommert W. Huygens' HOME IN WAYLAND and Peter Jefferson's COTTAGE IN THE BAHAMAS shown here were built to relate well to their locations. The house in Massachusetts

89 Pablo Picasso. YOUNG MAN'S HEAD. 1923. Grease crayon pencil. 24¾ x 19''. The Brooklyn Museum.

Picasso's drawing, YOUNG MAN'S HEAD, shows a use of lines that seem to wrap around in space, implying a solid or three-dimensional mass. The edge is underplayed to imply that the form is continuous in space. The drawing gives the appearance of mass because the lines act to define the surface directions and build up areas of light and shade. Picasso's control over the direction and grouping of his lines makes it seem as if we were seeing a fully rounded head. Yet the vigor of Picasso's lines shows clearly that the work is a drawing on a flat surface before it is anything else.

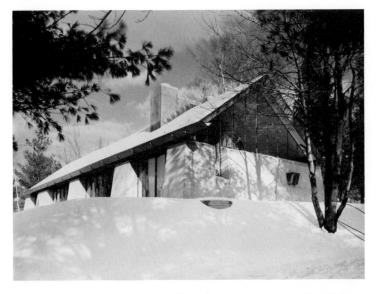

90 Rommert W. Huygens. HOME IN WAYLAND, MASSACHUSETTS.

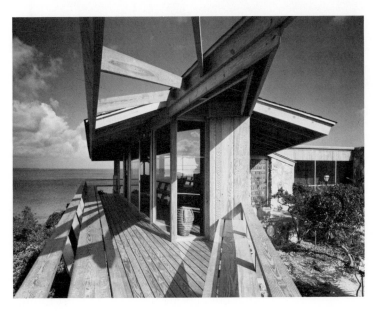

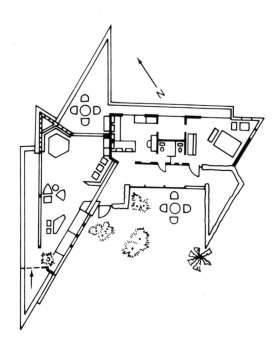

91 Peter Jefferson. COTTAGE IN THE BAHAMAS.

looks, and is, comfortably enclosed against harsh winters. The house in the Bahamas is open in form and reaches out to allow the moderate weather to enter. In both, mass and space work together and with the surroundings to provide a setting for enjoyable living. These houses illustrate the concepts of closed and open form as they apply to architecture.

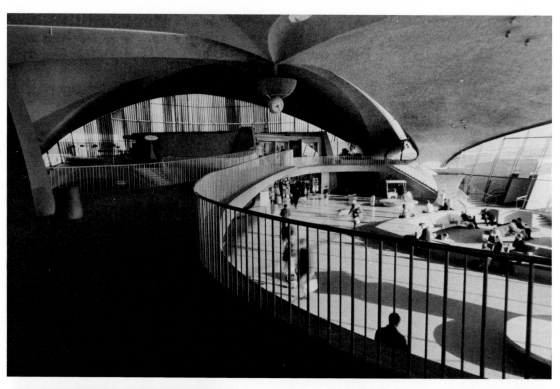

92　b.　Eero Saarinen. TWA TERMINAL, Interior.

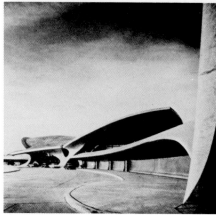

92　a.　Eero Saarinen. TWA TERMINAL, Kennedy Airport, New York. 1956–1962.

Another version of open form in architecture is seen in Eero Saarinen's TWA TERMINAL at Kennedy Airport. Mass encloses volume in such a way that people moving through the terminal are involved in a dramatically flowing horizontal space. The rigid horizontal and vertical structural elements that are found in most contemporary buildings are here softened and shaped. The resulting curved surfaces seem to suggest the aerodynamics of flight. Space moves in, around, and through this structure, uniting interior and exterior in a continuous flow of undulating rhythms. Space in the form of volume dominates mass in much contemporary as well as Gothic architecture. In ancient Egyptian architecture, mass dominates space.

The huge interior spaces created by the Gothic builders are some of the most impressive in the history of architecture. Space enclosed by mass is called *volume*. In the cathedral at Reims, for example, volume becomes a major expressive element in the structure. The vast vertical space dwarfs human scale, intensifying the difference between the infinite nature of God (or Heaven) and the finite quality of man. Gothic interior space also provided the perfect acoustical setting for music. Voices filled the cathedrals with tones of different pitch, sounding in new harmonies.

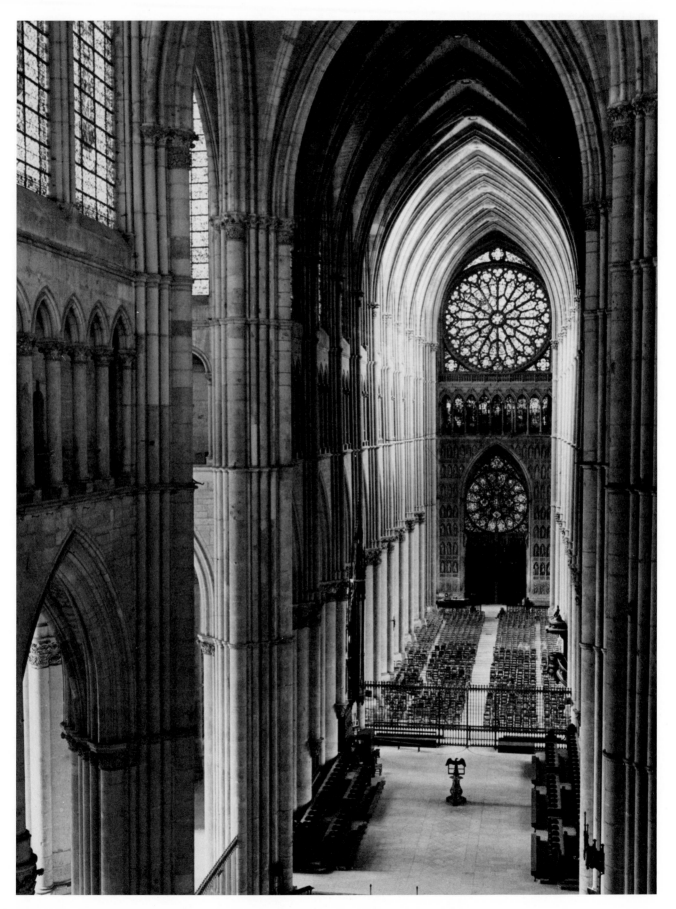

93 REIMS CATHEDRAL, Reims, France. ARCADES AND VAULTS OF NAVE, 1225–1299.

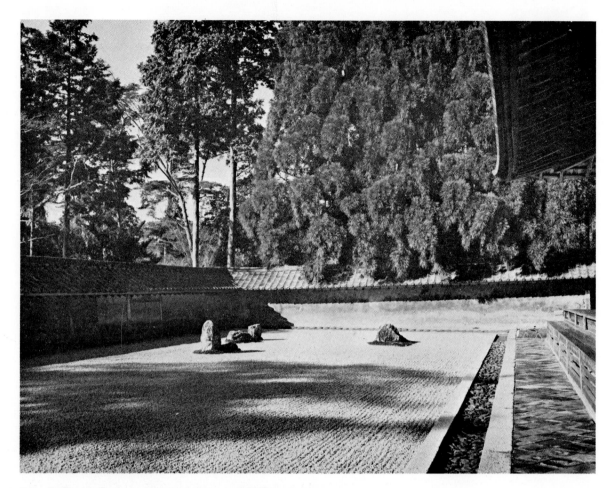

94 RYŌAN-JI GARDEN. Kyoto, Japan. c. 1490.

Art and engineering join in these great structures. This is ritual architecture—architecture in which the emphasis in the design is on celebrating an idea rather than simply enclosing a function.

On the edge of the city of Kyoto in Japan, there is a small garden within a garden that is part of Ryōan-ji Temple. This garden is famous, yet it is not what we usually think of as a garden. There are no plants. Abundant vegetation is all around, but this vegetation is separated from the garden by a low wall. On the surface RYŌAN-JI GARDEN is just a flat, rectangular area of raked gravel punctuated by a few stones. It is mostly empty space—a void.

It was completed about 1490 by Soami, who worked according to the ideals of Zen Buddhism. The garden was conceived as a place for quiet meditation. It still functions to promote quiet inner reflection when it is emptied of tourists and loud guides. It is a nothingness, or more accurately, a no-thing-ness garden, a great exterior space designed to be used for spiritual enlightenment. The apparent emptiness of the garden is designed to induce an egoless state in which the outward world of form and the inward intuitive and formless world are recognized as one. The garden's emptiness represents Zen's fullness.

95 Mu Ch'i. SIX PERSIMMONS. c. 1269. Ink on paper. 17⅝₁₆ x 14¼''. Ryoko-in, Daitoku-ji, Kyoto.

96

The usual surfaces for drawings, prints, photographs, and paintings are flat or two-dimensional. Artists working on a *picture plane* are dealing with actual space in two directions or dimensions; across the surface up and down (height) and across the surface side to side (width). Yet almost any mark or shape on a picture plane begins to give the illusion of depth or the third dimension.

For centuries, Asian painters have handled relatively flat or shallow pictorial space in very sophisticated ways. Mu Ch'i's SIX PERSIMMONS, like the garden, embodies and communicates many qualities such as intuitive spontaneity and a brusque and enigmatic simplicity which are central to Zen (Ch'an) Buddhism.

The persimmons appear against a pale background that works both as flat surface and infinite space. The painted shapes of the fruit punctuate the open space of the ground or picture surface and remind us of the well-placed rocks in the garden at Ryōan-ji.

Imagine what would happen to this painting if some of the space at the top were cut off. Space is far more than just what is left over after the important images have been placed. It is an integral part of total visual form.

Some depth is indicated by Mu Ch'i. When shapes overlap, we immediately assume from experience that one is in front of the other. This is probably the most basic way of achieving the effect of depth on a flat surface.

In the first diagram here the spatial effect of overlap is shown. In the second this effect is reinforced by diminishing sizes, which give a sense of greater intervening distance between the shapes.

Another method of achieving the illusion of depth is with placement. When elements are placed low on the picture plane, they appear to be closer to the viewer. This is how we see most things in actual space.

97 A POND IN A GARDEN. Fragment of a wall painting from a tomb in Thebes. c. 1400 B.C.
British Museum, London.

Paintings from ancient Egypt show little or no depth. Painters of that culture made their images clear by portraying objects in their most characteristic angle and by avoiding the visual confusion caused by overlap and the appearance of diminishing size. Objects within a given painting are shown as they would appear if seen from different locations. Thus, in A POND IN A GARDEN, the pond, viewed from overhead, is seen as a rectangle, while the trees, fish, and birds are all pictured in profile (or side view). The Egyptians felt no need for a single point of view or vantage point.

Shaykh Zadeh, the Persian painter who created the miniature painting INCIDENT IN A MOSQUE, was also interested in showing all the significant details of his subject without confusing things with illusions of deep space. Each figure and architectural form is presented from the angle that shows it best. The result is an intricate organization of flat planes knit together in shallow implied space. The painting has its own spatial logic consistent with the Persian style. Persian perspective emphasizes narrative clarity and richness of surface design. (See color plate 11, near page 67.)

Medieval pictorial space was symbolic and decorative, not intended to be logical or look

"real." Looking closely at Angelo Puccinelli's painting of TOBIT BLESSING HIS SON, can you tell whether the angel is behind or in front of the son? It does not really matter, of course; angels do not live in logical earthly space.

Toward the end of the fourteenth and the beginning of the fifteenth centuries artists began to develop techniques for implying actual space on a flat surface.

In general usage, the word *perspective* is used to refer to point of view. This common meaning relates to more specific meanings of the word. In the visual arts *perspective* refers to any method of representing or organizing the appearance of three-dimensional objects in implied space on a two-dimensional surface. It is correct to speak of the perspective of Persian miniatures, Japanese prints, Chinese Sung paintings, or Egyptian paintings, although none of these styles uses a system that is in any way similar to the linear perspective of the Italian Renaissance.

Linear perspective was developed by fifteenth-century Italian architects and painters as a method of achieving the illusion of actual three-dimensional space on a flat surface. The artists of the Renaissance established the idea of a painting as a window onto nature. This geometric linear system is based on what one eye sees at one moment in time fixed at one position in space. This "position in space" is determined by the location of the artist—and therefore also the viewer—and is called the *vantage point*, a phrase which relates back to point of view. Linear perspective is based on the observation that parallel lines appear to converge toward a common point, the *vanishing point*, and that objects appear to grow smaller as they recede into the distance.

It is interesting to note that we speak of parallel lines converging or going toward a vanishing point, whereas Italians of the fifteenth century and today think of these lines as coming from infinity toward the eye of the viewer.

98 Shaykh Zadeh. INCIDENT IN A MOSQUE. Persian minature painting. c. 1527. Opaque watercolor on paper. 28.9 x 17.8 cm. Private Collection. *See color plate 11, opposite page 67.*

99 Angelo Puccinelli. TOBIT BLESSING HIS SON. c. 1350–1399. Tempera on wood. 14⅞ x 17⅛". Philbrook Art Center, Tulsa, Oklahoma. Samuel H. Kress Collection.

100 Jacopo Bellini. ANNUNCIATION. c. 1440. Drawing.
The Louvre, Paris.

A preliminary drawing for a painting, done by Jacopo Bellini in the fifteenth century, ANNUNCIATION, is based on one-point perspective. The subject is the Annunciation, when an angel appeared to Mary to tell her that she was going to give birth to the Christ child. The figures of the angel and Mary are almost lost in this very detailed drawing of imagined Renaissance architecture. Bellini was obviously more concerned with the newly developed concept of linear perspective than he was with the traditional subject matter. Bellini put a great many converging "parallel" lines in his drawing. They all converge at one vanishing point on the horizon.

Recognition of eye level is basic to the ability to see and draw objects and spaces in terms of linear perspective. *Eye level* is the height above the ground plane at which your eyes observe an object. This place of observation is also called the vantage point.

If you observe furniture in a room while lying on the floor on your stomach looking forward you will see the bottom sides of chairs and tables. You then have a very low eye level —a "worm's eye view" of the room. If you sit on the floor, then on a chair, and then stand,

your eye level rises accordingly. Sitting on the floor you will probably see the tops of chair seats and may notice that a table top is right at your eye level so that you see neither its bottom nor its top. When you sit on a chair you see the top of the table, but its shape may be difficult to distinguish. When you stand, the table top is far below your eye level. Now it appears more rectangular than it did when you were sitting on the chair. You can get a "bird's eye view" of the room and its furnishings by climbing to the top of a stepladder.

Eye level extends as an imaginary plane parallel with the ground plane to the *horizon line* where the two planes converge at infinity. When actual distance is implied on the two-dimensional picture plane, the artist's and therefore the viewer's eye level is equivalent to the horizon line.

The height of the horizon line in relation to other objects is determined by and equivalent to the eye level of the observer. Whether an actual horizon (where earth or sea meet sky) can be seen or not, the horizon line is imagined as a circular plane around the observer at eye level. For someone in an airplane or standing on a mountain top, the horizon line is very high in the field of vision. For someone lying on the ground it is very low.

Although the horizon is frequently blocked from view, it is necessary to establish the combined eye level–horizon line in order to construct images using linear perspective.

Parallel lines moving away from the viewer above the eye level appear to go down to the horizon line, while those below the eye level appear to go up to the horizon line. See if you can find the eye level in Bellini's drawing from this description.

In a *one-point perspective* system all the major receding "lines" of the subject are actually parallel, yet visually they appear to converge on a single vanishing point at the horizon line.

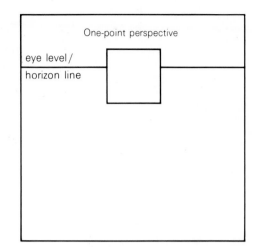

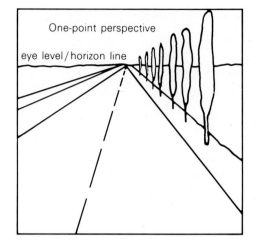

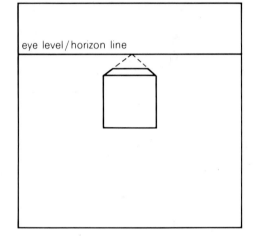

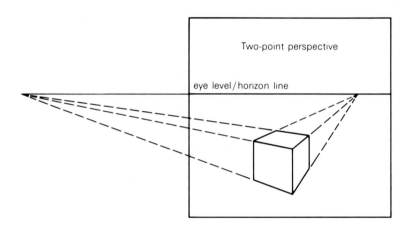

101 Linear Perspective

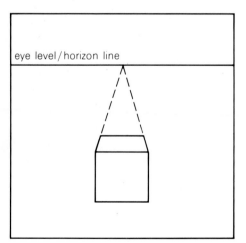

In a *two-point perspective* system two sets of parallel lines appear to converge at two points on the horizon line. There can be as many vanishing points as there are sets of parallel lines.

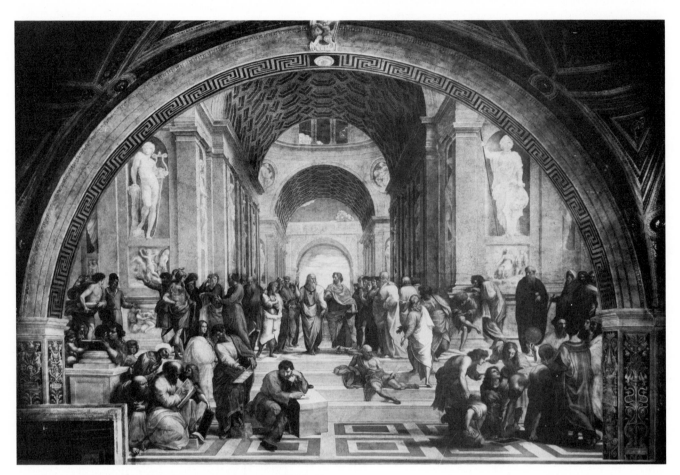

102 Raphael Sanzio. THE SCHOOL OF ATHENS. 1509. Fresco. Approx. 26 x 18′. Stanze della Segnatura, Vatican, Rome.

In Raphael's THE SCHOOL OF ATHENS we see imagined architecture in the Renaissance style, providing a grand setting for the figures. Raphael has achieved balance here between interest in the group of figures and the pull into implied deep space created by linear perspective. The size of each figure is to scale according to its position in space relative to the viewer, thus the entire group seems natural. Lines superimposed over the painting reveal the basic one-point perspective system used by Raphael.

The great teachers of the School of Athens are Plato and Aristotle. We know that they are the most important figures in this painting because they are placed at the center of the series of arches and are framed by the one farthest

emphasizes the origin of a linear perspective view. The mirrored surface of Escher's globe distorts normal perspective, giving a more complete view of his room than could normally be seen from a single position without eye movement. Four walls, the floor, and the ceiling are compressed into a single image. The lines defining these planes curve with the sphere's surface. The absolute center is the point between the artist's eyes. Whichever way he turns, he is still the center.

Linear perspective is simply a device the artist may or may not choose to use. The Swiss artist Paul Klee rarely employed the concept but when he did, he used it freely to achieve a particular spatial concept. In UNCOMPOSED OBJECTS IN SPACE he created an ominous dreamlike mood in which objects seem to be flattened by an unseen force coming from the dark doorway.

103 M.C. Escher. HAND WITH REFLECTING GLOBE. 1935. Lithograph. 32 x 21.5 cm. Escher Foundation, Haags Gemeentemuseum, The Hague.

away. Perhaps more important is the fact that they are placed on either side of the vanishing point. They are in the zone of greatest implied depth. At the point at which the viewer is pulled farthest back in space, the two figures come forward, creating a dynamic tension between push and pull in implied deep space.

M. C. Escher's lithograph HAND WITH RE-FLECTING GLOBE uses linear perspective inventively. By reflecting his own gaze, Escher

104 Paul Klee. UNCOMPOSED OBJECTS IN SPACE. 1929. Watercolor. 12⅝ x 9⅞". Private Collection.

105 GRASSY HILLS AND LEAFY TREES IN MIST (MISTY LANDSCAPE).
Attributed to Mi Fei. c. 1090. Hanging scroll, ink on silk.
60'' long. The Smithsonian Institution, Freer Gallery of Art,
Washington, D.C.

Another kind of perspective developed during the Renaissance is called *atmospheric perspective*. As the distance between us and large objects like buildings and mountains increases, the quantity of atmosphere between us and the objects changes their appearance. Atmospheric perspective is based on the fact that as objects get farther away from us, they appear less distinct, cooler, or bluer in color, and more moderate in color saturation and in dark and light contrast. The artists of the Orient used atmospheric perspective differently from their European counterparts.

Four centuries before the beginning of Western landscape painting as we know it, Chinese painters of the Sung dynasty (960–1279) developed a monumental landscape style.

The soft rolling shapes of mountains stack up in rhythmic layers of suggested space in this painting in the style of Mi Fei, titled GRASSY HILLS AND LEAFY TREES IN MIST. Representational features are minimized to create an abstract reference to the low-lying coastal hills of southern China. The famous Sung master and connoisseur Mi Fei developed a technique of daubing the ink on the silk surface to build up forms layer by layer without outline. Atmospheric perspective is seen by the way the mist seems to progressively dissolve the graying form of the hills. The resulting mood of quiet yet impressive dignity leaves a lasting memory.

The painting was created from memory, away from the subject; therefore the implied high vantage point of the viewer is not an actual observation point, but a device offering a detached view of distant hills in a subtle pattern that moves primarily across rather than into the picture plane.

The Renaissance idea of a painting as a window onto nature is readily apparent in Claude Lorrain's painting THE HERDSMAN. As we observe this work, our vantage point is low. In

106 Claude Lorrain. THE HERDSMAN. c. 1655–1660. Oil on canvas. 47¾ x 63⅛''. National Gallery of Art, Washington, D.C. Samuel H. Kress Collection.

107 Paul Cézanne. THE TURNING ROAD. 1879–1882. Oil on canvas. 23½ x 28½''. The Museum of Fine Arts, Boston. Bequest of John T. Spaulding.

this position we feel that we could walk right into the painted landscape, as though its implied space were an extension of our own space. However, the sun and its light come toward us from the distance, stopping us in a sense from stepping into this space and into infinity. Atmospheric perspective is effectively employed in the painting to heighten the illusion of deep space. Yet our interest is held in the foreground by the figure of the herdsman and his flock.

In Lorrain's painting, the direction of implied movement in space is into (or through the painting), suggesting three-dimensional depth. In contrast, the implied movement in the Mi Fei-style Chinese landscape painting is primarily across the two-dimensional space of the picture plane.

In Paul Cézanne's THE TURNING ROAD another kind of pictorial space is constructed. Because our vantage point is high above the ground plane, we are not led into this painting as we were in Lorrain's landscape. Cézanne intentionally tipped up the road plane, making it a major shape in the composition. He also changed other planes in order to strengthen the dynamics of the picture surface. He does not rely on the window view from one vantage point. Color helps determine the implied spatial position of the various planes. Cézanne's goal was to reconcile in his own way the three-dimensional reality of nature with the character of the flat picture surface on which he worked.

After 400 years of the painting-as-a-window tradition, Cézanne's approach led to a total reexamination of pictorial space.

About 1907 Georges Braque and Pablo Picasso began developing a new kind of spatial configuration in their paintings. The new style completely abandoned the use of logical sequential progression into deep space which had been the foundation of painting since the Renaissance.

108 Georges Braque. HOUSES AT L'ESTAQUE. 1908. Oil on canvas. 73 x 59 cm. Bern Foundation.

The simultaneous perception of multiple views became more important than the consistent presentation of appearances from one vantage point in time and space. From this time on, many artists paid more attention to the effects they could create across a picture surface rather than into it.

Instead of denying the two-dimensional limitations of the picture surface, twentieth century artists have accepted these limitations and used them advantageously to create other kinds of spatial illusions relevant to the concerns of our age.

In the beginning of the twentieth century, painters began to work primarily on two spatial problems: how to come back to the strength of the picture plane and how to express the totally new concepts of space. Changes in science paralleled changes of time and space in art. Major discoveries, such as Einstein's theory of relativity, the splitting of the atom, and the airplane gave us new ways of perceiving. These discoveries created the first major revolution in Western spatial concepts since the Renaissance invention of linear perspective. Changes in philosophy, theology, technology, and art together brought us into a new era.

For many of us, the works we define and accept as "art" are in the tradition of Renaissance illusionistic space which was achieved through the use of linear and atmospheric perspectives. But if we consider art history as a whole, we will realize that most paintings in the world have been designed in terms of shallow space, ambiguous space, or flat surfaces. Therefore, they have more in common with the spatial concepts of international contemporary art than with the Renaissance concepts of space. The Chinese, Egyptian, Persian, and medieval Italian paintings at the beginning of this section and non-European paintings shown elsewhere serve to illustrate this assertion.

Their style is called Cubism. HOUSES AT L'ESTAQUE is an early Cubist painting done by Braque in 1908. In this twentieth-century landscape painting, the abstract geometric shapes define a rush of forms that pile up rhythmically in shallow space. Buildings and trees seem interlocked in an active spatial system that pushes and pulls across the picture surface.

Logical, step-by-step progression into pictorial space was abandoned in Cubism. Painters used multiple vantage points to show more of a subject at one moment than was possible from a single, fixed position.

Time

Time is the period between events or during which something exists, happens, or acts. We recognize that both clock time and psychological time are significant, yet in our actual experience they are often opposing. The passage of time can be expressed by association. To visually express actual time it is necessary to utilize space and motion.

Sassetta implied the passage of time in THE MEETING OF SAINT ANTHONY AND SAINT PAUL. The painter depicted certain key moments during Saint Anthony's progression through time. Saint Anthony begins his journey far back in time and space at the city barely visible behind the trees. He comes into view as he first approaches the wilderness. Next we see him as he encounters the centaur. Finally he emerges into the clearing in the foreground where he meets Saint Paul. The road implies a continuous movement.

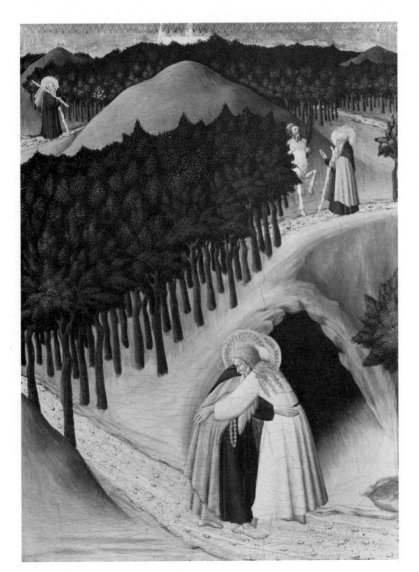

109 Sassetta and assistant. THE MEETING OF SAINT ANTHONY AND SAINT PAUL. c. 1440. Tempera on wood. 18¾ x 13⅝''. National Gallery of Art, Washington, D.C. Samuel H. Kress Collection.

91

The desire to preserve images out of the flow of time goes back to prehistoric cultures. This urge was part of the inspiration for the development of photography. In photography's initial development, only static, inanimate objects could be recorded on photosensitive material that required a long exposure time. By 1839 it was possible to photograph people standing or sitting very still, and by 1853, to record people, animals, and things in motion. See Muybridge's work on page 152.

Harold Edgerton's high-speed photograph of a milk splash "freezes" an event in time that would not be visible otherwise. Edgerton bounced a tiny ball off the milk surface and lit the event with the flash of a stroboscopic lamp for a mere 1/100,000th of a second. There are two ways to control the length of time that film is exposed. One is with the shutter speed, and the other, which Edgerton used, is with the light source.

Time within two-dimensional works such as drawings, photographs, and paintings must be implied. The work can be seen instantly and wholly; the total work is like a still moment out of moving time. The physical experience of actual time in motion pictures is sequential. The term *movies* derives from the

110 Harold Edgerton. MILK SPLASH RESULTING FROM DROPPING A BALL. 1936. Photograph.

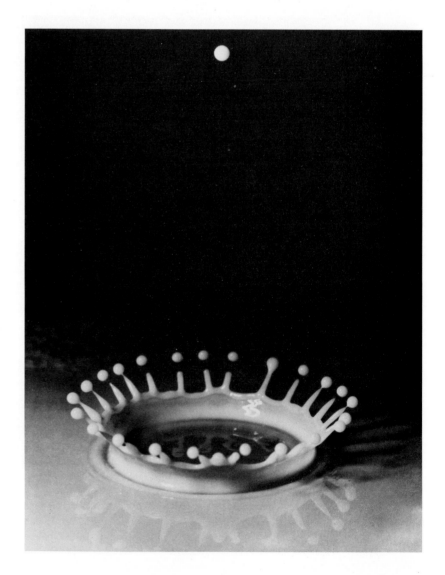

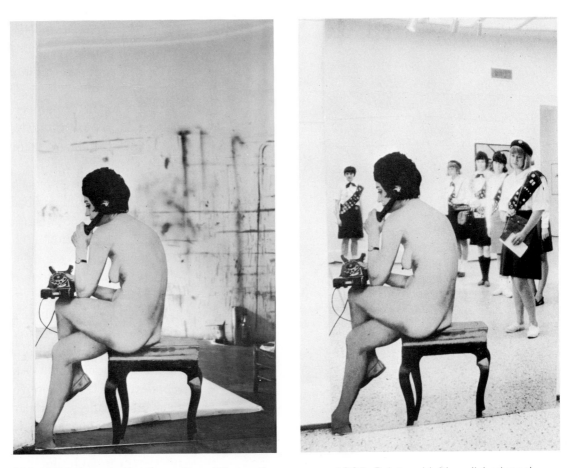

111 Michelangelo Pistoletto. NUDE WOMAN TELEPHONING. 1965. Paint on highly polished steel. Life-size. Private Collection.

central feature of the filmmaker's art where the appearance of motion from one frame to the next introduces sequence and thus creates a different time frame from those in painting or still photography. The concept of time in cinema is discussed in detail under Cinematography, page 156. With the development of television it became possible to transmit images of present time. In both film and television, clock time can be manipulated to conform to psychological time. Past, present, and future time can be implied and intermixed, and events that occur too quickly or too slowly to be visible to the human eye can be made visible by slowing down or speeding up events in time.

In NUDE WOMAN TELEPHONING, Michelangelo Pistoletto has contrived to capture events in actual time on a flat surface. He created the figure with paint on paper. Then the painting was glued to a reflective, stainless steel surface, which mirrors the surroundings.

The only way to suggest the effect of time in a reproduction is to show the work in two different photographs as seen in two different locations. The woman goes on telephoning whether she is alone or with, for example, the Girl Scouts who are here observing the work. If we were there viewing it, we would see a variety of different groupings over time and would be able to see actual motion—perhaps our own.

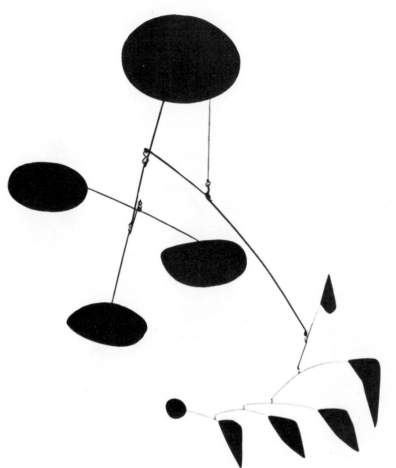

112 Alexander Calder. FOUR BIG DOTS. 1963. Sheet metal and steel wire. 29 x 113''. San Francisco Museum of Modern Art. T. B. Walker Foundation Fund Purchase.

Motion

Motion is action created by actual or implied change of position. Traditionally, the visual arts have been considered as primarily spatial arts. Now a growing number of artists and architects working with new and traditional media are expanding the temporal dimension of the visual arts.

Dance is a major temporal and spatial visual art. In dance, the human body itself becomes the expressive three-dimensional medium in space. The live motion of bodies, their mass, their changing shapes and the changing shapes of space among them form the basic vocabulary of dance.

Fountains have long been a favorite kind of moving or *kinetic sculpture*. Kites, banners, and flags are forms of art in motion activated by the movement of air. Alexander Calder's *mobiles* also rely on air movement to perform their subtle dances. Many artists are now devoting all their energies to designing forms in motion. Artist Robert Breer is working with movement in both film and sculpture.

Imagine walking along a country road and suddenly coming upon a herd of small white blocks moving slowly along, powered by battery operated motors. Breer made the apparitions he calls FLOATS out of shaped blocks of styrofoam. (See also Tinguely's work, page 369.)

To fully experience the total form of any three-dimensional work of art, it is necessary for either the viewer, the object, or both to move. Photographs of sculpture and architecture do not have this dimension since they limit the viewer to one point of view. When seeing the actual object in space, one becomes involved with the dramatic interaction of the various planes of the mass, which ultimately resolve into the memory image of a total integrated form. See Saarinen's TWA TERMINAL page 78, and KANDARYA MAHADEVA TEMPLE page 255.

113 Robert Breer. FLOATS. 1966. Motorized styrofoam.

114. Giacomo Balla. DYNAMISM OF A DOG ON A LEASH. 1912. 35¾ x 43¼". Albright Knox Art Gallery, Buffalo, New York.

Architect and urban designer Lawrence Halprin in his book *R.S.V.P. Cycles* describes how he interweaves designed spaces into a performance with the indeterminant elements of people moving and at rest. His firm's FORECOURT CASCADE, in Portland, Oregon, is an excellent example of this concept of chance human movement interacting with planned water movement in designed space (see page 397). The whole work is a dynamic performance of space, always changing like a Calder mobile, always creating new relationships.

Anuszkiewicz's Op painting INJURED BY GREEN was designed to produce involuntary eye movement. (See color plate 8 and discussion, page 66.) Another type of eye movement is induced by Bridget Riley's CREST, page 49. Emphasis on optical sensations such as these is the common factor in Op (short for "optical") paintings. Both actual and implied motion have become important in the visual arts in recent years.

Implied motion in drawing and painting is linked with the action of lines and the repetition of shapes or other rhythmic elements. In DYNAMISM OF A DOG ON A LEASH, Futurist painter Giacomo Balla shows the simultaneous movement of forms in space as seen from a fixed vantage point over a period of time. (See also pages 332 and 333.) Through rhythmic repetition Balla captured the visual excitement of motion. His image depicts the concept presented in the *Futurist Painting: Technical Manifesto* of 1910:

In fact, all things move and run, all things change rapidly. The profile before our eyes is never static but constantly appears and disappears. Given the persistence of the image in the retina, moving objects are multiplied, changing their shapes as they pursue one another like lively vibrations across space.[8]

Sassetta implied that Saint Anthony moved in time and space. Two-dimensional images often imply movement across and/or into the picture plane. In film, rapid sequences of still pictures are shown at the rate of twenty-four per second, creating the illusion of actual motion. In this sense, the motion of the "movies" is also implied.

PRINCIPLES OF DESIGN

We have a basic need to find and make order in the world around us. We make plans, compose letters, form groups, and organize the objects we deal with in daily life. If we go too far with this activity, insisting that life be always according to plan, life is very dull and many unexpected opportunities are missed. If, however, we have no plans, no sense of order in organizing our affairs, life is uncomfortably chaotic.

Each person must strike a balance between these extremes. The design process in both life and art is at its best when it is a lively open dialogue between the intention and intuition of the designer and the characteristics of the medium he or she is using. We may carefully design a room, a picnic, a painting, a day, or even a life, but what actually happens in every case is the result of interaction between our design and the material being designed. Many times the "material" takes over, and for better or worse, we have a spontaneous design. The procedure, depending on the person(s) involved, can range all the way from tightly controlled order to open chaos. A workable or "good" design solves a problem or problems. An unworkable or "bad" design is itself a problem that creates other problems.

Our need to design stems from our desire for harmony. Harmony is a refined form of order. Each day our actions affect the form of our surroundings. As a conscious process, design can enhance and clarify the relationship between ourselves and our environment.

Design in nature and in art grows from inner necessity. In nature, survival depends on the interrelationship of form and function. Function determines the design of living forms, yet their design is more than mere utility.

We are reacting to design when we respond to the aesthetic qualities of the creations of nature. The designs of living things evolve through the process of natural selection. The fact that there are two sexes has produced a dazzling variety of species whose designs are continuously enhanced by courtship and mating processes. The entire array of shapes, colors, and patterns of a male peacock on display for the female is organized in a rich and subtle harmony of form. Even the "eye" of a single feather is a fascinating echo of the shape and color of the entire bird. (See color plate 9, near page 67.)

Nature's designs inspire our own. Human design at its best is an extension of nature's design.

Forms in the visual arts are created by organizing various elements or units to make a whole. The process of ordering or structuring these elements is called designing and/or composing. The arrangements that result are often spontaneous or intuitive, but they usually follow a plan, frequently called *design* or *composition*.

Design is a broader term than *composition*. "Composition" is the older term; it is used in all the arts, particularly literature and music. In the visual arts "composition" is frequently used when discussing an individual work.

The following discussion will demonstrate some of the most fundamental principles of basic design. These principles can be applied to all visual design problems.

The *principles of design* refer to the character or quality of relationships between visual elements. They include: scale, proportion, variety within unity, repetition and rhythm, balance, directional forces, emphasis and subordination, and contrast.

Any work of art or natural object has most of the visual elements and principles of design working simultaneously within its form. However, as with the elements, design principles will be defined and demonstrated one at a time.

115 a. Peacock

115 b. Detail of peacock feather. *See color plate 9, near page 67.*

Scale

The scale of a work of art affects the viewer immediately. *Scale* refers to relative size, such as the size relationship between the work and the observer. Our senses register size as part of our overall responses. Responses to objects change as the relationship of an object's size to our size changes. Artists who paint exceptionally large canvases or construct environmental sculpture make use of the impact of things that are larger than human scale.

When the size of any work is modified to be reproduced in a book, its character changes. The sizes of almost all the works in this book have been changed in order to fit them on the page. A few exceptions are Rembrandt's SELF-PORTRAIT IN A CAP, OPEN MOUTHED AND STARING (page 24), reproduced actual size; Weston's PEPPER #30 (page 37), and the POMO FEATHERED BASKET (page 234), reproduced close to actual size. Chartres Cathedral (page 256), and Versailles (page 280) are, of course, shown as tiny fractions of their actual size.

A form dominated by bold simplicity and uniformly massive proportions in either two or three dimensions may be monumental in quality, yet actually very small. See the Aztec carving on page 42. Conversely, a large work may appear intricate or delicate and consequently feel smaller than its actual size.

Visual design is concerned with the qualities of visual relationships. Everything we perceive is relative. One-to-one scale relationships demonstrate this universal concept. A tall man next to a short woman exaggerates the tallness and shortness of each. In the diagram, the inner circle in both groups is the same measurable size, but they appear different.

116

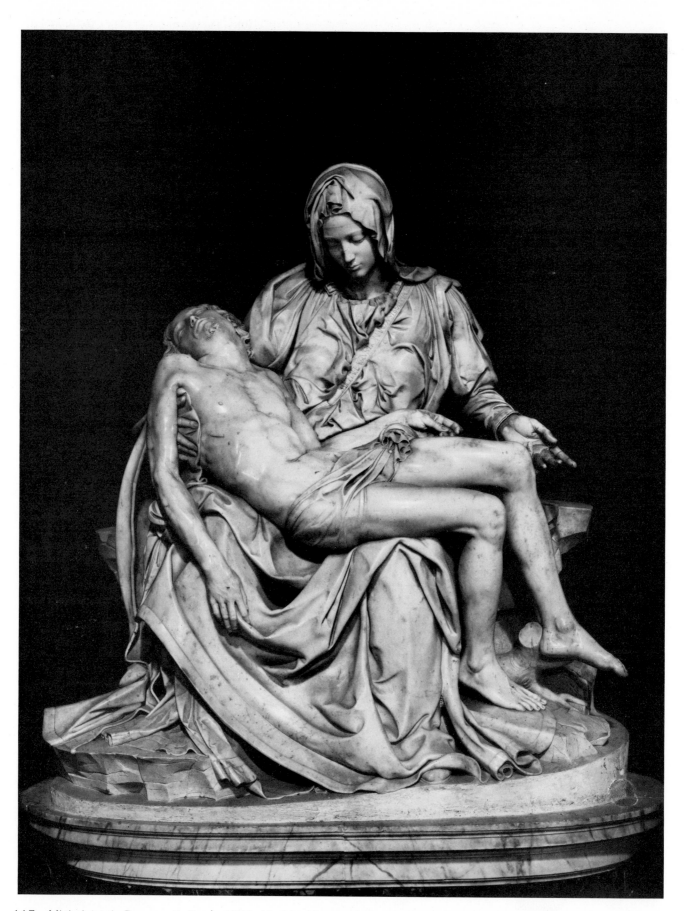

117　Michelangelo Buonarroti. Pietà. 1501. Marble. Height 6′ 8½″. St. Peter's Basilica, Rome.

Proportion

Proportion is the size relationship of parts to a whole and to one another. In terms of scale, the figure of Christ in Michelangelo Buonarroti's PIETÀ is life size but the figure of Mary is larger than life. Creating a composition in which a baby appears on its mother's lap is much easier than showing a fully grown man in such a position. Michelangelo solved this design problem by changing normal human proportions. He greatly enlarged Mary's body in relation to that of Christ's and concealed her immensity beneath massive folds of drapery. Her seated figure spreads out to accommodate the almost horizontal curve of Christ's limp body. Imagine what Mary would look like if she stood up. Michelangelo made Mary's body into that of a giantess. She may be nine feet tall! Her hands are about twice normal size. Yet we do not notice the unique proportions of Mary's figure because Christ's figure has normal proportions and because Mary's head is in scale with the head of Christ. We are so taken with the natural appearing relationship between the figures that the distortion of human proportions is unnoticed. Yet this distortion is essential to the way we experience the content of the work.

In comparing an earlier medieval PIETÀ done by an unknown sculptor with Michelangelo's work, we see that in these terra cotta (clay) figures the proportions are true to life, yet they seem unnatural at first. Christ's body appears to hang uncomfortably out in space without any support. The discomfort caused by the more normal proportions in this version has given the work an added sense of suffering and despair appropriate to the subject, yet quite different from the serene stability of Michelangelo's design.

Much later in life Michelangelo carved a DEPOSITION FROM THE CROSS in which the proportions and size of Mary on the right and Christ in the center are closer to normal scale.

118 Unknown Italian artist. PIETÀ. c. 1430. Polychromed terra cotta. Dyrekeji Museum, Danzig.

119 Michelangelo Buonarroti. DEPOSITION FROM THE CROSS. Left unfinished. 1555. Marble. Height 7' 5''. Florence cathedral.

In this late work, Christ's body takes a sagging vertical position, giving a feeling of collapse, which again is much different from the calm security of Michelangelo's earlier Pietà.

Variety Within Unity

Consistency of concept causes various elements within a work to appear as part of a complete form. An artist develops a sense of design as part of a personal way of seeing. Each work of art derives its unity from a single unifying concept operating within it. This does not mean that every work must have an intellectual idea behind it. The unifying concept often begins as a strong, motivating feeling within the artist.

Unity is the appearance of oneness. All artists work within self-imposed limitations. Such limitations often provide unity in their work. Yet enough variety must be incorporated within visual unity to keep the viewer's interest. *Variety* is diversity, but without design, it is confusion. Variety within unity achieves a balanced interest.

Within this century several artists have severely limited the kind and number of elements in their work in order to concentrate on the expressive possibilities of one element. Barnett Newman worked primarily with vertical bands or lines for more than a decade. In the work reproduced here, DRAWING, two vertical lines balance one another as the plain white background of the paper on the left interacts with the active dry brush textures, setting off the negative space line on the right. In this drawing, unity is found in the similarity of the dominant vertical straight lines. The inventive contrast between the way these simple elements are presented provides variety within the basic unity.

120　Barnett Newman.
DRAWING. 1959.
Collection Francine
Gray.

121 Pieter de Hooch. INTERIOR OF A DUTCH HOUSE. 1658. Oil on canvas. 29 x 25''. The National Gallery, London.

Repetition and Rhythm

The reoccurrence of a design element provides continuity, flow, and dramatic emphasis. This *repetition* may be exact or varied and it may establish a regular beat. Visual *rhythm*, like audible rhythm, operates when there is an ordered repetition of elements.

A rhythmical pattern results from near exact repetition in Andy Warhol's GREEN COCA-COLA BOTTLES (see page 363). Here each bottle receives the same emphasis, producing an endless succession of beats with no relief through variety.

However, repetitions need not always produce a regular beat or rhythm. Changing the size of the repeated element is another way in which unity is achieved. In INTERIOR OF A DUTCH HOUSE by Pieter de Hooch, the definite rhythm set up by the rectilinear pattern of the floor and windows is relieved by the larger rectangles representing the map, painting, fireplace and table. The overall rectilinear theme repeats the horizontal and vertical directions that begin with the edges of the picture plane.

In Raphael's MADONNA OF THE CHAIR, the curved shapes echo the circular format of the painting. But this repetition of curved elements, convex and concave, large and small, does not set up a rhythmical beat. Instead, they provide a flow and continuity which is stabilized by the single vertical axis of the chair post.

122 Raphael Sanzio. MADONNA OF THE CHAIR. c. 1514. Oil on wood. 2' 4'' diameter. Pitti Gallery, Florence.

123 José Clemente Orozco. ZAPATISTAS. 1931. Oil on canvas. 45 x 55''. The Museum of Modern Art, New York.

A progressive visual rhythm is set up across the picture plane in José Clemente Orozco's ZAPATISTAS. The line of related figures is a sequence of alternating light and dark diagonal shapes grouped in a rhythmic pattern that expresses the aggressive force of oppressed humans in revolt. The strong visual beat of this design is established by the marchers and by the repeated, yet varied, shapes of the sombreros.

Duchamp's NUDE DESCENDING A STAIRCASE is an example of rhythmic progression showing sequential change and suggesting movement. See page 333.

Balance

When we experience works of art, the same sense of *balance* that enables us to stand and move in an upright position comes into play in terms of purely visual forces. In Hans Holbein's portrait ANNE OF CLEVES, basic shapes are organized along a vertical axis. When elements on either side of an actual or implied central axis are similar or identical, the work is symmetrically balanced—or, specifically, there is *bilateral symmetry,* one of the simplest and most static forms of balance.

When we compare the symmetrical design of ANNE OF CLEVES with other symmetrical compositions, such as Käthe Kollwitz's SELF-PORTRAIT and the Aztec mother goddess (see pages 33 and 42), the characteristic stable quality found in this type of symmetry becomes obvious. All of these works give the viewer a sense of monumental, almost motionless stability. The formal dignity of Holbein's ANNE OF CLEVES derives from its design.

Richard Lippold's sculpture of the sun on page 165 and the plans on pages 220 and 221 have *radial balance;* elements radiate from or converge on an actual or implied central point.

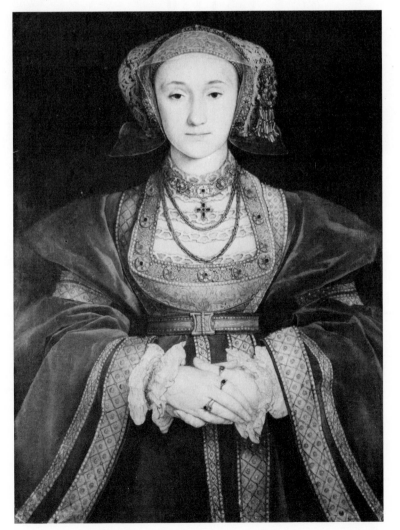

124 Hans Holbein. ANNE OF CLEVES. 1539. Oil on wood panel. The Louvre, Paris.

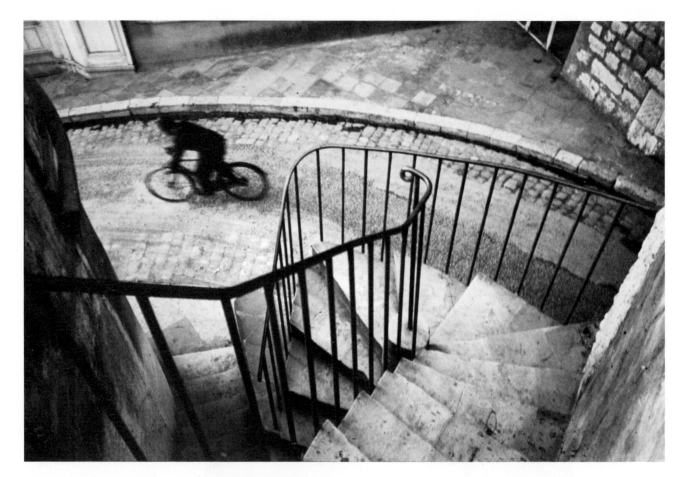

125 Henri Cartier-Bresson. HYÈRES, FRANCE. 1930. Photograph.

Asymmetry is the absence of symmetry. Asymmetrical balance is more frequently brought into play than symmetrical balance because it is inherently more subtle and dynamic. In this form of balance, elements of varying visual weight are brought into equilibrium. In the child's drawing on page 17, the single figure is placed far to the left of center. Yet the whole image feels balanced because the figure's left arm is made long enough to place the radiating finger lines of the circular hand in the center of the almost square background area. This placement balances the visual weight of the figure. If the left arm were the same length as the right, the drawing would be weak and incomplete because its balance would have been lost. Visual unity is achieved by repetition of the radials of the hands and feet, and the repeated curves of the mouth, chin, and lower dress edge. The line that surrounds the figure, roughly parallel to the outer edges of the paper, reveals the child's unconscious awareness of balance on the picture plane.

In Henri Cartier-Bresson's photograph of stairs and a moving cyclist, dynamic asymmetrical balance is achieved between the triangular gray shapes in the lower right and the dark

figure of the cyclist leading off to the upper left. Our eyes follow the spiraling lines of the railings and the rhythmic pattern of the stairs to the bicycle rider. This figure would take us out of the frame and leave us there if it were not so skillfully balanced by the elements in the lower right corner.

The photographer probably selected this exciting series of curves and shapes, then waited for a moving cyclist to complete the picture. Everything in the image contributes to a spiraling sense of thrust. The rider is the final climax, emphasizing and completing the dynamic movement pattern that builds to send him on his way.

In photography the smallest thing can be a great subject.[9]

Thinking should be done beforehand and afterwards—never while actually taking a photograph.[10]

Because of the purity of his vision and technique, Cartier-Bresson is highly regarded by other photographers. He neither manipulates reality while shooting, nor does he crop or manipulate his photographs during the printing process.

Directional Forces

Designed objects or works of art often have dominant directional linear forces operating within them and tying them together into a consistent form. _Directional lines_ are implied or actual lines creating the basic structure of a work. _Implied lines_ may be suggested by the imagined connection between similar or related adjacent forms such as the dots in a dotted line. An implied line may also be the unseen _axis_ line that indicates the dominant direction of a single form or a complete symmetrical design.

Vertical and horizontal lines repeat the human experience of standing and lying down. A horizontal line has a feeling of rest and inaction and provides a ground plane for a vertical. A vertical line is one of poise. The two together provide a sense of composure. Both horizontal and vertical lines, either implied or actual, are relatively motionless or static.

Diagonal lines are lines of action. They often seem to want to fall to horizontal or rise to vertical. Diagonal lines cause tension because they disrupt our sense of vertical balance. Gravitational pull provides the feeling of motion. We may feel their dynamic tension because we identify with their likeness to the human figure—diagonal when in motion and still or at rest only when vertical or horizontal.

Our physical reactions to gravitational forces are applied to what we see. Shapes within a form appear to fall, be pulled, float, move, be free, or be confined. Jokes are often made about hanging nonobjective paintings upside down. But it makes quite a difference, because as soon as something is turned, its whole relationship to our world of up and down changes. Try turning Barnett Newman's DRAWING (page 100) on its side.

When designing an image on a picture plane, the _format_ or basic picture shape and the dominant direction of _implied movement_ within the design are basic sources of expressed mood or content. The rectangle formed by the edge of the picture plane in Holbein's portrait (page 103) provides a vertical format in which the dominant subjective or implied axis line is also vertical. The mood of verticality is one of alert poise, attention, or standing, whether we are looking at an actual standing figure, a sculpture of a standing figure, or actual or implied vertical line(s) or form(s), as in the facade of Chartres Cathedral (page 256), or Barnett Newman's drawing (page 100).

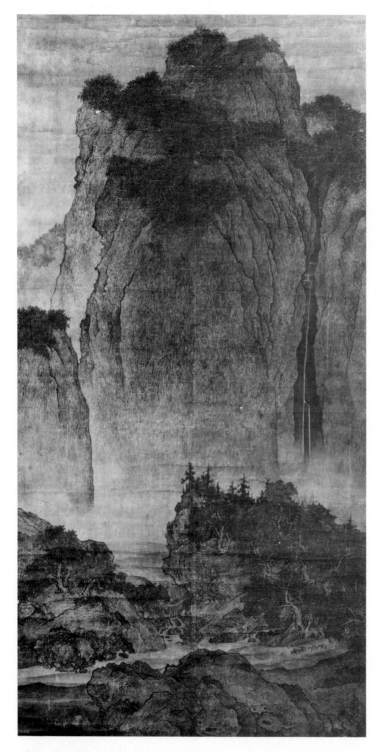

126 Fan K'uan. TRAVELERS ON A MOUNTAIN PATH.
c. 900–1030. Hanging scroll, ink on silk. Height 81¼".
National Palace Museum, Taipei, Taiwan.

Vertical, horizontal, and diagonal forces interact in Fan K'uan's TRAVELERS ON A MOUNTAIN PATH. The vertical emphasis of the composition is set off by the almost horizontal line of the light area behind the rocks in the lower foreground. The scale of the travelers expresses a traditional Chinese attitude toward humanity's place in nature.

When a vertical line intersects a horizontal line, the opposing forces generate a visual attraction that acts as a strong center of interest in the design. Fan K'uan has taken advantage of this phenomenon by extending the implied vertical line of the upper falls to bring our attention to the caravan. Although the tiny size of the figures serves to indicate the vastness of nature, the figures must be seen in order to give human significance to the painting.

The diagonal line moving from left middle ground to lower right on the edge of the two groups of rocks and the lower falls provides a secondary movement which, along with the forward cliff on the left, helps balance the visual weight of the slender upper falls. The simplicity of this monumental landscape is maintained by grouping the complexity of fine details into dark areas set off by light intervals. Rising mists are suggested by the light area at the base of the cliffs that divides the major portions of the composition into lower third and upper two-thirds.

Francisco Goya's remarkable etching BULL FIGHT is a good example of dramatic asymmetrical balance. Most of the subject is concentrated in the left two-thirds of the rectangle. We are drawn to the *point of emphasis* by the intersecting horizontal and vertical lines behind the lower hand of the man on the pole. This linear movement seems to hold the design together in spite of the tension and movement implied by the diagonal force lines of the bull and the man. Through design, Goya emphasized the feeling of suspense and potential danger.

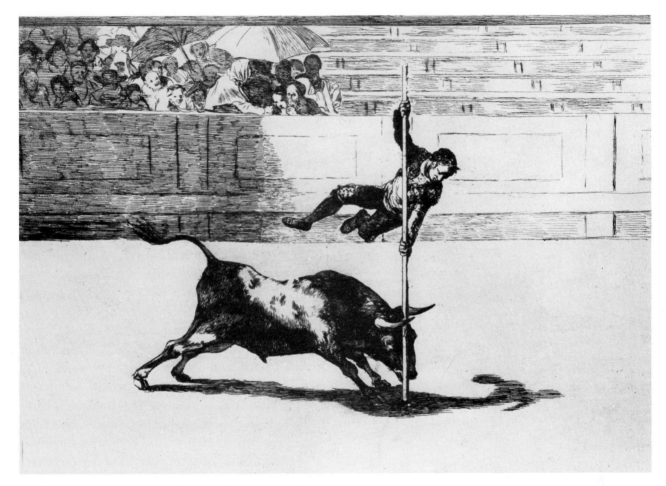

127 Francisco Goya. BULL FIGHT. 1810–1815. Etching.
12¼ x 8⅛″. The Fine Arts Gallery of San Diego.

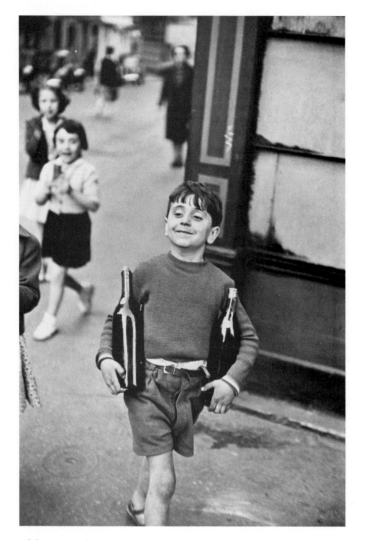

128 Henri Cartier-Bresson. SHOPPING ON A SUNDAY MORNING, RUE MOUFFETARD. Paris, 1958. Photograph.

In SHOPPING ON A SUNDAY MORNING, RUE MOUFFETARD, Cartier-Bresson released his shutter just at the moment when everything went together to emphasize the jaunty swagger of the boy. He walks in one direction, yet looks in a counter direction, thus balancing the tension between the two. The major axis of the composition runs diagonally through the boy's figure, giving a sense of swinging movement to the whole design. If this axis were vertical, the photograph would lose its visual impact.

Implied lines of visual force or energy are not actually visible but are felt to connect elements, groups, sequences of shapes, and lines or shapes seen in pairs. Such lines are also called "subjective lines" because they exist only in terms of the viewer's response. The implied lines of sight that are of or between people or animals depicted in a work of art are usually important "lines" in the total design of that work because they can connect major figures and create significant directions of movement within the work. Edgar Degas's PLACE DE LA CONCORDE has many such lines.

During the nineteenth century, Edgar Degas was a member of the Impressionist group in Paris, but he saw things in his own way and remained on its fringes. He went further in his presentation of the fleeting world, using a camera as a studio tool. Degas was intrigued by the way in which the camera fragmented objects seen in actual, continuous space. In PLACE DE LA CONCORDE, we see people grouped by chance on a street. Degas based his composition on the accidental quality of normal visual experience, as well as on spontaneous poses captured by the camera. He chose to paint marginal events, as though the meaning of a given moment is expressed by the synchronicity of seemingly accidental events

The implied lines set up by the directions in which the dog, the girls, and the man are looking act as axes of force in the composition. Everyone is looking in a different direction. At the far left a man appears, cut off by the top and side edges of the picture plane, giving the impression of a candid photograph. If we study the composition carefully, we realize that Degas has ultimately called our attention to the empty area just in front of the dark doorway in the distant wall. See diagram. The quality of Degas's vision and his sense of meaning in interrelationships help us see the revealing impact of certain common visual occurrences that are usually ignored.

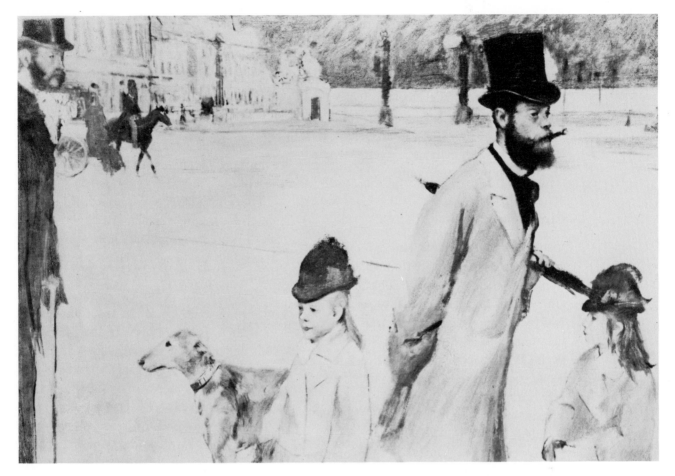

129 Edgar Degas. PLACE DE LA CONCORDE. c. 1873. Oil on canvas. 31¾ x 41⅜". Location Unknown.

Emphasis and Subordination

Mu Ch'i's painting of SIX PERSIMMONS on page 81 is a straightforward example of the principle of *emphasis and subordination*. The group is like a family, with one persimmon emphasized and therefore recognized as dominant. Each of the other five persimmons has its own individual character in diminishing sequence of importance within the group, thus providing a rich variation on a simple theme. For contrast, compare Andy Warhol's GREEN COCA-COLA BOTTLES (page 363) which forces the viewer to seek variations within the intentional monotony of the image.

A more oblique version of the principle of emphasis and subordination is seen in Degas's PLACE DE LA CONCORDE. Objects, people, and a dog lead the viewer on a circuitous route past the gentleman with the top hat on the right, who is the expected point of emphasis, to the blank area, which cannot hold our attention. Thus we begin again a restless search for the painting's focal point.

Contrast

Visual interest, emphasis, and expressions of content can be achieved through contrasts. *Contrast* is the interaction of contradictory elements that express the duality seen in opposites. In line, it can be the contrast between the thick and thin areas of a single brush stroke. With shapes, it may be between regular geometric and irregular organic shapes or between "hard" and "soft" edges of shapes. Value contrasts occur between adjacent light and dark areas on a surface.

Color contrasts are seen in a variety of ways, including contrast of hue, contrast of complements, contrast in saturation (between bright and dull), or contrast in temperature between the warm and cool qualities of color.

The contrast between solid mass and empty space is a major factor in Henry Moore's RECUMBENT FIGURE (see page 75). In two-dimensional works there is often a dynamic tension set up between the push and pull in implied space as in Raphael's SCHOOL OF ATHENS, where the major figures are emphasized by their implied forward motion in the area of greatest implied depth. (See page 86.)

EVALUATION

It is the *way* in which something is put together or designed that makes it art.

Artists achieve lasting quality in their work by evaluating their own efforts. In his finished works, Matisse showed the results of a long search, not the search itself. Thus, many of his paintings look easy—as if they were done with little effort.

The effort involved in his long, patient search for the right design can be seen in the six working stages of PINK NUDE shown here. Matisse attached pieces of colored paper to the surface of the picture to determine how the possible changes would look before he began repainting. In each stage Matisse selected and strengthened those aspects of the image that contributed most to the overall design. Finally, when he felt that everything worked together, he stopped.

The rhythm of the background grid contrasts with the sweeping, sensuous shapes of the figure. The awkwardness of the spacing and the rather disjointed proportions in the earliest version of the figure have gradually been resolved. In the final painting, the bold distortions of the figure add up to a calm and elegant abstraction of the subject.

Then a moment comes when every part has found its definite relationship and from then on it would be impossible for me to add a stroke to my picture without having to paint it all over again.
Henri Matisse[11]

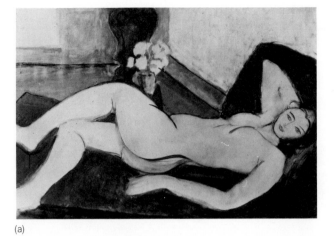 (a)

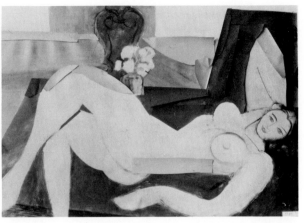 (b)

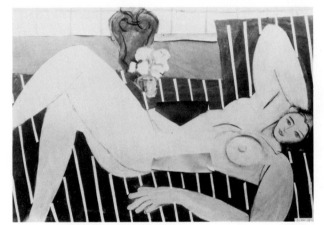 (c)

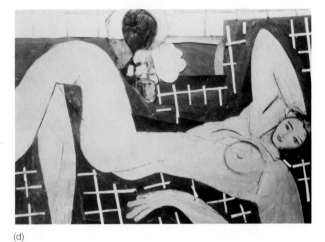 (d)

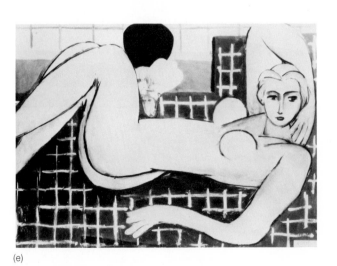 (e)

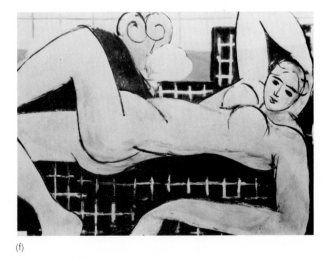 (f)

130 Henri Matisse. Six states of PINK NUDE. Oil on canvas. (a) State 1, May 3, 1935; (b) State 6, May 23, 1935; (c) State 9, May 29, 1935; (d) State 11, June 20, 1935; (e) State 13, September 4, 1935; (f) State 23, September 15, 1935.

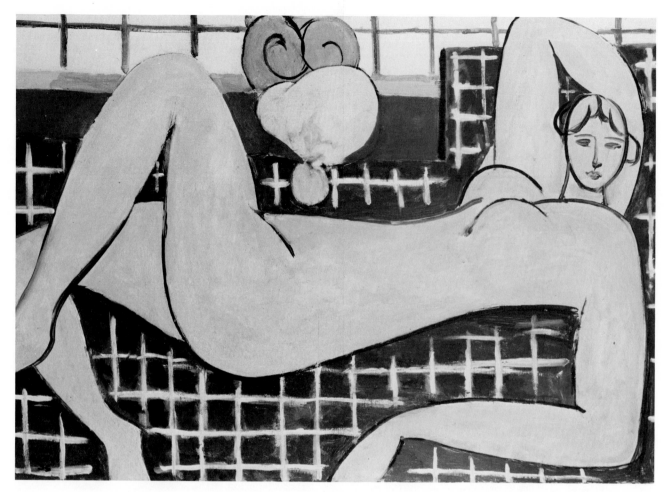

131 Henri Matisse. PINK NUDE. September 15, 1935. Oil on canvas. 26 x 36½''. The Baltimore Museum of Art.

Value judgments in art involve subjectivity. Objective considerations usually miss the point. Factors such as physical permanence are easily measured but meaningless unless the work is worth preserving. Quality in art has little to do with complexity of technique, degree of difficulty, training, or education of the artist. Often the art process and accompanying experience are far more significant than the resulting work. This is noticeably true in the creative expressions of children. How can we evaluate the quality of another's personal or creative experience?

Quality is relative. Concepts of what is valuable in art or anything else change from person to person, from age to age, and from culture to culture. Changes in taste are not the same as changes in value. Preference and evaluation are quite different. We can recognize aesthetic quality in works we do not like.

Almost all of us have critical opinions on works of art, regardless of how familiar we are with art or theories of art criticism. There are no absolutely correct evaluations of art, although there are many procedures for analyzing, interpreting, and evaluating. When we look at art and find that we are pleased or displeased, we may seek to find out why. We may derive added pleasure from understanding those qualities of a work that evoke our responses. The trained viewer can contribute his or her experience and add to the satisfactions another person may derive from a given work. In reading and hearing comments by critics, our capacities for understanding can be expanded. Art criticism in this sense is a sharing of discoveries about art and life.

An individual may develop a level of personal taste and an ability to evaluate art on the basis of acquired knowledge and years of experience. This experience would give such a person a perception of style and lasting value as opposed to mere fashion. The word *style* is usually used to refer to works done or made in a characteristic way or manner. It is also used to indicate a high level of imagination and individuality expressed in action or taste. Although in popular usage the words *style* and *fashion* are often interchangeable, the term *fashion* generally refers to things that are currently popular. Problems of both style and fashion enter the picture as we attempt to evaluate the ultimate worth of an art object.

The many theories of art criticism can be categorized as basically subjective, objective, or a balance of the two. A subjective approach holds that judgment is totally personal, changeable, and unchallengeable, and that all individual responses are thus equally valid. Here the value of a work is in the response of the viewer rather than in the work itself.

Objective theories are based on an assumption that there are unchanging standards upon which absolute judgments can be made regarding all art, from any time and place. Nearly any such fixed set of standards results in rejection of the art of many cultures.

Between these extremes are relativist theories which hold that value stems from the interaction between the subjective response of the viewer *and* the intrinsic qualities of the art object. With this approach, each culture forms its own standards. There is often an attempt to understand the aims of the artist and then to evaluate the extent to which the aims were achieved. A work might have high aesthetic value, yet not meet the artist's intention, or it might fulfill the intention, yet be a work that is aesthetically lacking.

The fact that our society has a dominating desire to possess things of value, particularly of monetary value, undoubtedly accounts for the development and seriousness of art criticism as both an avocation and a profession. Such judgments relate to large amounts of money. Collecting art always relates to art criticism—either by the owner or by someone the owner considers knowledgeable.

113

Published art criticism understandably influences the creativity of today's artists. It is believed by some that art critics and gallery owners can promote and make "successes" of the artists they choose to favor. In recent years we have seen some artists rebelling against art that can be explained, bought, sold, and collected as investments. Happenings, environmental works, and conceptual art are evidence of this attitude.

Many artists feel that only artists themselves are qualified to evaluate works of art—that direct participation is essential to a full knowledge of art. There are critics, however, who argue that artists themselves are individually biased and incapable of making objective evaluations.

The professional art critic generally has a wide knowledge of art and often has studied art history in depth, or is experienced in practicing art, or both. This knowledge includes an awareness of art's functions, styles, and social and historical contexts, and a familiarity with particular artists and their work. With a broad knowledge of art, one generally acquires breadth of taste. An art critic should be able to relate to a wide range of creativity.

132 Leonardo da Vinci. MONA LISA. c. 1503–1506. Oil on wood. 30¼ x 21″. The Louvre, Paris.

Art criticism is found in books, magazines, classrooms, and in the conversations of trained artists, art historians, and others. Art writers generally seek to inform people about shows and events. *Reviews* are most often summaries of exhibits, much like theater reviews. Criticism in the classroom is intended to help the students develop aesthetic maturity. More important than passing judgment on works is a teacher's or critic's ability to help others make their own critical evaluations.

As art critics and art historians examine and reexamine artists, styles, and movements of the past, they often find artists and styles that were largely unnoticed in their own time, yet had great influence on other artists, perhaps leading them into well-known movements. For instance, Jan Vermeer received some recognition in his own time, but he was generally ignored or forgotten in the eighteenth century. He was rediscovered in the nineteenth century, and in the twentieth century has received international acclaim.

Ideally, each person viewing a work of art will determine his or her own idea of its quality. This is difficult to achieve because each of us brings preconceptions to everything we see. We have heard that Leonardo da Vinci's painting MONA LISA is a great work of art. If this is foremost in our minds when we see the MONA LISA, our own direct experience of the painting becomes limited.

It is as misleading, however, to rely entirely on immediate personal reactions to a work as it is to go solely by objective information or the accumulated knowledge of experts. It is best to develop a position meaningful to you between these extremes.

It is important to remember that, throughout this book, we are looking at photomechanical copies or *reproductions* of works of art, even though we are discussing them as if they were the original works.

There is a great deal of difference between an actual work and a reproduction. Almost all works suffer when they are photographically reproduced because they lose not only size and scale, but also the physical and sensual qualities of the material from which they were made. A good color slide of a painting may seem to have more color brilliance than the original, but it will seldom convey the surface qualities of the paint. Photographic reproductions of three-dimensional works such as sculpture and architecture, in which space is a crucial element, are mere shadows of the originals when reduced to two dimensions. And since actual motion cannot be reproduced in a book, the presentation of kinetic sculpture, film, and television must be superficial. Reproductions you will encounter in your study of the visual arts can only suggest the richness of experiencing the original works themselves.

A work of visual art may be anything made by humans in which appearance is a primary consideration in its creation. The appearance of any visual form can be determined as much by the material from which it is made and by the way it is made as by its design or subject.

Wood, stone, plastic, metal, glass, paper, paint, and clay are all materials. Each has its own unique properties. Wood has a natural warmth that is quite different from the fluid yet hard and brittle character of glass. Each material employed by the artist has unique form-making possibilities.

Certain materials and ways of working with them have long been favorites. A particular material, along with its accompanying technique, is called a *medium.* Some popular media are carving in stone or wood, shaping clay by hand or on a potter's wheel, weaving with fibrous material, and oil painting on stretched canvas. Artists often combine or mix materials and their accompanying techniques in one work; the result is referred to as *mixed media.*

The body itself becomes the basic material for visual expression in performing arts such as mime, dance, and drama. Recently developed media such as photography, film, video, and materials like polyester resin and electric light offer new ways to express our insights and concerns.

Today's artists are involved with the broad range of print and broadcast media. Newspapers, magazines, books, and brochures are considered print media; television and radio are broadcast media. Marshall McLuhan has called attention to the importance of media by pointing out that the communicative form of a message is a major and inseparable part of its content.

There are certain things a medium does naturally, and other things it simply cannot do. The craftsman/artist must develop a keen sensitivity to the character and limits of the material used. It is self-defeating to try to make glass do what clay can do better. In each case, the artist uses that medium which best suits the ideas and feelings he or she wishes to express. The starting point may be the desire to work in a particular way with certain kinds of materials.

The arts presented in this book have a common bond in their visual form. In this chapter we have divided these arts into: drawing, painting, printmaking, camera arts, performing arts, sculpture, crafts, design disciplines, architecture, and urban design.

In the Western tradition, the visual arts have been divided into _fine arts_, those involved in making objects only for contemplation or visual enjoyment, and _applied arts_, those involved in making objects to serve utilitarian purposes, as well as to provide visual delight. The idea has been to prevent confusion. On the one side are those arts which, by their very nature, are capable of communicating human experience in all its depth and complexity. On the other are those arts whose primary aim is to enhance the appearance and other functions of utilitarian objects or to serve a function other than pure visual communication or delight. Examples of this latter are furniture design and advertising art. However, appearance is a function that suffers when it is separated from other functions.

The terms _fine arts_ and _applied arts_ were coined when craftsmen were the sole suppliers of utilitarian objects for everyday use. The arts of drawing, painting, printmaking, sculpture, and architecture were considered to be of a "higher" order since they were involved primarily with aesthetics and the intellect.

Some art historians have tended to overlook the newer media that can be used to create images for visual enjoyment alone, photography, cinematography, and video for example. And craftsmen, no longer charged with the responsibility of providing all of our household goods, are now free to use their media to create visual forms whose only purpose is to delight the eye. Considering all this, it is difficult to maintain the traditional separation between fine and applied arts.

Do we classify Kay Sekimachi's woven form (page 179) and Toshiko Takaezu's pot (page 171) as fine or applied art? They are made from what has been applied art media, but they are certainly fine art by intention. The distinction between the fine and applied arts perhaps needs redefining in terms of the purpose of the object created, rather than the discipline or media used. Although the separation is still valid in some cases, it may be a concept that has outlived its usefulness.

Since there is no clear line separating fine from applied arts, the order of the visual arts in this chapter is based on the character and purposes of each. The sequence starts with drawing because artists working in other media often begin their work with drawings, and because it is a relatively simple and accessible means of developing and sharing ideas visually.

A logical progression goes from drawing to painting, printmaking, camera arts, performing arts and sculpture. Except for the commercial use of the camera arts each of these disciplines is primarily concerned with creating works for contemplation, and in that sense fits into the traditional "fine arts" definition.

Although today's sculpture and crafts overlap, the crafts have traditionally been concerned with utilitarian objects. Therefore, in the remainder of the chapter covering crafts, design disciplines, architecture and environmental design, there is a gradually increasing concern for functions in addition to communication through appearance.

133 Henri Matisse.
PORTRAIT OF I.C.
c. 1935–1945.
Drawing.

134 Georges Seurat. THE ARTIST'S MOTHER (WOMAN SEWING). c. 1883. Conté crayon on paper. 12¼ x 9½''. Metropolitan Museum of Art, New York. Joseph Pulitzer bequest, 1955.

135 Drawing tools and characteristic lines.

DRAWING

Drawing is one of the most immediate ways of becoming more aware of the visual world. Line is the fundamental element of drawing. To draw, in the most elementary sense, means to pull, push, or drag a marking tool across a surface to leave a line or mark. Legend has it that someone, seeing a portrait with great economy of line, drawn by Matisse, asked with some disgust, "How long did it take you to do this?" Matisse answered, "Forty years."

Many other kinds of marks are also employed in drawings, including dots, shapes, and light to dark tones or values. It is even pos-

sible to make a drawing without lines. Georges Seurat relied on value gradations (chiaroscuro) in this drawing of his mother sewing.

Notice the different types of marks made by drawing tools. Some lines, like those made by the flexible brush and crow quill pen, are varied and fluid. Others, like the lines made with crayon and charcoal, are soft and textured; those made by the pencil and rigid pens are even, sharp lines. Compare the various qualities of the drawings reproduced in this section, noting the character of the medium used for each.

119

136 Alberto Giacometti. SELF-PORTRAIT. 1959.
Ball point pen on paper napkin. 7¼ x 5″. Private Collection.

137 Le Corbusier. DRAWING FOR NOTRE-DAME-DU-HAUT.
Ronchamp, France. c. 1949.

Drawing is practiced by artists working in most of the visual arts as a basic means of expressing ideas quickly. Things as diverse as stamps and transportation systems begin as drawings. The differences between drawing and painting are sometimes vague. In one sense painting is drawing with paint. Direct drawing is often necessary in the process of printmaking and in making relief sculpture. Drawing is also a separate discipline. A drawing can function in one or all of these ways:

■ as a notation or record of something seen, remembered, or imagined;

■ as a study for something else (sculpture, film, painting);

■ as an end in itself.

Many drawings can be seen and enjoyed as self-sufficient works of art, in addition to serving one or both of the first two functions.

Alberto Giacometti drew his face as he saw it reflected in a nearby mirror, using the materials at hand—a ball-point pen and a napkin. The idea of exhibiting or selling this SELF-PORTRAIT was undoubtedly far from his mind. His primary impulse was to satisfy his compulsion to record what he saw and felt.

Anyone who is intrigued by the rich complexity of the visual world can develop that interest by drawing. Once involved, an artist draws whatever catches his or her eye or imagination. Many artists keep a sketchbook to serve as a visual diary. From it, ideas may develop and reach maturity as complete works in drawing or other media.

A drawing can act as the embryo of a complex work. A simple drawing can lead to a building or a painting, in the same way that a melody can lead to a symphony. When Le Corbusier did his early drawings for the chapel at Ronchamp, he had the shell of a crab lying on his drawing board. The drawing and the roof of the finished building reflect the character of the shell. (See page 351.)

138 Pablo Picasso. FIRST COMPOSITION STUDY FOR GUERNICA. May 9, 1937. Pencil. 9⅛ x 17⅞". On extended loan to the Museum of Modern Art, New York, from the artist's estate.

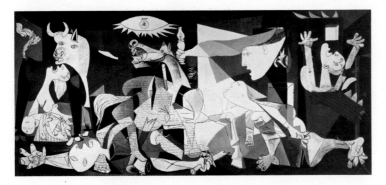

139 Pablo Picasso. GUERNICA. 1937. Oil on canvas. 11' 5½" x 25' 5¼". On extended loan to the Museum of Modern Art, New York, from the artist's estate.

GUERNICA is a very large painting, measuring more than eleven feet in height by twenty-five feet in length. Picasso did many preliminary drawings in preparation for the final painting. Forty-five of these are preserved, all but one dated to a particular day. Yet the overall concept of this complex work is contained in the very first drawing. If GUERNICA had never been painted, this drawing might have little significance. But as a study for such a painting, the drawing takes on meaning.

It is dominated by a woman with a lamp, apparently an important symbol to Picasso. The woman leans out of a house in the upper right. Below her, the lines indicate a horse lying on the ground with its head thrown up in a gesture of agony. On the left a bull appears with a bird on its back. These major elements in the final painting are indicated with Picasso's rapid, searching lines. This study was probably drawn in a few intense seconds. It captures in sudden gestures the essence of the final painting.

Two years before doing this drawing, Picasso wrote:

It would be very interesting to preserve photographically, not the stages, but the metamorphoses of a picture. Possibly one might then discover the path followed by the brain in materializing a dream. But there is one very odd thing to notice, that basically a picture doesn't change, that the first "vision" remains almost intact, in spite of appearances.[1]

When Michelangelo made these detailed STUDIES FOR THE LIBYAN SIBYL, he had no idea that reproductions of this sheet of working drawings would be seen and loved by perhaps as many people as have enjoyed the finished painting of the figure on the ceiling of the Sistine Chapel. The drawings are a record of search and discovery. Michelangelo carefully observed each part and put on paper a record of his observations. His understanding of anatomy helped him to define each part. The rhythmic flow between the head, shoulders, and arms of the figure is based on Michelangelo's feeling for visual continuity, as well as his attention to anatomic accuracy. The parts of the figure that he felt needed further study were drawn more than once. These include the muscles of the left shoulder, the

140 Michelangelo Buonarroti. STUDIES FOR THE LIBYAN SIBYL IN THE SISTINE CHAPEL CEILING. c. 1508. Red chalk. 11⅜ x 8⅜". Metropolitan Museum of Art. Purchase 1924, Joseph Pulitzer Bequest.

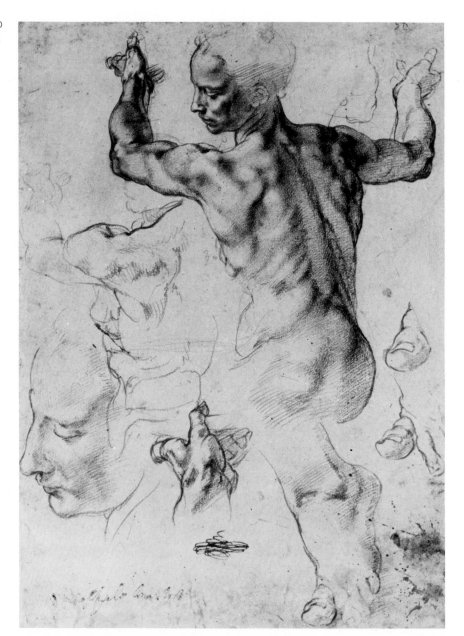

face, the foreshortened left wrist and hand, and the foreshortened big toe of the left foot which was drawn three times on this one sheet.

Vincent van Gogh, like Michelangelo, learned a great deal about visual form by drawing. Michelangelo had fully developed his artistic ability when he drew the studies of the Libyan Sibyl. Van Gogh was just beginning his short career as an artist when he completed this drawing of a carpenter. Although clumsy in proportion, this drawing reveals the careful observation of a persistent, hardworking man. Both van Gogh and Michelangelo remained true to themselves in their work, each leaving an account of their individual feelings and perceptions.

In the following drawings, the use of different media and techniques produce unique images that contrast in both appearance and mood. Each drawing tool and each type of paper has its own characteristics.

The head study by Alphonse Legros, HEAD OF A MAN, gives the appearance of low relief sculpture. (See the Greek coin, page 161.) The medium used was *silverpoint*. No variation in width of line or gradation in value is possible with this medium. Tones, or values, are built up with parallel lines called *hatching*, or with *crosshatching* of various types. See diagram. Silverpoint will only mark a specially coated surface. Lines are made of actual silver, which gives an even gray line that soon darkens with oxidation. The line quality produces a refined style of drawing.

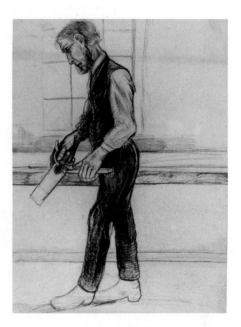

141 Vincent van Gogh. CARPENTER. c. 1880. Drawing. State Museum Kröller Müller, Otterlo, Netherlands.

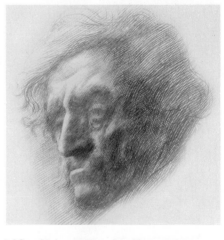

142 Alphonse Legros. HEAD OF A MAN. 1892. Silverpoint. 8¾ x 7''. The Metropolitan Museum of Art, New York. Gift of the artist, 1892.

143 a. Hatching b. Cross-hatching c. Contour hatching

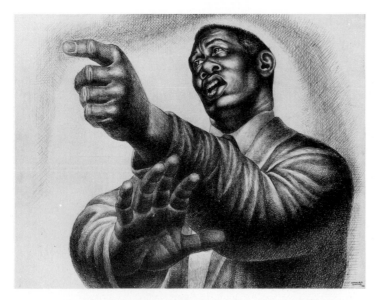

144 Charles White. PREACHER. 1952. Ink on cardboard.
21⅜ x 29⅜". Whitney Museum of American Art, New York.

145 Charles Sheeler. FELINE FELICITY. 1904. Crayon.
14⅛ x 13¼". Fogg Art Museum, Harvard University.
Louise E. Bettens Fund.

Charles White used a bold technique of crosshatched ink lines in PREACHER to build up the figure's mass and gesture in a forceful manner. The strongly *foreshortened* left hand and forearm adds considerably to the dramatic impact of this drawing.

Charles Sheeler drew FELINE FELICITY with artist's crayon on fairly rough paper (paper with "tooth"). The result is a very detailed image, rich in value changes. Light and shade work together in an intricate pattern. This is a good example of drawing done as an end in itself, although drawings do not have to be this refined or detailed to be considered finished independent works.

The nineteenth-century Japanese artist, Hokusai, was a skilled draftsman. It is estimated that he created 35,000 images in his lifetime. Yet his humorous statement about the development of his own ability reveals a person who has experienced the feelings of self-doubt known to many of us, and has prevailed against them.

I have been in love with painting ever since I became conscious of it at the age of six. I drew some pictures which I thought fairly good when I was fifty, but really nothing I did before the age of seventy was of any value at all. At seventy-three I have at last caught every aspect of nature—birds, fish, animals, insects, trees, grasses, all. When I am eighty I shall have developed still further and will really master the secrets of art at ninety. When I reach one hundred my art will be truly sublime and my final goal will be attained around the age of one hundred and ten, when every line and dot I draw will be imbued with life.
(signed) Hokusai
"The art-crazy old man"[2]

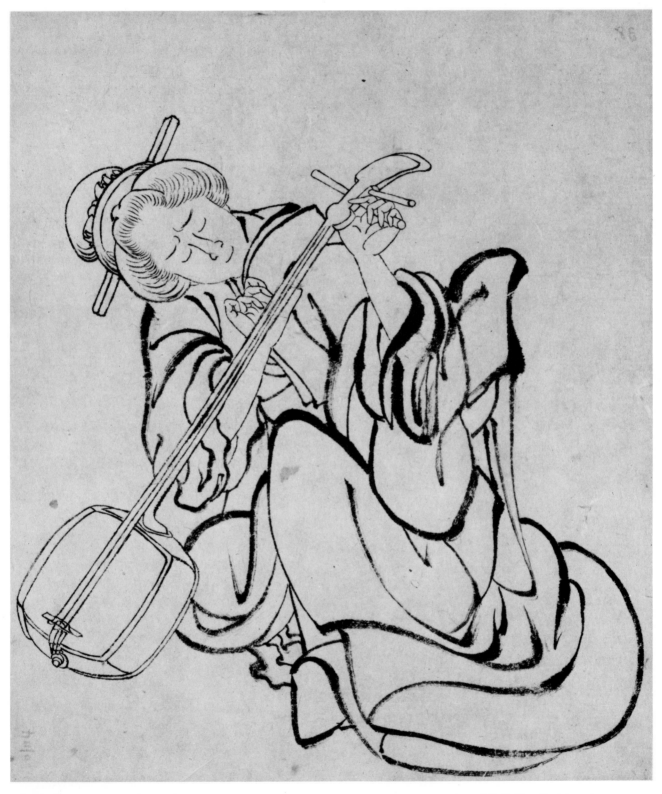

146 Katsushika Hokusai. Tuning the Samisen. c. 1820–1825. Brush drawing. 11 x 8⅞''. The Smithsonian Institution, Freer Gallery of Art, Washington, D.C.

Rembrandt used brush, ink, water, and paper to draw his wife, Saskia. The result, SASKIA ASLEEP, is at once bold and subtle, representational and nonrepresentational, finished and unfinished. As a total image, it is complete. His technique bears comparison to the Oriental brush painting tradition, as seen in the work of Hokusai.

Cartooning is illustrative drawing in which humorous or satirical content is emphasized. (See pages 6, 12, and 48.) The term is also used to refer to a full-sized preliminary drawing made as a guide for a finished painting, particularly a fresco painting.

Although drawing involves relatively simple means, the impact of ideas expressed in drawings can be great. Art used as a means for bringing about social change is seen in this caricature, A GROUP OF VULTURES WAITING FOR THE STORM TO BLOW OVER, LET US PREY, by American cartoonist Thomas Nast. Through his visual indictments of "Boss" Tweed and his henchmen, Nast effectively aroused public indignation that led to the downfall of the Tweed Ring, a corrupt group of politicians and city officials who held absolute power in New York City from 1857 until their demise in 1871. Nast's drawings were

147 Rembrandt van Rijn. SASKIA ASLEEP. c. 1642. Brush and wash. 9½ x 8''. British Museum, London.

148 Thomas Nast. A GROUP OF VULTURES WAITING FOR THE STORM TO ''BLOW OVER''—''LET US PREY''. Wood engraving from Harpers Weekly, Sept. 23, 1871.

probably copied by a skilled engraver in order to reach the public by way of the press.

Any person who can learn to write can learn to draw. Learning to draw is in some ways easier than learning to write because it is less abstract. The most important factors in learning to draw are interest, integrity, and the ability to see. No one can pick up where someone else left off. We must all begin in our own way just as Michelangelo, Hokusai, van Gogh, and Thurber did.

James Thurber always said he could not draw, but he drew anyway. (See page 6.) He could not draw if by drawing we mean drawing in a representational style. But if we mean realizing our potential to make images of ideas or experiences, then Thurber could draw.

PAINTING

The nature of paint makes it possible to do certain things that cannot be done with other media. Painting media consist of three components: pigment, vehicle, and binder. _Pigments_ provide the range of colors. The _vehicle_ is a dispersing agent for spreading the pigments and the _binder_ holds the pigments together.

With oil paints, turpentine is the vehicle that spreads or disperses the pigment particles and linseed oil is the binder that holds the pigment particles together for permanence. With acrylic-based paints, water becomes the vehicle and polymer medium is the binder. With tempera, water is the vehicle and egg becomes the binder. In fresco the plaster is the binder.

Pigments are dry coloring agents in powder form. The same pigments used in paint media are also the coloring agents for dry media such as crayons and pastels. Until recently pigments were earth colors and natural dyes. Today many pigment colors are produced synthetically.

Paints are usually applied to a flat _support_, such as stretched canvas for oils and paper for watercolors. The surface of the support may be prepared by _sizing_ and _priming_ to achieve a _ground_ that will have the proper absorbency and permanence. A paper surface provides both the support and the ground for watercolor.

Sometimes it is hard to differentiate between drawing and painting. Rembrandt's drawing of SASKIA ASLEEP is halfway between the two. Large areas of ink are washed on like paint, contrasting with the active, brush-drawn lines.

To a large extent, the evolution of various kinds of visual images has been determined by the development of painting media. Each painting medium has its own characteristics that influence the type of images the artist creates.

149 Joseph Mallord William Turner. THE BURNING OF THE HOUSES OF PARLIAMENT. 1834. Watercolor from a sketch book. 9¼ x 12¾''. The British Museum, London.

Watercolor

Watercolor paintings are made by applying pigments suspended in a solution of water and gum arabic to white paper. Rag papers are the preferred supports. Paper quality is important because the whites or highlights in the paintings depend on the lasting whiteness of the paper. Paint is laid on in thin transparent *washes*. Sometimes *opaque* watercolor is added for detail. When employed carefully, watercolors provide a medium well suited to spontaneous application. In spite of the simple materials involved, it is not an easy medium to handle because it does not allow for easy change or correction. Watercolor paint must be applied quickly, and cannot be worked over without losing its characteristic freshness. It is a one-way process.

The fluid spontaneity possible with watercolor makes it a favorite medium for landscape painters who use it to catch quick impressions of outdoor light. Transparent washes are masterfully presented in William Turner's watercolor sketches, like this THE BURNING

OF THE HOUSES OF PARLIAMENT. This immensely prolific English painter was fascinated by the atmospheric or aerial qualities of light and color and their effect on space.

Both transparent and opaque areas are used in John Marin's MAINE ISLANDS. (See color plate 13.) Foreground and background interact, giving a sense of energy and flow in nature. Marin developed his own fusion of representational and abstract elements. In MAINE ISLANDS he combined suggestions of a panoramic view with diagonal lines that fragment the picture plane, giving the feeling of seeing through transparent planes into deep space. This look of transparency is in keeping with the major characteristic of the medium.

Chinese watercolor painting employs ink as well as color. The artist and the viewer are expected to know the basic visual elements and the attitudes that animate them. Paintings may be developed with opaque, individually significant brush strokes, as well as with washes of ink or color. When ink is diluted with water it can be applied in transparent washes as in watercolor, making a wide range of gradation possible.

Tao Chi probably painted A MAN IN A HOUSE BENEATH A CLIFF with a single brush. The vigorous strokes indicate a mountain cliff full of energy. Because the work is completed by light color areas, yet emphasizes drawn lines, it can be considered either a drawing or a graphic painting.

Gouache is opaque watercolor, commonly known as *poster paint* and occasionally incorrectly called "tempera." Effects similar to those obtainable with oil painting can be achieved with less trouble and expense, yet gouache is not as permanent as oil, and colors dry much lighter in value than they appear when wet. It is a good medium for children and other beginners and is good for making quick studies for paintings done in other media. (See CHILD'S PAINTING OF A TREE, color plate 2.)

150 John Marin. MAINE ISLANDS. 1922. Watercolor. 16¾ x 20″. The Phillips Collection, Washington, D.C. *See color plate 13, opposite page 130.*

151 Tao Chi (Shih Tao). A MAN IN A HOUSE BENEATH A CLIFF. C. 1800. Ink and light color on paper. 9½″ x 11″. Collection Mr. and Mrs. C. C. Wang, New York.

Oil

Linseed oil has been a favorite painting medium for five hundred years. The paintings at Lascaux caves (see color plate 20) were made by mixing earth pigments with animal oils. Pigments mixed with various vegetable oils such as linseed, walnut, and poppyseed were used in the late Middle Ages for decorative purposes. But it was not until the fifteenth century that the early Flemish painter, Jan van Eyck, and others first used oil medium for fully representational paintings on wooden panels. In this early period, oils were applied to a panel covered with smooth layers of *plaster of paris* or *gesso* as in the older tradition of tempera painting. Van Eyck began on the panel with an ink drawing that was followed by underpainting in tempera. He finally worked over the surface in oil. (See GIOVANNI ARNOLFINI AND HIS BRIDE, page 273, and color plate 22.)

In the sixteenth century, Venetian painters began using stretched canvas primed with a mixture of glue and white pigment as a way of providing a larger lightweight support for oil paintings. The bolder imagery of these Italian painters was achieved directly in oil without underpainting in tempera.

Linseed oil made from flaxseed became the standard binder for oil paint. Oil offers more flexibility than other traditional media, such as tempera. One of its greatest advantages is its slow drying time and its capacity to be reworked repeatedly. Colors can be smoothly blended. In contrast to tempera and gouache, oil colors change very little when drying. High color saturation is possible even at low values. Traditional representational paintings are generally begun with underpainting to establish the pattern of light and dark areas. This is followed by additional color often applied in thin transparent layers called *glazes*. Through the use of glazes, subtle illusionistic effects can be created giving a feeling of rich luminosity and atmosphere. After the paint dries, varnish may be applied to heighten the color and protect the surface.

Oil can be applied thickly or thinly, wet into wet or wet into dry. Applied thinly, mixed with varnish, it is excellent for building up deep transparent glazes. When applied thickly it is called *impasto*. In Rembrandt's HEAD OF SAINT MATTHEW on page 71, the head is modeled by building up an impasto of heavy daubs of light and dark pigment, creating a solid, substantial looking image.

To see the wide range of styles possible with oil paint, compare Vermeer's rich detail and subtly glazed colors in color plate 3 with Hans Hofmann's GOLDEN WALL, color plate 12.

152 Hans Hofmann. THE GOLDEN WALL. 1961. Oil on canvas. 60 x 72½''. The Art Institute of Chicago. *See color plate 12.*

Color plate 12 Hans
Hofmann. THE GOLDEN
WALL. 1961. Oil on
canvas. 60 x 72½''. The
Art Institute of Chicago.

Color plate 13 John
Marin. MAINE ISLANDS.
1922. Watercolor.
16¾ x 20''. The Phillips
Collection. Washington,
D.C.

Color plate 14 Ed
Emshwiller. SCAPE-MATES.
1973. Video. 30
minutes. The Television
Laboratory. WNET,
New York.

Color plate 15 Victor
Vasarely. UNTITLED. 1967.
Serigraph. 23½ x 23½″.
Private collection.

Acrylic

Synthetic painting media are now in wide use. The most popular are *acrylics*, in which the pigments are suspended in acrylic polymer medium, providing a fast-drying, flexible film that can be opaque or transparent. They are relatively permanent and may be applied to a wider variety of surfaces than can traditional painting media. Most acrylics are water-thinned and water-resistant when dry. Unlike oil paint, acrylics do not darken or yellow with age, and they dry more rapidly than oils.

When dry, acrylic paint is inert and will not damage cloth fibers over a long period of time the way oil paint does. Thus, acrylics can be applied directly to unprimed canvas. This quality has resulted in a variety of staining techniques in which the paint, thinned with water, acts more as a dye than as a coating on top of the canvas. Helen Frankenthaler's painting INTERIOR LANDSCAPE was achieved this way. See color plate 38.

Traditionally, the pigments used in painting media were derived from natural sources: earth, mineral, plant. In contrast, the pigments used today in both oil and acrylics are often chemical and produce a heightened sense of brilliance and vividness. See, for example, Anuszkiewicz's INJURED BY GREEN, color plate 8.

In recent years, a large number of painters have used *air brushes* to apply their paint. An air brush is a refined, small-scale paint sprayer capable of projecting a fine controllable mist of paint. It creates a smooth, even surface, which is well-suited to the impersonal imagery found in many paintings of the 1960s and 1970s.

153 Helen Frankenthaler. INTERIOR LANDSCAPE. 1964. Acrylic on canvas. 104¾ x 92¾''. San Francisco Museum of Modern Art. Gift of the Women's Board. *See color plate 38, near page 322.*

154 Charles Close.
FRANK. 1968–1969.
Acrylic on canvas. 7 x 9'.
The Minneapolis Institute
of Arts.

Photorealist painter Don Eddy uses an air brush to paint detailed illusions of reflective surfaces. (See page 378.) Compare Eddy's PRIVATE PARKING X to the work of another Photorealist, Richard Estes, who uses a traditional brush and achieves a subtle painterly quality in his painting of window reflections titled HORN AND HARDART AUTOMAT. (See also color plate 42.)

The huge portrait of FRANK by Charles Close was painted on primed canvas using only a few tablespoons of black acrylic paint. Close works from his own photographs, enlarging them to monumental scale and adding the surface qualities of thin paint applied with a fine brush. The final image has the cool, detached quality of a photographic recording of the subject as an object, without revealing the inner life of either the artist or the person portrayed. Compare FRANK with the somewhat warmer portrayal of another curly haired young man painted in wax almost 1900 years ago in Egypt.

155 PORTRAIT OF A MAN. Fayum, Egypt. 100 A.D. Encaustic on wood. 13¾ x 8''. Albright Knox Art Gallery, Buffalo, New York. Charles Clifton Fund.

156 Andrew Wyeth. THAT GENTLEMAN. 1960. Tempera on board. 23½ x 47¾''. Dallas Museum of Fine Arts. Dallas Art Association purchase.

Encaustic

Encaustic, in which pigments are suspended in hot refined beeswax, is an ancient painting technique. Encaustic paintings have a lustrous surface which brings out the full richness of colors. Encaustic is not a popular medium, due to the difficulties involved in keeping the wax binder at just the right temperature for proper handling. The results seem to justify the effort, however. The PORTRAIT OF A MAN from Egypt was painted in encaustic on wood. Its lifelike vigor and individuality remain strong. (See also Jasper Johns's TARGET WITH FOUR FACES on page 359.)

Tempera

Today the word *tempera* is used to include water soluble paints with binders of glue, casein, egg, or egg and oil. Tempera paints are water-thinned, and have a matte surface when dry. They are good for working in precise detail, and will not darken with age. Their main disadvantages are color changes during drying and difficulty in blending and reworking.

Tempera, in historical terms, refers to *egg tempera*. Its bright and highly durable quality cannot be matched by any other traditional painting medium. The use of egg tempera was widespread in Europe until it was largely replaced during the Renaissance by oil paints. (See Fra Filippo Lippi's MADONNA AND CHILD, page 44.) Andrew Wyeth is a contemporary American artist who works in this medium. In his painting THAT GENTLEMAN, Wyeth has selected and defined the elements working together to create an interweaving of rich detail and subtle color.

157 Diego Rivera. ᴇɴsʟᴀᴠᴇᴍᴇɴᴛ ᴏғ ᴛʜᴇ Iɴᴅɪᴀɴs. 1929–1930. Palace of Cortez, Cuernavaca, Mexico. Fresco.

Fresco

Fresco is an ancient wall-painting technique in which pigments suspended in water are applied to a damp lime-plaster surface. The artist has to work quickly on the wet plaster. Generally, a full-size drawing, called a "cartoon," is prepared; this is transferred to the damp, freshly laid plaster wall before painting. Since the plaster dries quickly, only the portion of the wall that can be painted in one day is prepared, with joints usually arranged along the edge of major shapes. The pigment and the plaster combine and, if properly prepared, create a smooth, extremely durable surface. Not all pigments can be used in fresco; some, especially the blues, interact with the lime and eventually change color. Since no changes can be made after the paint is applied to the fresh plaster, the artist must know exactly what he or she wants to portray.

Fresco has a long history. The technique has been used in many diverse cultures and geographical areas. It became the favored medium for decorating church walls in Italy during the Renaissance. Giotto's DESCENT FROM THE CROSS in the Padua Chapel, on page 265, is representative of frescoes from this period. After the Renaissance, the medium fell into disuse, eclipsed by more flexible and eventually more portable media such as oil. A revival of the fresco technique began in Mexico in the 1920s encouraged by the new revolutionary government's support for public murals. Diego Rivera was a major figure in the group of artists who revived fresco mural painting. His personal style is related to that of others in the group in its blending of European and native traditions with contemporary subject matter and abstract form. His murals for the National Palace show his sense of monumental form in the handling of images. The detail of Rivera's painting ENSLAVEMENT OF THE INDIANS dramatizes a tragic chapter in Mexico's history.

PRINTMAKING

Printmaking began with the desire to make multiple images of a single work of art. It is now a creative medium in its own right. Because our lives are full of images printed as multiples, it is difficult for us to imagine a time when the only pictures ever seen were one-of-a-kind originals.

This book was reproduced by a mechanical printing method called "offset lithography." Lithography was not developed until early in the nineteenth century, but other forms of multiple printing were used in China as early as 200 B.C. and in Europe by the end of the fifteenth century A.D.

Until the twentieth century, multiple image-making procedures usually included artist, artisans, and laborers. As photomechanical methods of reproduction developed, handwork by artists played an increasingly minor part in the process. Images of original works were no longer drawn or cut into the printing surface by hand copying. Artists, however, have themselves continued earlier printmaking processes in order to take advantage of the unique properties inherent in the printmaking media. They also make their works less expensive and more readily available to the public by designing and printing multiple originals. The two distinguishing words are *print*, signifying the artist's handmade multiple originals, and *reproduction*, signifying machine-made copies of originals.

158 Wes Wilson. THE SOUND. 1966. Silk Screen. 36 x 20''.

Original prints, regardless of type, are hand-made by the artist or handmade under the artist's supervision. Any original art work reproduced photographically or by a purely mechanical process is <u>not</u> an original print. If close scrutiny, perhaps with a magnifying glass, reveals a regular pattern of small dots, then the work is a reproduction, not a hand-made print. Original *serigraphs* (silk-screen prints) have a layer of ink that looks like paint, appearing to be on top of, rather than absorbed by, the paper. Etchings and engravings are produced with a printing press, which leaves a physical impression on the paper.

As part of the printmaking process, sample prints or *proofs* are made at various stages to indicate how the block, plate, stone, or screen is developing.

Most original prints are signed in pencil by the artist to indicate personal involvement and approval of the individual print. Because of the time involved in hand-printing, original prints are produced in limited *editions*. Artists usually destroy the plate after the edition has been printed to ensure the integrity of their work. Nearly all original prints are numbered with a figure that indicates the number of prints "pulled," or made, in the edition, and the number of the individual print in the sequence. A figure 6/50 would indicate that the edition totaled fifty prints and that this was the sixth print pulled.

In the mid-1960s young people began covering their walls with popular posters, many of them conceived as advertisements for rock concerts and given away at the door. Some of the best poster artists, Wes Wilson among them, became well known. Few people seemed to know the difference between these posters and original prints. The posters, printed using commercial silk-screen process techniques, were simply enjoyed for the images they presented. They recall the lithographs of Toulouse-Lautrec, produced in the late 1800s to publicize the Moulin Rouge. See page 143.

The concept of original prints may be difficult to maintain at a time when good reproductions are readily available. It may be hard to imagine a world without these reproduc-

159 Relief block

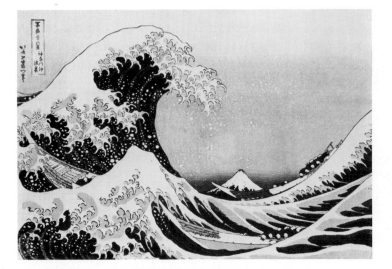

160 Katsushika Hokusai. Mt. Fuji Seen Below a Wave at Kanagawa (The Great Wave), from Thirty Six Views of Mount Fuji. c. 1830. Color woodblock print. Width 14¾". Museum of Fine Arts, Boston. Spaulding Collection.

the original and the extent to which art should be governed and motivated by profit.

There are four basic printmaking methods: *relief, intaglio, lithography,* and *silk screen.* All but silk screen will produce a reversed version of the original image as drawn on the plate, block, or stone. As printmakers combine traditional methods and add new ones, the possibilities inherent in print media change and expand.

Relief

In a *relief* process, the parts of the printing surface not meant to carry ink are cut away, leaving the design to be printed in relief at the level of the original surface. This surface is then inked and the ink is transferred to paper with pressure. Relief processes include *woodcuts, wood engravings, linoleum* (or *lino) cuts,* and *metal cuts.*

The woodcut process lends itself to designs with bold contrasts of black and white. Color can also be printed by this method if blocks for each color are cut and carefully *registered,* or lined up, to ensure that each color is exactly placed.

Color block printing was invented in Japan in 1741 and eventually developed into a complex process using many separate blocks to achieve subtle color effects. In Hokusai's print, Mount Fuji Seen Below a Wave at Kanagawa, the bold asymmetrical design and the tension of potential disaster capture the viewer's attention. A giant clawing wave dwarfs the tiny fishermen in their boats, climaxing the rhythmic curves of the churning ocean. The only stable element is the distant peak of Mt. Fuji. An artist-designer such as Hokusai worked in close collaboration with highly skilled engravers and printers to realize the final prints. The fine detail of traditional Japanese woodcuts was possible because the cutting was done in end grain using hard wood such as cherry.

tions, yet highly accurate color reproductions have become possible only within the last twenty years. Although they are only mechanical copies, rather than originals, modern reproductions make the art of the world available to us as never before. As French critic André Malraux stated, "A museum without walls has been opened to us. . . ."[3]

Some artists use photomechanical means to reproduce their own works; these are then sold as signed original prints. This action is based on the feeling that it is most important to get one's work seen and to be able to make a living from selling it. The practice raises interesting ethical questions about the value of

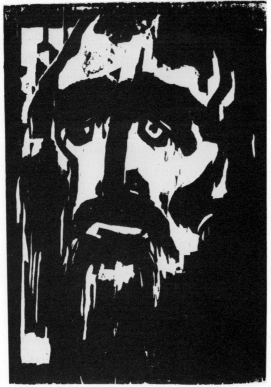

161 Emil Nolde. PROPHET. 1912. Woodcut. 12⅝ x 8⅞". Kunstmuseum der Stadt, Dusseldorf, Germany.

The detail found in Hokusai's print is quite different from the bold simplicity of PROPHET, a woodcut print made by German artist Emil Nolde in 1912. Softer grain wood was used. Each cut in the block reveals the expressive image of an old man and also the natural character of the wood itself. The resulting light and dark pattern is powerful in its total effect.

162 Etched plate

163 Engraved plate

ink

ink

164 Exaggerated characteristics of an etched line and an engraved line.

(a) an etched line

(b) an engraved line

Intaglio

Intaglio is an Italian word meaning "to cut in." Intaglio printing is, in a sense, the reverse of relief because areas below the surface hold the ink. The design to be printed is either etched into a metal surface by "biting" with acid or incised by "engraving" the lines with sharp tools. The plate is coated with ink, then wiped clean, leaving ink only in the cuts. A print is made by transferring the ink to damp paper with pressure, using a printing press. Intaglio processes most frequently used are *etching* and *engraving*.

An *etching* is made by drawing lines through a soft material made of beeswax and lampblack, which covers a copper or zinc plate. The plate is then placed in acid. Where the drawing has exposed the metal, acid eats into the plate, making a groove that varies in depth according to the strength of the acid and the length of time the plate is in the acid.

In metal *engravings*, the lines are cut into the plate with a graver or burin. This process takes strength and control. The precise lines of an engraving are not as fluid as etched lines due to the differences in the two processes.

In the United States, paper money is printed from engraved plates. The precise smooth curves and parallel lines of engraving are apparent in the portraits on paper currency.

Compare the line quality in Rembrandt's etching, CHRIST PREACHING, with the line quality in Albrecht Dürer's engraving, KNIGHT, DEATH AND DEVIL. The hard precision of Dürer's lines seems appropriate to the subject of the print. It is an image of the Christian soldier going with steadfast faith to the heavenly city of Jerusalem, seen in the upper background of the print. The dog, the central vertical position of the knight's figure, and the smooth, geometric contours of the powerful horse assure us that the knight will arrive at his destination in spite of the sinister figures of death and the devil.

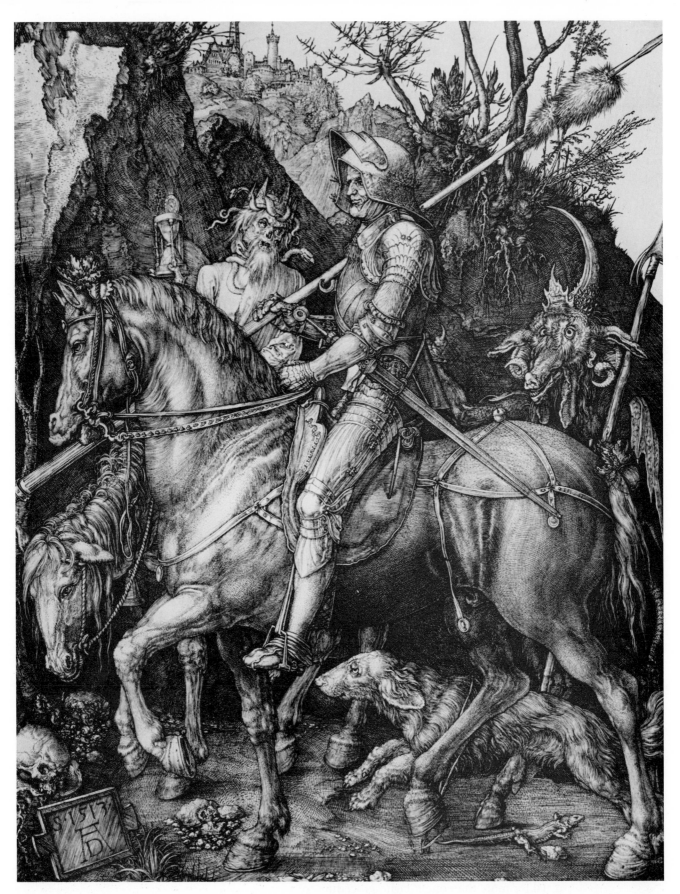

165 Albrecht Dürer. KNIGHT, DEATH AND DEVIL. 1513. Engraving. 9¾ x 7⅜″. The Brooklyn Museum. Gift of Mrs. H. O. Havemeyer.

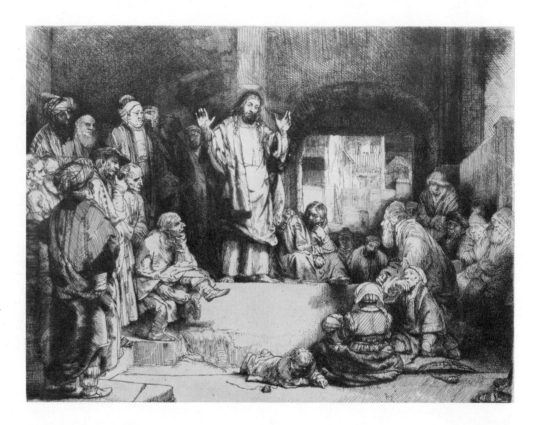

166 Rembrandt van Rijn. CHRIST PREACHING. c. 1652. Etching. 6¹⁄₁₆ x 8⅛". The Metropolitan Museum of Art, New York. Bequest of Mrs. H. O. Havemeyer.

In CHRIST PREACHING, Rembrandt's gentle compassion is evident in the slightly more relaxed quality of his etched lines. In the seventeenth century, woodcuts and engravings were commonly used to reproduce paintings. Creative printmakers, such as Rembrandt, preferred etching, often adding lines scratched directly into the plate for additional subtle effects. Such lines are called *drypoint* lines because liquid acid is not used. In his depiction of Christ preaching, Rembrandt worked in a wide range of tonal values, creating variety within each value area. The strong light and dark pattern is typical of much of the art of that period (see Baroque art, page 275) and a major component of Rembrandt's style. It adds clarity and emotional feeling to his sympathetic portrayal of the religious story.

In modern etching or engraving, it is not unusual for more than one intaglio procedure to be used in one plate.

Lithography

In *lithography*, the printing surface is left flat, or on one plane. The process lends itself well to a direct manner of working because the image is drawn on the surface of the stone or plate without any biting or cutting of lines. This directness makes lithography faster and more flexible than other methods, and difficult to distinguish from drawing.

Lithography is a form of planographic (surface) printing. Prints can be pulled from a single plane because of the antipathy of water and grease. Lines or areas are drawn or painted on smooth, fine-grained, Bavarian limestone or a metal surface developed to du-

167 Litho stone or plate

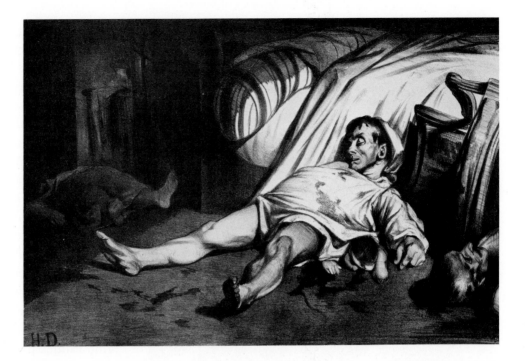

168 Honoré Daumier. TRANSNONAIN STREET. 1834. Lithograph. 11¼ x 17⅜". The Cleveland Museum of Art. Gift of Ralph King.

plicate the absorbent character of the stone. An image is created with lithocrayons, pencils, or inks containing a greasy substance called *tusche*. The surface is then chemically treated so that the drawing is etched or fixed to become part of the upper layer of the stone. The surface is dampened with water, and inked. The ink is repelled by the moisture, but adheres to the greasy area of the image. When this surface is covered with paper and run through a press, a printed image of the original is produced.

Although lithography was a relatively new medium in the early 1800s, it had a major impact on society because of its comparative ease and speed of execution. It provided the visual material for newspapers, posters, and handbills. Honoré Daumier, one of the first great lithographers, made his living drawing lithographs for French newspapers. His personal style was well suited to the direct quality of the lithographic process.

In TRANSNONAIN STREET, Daumier carefully reconstructed an event that occurred during a period of civil unrest in Paris in 1834. The militia claimed that a shot was fired from a building on Transnonain Street. The soldiers responded by entering an apartment and killing all the occupants. Daumier's lithograph of the event was published the following day. The lithograph conveyed information in the way photographs do today, but it clearly reflects the artist's sentiments. The prone figures and disheveled bedding suggest chaos and violence. Rembrandt's influence is felt in the organization of strong light and dark areas which increase the dramatic sense of tragedy.

The lithograph shown here is not typical of Daumier's work, which usually took the form of political cartoons. He was a master of caricature. Political cartoons have become an important means of social satire and criticism, thanks to the sensitivity, skill, and integrity of artists like Daumier. Art used for social change can also be seen in the lithographs of Käthe Kollwitz, pages 32 and 33, and Thomas Nast's political cartoon in the form of a wood engraving on page 127.

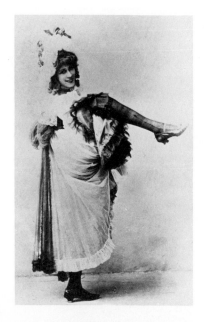

169 Henri de Toulouse-Lautrec. JANE AVRIL. c. 1893. Photograph.

In the space of about ten years, master painter and graphic "designer" Henri de Toulouse-Lautrec created over three hundred lithographs. Many of these were posters advertising people and products ranging from nightclub entertainers to bicycles. His posters of cabaret singer and dancer Jane Avril made her a star and simultaneously gave Parisians of the 1890s a firsthand look at "modern art" by a leading artist. The popular lithographic poster shown here began with an awkward photograph and came to life in a dynamic and highly colorful oil sketch. The sketch was then incorporated as the key element in a strong lithograph drawn with brush and liquid tusche on the litho stone. Compare the angles of feet and legs in the photograph with the sketch and print. Lautrec used diagonal lines and curves to give a sense of motion to the photo image. In the print the figure is placed in the proper setting, offset by the silhouetted shape of a bass player. Rich black shapes and fluid brush lines retain much of the lively vigor and dramatic pattern of the sketch, and reflect as well Lautrec's early love for Japanese prints.

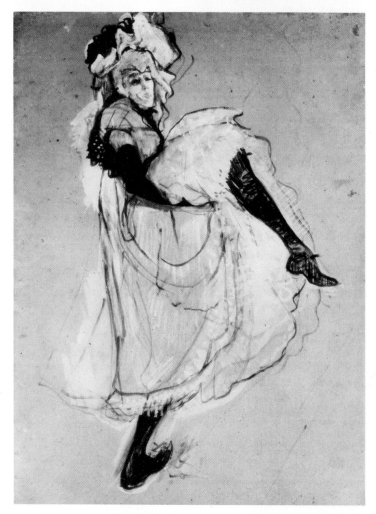

170 Henri de Toulouse-Lautrec. JANE AVRIL. c. 1893. Oil on cardboard. 38 x 27".

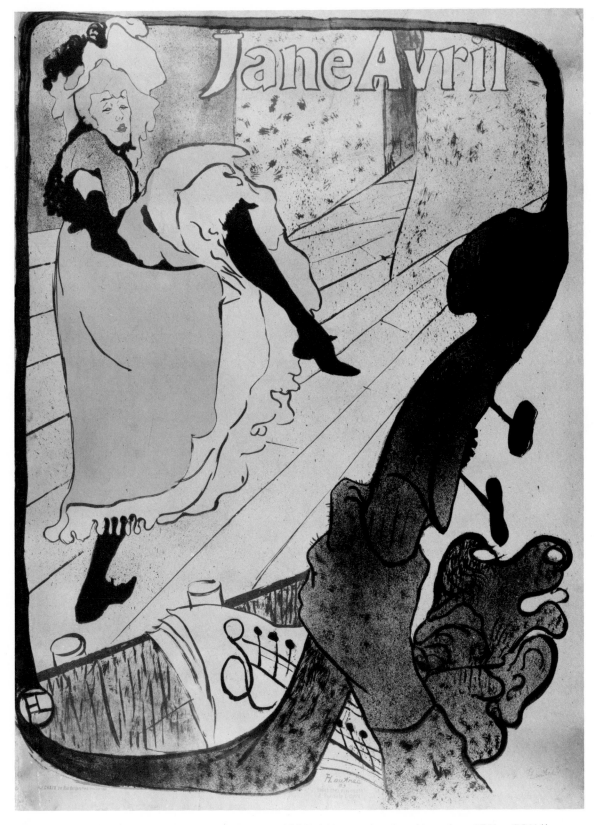

171 Henri de Toulouse-Lautrec. JANE AVRIL. c. 1893. Lithograph printed in color. 49⅝ x 36⅛″.
The Museum of Modern Art, New York. Gift of A. Conger Goodyear.

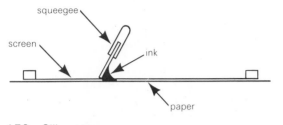

172　Silk screen

173　Victor Vasarely. UNTITLED. 1967. Serigraph.
23½ x 23½''. Private collection. *See color plate 15. opposite page 131.*

Silk-Screen Printing (Serigraphy)

The most recently perfected printmaking process is essentially a stenciling technique known as *silk-screen printing* or *serigraphy*. Common stencils are used as a means of transferring letters and other shapes to a flat surface. An opening is cut in a nonporous material, then held firmly against a surface and pigment is brushed through, leaving a corresponding image. Complex shapes must be planned so that connecting links prevent parts from dropping out. Early in this century stencil technique was improved by adhering the stencil to silk fabric stretched across a frame. This screen is placed on paper and a rubber edged tool called a *squeegee* pushes the paint or ink through the open pores of the fabric leaving the design on the surface below.

Silk-screen printing is well-suited to the production of multiple color images. Each separate color change requires a different screen, but registering and printing are relatively simple. Victor Vasarely's serigraph, UNTITLED, uses an optical illusion to create an impression of rhythmic movement. (See color plate 15.) He found serigraphy met his needs for a printing process that would lend itself well to the kinds of precision his art required.

Freer, more expressive images may be made by brushing liquid tusche, the same substance used for drawing in lithography, on the screen to block out areas.

The latest development in screen printing is the photographic stencil or *photo silk screen*, achieved by attaching light-sensitive gelatine to the screen fabric. A developing solution and exposure to light make the gelatine insoluble in water. The gelatine is exposed to light through a positive image on film. The soluble, unexposed areas are then washed away, leaving open areas in the fabric that allow the ink to pass through to the print surface. See Rauschenberg's mixed media painting with photo silk-screen images, page 358.

174 CAMERA OBSCURA.

CAMERA ARTS

Much of our present understanding of the world, the universe, and each other comes from images recorded through lenses of still, motion picture, and television cameras. These camera arts have made a great wealth of information and poetic vision available to us. Yet, if they dominate our visual experience, they can just as easily dull our vision with a preponderance of canned or ready-made images. There are many photographic and electronic images in our lives today, yet we may not be aware of the extent to which these media influence our perception. Much of our view of life—and therefore, our way of life—is recorded, challenged, and changed by the camera.

Photography

Photography is both a scientific process and a relatively new art form. As a science, it involves the recording of optical images on light or photosensitive surfaces. As an art, this process also reveals the inner vision of the individual who releases the shutter as clearly as the objective details of the subject being photographed. Ten different photographers working with the same subject will photograph ten different aspects of the visual truth before them.

Photography literally means light-writing or light-drawing. The basic concept of the camera preceded actual photography by more than three hundred years. A *camera obscura*, or darkened room, was one of several optical sighting devices developed in the sixteenth century as aids for drawing and painting.

175 PUPIL OF HUMAN
EYE AND APERTURE
OF CAMERA
LENS.

The development of the camera was motivated by the fifteenth-century Europeans' desire to portray the physical world in images that were the exact equivalent of what the eye sees. Because visual perception results from a combination of optical and mental phenomena, this idea can never be fully realized with a mechanical device, yet the camera has been able to contribute immensely to the extension of human vision. The camera is like a simplified mechanical replica of the human eye. The major difference is that the eye brings a continual flow of changing images that are received by the brain, whereas the still camera depends on light-sensitive film to record an image, and only a single image at a time can be picked up. Motion picture and television cameras come closer to the human visual experience because they record motion.

The photographic process begins as light enters the dark interior of the camera. The camera is a lightproof box. It has an opening or *aperture* fixed with a *lens* to focus or order the light rays passing through it. It also has a *shutter* to control the length of time the light is allowed to strike the light-sensitive film or plate held within the body of the camera.

Photographic *film* is a transparent plastic, coated with a layer of light-sensitive emulsion. Exposed and developed film is called a *negative* because the light and dark areas of the original subject are reversed.

In a darkroom the negative is placed in an *enlarger* which projects and enlarges a negative light image onto light-sensitive paper. This paper, when developed, chemically darkens in those areas where it has been exposed to light thus producing a photographic positive print.

Photography can record personal moments for the family album, the surface of the moon, the interior of the human heart, or the exact visual details of some unrepeatable moment in history. It can be used to record as well as

176a HUMAN EYE AND CAMERA.

176b CHANGES IN DEPTH OF FIELD WITH APERTURE ADJUSTMENTS.

create images we could never see otherwise, and to reveal the extraordinary qualities of ordinary objects and events. Looking through the camera, the photographer finds significant images within the actual world. By representing (or re-presenting) these images, he or she extends and enriches the vision of others.

Selection is an important part of the art process in any medium. In photography the selection of subject, light, angle of view, and final print qualities make the crucial difference between an ordinary snapshot and a work of art.

Although not as free to invent imagery as other two-dimensional arts and not as capable of making rich tactile surfaces, photography has many unique advantages over related media in drawing and painting. The most apparent of these advantages is the camera's ability to capture images with great detailed accuracy even when the subject is in motion. High-speed photography has made invisible events visible.

A work of art is created by a subtle, complicated process of selection based on knowledge, feeling, and intuition. When Michelangelo carved, he made thousands of decisions as he sought to create a figure from a block of marble. When a photographer like Henri Cartier-Bresson or Edward Weston (see pages 108 and 37) creates a photograph, he makes thousands of choices in order to arrive at the point at which he releases the shutter and captures a memorable image. Cartier-Bresson calls this the "decisive moment."[4] See Cartier-Bresson's HYÈRES, FRANCE, page 104, and SHOPPING ON SUNDAY, page 108.

To me, photography is the simultaneous recognition, in a fraction of a second, of the significance of an event as well as of a precise organization of forms which give that event its proper expression.[5]

In the 1930s the photo essay became an important part of journalism. Factual images presented in the form of documentary photographs have had a significant impact on society. Many photographers led the way toward a renewed concern with social reform. In AT THE TIME OF THE LOUISVILLE FLOOD, Margaret Bourke-White confronts us with the brutal difference between the glamorized life of advertising promises and the actual reality people faced.

The wide range of Bourke-White's creativity is demonstrated by the diversity of her imagery—from social commentary to monumental abstraction. In her photograph CON-TOUR PLOWING, the design of the visual elements combines with subject matter to create a new understanding of the relationship between humanity and nature. The large curving shape dominating the composition is made up of richly detailed, rhythmically vibrating furrow lines. The tiny scale of the plow adds a human element. The airplane and the space vehicle have provided new vantage points from which to see and record the natural beauty of Earth, as well as the creative and destructive patterns of human enterprise. The abstract power of this photograph relates to the forms being generated by leading painters in New York at the time.

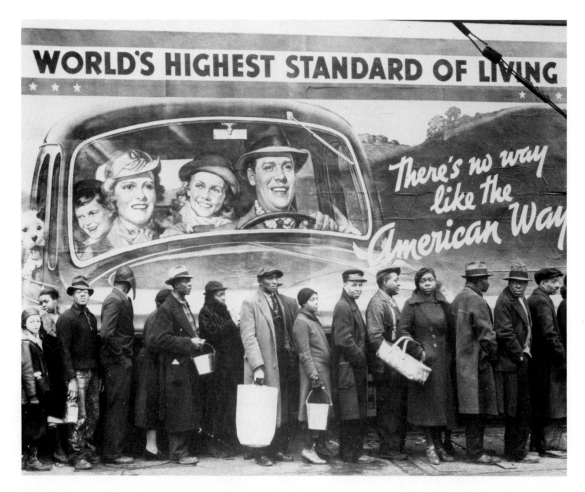

177 Margaret Bourke-White. AT THE TIME OF THE LOUISVILLE FLOOD. 1937. Photograph.

178 Margaret Bourke-White. CONTOUR PLOWING. 1954. Photograph.

179 Jerry Uelsmann. UNTITLED. 1969. Photograph.

Photography provides a way of seeing that extends and expands personal perceptions. Jerry Uelsmann is one of many artists who are adding new dimensions to the art of photography by altering the straight photographic image. In the darkroom, which is for him "a visual research lab," he combines the images from several separate negatives in one print.

By manipulating the print, Uelsmann achieves a mystical visionary power with his highly unusual combination of symmetrical design offset by subtle asymmetrical elements. Trees float above the reflected image of a giant seed pod invoking a mood of timeless generative forces.

Color can become a liability for the photographer. It can weaken a photograph by acting as a superficial afterthought, or it can so tantalize the person behind the camera that he or she forgets about the other aspects of form, without which color has little meaning. But this is not the result with Richard Cooke, who sees color and light as integral aspects of form. In his photograph GRASS IN THE FOG (see color plate 16), the two elements produce a subtle pattern of horizontal and vertical lines. This segment of nature usually goes unobserved.

180 Richard A. Cooke III. GRASS IN THE FOG. Molokai, 1972. Photograph. *See color plate 16, opposite page 178.*

Laser light has been used as a sculptural element and has provided a new form of photography called *holography*. With holography, it is possible to reconstruct the appearance of a fully three-dimensional image that actually exists only as a light pattern appearing within and behind the holographic plate. There is no camera or lens involved. The hologram is a recording of lightwave interference patterns. A reference beam from the laser is reflected and scattered by the object, then reassembled on a holographic plate, along with a portion of the still coherent reference beam that has bypassed the subject.

After the light patterns have converged on the holographic plate, it is developed by standard photographic techniques, freezing a complete "memory" of the subject. When illuminated by laser light, this holographic plate releases a three-dimensional image of the original subject.

Holography is still in its infancy. So far little has been accomplished with it as an art medium. It is included here because it will undoubtedly become an important medium in the future.

Cinematography

Cinematography is the art of making pictures appear to move. Motion pictures seem to move because of the function of the eye known as the *persistence of vision.* When we look at a bright light and then close our eyes, we are able to "see" the light after our eyes are closed. What we are seeing is an *afterimage* (see page 64). Afterimages occur when the retinas of our eyes retain for a moment the image we just experienced. The motion picture projector shows pictures at the rate of twenty-four per second. Each picture differs only slightly from the one before it. Our vision persists through the instant of darkness that occurs between pictures, and we experience the illusion of movement. If the pictures are photographed at the same rate that they were projected (twenty-four per second), then we experience the illusion of natural movement. If slow motion is desired, the camera takes pictures at a rate of more than twenty-four per second, so that when they are projected at twenty-four frames per second, the motion will be slowed down. If fast motion is desired, fewer than twenty-four frames per second are shot and the final film is projected at the usual twenty-four frames per second, thus speeding up the action by compressing actual time.

The photographic basis for the motion picture process was first discovered in 1877 by Eadweard Muybridge, a photographer who was engaged by Leland Stanford to settle a disagreement Stanford had with a friend. Stanford believed that when a horse gallops there is a point at which the horse has only one hoof on the ground. His friend disagreed.

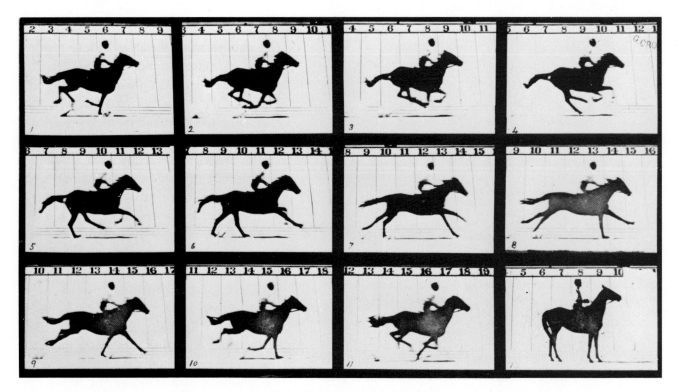

181 Eadweard Muybridge. GALLOPING HORSE. 1878. Photograph. George Eastman House, Rochester, New York.

Muybridge lined up twenty-four still cameras beside a race course. Each camera was fixed with a string to be tripped by the horse's front legs, causing the horse to be photographed twenty-four times as he galloped. In settling the disagreement to his satisfaction, Stanford advanced the revolutionary idea of the motion picture. Muybridge found that if he projected all twenty-four pictures in rapid succession, the horse appeared to move. Soon others began experimenting with sequences of photographs projected in rapid succession.

The motion picture camera was invented in 1887. One of the very early films was made in Thomas Edison's laboratory. Made in 1894 by cameraman W. K. Dickson, it shows Edison's assistant, Fred Ott, sneezing. It was among the first motion pictures to be granted a copyright from the Library of Congress. This is not only one of the first movies, it is one

182 W.K. Dickson. FRED OTT'S SNEEZE. 1894. Film.

of the shortest. It lasts just as long as it takes to sneeze. In the beginning, anything that moved was worth watching.

Early newsreels were similar to the reports we see on television today. Early fiction films, however, were quite different from today's movies. Like many new art forms, film in its infancy was not considered respectable. In order to gain public acceptance, early film-makers tried to make their movies look like filmed theatrical performances. Actors made entrances and exits in front of a fixed camera as though it were the eye of a great audience watching them on stage.

A later concept, the *mobile camera*, was not a kind of camera, but a way of using one. D. W. Griffith took the camera out of its stage-bound setting and filmed on location—out of doors, from moving trains, automobiles, and even in balloons. Between 1907 and 1916 Griffith helped bring the motion picture from its infancy as a nickelodeon amusement to full stature as an art.

Griffith also developed *editing*, the cutting and reassembling of film. During the process of editing, the film goes from raw material in the form of separate shots to meaningful sequences, and finally to a total work. As in the other visual arts, selection is a crucial part of the process. A good editor shows us carefully chosen aspects of the subject, timed and ordered to build the desired feeling and experience in the viewer. The *cutting ratio* tells how much exposed film footage was finally used, as opposed to what was discarded. In the traditional Hollywood movie the ratio is at least 10 to 1, or ten feet thrown away for every foot used. In filming television commercials for national broadcasting, the ratio can range from an average of about 60 to 1 to as much as 1000 to 1. However, it is possible to make an excellent film with a low cutting ratio.

183 Edwin S. Porter. THE GREAT TRAIN ROBBERY. 1903. Film.

Narrative editing was introduced by Edwin S. Porter in his 1903 film, THE GREAT TRAIN ROBBERY. Porter set up his camera in several locations to film parts of the story. Each camera setup or take is called a *shot*. Porter glued all the shots together and projected them in a *sequence*, or grouping of shots.

Parallel editing, a refinement of narrative editing, involves switching back and forth between events. Griffith developed this technique and used it to build suspense by comparing events occurring at the same time in different places. We see this frequently in films and on television when we are shown alternate shots of someone in a desperate situation and a would-be rescuer. Griffith also used parallel editing to compare events occurring at different times, as in his film INTOLERANCE, in which he cut back and forth between four stories set in different periods of history. The most recent development in parallel editing is the *multi-image*, in which events occurring in different locations at the same time are presented on sections of the screen simultaneously. This is now common in television.

Quite by accident Griffith discovered the best way to divide films into sequences. His camera operator accidentally let the shutter of his camera close slowly, causing the light to gradually darken. On viewing this, Griffith decided that it might be a good way to begin and end love scenes. *Fading in* or *out* remains the most common transition between scenes. A later refinement of the fade-in, fade-out idea is the *dissolve*, in which the two are overlapped. As the first shot dims or fades out, the next appears behind it and grows clearer. Griffith also introduced the concept of *flashback* and *flashforward* in his films. He admired the novels of Charles Dickens in which the action moved forward or backward in time to tell the story, and he made the same thing happen in movies.

184 D.W. Griffith. THE BIRTH OF A NATION. 1915. Film.

Close-up and *longshot* were also introduced by Griffith while movies were still stagebound. Later he used the concept of the longshot to film whole armies in battle in *The Birth of a Nation* made in 1915.

In filmmaking, the term *montage* refers to the editing together of a number of shots of a single event to give a sense of heightened importance and drama. In montage a great deal seems to happen in little time, much more than could happen in real life in the same period of time. Griffith used this technique as early as 1916.

Griffith also worked to introduce other elements, which, although not essential to film as art, are nonetheless strong technical additions. He recognized early that movie screens might be wider. Lacking the means of doing that himself, he compensated by masking the top and bottom of some of his shots to give the impression of width. Now we have Cinemascope, Panavision, and Cinerama.

Griffith pioneered the use of music with films. He helped write the musical score for *The Birth of a Nation*, which opened in New York in 1915 accompanied by the full orchestra of the Metropolitan Opera. And he knew that color film photography would someday become a reality.

The coming of sound in 1928 added a new dimension to cinema. Many actors who did well in the silent period failed to make the transition into sound. Sound did not, however, change the fundamental grammar of film art. Color was introduced in the 1930s; the wide screen and a variety of three-dimensional images came in the 1950s; 360 degree projection was first seen by the public in the 1960s; but all of these techniques had been conceived and researched by 1910.

From modest beginnings, cinematography has rapidly developed into one of the most powerful visual arts.

. . . I am using a device (the motion picture camera) . . . by means of which I can transport my audience from a given feeling to the feeling that is diametrically opposed to it, as if each spectator were on a pendulum; I can make an audience laugh, scream with terror, smile, believe in legends, become indignant, take offense, become enthusiastic, lower itself or yawn with bordeom. I am, then, either a deceiver or—when the audience is aware of the fraud—an illusionist. I am able to mystify, and I have at my disposal the most precious and the most astounding magical device that has ever, since history began, been put into the hands of a juggler.

Ingmar Bergman[6]

The enormous range of possible manipulations and special effects used in films today has been developed over a period of time, as the technology was invented to implement the ideas of filmmakers.

Unfortunately, most people seldom think of cinema as more than entertainment. We have all grown up watching Hollywood films made primarily for huge, fast profits. But today, increasing numbers of commercial filmmakers are committed to producing works of lasting aesthetic quality.

Although cinematography and television have made the photographic image move, the camera is still the basic tool. All of the visual elements discussed in Chapter 2 occur in films. The major elements in cinema are time, motion, and space. There is also the very important nonvisual element of sound. In the twentieth century, when time consciousness has become acute, the medium of film has added to that awareness. Cinema time is flexible, like mental time. Film can compress and expand time and can go forward and backward in implied time. Its ultimate power is to integrate all time into the present.

By creating the effect of motion with photographic images, films produce the most vivid appearance of visual reality. Motion greatly increases our sense of participation. When motion is synchronized with sound, two major facets of total sensory experience are joined. The photographic image, plus sound, motion, and color make cinema and television highly persuasive media. These media can convince us that we are actually seeing events as they occur in life. Television adds to the other camera arts the dimension of live action as it takes place in present time.

Television/Video

Television is the electronic transmission of still or moving photographic images with sound by means of cable or wireless broadcast. Today, in the United States, it serves primarily as a distribution system for the dissemination of advertising, news, and entertainment—in that order of importance.

Television has its own characteristic advantages and disadvantages. One of the unique characteristics and limitations of television is its small scale and peculiar round-cornered format. Large-screen video projection is still far too expensive for regular domestic use, and the projected image lacks the quality available with film. Like photography and film, television uses light impulses collected by a camera. The television camera is unique, however, because it converts lightwaves into electricity. Most of the visual arts produce images manually or mechanically; television produces and transmits images electronically.

Early broadcasts were always "live," except for televised movies. With the introduction in the 1960s of magnetic videotape, which has the capacity to record audio and visual material simultaneously, it became possible for lightwaves collected and converted by television cameras to be stored for later transmission to receivers.

185 APOLLO ASTRONAUT. July 20, 1969. Television. CBS News.

Now multiple audio and visual material can be mixed instantaneously with live action elements on television. This, along with the modification of images through such methods as electronic feedback, gives television the potential for even greater flexibility and more complex and immediate forms than film. Television time can incorporate film time and can also bring us events instantly.

The first memorable live television broadcast in the United States occurred in 1939 when President Franklin D. Roosevelt spoke to a gathering at the World's Fair in New York. He appeared on about 100 monitors situated on the fairgrounds and in the city, thus demonstrating a major characteristic of television—its *liveness*. Television has made it possible for the people of the world to share events as they happen.

By 1969 it was possible for an estimated 400 million people to see Neil Armstrong as he stepped onto the moon and made the historic statement "...one giant step for mankind." People around the world watched as the first

moon landing became a milestone in human history. Those who viewed it were simultaneously seeing one or more images and hearing several conversations, separated by one quarter of a million miles, bringing the viewers and participants together with the event and with each other in present time.

The vast potential of television as a creative medium for world communication has only begun to be understood by the industry, and has barely been considered by any sizable portion of the television audience, by government officials, or by educators. The technology continues to outstrip content. By the early 1980s individual television sets may be able to pick up programs direct from communications satellites. Any presentation of television will potentially have the whole world as an audience. Television will then become a crucial tool for achieving and maintaining world peace through mutual understanding. Yet to realize this capacity, international laws will have to be designed to preserve the right of all people to be fairly and impartially informed.

Although television has made it necessary for educators to compete with entertainment in order to sell course material, it has also greatly enriched some areas of education. These areas range from the preschool programming of "Sesame Street" by the Children's Television Workshop to Britain's Open University and its expansion of lifelong learning possibilities for those who cannot or would not otherwise get an on-campus education.

The average American spends over twenty hours per week watching television. Young adults have usually spent more time watching television than attending classes in school. Today's university students are less inclined to read than their predecessors and have little desire to learn to write because of their television habit. Yet children of nursery school age have become increasingly sophisticated because of television.

186　Nam June Paik. ELECTROMAGNETIC DISTORTION OF THE VIDEO IMAGE. c. 1965. Video, photograph by Peter Moore.

As adults we have learned to tune out much of the colorful advertising, noise, and high pressure salesmanship of television, but the medium's pervasive influence continues. The effect of television crime on actual crime has been documented. A 1976 study completed for the U.S. Congress indicated that the average American child between ages five and fifteen will view the killing of 13,000 persons on television. Commercial network television may often sacrifice imaginative programming in the public interest for saleability. Ways should be found to encourage creative programming capable of generating funds that are independent of product advertising.

The space exploration program has hastened the development of lightweight television cameras and recording and transmission equipment. What television will be like in the future may well depend on this new lightweight gear. It offers the chance to break with the traditional heavy and expensive equipment and with the economic demands of network broadcasting. With this equipment, a more direct approach is possible and it is easier to record events outside of the studio. Experimentation and individual expression are facilitated.

The term *video* came into use in the late 1960s when it was used to identify television activity by individuals or groups that were not part of the broadcast television "establishment." In spite of this, many techniques developed during video experimentation have been successfully applied to commercial television. Video also emphasizes the visual as distinguished from the audio portion of the medium.

Video art became possible on a fairly large scale with the development in the late 1960s of relatively inexpensive portable recording and playback equipment such as the Portapack. Video pioneers using the new equipment were united initially by a common desire to go beyond the bland sameness of broadcast television as offered by the major networks. Dominant trends can be seen in their work. One is an emphasis on the direct approach, to meet the need for contact with everyday reality. Lightweight video cameras can be taken into the streets and into the countryside to record people in down-to-earth, "real" situations. Another trend involves the search for new dimensions within the electronic nature of the medium itself. This includes producing nonrepresentational light imagery related to the earlier twentieth-century light art by such artists as Thomas Wilfred. (See page 367.)

Nam June Paik is the foremost pioneer of video art and the first to explore the multiple possibilities of manipulated television imagery. Paik's musical background gives his nonrepresentational free forms a richness and depth not found in the work of some of his followers. Paik has been the leader in using television technology and craftsmanship as a means of *creating* imagery, rather than simply reproducing.

187 Ed Emshwiller. SCAPE-MATES. 1973. Video. 30 minutes. The Television Laboratory, WNET, New York. *See color plate 14, opposite page 131.*

Ed Emshwiller, one of the best known avant-garde filmmakers in the United States, began working in videotape in 1972. He feels that video has greater image-making flexibility than film. He demonstrates this flexibility in SCAPE-MATES, a thirty-minute kaleidoscopic video fantasy blending two dancers with an everchanging electronically generated environment. The work is an unusual and highly effective application of the latest video technology available in the spring of 1973 when this piece was created. Emshwiller used both the new video techniques and traditional broadcast tools. His choreography began with black-and-white artwork from which he designed basic shapes and movements electronically with a computer. The dancers were then color-keyed into the environment. Final background and color were added with a synthesizer. (See color plate 14.)

Emshwiller is enthusiastic about the future of computer-assisted video imagery, which until now has been used primarily for special effects in television commercials. This new medium provides a means for evoking human and visual dimensions that previously could not be expressed.

Another group has worked to counteract the dominant one-directional character of regular broadcast television by providing the viewer with a way to interact through a direct response. An example of their work is the closed-circuit video environment containing both cameras and monitors that gives the viewer the means to see and react to his or her own image and to the images of others. This approach involves the real-time consciousness of the viewer in a way that is uniquely suited to video.

Television's immense flexibility has made it an important new medium for art. Recognition of its capabilities has coincided with the growing desire of many artists to move away from the idea of art as precious finished object to art as a process. With the video movement, television has gone from a distribution system passively received, to a more active medium offering personal involvement and heightened awareness. The problem is that this latter use of video is not yet readily available to the public at large due to the costs involved.

Historically, people working in each new medium often begin by copying the style and content of the medium's closest predecessor. Early photographers copied the styles of painting that were popular at that time. Filmmakers copied traditional theater, and television has depended heavily on film. This phenomenon is exaggerated by the practical and profit-making applications of new media. Television, like printmaking, has gone from performing a reproduction function to becoming a medium of conscious creativity. Video art combines much of the visual richness of painting, the rhythm of music, and the movement of the performing arts.

188 CHINESE SCARF DANCE. Photograph: Francis Haar.

THE PERFORMING ARTS

In a sense, all the arts are an extension of the inherently expressive qualities of the human body. Following from this, all art can be considered as performance, with works of painting, sculpture, and even architecture conceived as frozen performances or, at least, the complete record of an event.

The performing arts are not usually discussed as "visual" arts, yet a major aspect of these arts is visual. Development of the camera arts led directly into the inclusion of performance as a basic ingredient of film and television and helped change the concept of visual arts. This change has also been aided by many twentieth-century movements that have challenged traditional concepts of painting and sculpture. These movements include Cubism, kinetic sculpture, Dada, Abstract Expressionism, and happenings. See Chapter 5.

The emergence of these styles and developments shows a growing interest in new ideas about the nature of movement in space. Sculpture, formerly static, may now move. An increasing emphasis on action and process in both painting and sculpture has led to thinking of the visual arts as events. From this thinking comes such concepts as the *happening*—a semiplanned, semispontaneous event in which the audience becomes the actors in a scriptless, stageless theater piece.

The basic expressive material in the performing arts is the human body. In mime, or pantomime, an ancient form of silent drama, real situations or persons are mimicked and imaginary events portrayed by means of exaggerated gestures and full body movements, without external help from costumes or scenery. Dance is another form of body motion in space; it is usually accompanied by music. The sculptural qualities of the body offer variations in shape and mass, extending outward by means of movement to become rhythmic sequential patterns in time and space. States of mind and dramatic or narrative sequences can be eloquently expressed.

With drama, the art of the written word enters as prose or verse composition, forming the base for performance by actors. Again the facial expressions and body gestures of the actors are important ingredients. As with dance, makeup, costumes, stage movement patterns, lighting, and set design extend and complement the actor's performance.

These observations on the overlapping concerns and means of expression in the visual and performing arts are intended to encourage understanding of their changing interrelated natures.

189 From the dance JOURNEY TO A CLEAR PLACE. Choreographed by Martha Wittman, danced by Betty Jones and Fritz Lüdin. Photograph: Francis Haar.

190 APOLLO. c. 415 B.C. Silver coin. Diameter 1⅛″.

SCULPTURE

Sculpture, along with other three-dimensional disciplines, is both a visual and a tactile art form. It can be made and enjoyed without being seen. The earliest prehistoric "art" objects known today are hand-sized sculptural pieces that were apparently intended to be held. Although the touch of many hands can eventually wear away a work of sculpture, the tactile dimension is an important one to be considered by a sculptor.

When sculpture projects from a background surface, it is not freestanding, but in *relief*. In *low-relief* sculpture, the projection from the surrounding surface is slight and no part of the modeled form is undercut. As a result, shadows are minimal. In *high-relief* sculpture, at least one-half of the natural circumference of the modeled form projects from the surrounding surface. High-relief sculpture begins to look like sculpture that is freestanding. As sculpture enters the fully three-dimensional space that we occupy, our perception of the total form changes as we move around the object. *Freestanding* sculpture seems more real than any of the two-dimensional arts because it occupies three-dimensional space as we do.

A piece of sculpture, such as a coin or a piece of jewelry, may be small enough to hold in the hand and admire at close range. Most coins are small works of low-relief sculpture. Sometimes hand-sized sculpture has a monumental quality because of the abstract simplicity of its design. This is true of much prehistoric sculpture. Or, sculpture can actually be monumental in size. The Sphinx of ancient Egypt is a good example. Colossal Buddha figures in China, Japan, and Southeast Asia are equally impressive.

191 Michelangelo Buonarroti. THE AWAKENING SLAVE.
1530–1534. Marble. Life-size. Academy Gallery, Florence.

Traditionally, sculpture has been made by modeling, carving, casting, assembling, or a combination of these processes. *Modeling* is an *additive* process in which pliable material such as clay or wax is built up from inside to a final outer form. In their working consistency, these materials may not have much strength. But sagging can be prevented by starting with a rigid support called an *armature*. The emaciated figures of Giacometti's lonely people are modeled on a metal armature with clay or wax, then cast in bronze (see page 73).

The process is *subtractive* when sculptural form is created by cutting or *carving* away unwanted material. Michelangelo preferred this method. For him, the act of making sculpture was a process of finding the desired form within a block of stone. In his THE AWAKENING SLAVE, it seems as if this process is continuing as we watch. As it struggles against the marble that imprisons it, the figure seems to symbolize the human spirit. Close observation of the chisel marks on the surface reveals the steps Michelangelo took toward more and more refined cutting.

It takes considerable foresight to use the subtractive process. Each material has its own character and must be approached on its own terms. The stonecarver must apply strength and endurance to unyielding material. In wood carving, grain presents special problems and unique results. Both wood and stone must be carefully selected beforehand if the artist is to realize the intended form.

The process of casting was highly developed in ancient China, Greece, Rome, and parts of Africa. It has been used extensively in western Europe since the Renaissance.

All *casting* involves the substitution of one material for another with the aid of a mold. The mold is taken from an original work made in clay, wax, plaster, or even styrofoam. The process of preparing the mold for casting varies, depending on the material to be used.

192 BENIN HEAD. Nigeria. 16th century. Bronze casting. 9¼" high. The Metropolitan Museum of Art, New York. The Michael C. Rockefeller Memorial Collection of Primitive Art.

Any material that will harden, such as clay diluted with water, molten metal, concrete, or liquid plastics can be used. When the mold is made and the original material removed, the casting liquid is poured into the resulting hollow cavity. After an outer layer or skin has hardened, the remaining casting liquid is poured back out. Most castings are hollow.

If a large object, like Giacometti's MAN POINTING, is to be cast in bronze, the process is extremely complicated. In the past, the artist and several assistants did the actual casting of bronze. Today, except for small pieces that can be cast solid, most artists turn their original over to foundry experts to be cast under their supervision.

The cast low-relief Greek silver coin, although only about one inch in diameter, is a sensitive portrait of a young man idealized to represent Apollo, the sun god. At Benin, in Nigeria, bronze casting was used in the sixteenth century to cast freestanding likenesses of royal personages. The decoration, although elaborate, helps to center our attention on the expressive features of the simplified face.

Before this century, the major sculpture techniques were modeling, carving, and casting. Since Picasso constructed his cubist GUITAR in 1912 (see page 324), *assembling* methods have become widely used. In some cases, preexisting objects are brought together in such a way that their original identity is still apparent, yet they are transformed in this new context. This type, or subcategory, of assembled sculpture is called *assemblage*.

193 Pablo Picasso.
BULL'S HEAD. 1943.
Bronze. Height 16⅛''.
Galerie Louise Leiris,
Paris.

In Picasso's BULL'S HEAD, the creative process has been distilled to a single leap of the imagination. The components of this assemblage are simply a bicycle seat and handle bars. Almost anyone could have done the actual work of putting them together. Yet the finished work is based on a particular kind of empathy with things, which is far from common. The metamorphosis of ordinary manufactured objects into animal spirit is still occurring for the viewer.

Louise Nevelson began making sculpture using found wooden objects in 1955. She assembles boxes and assorted objects in a variety of shapes and forms, creating new images from carefully selected discards of modern society. Each compartment is both part of the total form and a completely satisfying composition in itself. Her works are usually wall pieces, viewed frontally as reliefs and are painted a single unifying color, usually black, white, or gold. ROYAL TIDE #1 is a good example of her sense of theme and variation in three-dimensional form.

194 Louise Nelson. ROYAL TIDE #1. 1961. Gilded wood. 8 x 3'. Collection Mr. and Mrs. Howard Lipman.

Since 1930, the cutting and welding of metals like steel and aluminum to make sculptures has developed and become widespread. Equipment such as the oxyacetylene torch greatly facilitated these developments. David Smith pioneered in this type of assembled sculpture. (See page 371.) He used such industrial materials as I beams, pipes, and rolled metal plate for raw materials and adopted industrial methods of fabrication.

Richard Lippold's VARIATIONS WITHIN A SPHERE, NO. 10: THE SUN is a technically amazing piece of work. Its complex linear form is assembled from several thousand feet of gold-filled wire. The eleven-foot height puts the center of the structure at about eye level. Light is reflected from the shimmering gold surfaces and translucent planes built up with wire. The pure mathematical precision of this construction creates a symbolic image of the sun's radiant energy.

The form of sculpture changes as technology develops new material and processes and makes them available to sculptors.

195 Richard Lippold. VARIATIONS WITHIN A SPHERE, NO. 10: THE SUN. 1953–1956. Gold filled wire construction, 22k. 11 x 22 x 5½'. The Metropolitan Museum of Art, New York. Fletcher Fund, 1956.

196 Alexander Calder. FOUR BIG DOTS. 1963. Sheet metal and steel wire. 29 x 113". San Francisco Museum of Modern Art. T.B. Walker Foundation Fund purchase.

Alexander Calder, along with David Smith, was among those who gave renewed life to the blacksmith's ancient craft. Calder pioneered *kinetic sculpture*. By 1932 he was designing wire and sheetmetal constructions, such as his FOUR BIG DOTS, that are moved by natural air currents. Duchamp christened them "mobiles," a word he had coined for his own work in 1914. (See page 335.) The traditional emphasis on mass is replaced in Calder's work by an emphasis on shape, space, and movement. Other sculptors today use motors to move their work. (See Breer's FLOATS, page 95.)

THE GATES OF SPOLETO has shapes related to Calder's mobiles. He called this type of structure a "stabile." The cutout sheetmetal planes are transformed into lines and back to planes again as the viewer moves through and

197 Alexander Calder. THE GATES OF SPOLETO. 1962. Steel. 65'7" x 45'11" x 45'11" Spoleto, Italy.

198 Takis. ELECTROMAGNETIC SCULPTURE, Paris, 1960, modified 1965. Metal. Collection of the artist.

199 Andy Warhol. CLOUDS. 1966. Mylar, helium filled. 48 x 42½'' each. Leo Castelli Gallery, New York.

around the work. Monumental scale and openness invite the viewer to be environmentally involved. Sculpture becomes architectural.

Cooperation between art and technology has produced a variety of new sculptural forms. Live energy in the form of magnetic force plays an important role in the kinetic work of Takis. In ELECTROMAGNETIC SCULPTURE, a sphere, suspended from the ceiling by an almost invisible fine wire, moves and pauses in an orbital pattern around an upright electromagnet that automatically turns on and off. The duality of stillness and motion is reminiscent of the alternating rhythms implied by the multiple arms of the dancing Shiva (see page 254).

Andy Warhol took advantage of new materials in his playful dance of floating pillows called CLOUDS. The environmentally inclusive work consists of helium-inflated containers made of thin metalized plastic sheeting known by the trade name Mylar.

Artists such as Dennis Oppenheim and Christo (see pages 374 and 376) have been working with environmental concepts on a vast scale. Their unique sculptural forms deemphasize the separate material of the single work in order to incorporate features of the surroundings into a total sculptural experience.

200 SMITH FROM NORTHERN DAHOMEY. 1969. Photograph:
Rene Gardi.

CRAFTS

Many of the traditional media of the so-called crafts are now being used to create sculpture, even though individuals working with these media may think of themselves as craftsmen rather than artists. The term artist-craftsman has been used recently in reference to people working in areas traditionally called crafts when their work is considered to have high aesthetic merit. Although classified here under the heading "crafts," much of this work is really sculpture.

All art begins with craft. If a work is not well made, there is little chance that it will be experienced as art; but craftsmanship alone does not make art.

The crafts practiced today link us with a long tradition. If the fossil fuels and metal ores that now support our industrialized society run out, we may depend more on the crafts to provide for our daily needs, as they have done throughout much of human history. A seemingly infinite variety of material goods, such as fabrics and dishes, are now produced in quantity by mechanical methods. This development has made it possible for many people to make handcrafted objects without the pressures of earlier demands for quantity, economy, and practicality.

From the days when someone first wove a simple basket from reeds, or pinched some clay into a pot and found that fire hardened it, the crafts have been an integral part of everyday life. Until the Industrial Revolution, few saw them as separate, or as "minor" arts, as they are sometimes called today. As much artistic thought went into the painting on a Greek vase as into a wall painting. When machines took over weaving cloth, making dishes, and stamping out metal utensils, the close relationship between the maker and the object was lost, and with it much of the beauty. Of course there is good and bad design in both handmade and factory-made things.

Handmade articles can have a quality that enhances the spiritual aspects of life. Many people are discovering the lasting satisfaction that comes from using their own hands to create objects for everyday use. This trend is evidently more than a passing fad; it is part of the foundation of a new era. Ceramics and weaving have been the most widely practiced of the crafts, but the recent revival of interest in handwork has reintroduced a wide variety of other crafts, including jewelrymaking, enameling, and glassblowing.

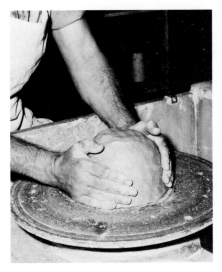

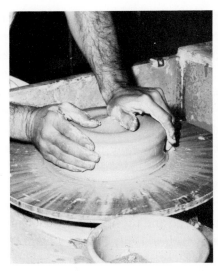

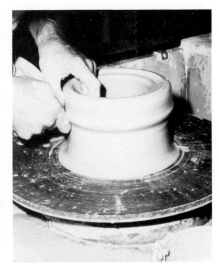

201 Six stages in forming a vase.
a. placing the ball of clay on the wheel

b. centering the clay

c. opening a cylinder

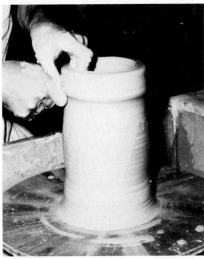

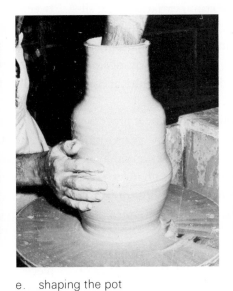

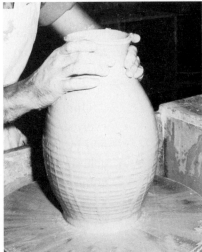

d. pulling up the cylinder

e. shaping the pot

f. finishing the neck

Ceramics

Ceramics is the art and science of making objects from clay. The earth provides a variety of clays that can be mixed with one another and refined to obtain the desired body and plasticity. Clay has long been a valuable raw material for the human race. It offers ample flexibility and relative permanence because of its capacity to harden when exposed to intense heat.

A person who works with clay is usually called a *potter.* Potters create functional pots of purely sculptural forms using hand-built methods, such as building with slabs or coils, or by throwing forms on a wheel that may be driven by motor, hand or foot.

The term *ceramics* includes a wide-range of objects made of fired clay, including tableware, vases, bricks, sculpture, and many kinds of tiles. Most of the basic materials and processes in ceramics were discovered thousands of years ago. Ceramics is one of the oldest crafts, and was highly developed in ancient China and Egypt. Originally pots were made by pinching or building up with coils. However, since the invention of the potter's wheel in Egypt about 4000 B.C., potters have been able to produce with greater speed and uniformity. When a piece of pottery is thoroughly dry, it is fired in a *kiln*, a kind of oven. Heat transforms it chemically into a hard, stonelike substance. *Glazes* or other decoration may be added for color and textural variation. The silica in glaze vitrifies during firing, fusing with the clay body to form a glassy, nonporous surface. Glaze can be transparent or opaque, glossy or dull, depending on its chemical composition.

Until the twentieth century, new processes evolved very slowly. In recent years, new and even synthetic clays have become available to potters. But the biggest changes have come in more accurate methods of firing and improved production techniques and equipment.

Works made by individual artist-potters who perform all, or nearly all, the processes of production with their own hands are usually very different from the ceramic products of industrial mass production. While both may reach a level of artistic excellence, the machine-made pots do not have the unique personal qualities of handmade pots.

Ceramic wares are categorized according to the kind of clay used and the specific firing temperatures. Color variations are caused by different chemical compositions of clays. *Earthenware* is made from coarse surface shale and clay and is fired at low temperatures (under 2100°F.). It is usually red or tan in color and has a porous structure. *Stoneware* is made from finer clays and is fired at higher temperatures than earthenware (2100–2300°F.). It is gray, tan, or reddish in color and has a very dense structure. *Porcelain* contains large amounts of kaolin, a very pure, fine white clay, and feldspar. A high firing temperature (2300–2786°F.) is used, producing a completely vitrified or glassy ware. Stoneware and porcelain are waterproof; low-fired wares are not.

These standard categories are not always completely distinct from one another. Since most clay bodies are a mixture of different clays, there are clay bodies that fall between these categories. *China*, for instance, falls between stoneware and porcelain in firing temperature, and is semivitreous. Commercial tableware is usually made from china and varies widely in thinness and translucency.

Most of today's handmade ceramics are either earthenware or stoneware. Pieces are formed using a variety of methods. Clay may be simply *pinched* into shape. Another method uses *coils*, and is employed in many parts of the world for both small and large pots. Clay is rolled into ropelike strands, which are then built up in layers, pinched, and smoothed together. The *slab* method involves rolling the clay out like cookie dough, cutting it into pieces, and fastening it together. *Throwing* is the term used for shaping clay on a potter's wheel.

Some people, living apart from the modern world or seeking to preserve traditional methods, still fire their pots in open fires that reach only low and generally varied temperatures. Maria Chino of Acoma Pueblo made this ceremonial water jar using the methods of her ancestors. The pot was hand-built, using thick coils that were smoothed as each one was added. The design was applied using red and black oxides, with areas of exposed white clay. No glaze was used.

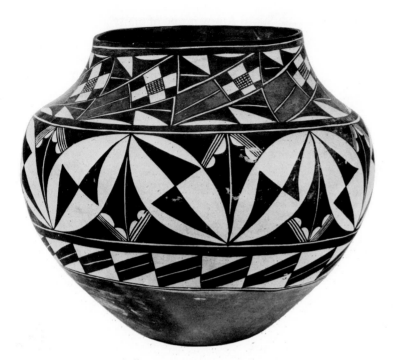

202 Maria Chino. CEREMONIAL WATER JAR. 1927. White clay, decorations in black and red. 11¼ x 13½''. Honolulu Academy of Arts.

203 Toshiko Takaezu. CERAMIC POT. 1971. Height 13''. Private Collection. *See color plate 17, opposite page 179.*

This pot was made for ceremonial purposes. The making of such vessels takes four or five days, during which the artist eats and sleeps very little. The soul of the artist is possessed by the pot. The motifs are the artist's own. In the bands that separate the upper and lower portions of the design breaks are made to allow for the release of the soul after the work is completed. The survival of this jar is unique since it was meant to be broken at the ceremony for which it was made.

Toshiko Takaezu uses modern equipment, including a potter's wheel and gas-fueled kiln. Her sculptural forms become the foundation for rich paintings of glaze and oxides. (See color plate 17.) Artists are often as in love with the processes of working with their materials as with the satisfaction of seeing the results.

When working with clay I take pleasure from the process as well as from the finished piece. Every once in a while I am in tune with the clay, and I hear music, and it's like poetry. Those are the moments that make pottery truly beautiful for me.

Toshiko Takaezu[7]

204 Susan Amoy. Detail of THE TIME BETWEEN THE TWO. 1976. Stoneware. Height 29″. Collection of the artist.

Susan Amoy is one of many artists working with ceramics who is not limited to round forms made on a wheel or with coils. In this piece from THE TIME BETWEEN THE TWO the form was built up with slabs. Contrasting regular and irregular edges and the pressed and rolled pieces of the upper portion take advantage of the plasticity of clay.

To create his expressive sculpture, BIG BOY, Noguchi pinched clay to form the hands, legs, and feet, and rolled out a slab of clay, which became the garment worn by the child. This slab was pressed into the other pieces of clay to form a single unit. Both Noguchi and Amoy used modeling, cutting, and assembling to achieve the final result.

Glass

Chemically, glass is related to some of the materials used in ceramics, especially glaze, but, as a form-creating medium it offers a wide range of unique possibilities. Hot or molten glass is a sensitive, amorphous material. Molten glass can be shaped by blowing or pressing it into molds. Glass solidifies from its molten state without crystallizing.

For 4,000 years glass has been used as a material for practical containers of all shapes and sizes, as well as in architecture as clear and "stained glass" windows and mirrors, and in decorative inlays in a variety of objects, including jewelry. Elaborate colored blown glass pieces have been made in Venice since the Renaissance. Because our primary contact with glass is food and beverage containers and windows, we often overlook the fact that glass can also be an excellent sculptural material.

Although it can be said that the character of any material determines the character of the expression, this is particularly true of glass. Hot glass requires considerable speed and skill in handling. The glass blower must become one with the fluidity of the molten material.

205 Isamu Noguchi. BIG BOY. 1952. Kratsu ware. 7⅞ x 6⅞''.
The Museum of Modern Art, New York. A. Conger
Goodyear Fund.

This fluid nature of glass produces qualities of mass flowing into line and into translucent volumes of airy thinness. Glass can also be slumped, or used cold as cut pieces glued, assembled, or painted.

Bavarian artist Erwin Eisch provided inspiration for the glass revival that began in the United States in the early 1960s and was in turn influenced by American Pop Art of the period. In his untitled sculpture in the form of a teapot, Eisch took advantage of the soft, organic flow of the medium to create an intentionally "funky" and humorous piece which seems to have a rather absurd life of its own. A glass liquid of unknown origin dribbles down from the spout. Eisch enjoys *matte opaque* glass, often preferring it to shiny transparent or translucent glass.

206 Erwin Eisch. TEAPOT. c. 1970. Off-hand
blown glass. 10'' high. Private collection.

207 Hugh Jenkins blowing glass.

208 Hugh Jenkins. GLASS BOTTLE. 1976. Off-hand blown glass with silver, tin, manganese, and copper. Height 14". Collection of the artist.

Hugh Jenkins has recently concentrated on working with the shape, linear pattern, and color achieved from light reflected off the surface of glass and light transmitted through translucent glass.

Marvin Lipofsky is a leader in the American revival of blown glass, which began in the sixties. His work reproduced here is abstract sculpture in which form and sensuous color unite to tease the senses. This piece was made while Lipofsky was artist-in-residence at the Leerdam Glassworks in Holland. It was made by Lipofsky and Leerdam's master craftsman and reflects both the imagination of the artist and the crisp precision of commercial production technique. See color plate 18.

The medieval method of setting pieces of colored glass in lead and iron frames to create windows for Gothic cathedrals has been revived and augmented by a variety of new materials and techniques. Artists such as Matisse and Chagall have executed commissions for colorful windows in churches and synagogues.

209 Marvin Lipofsky. LEERDAM GLASVORMCENTRUM COLOR SERIES. 1970. Off-hand blown glass. 10 x 15 x 13". Collection Javier Garmendia, New York. *See color plate 18, opposite page 179.*

Jewelry

Self-adornment is universally practiced and is limitless in form. Jewelry has been made and worn for beauty's sake, to carry wealth, and to impress others. Jewelry involves such crafts as metalworking, enameling, and stonecutting. Decorative jewelry is a form of miniature sculpture. Ideally, it is designed to enhance the beauty of the wearer.

In prehistoric times and in remote cultures today, jewelry has been made of polished stones, shells, carved bone, teeth, feathers, and other materials. In the recent crafts revival, many artists have been influenced by the works of these cultures. Today's jewelry often includes unusual materials, as well as the more traditional metals and precious stones.

In her necklace of cut and hammered silver and pre-Columbian jade beads, Barbara Engle balanced positive and negative shapes. Her concern for shape carries into the hanging elements of this assembled piece.

Ron Ai's necklace is also assembled; soldering was used to form the sterling silver pendant, which is a small container with an operable lid.

Merle Boyer molded the basic form of these interlocking engagement and wedding rings out of wax, then cast them in gold. The diamond is a family heirloom that has been reset in this highly sculptural contemporary setting. The wedding band cradles and protects the diamond.

210 Barbara Engle. NECKLACE. 1975. Pierced and hammered sterling silver and pre-Columbian jade beads.

211 Ronald Ai. PILLBOX NECKPIECE. 1977. Sterling silver with Moonstone.

212 Merle Boyer. INTERLOCKING WEDDING AND ENGAGEMENT RINGS.

213 Sam Maloof. CHAIR.

Furniture

Most of the furniture in our homes today is produced by industrial mass-production methods. This does not mean that it cannot be well designed. See the chairs on page 183 designed by Mies van der Rohe and Charles and Ray Eames. But those who have the skills to make their own furniture, or are in a position to commission artists to create custom furniture for them, can enjoy the experience of handcrafted furniture in their own homes. Many handcrafted pieces are one-of-a-kind, and others are among a limited number of a given design.

Sam Maloof makes some unique pieces of furniture and also repeats some of those he finds particularly satisfying. The forms he uses are expressive of his love of wood and of the hand processes used to shape this material into furniture. Because he enjoys knowing that each piece is cut, assembled, and finished according to his own high standards, he has turned down offers from manufacturers who want to mass-produce his designs.

Maloof's chairs are not only beautifully sculptural to look at, they are exceptionally comfortable to sit in. Many pieces of furniture are pleasing to look at, and many comfortable to use, but relatively few fulfill both these functions so successfully.

Fiber Arts

Threadlike fibers, both natural and synthetic, are the basic materials for a variety of forms produced by processes such as weaving, stitching, knitting, crocheting, and macraméing (knotting).

Weaving, like ceramics, was developed when early man went from hunter to farmer. When skins were no longer available for warmth, garments made from cloth became a necessity. The basic processes of making

214 Alice Parrott. MESA VERDE. 1976. Wool and linen, tapestry and soumac techniques.
48 x 62''. Collection Paul M. Cook, Atherton, California. *See color plate 19, opposite page 179.*

215 WEAVING.

cloth, from spinning to weaving, are relatively easy to learn. All weaving is based on the interlacing of the lengthwise fibers, the *warp*, and of the cross fibers, the *weft* (also called the *woof*). Patterns are created by changing the numbers and placement of the threads which are interwoven.

Alice Parrott's weaving MESA VERDE uses vibrant warm colors to create an abstract image of the ancient protected community built high in the overhanging cliff of a Colorado mesa. (See color plate 19.)

Weaving may be complex or simple. A large floor loom capable of accommodating wide yardage can take several days to prepare. Large tapestry looms are capable of weaving hundreds of colors into intricate images. In contrast, a small weaving on a simple hand loom can be finished in a few hours.

216 NAVAJO WEAVER AND SPINNER. Monument Valley, Arizona. Photograph: Josef Muench.

The frame loom used by Navajo women to create blankets and rugs provides the necessary technology for handsome traditional forms. If no flaw occurs naturally in the process of making a woven form, it is traditional to weave in an intentional "flaw" in order for the spirit to get in and out.

Color plate 16 Richard A. Cooke III. GRASS IN THE FOG. Molokai, 1972. Photograph.

Color plate 18 Marvin
Lipofsky. LEERDAM
GLASVORMCENTRUM COLOR
SERIES. 1970. Off-hand
blown glass. 10 x 15 x
13''. Collection Javier
Garmendia, New York.

Color plate 17 Toshiko
Takaezu. CERAMIC POT.
1971. Height 13''.
Private collection.

Color plate 19 Alice Parrott. MESA VERDE. 1976. Wool and linen, tapestry and soumac
techniques. 48 x 62''. Collection Paul M. Cook, Atherton, California.

218 MACRAMEING.

217 Kay Sekimachi. SHIRATAKE III. 1965. Nylon monofilament. 50 x 12 x 15″. Collection Elena Anger. Stockholm.

The recent outburst of creative work in *off-the-loom* fiber arts has taken these arts far beyond their traditional roles and functions as crafts. Fiber sculpture is one of the new directions being taken in this area. Kay Sekimachi's SHIRATAKE III has an airy, weightless quality as it hangs in soft billowing curves of gossamer thinness. Fiber is sometimes combined with other media, creating rich textural variations.

Macramé is often thought of as a modern craft, used to make belts, plant hangers, purses, and wall hangings, but it was actually developed centuries ago as a functional art to make carrying bags, fishing nets, and slings to carry water gourds. Later, sailors on sailing ships spent leisure hours perfecting many types of knotting techniques. These skills have been adapted today to make decorative articles.

Textile Design

Tie-dye, batik, and silk-screen processes enhance cloth surfaces in a variety of ways that are different from those achieved through weaving.

The process of printing designs on cloth by stamping was used in very early cultures. Later, travelers to India brought to Europe the technique of printing cloth designs from carved wood blocks. Mass printing of cloth today is done by high-speed roller presses, but artists still use some of the ancient methods.

Tie-dyeing creates patterns on cloth by a process of tying or sewing folds of fabric to keep the dye from penetrating selected areas of the cloth. *Batik* is based on a resist process in which wax is applied to the fabric to keep it from absorbing the dye. Subtle designs using many colors can be created by using numerous applications of wax and several dye baths. *Silk screening* (see page 144) can also be used to transfer designs to cloth.

DESIGN DISCIPLINES

Everything man-made needs to be designed either before or during the process of its construction. The design process is often spontaneous. After a work is finished, we respond to the quality or lack of quality in its design.

Design is also a professional discipline of the visual arts. Designers are paid to apply their knowledge of design to a wide variety of objects and spaces. Their role is to enhance living by applying their developed sense of aesthetics and utility to the solution of human problems. As the buying public becomes more visually aware, it will look for, and be more likely to find available, a wider selection of well-designed graphics, objects, and spaces.

Many people today, and most of our descendants, will spend their lives in urban areas where man-made designs are dominant. It is in these areas that a major struggle goes on between the demands of human sensibility and those of technical and economic expediency

219 COCONUT GRATER from Kapingamarangi, Caroline Islands. 1954. Wood with shell blade attached with sennet. Private collection.

on all levels, from the design of books to the design of the urban environment. Today's leading designers see their art as an urgent necessity, not as mere cosmetic addition.

In today's technological civilizations art, like religion, has been separated from daily life. Author Pearl Buck has noted that Americans do not realize the spiritual need for beauty in their lives.

Many contemporary designers working in the applied arts have been inspired by the works of nonindustrial cultures, enjoying their directness and sensitivity to the qualities of the materials they employ.

All over the world traditional cultures have met, and still meet, their basic needs for survival and spiritual fulfillment by designing articles for daily use. Generations of craftsmen have refined the design of these objects in order to improve their functions.

In this coconut grater from the Caroline Islands in the South Pacific, the sweeping curves of the abstract animal form blend totally with the user's need to sit comfortably in relation to the serrated blade at the head of the figure. The angle and placement of the blade is most important if it is to function well in removing the meat from the nut halves.

The traditional, functional objects of Japan exhibit a high degree of design sophistication, even when the object is a disposable wrapping such as the one shown here. This package design is basic, low cost, yet elegant.

220 RICE STRAW EGG CONTAINER. Yamagata Prefecture, northern Japan. Photograph: Michikazu Sakai.

Industrial Design

Industrial design is art working within industrial media. Its purpose is to design objects for machine production, to make sense of technology and to enhance objects designed primarily for functional purposes. An industrial designer can work on things as simple as a bottle cap or as complex as an information-processing system. Always the designer needs to be able to learn anew. He or she must become familiar with how the object being designed will be fabricated and must work, and how it can become a meaningful, economical contribution to living processes. This means designing so that the relationship between the object and the people who use it is a means, rather than a hindrance, to human fulfillment. Industrial design is an important and demanding field whose products have a major effect on our daily lives.

This sketch shows a few of the specific details and possibilities that a designer must consider when trying to comprehend the design of any common yet always complex object, in this case, a coffee percolator.

SOME THINGS TO CONSIDER IN A PERCOLATOR DESIGN

221 Richard I. Felver. PERCOLATOR DESIGN. 1972.

222 Ludwig Mies van der Rohe. BARCELONA CHAIR. 1929. Chrome plated steel bars, leather. 29½'' high. The Museum of Modern Art, New York. Gift of the manufacturer, Knoll Associates, Inc.

The architect Ludwig Mies van der Rohe designed a chair in 1929 that has become a classic. The BARCELONA CHAIR is a graceful and comfortable place for one or two people to sit.

Husband and wife Charles and Ray Eames have worked together since the 1930s. Ray studied painting with Hans Hofmann and brought to the partnership a feeling for sculptural shapes in space and a sense of color and total design. Charles provided architectural, technical, and scientific skills, as well as a fine sense of design and a very active imagination.

The Eames first became known for their innovative chair designs. They saw the potential of the simple material plywood, and were among the first to successfully design both molded plywood and molded plastic chairs for industrial production. They have worked with a wide range of media, designing chairs, houses, films, toys, packaging, exhibitions, and a variety of other consumer and industrial products. The Eames have also been active in design education.

223 Charles and Ray Eames. MOLDED PLYWOOD CHAIR. c. 1942.

183

224 TEAM OF INDUSTRIAL DESIGNERS AT WORK. Isuzo Motors Ltd., Tokyo. c. 1968.

There can be a considerable difference between redesigning to improve an object's total function and exterior restyling to increase sales. It has been estimated that over the last twenty years, one-half to two-thirds of the purchase price of the average American car has been for visual design alone.

The aspect of car design that is expensive is the retooling of the machinery that makes the car. Thus it is the change in design, rather than the design itself, that is costly.

Transportation design has a major impact on life in urban areas today—in many ways it shapes the form of cities. Designers working in this field may deal with anything from solving problems related to automobile improvement to designing mass transit systems attractive and efficient enough to entice people away from the automobile. (See page 216.)

Graphic Design

The term *graphic design* is presently used to refer to applied design on two-dimensional surfaces ranging in scale and complexity from stamps and logos to television commercials and outdoor advertising. Much of graphic design involves designing material to be printed —books, magazines, brochures. *Typography* is the art and technique of composing printed material. Photography and typography are important media for the graphic designer.

The only "original" work that can be experienced as you read this book is the book itself. Its design is the art of graphic designer James Stockton, who carefully considered and integrated the ideas and requirements presented to him by members of the publishing staff and the author.

Many designers work in advertising design.

It has been estimated that the average American adult is assaulted by a minimum of 560 advertising messages each day. And we are building up our communications machinery in order to transmit an even greater array of images at an even faster rate.

In advertising, the arts frequently work together. In this sense television advertising is a kind of operatic art form that calls upon writers, musicians, and actors, as well as directors, camera operators, and graphics designers.

Printed visual advertising was not widely used before this century. Now, a writer, a designer, and often an illustrator or photographer work as a team to achieve the final ad. Both of the accompanying ads have been effective. They offer strong propaganda on two opposing sides of an argument. In the American Cancer Society's poster, the graceless form of the photograph and the typography intentionally contradict the content of the words, creating a blunt contrast to the delicate sophistication of the Eve advertisement. One of these may have been designed to counteract the other.

Clothing Design

Clothing design is a daily consideration. Clothes can warm, protect, and conceal the human figure, yet they fulfill their potential when they also enhance the body's inherent beauty. We express ourselves by the manner in which we dress. Clothing is communication; it is worn to indicate individual attitude and character, mood, identity with certain groups or occasions, occupation or profession, socioeconomic position, or all of these. Even with today's anti-false-front attitudes, the least clothes-conscious individuals express, through clothes, their desire to be comfortable, inconspicuous, and part of the group that shares their values. We all like to feel good or right in what we wear.

225 AMERICAN CANCER SOCIETY POSTER.

226 EVE CIGARETTE ADVERTISEMENT.

227 Contemporary Japanese fashion design incorporating traditional motifs. 1977. Photograph: G.N.M.

Apparel design is an occupation that includes designing everything from mass-produced clothing of all types to custom one-of-a-kind dresses costing thousands of dollars. Although their creations often seem far removed from the real world, fashion designers have a great deal of influence on popular taste and style selection. These designers are on the other end of the clothing spectrum from those who have tended to spurn the new styles advanced by the fashion industry each season. With the need to economize, recent nostalgia trends, and concerns over conservation and recycling, many people seem to pride themselves on wearing only old or second-hand clothes.

Old clothes and variations on blue denim have become fashion styles in themselves. To capitalize on the trend, the clothing industry has even manufactured replicas of old clothes, such as prefaded, machine-frazzled, cut-off shorts.

David Cook is a pharmacist by profession, who enjoys rebuilding old cars and designing and crocheting clothes in his spare time. He and his wife Lynn often work together, with Lynn selecting the colors and David inventing or modifying patterns, doing the crocheting, and assembling the garment. David's unique crocheted jacket features sections of leather, as well as needlepoint scenes, stitched by Lynn, of views from their home.

228 David Cook. JACKET. 1976.

229　Tom Sellers. OFFICE INTERIOR. Sellers Advertising Inc. 1974.

230　William Wenzler. Interior, NICOLL RESIDENCE. 1963.

Interior Design

Interior living spaces are designed consciously and unconsciously by those who inhabit them. Professional and amateur interior designers need to have both an awareness of the expressive character of architectural spaces and the ability to visualize how these spaces can be designed to contribute to the life within them. Regardless of who designs them, however, enjoyable interiors are positive expressions determined by the values and life styles of the occupants. For this reason, some of the best interior design is done by individuals for themselves.

Putting together enjoyable interiors takes thoughtful planning. Important aspects of the process include: developing ideas about the desired atmosphere or mood in keeping with the life style and intended purpose of the space; relating interior and exterior spaces when applicable; organizing rooms, and spaces and objects within rooms, to suit specific needs; selecting and arranging furniture for comfort and ease of circulation; and coordinating space, materials, colors, textures, and objects to create a consistent atmosphere appropriate to the function of the rooms.

Interior designs that work well are in harmony with the character of the architecture and complement the qualities of the exterior landscape or cityscape as viewed through windows. Meaningful, useful, and well-loved personal possessions provide the final touch.

The character of the living area of William Wenzler's NICOLL RESIDENCE is largely determined by the architectural space. Structural clarity in the building is echoed in the strong, simple form of the furnishings.

Our immediate environment has an enormous effect on our mental outlook. Visual and spatial qualities of interiors do more to shape the quality of lives within and beyond those interiors than any other visual art.

ARCHITECTURE

Architecture is the art and science of designing sculptural sheltering structures that organize and enclose space for practical and symbolic purposes. Because architecture grows out of human needs and aspirations, it clearly communicates cultural values.

Architecture, like sculpture, is expressive three-dimensional form. Both disciplines utilize space, mass, texture, line, light, and color. While sculpture is most often seen from the outside, architecture is experienced from within as well. The sculptural form of a building works best when generated from within—determined by those functions the structure is intended to serve.

Of all the visual arts, architecture affects our lives most directly. It determines the character of the human environment in major ways. While you are reading these words you are probably within a building. How does it feel? How does it look? Does it provide for and enhance the function for which it was intended? How does it express the values of those who designed and built it?

To be architecture, a building must achieve a working harmony among the factors that call it into being and that are, in turn, affected by its existence. We instinctively seek structures that will shelter and enhance our way of life. It is the work of architects to create buildings that are not simply constructions but also inspirations and delights to the viewer.

Buildings contribute to human life when they provide durable shelter, augment their intended function, enrich space, complement their site, suit the climate, and stay within the limits of economic feasibility. The client who pays for the building and defines its function is an important member of the architectural team. In any creative effort in which more than one individual is involved, the weakest link is the person who may be unaware of what is possible. The mediocre design of many contemporary buildings can be traced to both clients and architects. A more aware public is necessary before we can improve the quality of contemporary architecture.

Sculpture can be small and rarely needs a consistent structural system. Architecture, however, employs structural systems in order to achieve the size and strength necessary to meet its purpose. Methods of support utilized in architecture determine the character of the final form. These structural methods are based on physical laws and, for that reason, have changed little since man first started to build—even though the materials involved have changed dramatically.

The world's architectural structures have been devised in relation to the objective limitations of materials. Structures can be analyzed in terms of how they deal with downward forces created by gravity. They are designed to withstand the forces of *compression* or pushing ($\longrightarrow \longleftarrow$), *tension* or pulling ($\longleftarrow \ \longrightarrow$), *bending* or curving (), or a combination of these in different parts of the structure. There are dozens of basic variations of structural types—shells, folded plates, domes, hanging roofs, tents, and free-form castings. The diagrams here illustrate some of the most common structural systems.

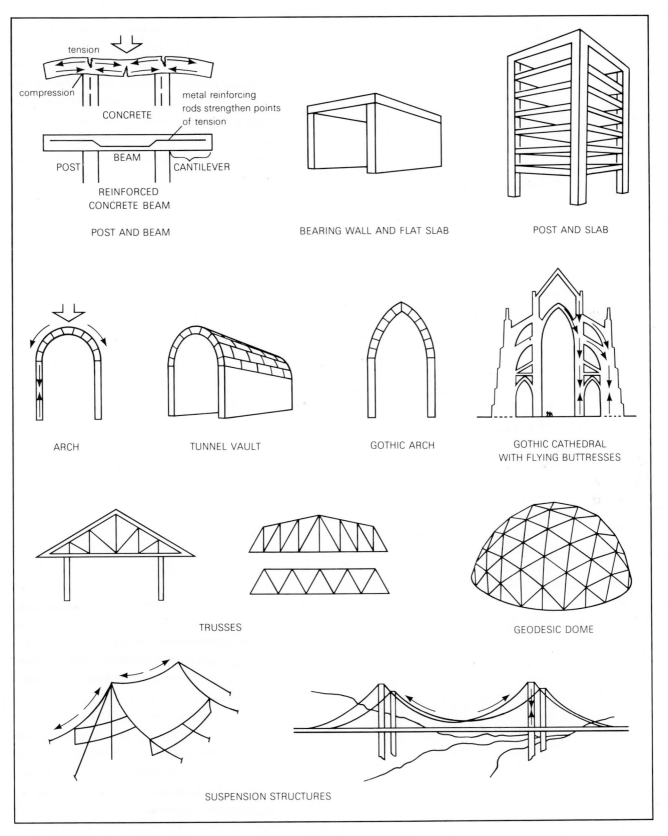

tension

compression

metal reinforcing rods strengthen points of tension

CONCRETE

POST BEAM CANTILEVER

REINFORCED CONCRETE BEAM

POST AND BEAM

BEARING WALL AND FLAT SLAB

POST AND SLAB

ARCH

TUNNEL VAULT

GOTHIC ARCH

GOTHIC CATHEDRAL WITH FLYING BUTTRESSES

TRUSSES

GEODESIC DOME

SUSPENSION STRUCTURES

231 BASIC STRUCTURAL SYSTEMS.

232 Architectural Drawings by Beverly Hoversland
a. plan

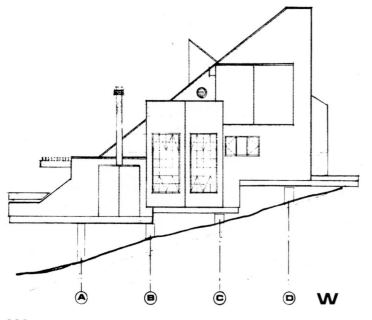

232 b. elevation

Materials and methods of construction are integral parts of the design of architectural structures. In earlier times it was necessary to design structural systems suitable for the materials, such as wood, stone, or brick that were available. Today technology has progressed to the point where it is possible to invent new building materials to suit the type of structure desired. Enormous changes in materials and techniques of construction within the last few generations have made it possible to enclose space with much greater ease and speed and with a minimum of material. Progress in this area can be measured by the difference in weight between buildings built now and those of comparable size built 100 years ago.

To achieve their purposes, architects manipulate solids and voids. As solid masses change in form, our feelings about them change. Straight edges tend to feel hard, curving edges soft. The brick and concrete architecture of the Romans was composed of many solid masses. In contrast, Gothic masonry has a lighter, more airy quality. Traditional Japanese houses are built of wood with sliding screens for both interior and exterior walls. These provide flexibility in the flow of space according to seasonal changes and the desires of the householder.

In order to develop and present their ideas, architects make drawings and models. Architectural drawings include (a) *plans*, in which the structure is laid out in terms of a linear pattern of spaces as seen from above; (b) *elevations*, in which individual exterior walls and major or complex interior walls are drawn to scale as if seen straight on, thus indicating to exact scale such elements as wall heights and window placement; (c) *sections*, in which a slice or cross section is drawn showing details along an imaginary vertical plane passing through the proposed structure; and (d) *perspective renderings* that give a pictorial rather than diagrammatic view of the finished building as it will appear on the site; these indicate

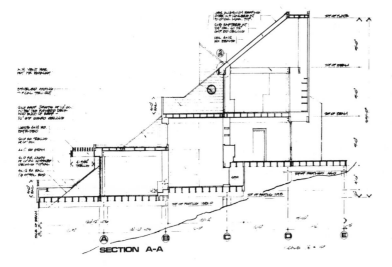

232 c. section

such features as land contours, landscaping, and adjacent streets and buildings if any.

Today's architecture has three essential components comparable to elements of the human body: a supporting *skeleton* or frame, an outer *skin* enclosing the interior spaces, and *equipment*, similar to the body's vital organs and systems. This equipment includes plumbing, electrical wiring, appliances for light, hot water, and air conditioning for heating, cooling, and circulating air as needed. Of course, in early architecture there was no such equipment and the skeleton and skin were one. We are again seeing the union of skeleton and skin in such contemporary architecture as *pneumatic* or air-inflated structures.

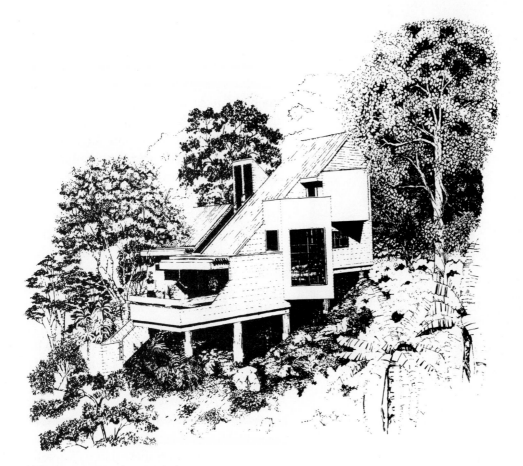

232 d. perspective rendering

233 INCA MASONRY AT MACHU PICCHU.

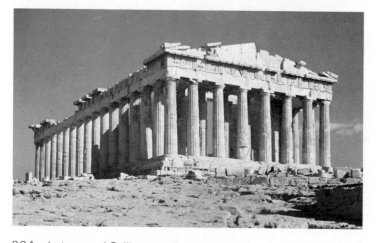

234 Ictinus and Callicrates. PARTHENON. View from the northwest. Athens, Greece, 447–432 B.C.

Much of the world's great architecture has been constructed of stone because of its actual and suggested permanence and its availability. In the past, whole cities grew from the painstaking and arduous tasks of cutting and stacking stone after stone. Some of the world's finest stone masonry can be seen in the ruins of the ancient Inca city of Machu Picchu, high in the eastern Andes of Peru at an elevation of 8000 feet. Inca masonry is characterized by mortarless joints and the "soft" cushioned faces of the granite blocks.

The openings of doors and windows are made possible through stone beams or lintels thick enough to provide the necessary strength to span the short distances while carrying the weight from above. Inca builders did not develop the arch, nor did the Greeks 2000 years earlier.

Greek temples were also made by placing carved stone upon carved stone without mortar. But Greek builders developed a much lighter structure by opening up walls with a *colonnade* or series of columns. Greek temple architecture is an elegant refinement of basic *post and beam* (or *lintel*) construction. Columns are spaced close together and interior spaces are narrow to accommodate the limited strength of stone. With any material, stresses in a beam increase as columns move farther apart. Compression at the top and tension at the bottom of the beam increase as the span lengthens. Stone is weakest when under tension, as in a beam.

A structural invention had to be made before the physical limitations of stone could be overcome and new architectural forms could be created. That invention was the *arch*, a curved structure originally made of separate stone or brick segments. Single-piece arches can now be made with such materials as reinforced concrete or welded steel.

The arch was used by early cultures of the Mediterranean area chiefly for underground

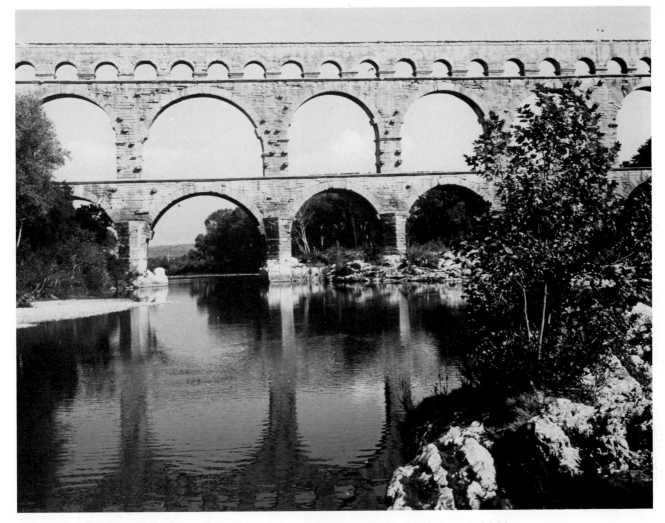

235 LE PONT DU GARD. Nimes, France. A.D. 15. Limestone. Height 161', length 902'.

drains and tomb chambers. It was the Romans who first developed and used the arch extensively in above-ground structures. Roman builders perfected the arch made of separate blocks of stone. As a method of spanning space, the arch structure makes it possible to carry the structural load fairly evenly throughout, and therefore it can be made of separate parts all under compression. The Roman arch is always a semicircle with wedge-shaped stones fitted together with joints at right angles to the curve. Temporary wooden supports carry the weight of the stones during construction. The final stone to be set in place is the *keystone* at the top of the arch. When that stone is placed, its weight holds the other stones below it. A series of arches supported by columns or piers is called an *arcade*.

The Romans built roads and waterways over much of southern Europe. The aqueduct called LE PONT DU GARD at Nimes, France, is a fine example of the functional beauty of Roman engineering. That it is still standing after almost 2000 years attests to its excellence of design and construction. Water was carried in a conduit at the top, with the first level serving as a bridge for foot traffic. The combined height of the three rows of arches is 161 feet.

193

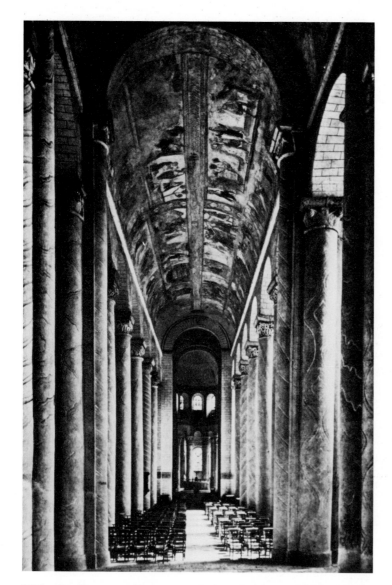

236 ST.-SAVIN-SUR-GARTEMPE, choir and nave. c. 1095–1115.

By extending the arch in depth, the Romans were able to build large vaulted interiors. Such a structure is called a *tunnel vault*. During the Middle Ages, the Roman art of vaulting died out with the loss of the technical knowledge for engineering such structures. In the eleventh and twelfth centuries, the architects of northern Europe, seeking to replace the timber roofs of churches with something less flammable and more dignified, returned to building tunnel vaults based on the Roman arch concept. Until then, arches had been used only in bridges and arcades along the side walls of church interiors and courtyards. The resulting style is known as *Romanesque*, signifying its Roman origin. Romanesque architecture is massive and solid, with emphasis on simple geometric form. Because the walls sup-

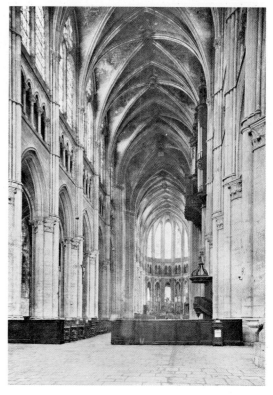

237 NOTRE DAME DE CHARTRES. Interior. Nave, approx. height 122′, width 53′, length 130′.

port the roof, windows had to be small and thus admit little light into the interior.

The first great structural breakthrough after the semi-circular arch was possibly the result of influence from outside Europe, most notably the Islamic architecture of Spain and the Middle East. It was a new arch based on the oval rather than the circle. At first this seemed a small change, but its effect on architectural structure was spectacular. The *pointed arch* is higher and therefore capable of enclosing more volume.

During this same period, architects realized that it was not necessary to fill the entire vaulted ceiling with the same thickness of heavy masonry. Thin "rib" arches crossing

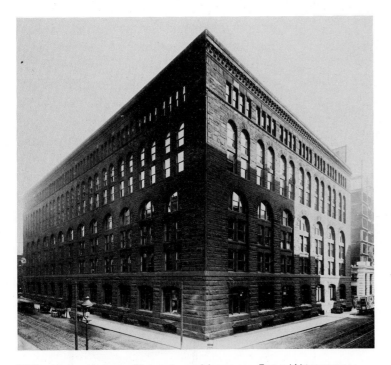

238 Henry Hobson Richardson. MARSHALL FIELD WHOLESALE STORE. Chicago. 1885–1887. (Demolished 1930.) Chicago Historical Society. Photograph: Barnes and Crosby.

diagonally between opposite arcades could carry the major weight of a vault downward to the columns. In the mid-twelfth century this *rib vault* concept combined with the pointed arch to produce the basic structure of *Gothic* architecture. (See Chartres Cathedral, page 256.) Space was contained in a new way. Walls, which no longer carried their own weight and the weight of the ceiling, were filled with nonload bearing *curtain walls* of stained glass. These buildings became open structures because their skeletons were worn largely on the outside, where half arches or *flying buttresses* carried the weight of the vault downward to the ground.

There was a return to the round arch during the Renaissance (see page 265), and this arch form prevailed until the nineteenth century when steel beams were first used for wide spans. Since then the arch has been relegated to a merely decorative function.

Henry Richardson's huge MARSHALL FIELD WHOLESALE STORE occupied an entire city block. The heavy, almost Romanesque, character of its masonry exterior was pierced by superimposed window arcades reminiscent of Roman aqueducts. These thick walls carried their own weight, as did their ancient predecessors. Yet within the building, an iron skeleton actually supported the seven floors. The logical simplicity and strength of this structure, with its opened vertical window "bays," linked the beauty of ancient stone structures of the past with the uniquely modern architecture of Louis Sullivan.

After the development of the arch in its various forms, the next major breakthrough in methods of large-scale construction came between 1890 and 1910 with the development of structural steel, and steel as the reinforcing material in reinforced concrete. Extensive use of cast-iron skeletons in the mid-19th century had prepared the way for *steel cage construction* in the 1890s.

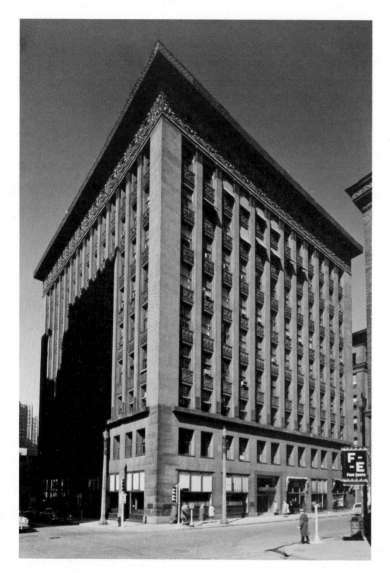

239 Louis Sullivan. WAINWRIGHT BUILDING. Saint Louis. 1890–1891.

nities in Chicago, where the big fire of 1870 had cleared the way for a new start.

Chicago architect Louis Sullivan is regarded as the first great modern architect because he rejected the nineteenth-century practice of borrowing various aspects of historic styles (called *eclecticism*, see page 286) and made an all-out effort to meet the needs of the present by using the new building methods and materials made available by technology.

Sullivan's first tall building, the WAINWRIGHT BUILDING in St. Louis, was made possible by the invention of the elevator and the development of steel used for the skeleton. The building breaks with nineteenth-century tradition in a bold way. Its exterior design reflects the internal steel frame and emphasizes the height of the structure by underplaying horizontal elements in the central window area. Sullivan demonstrated his sensitivity to the harmony of traditional architecture by dividing the building's facade into three distinct zones. These areas also reveal the function of the building, with shops at the base and offices in the central section. The heavily ornamented band at the top acts as a capital, stopping the vertical thrust of the piers between the office windows.

The interdependence of form and function is basic to nature and to all well-designed human forms. Sullivan's idea that "form fol-

New building techniques and materials, as well as new functional needs, demanded a fresh approach to structure and form. The architects who met this challenge during the last one hundred years were strong, articulate thinkers who developed a philosophy of architecture closely linked in their minds to social reform. The movement began to take shape in commercial architecture, became symbolized by the skyscraper, and found its first opportu-

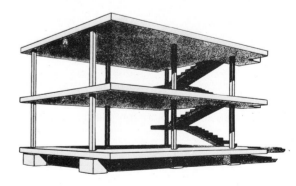

240 Le Corbusier. DOMINO CONSTRUCTIONAL SYSTEM. 1914–1915.

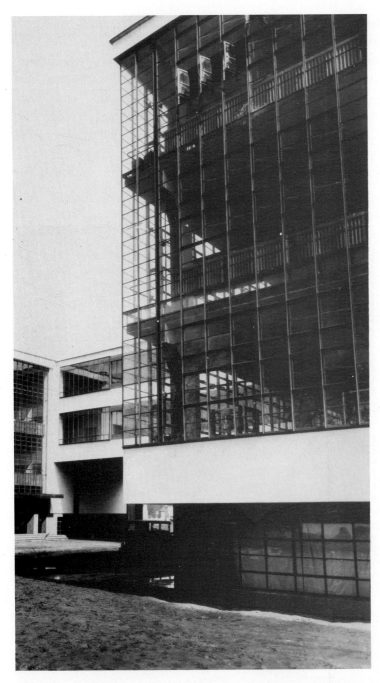

241 Walter Gropius. BAUHAUS. Dessau, Germany. 1925.

lows function" eventually helped architects break from reliance on past styles and rethink architectural design from the inside out.

In the spirit of Sullivan's ideas on the relationship of form and function, a new international architecture arose in Europe between 1910 and 1920 that rejected all decorative ornamentation, as well as traditional materials like stone and wood, and broke away from the traditional idea of a building as a mass. The principles of Cubist painting and especially the later "pure" geometric planes of Mondrian were highly influential. (See page 39.)

With the simple drawing shown on the opposite page, the young architect, painter, and city planner, Le Corbusier, demonstrated the basic components of steel column and reinforced concrete slab construction. It is a concept that was to be used extensively later in the century as architects adopted the look and sometimes the principles of the contemporary International Style. Le Corbusier's idea made it possible to vary the placement of interior walls and the nature of exterior coverings, since neither one plays a structural role. His sense of beauty was inspired by the efficiency of machines and a keen awareness of the importance of spaciousness and light.

Walter Gropius carried out the principles of this International Style in his new building for the BAUHAUS, a school of design in Dessau, Germany.

The workshop wing, built in 1925–1926, follows the basic concept illustrated in Le Corbusier's drawing. Reinforced concrete floors are supported by interior steel columns, allowing a non-load bearing curtain wall of glass made of the largest pieces of window glass available at that time. There is no feeling of separate mass enclosed by space. Space flows through the structure. The exterior and interior of the building are presented simultaneously in a design of opaque and transparent overlapping planes.

In America the skyscraper, evolving out of the work of turn-of-the-century pioneers like Louis Sullivan, became the most potent architectural form of the early to mid-20th century. The 1920s, 1930s and 1940s found New Yorkers suffering from poor air circulation and a reduction of sunlight as skyscrapers were built straight up from the sidewalk. By the 1930s the so-called *set-back* law required architects to terrace their structures back from the street to allow sunlight to enter what were becoming dark canyons. This law brought in sun, but most of the resulting buildings, constructed for maximum profit, merely complied with the law, and the result was a monotonous stair-stepped form still common in much of New York.

The idea of solving these problems by using

242 Gordon Bunshaft of Skidmore, Owings, and Merrill. LEVER HOUSE. New York City. 1950.

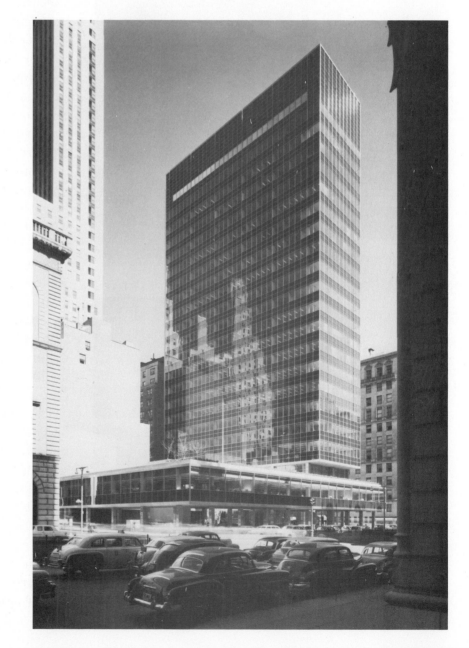

a tall, narrow slab fronted by open space came from Le Corbusier and was used for the Secretariat Building of the United Nations. It was designed by a team of architects and built in the period 1947 to 1950. The most widely acclaimed building using this concept is LEVER HOUSE built in 1951–1952, designed by Gordon Bunshaft of Skidmore, Owings, and Merrill. Both the major vertical slab and the horizontal area at the bottom are set on posts, providing flow-through pedestrian space at street level and access to an open central court. This concept of a building on legs was first proposed by Le Corbusier as a way of offering visual continuity at the ground level. (See VILLA SAVOYE, page 331.) The glass windows covering the tower are tinted to avoid glare. Floors are marked off by panels of dark green glass. The harmony of this building is all the more notable when it is compared to the many unsuccessful attempts to imitate it.

Buildings constructed using huge expanses of glass became highly fashionable during the building boom of the 1950s and 1960s and were not seriously questioned until the energy crisis of the 1970s. The thin glass skins result in the buildings requiring enormous heating, cooling, and ventilating systems that consume huge amounts of energy.

When a beam or slab is extended a substantial distance beyond a supporting column or wall, the overhanging portion is call a *cantilever*. Before the use of steel and reinforced concrete, cantilevers were not used in any significant way because available materials could not extend far enough to make it a viable concept. Early demonstrations of the possibilities of this structural idea include the extensive overhanging roof of Frank Lloyd Wright's ROBIE HOUSE on page 323 and the extended slab in Le Corbusier's drawing of 1914–1915 on page 196. One of the boldest and most elegant uses of this principle occurs in Wright's KAUFMANN HOUSE at Bear Run, Pennsylvania. Soaring horizontal masses cantilevered from supporting piers echo the huge rock outcroppings and almost seem to float above the waterfall. The arrogance of building on such a unique and beautiful location seems justified by the harmony Wright achieved between this bit of nature and his equally inspiring architecture.

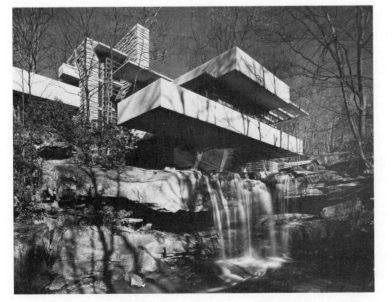

243 Frank Lloyd Wright.
KAUFMANN HOUSE.
Bear Run,
Pennsylvania.
1936.

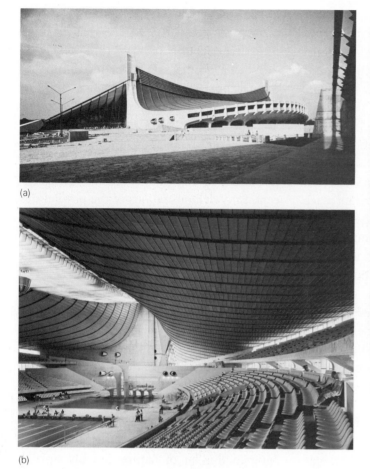

(a)

(b)

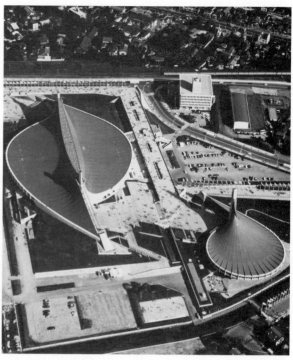

(c)

244 Kenzo Tange. OLYMPIC STADIUMS. Tokyo, 1964 (a) Exterior, Natatorium; (b) Interior, Natatorium; (c) Aerial view.

Reinforced concrete and steel have provided the raw materials for other new structural forms. The giant roofs of Kenzo Tange's indoor stadiums built in Tokyo for the 1964 Olympics are hung from steel cables, using a *suspension system* used previously for bridge construction. Tange's two OLYMPIC STADIUMS are beautifully interrelated structures. These buildings reveal a unique harmony between the spatial, structural, and functional requirements of the design. In the main building, which houses the swimming pools, Tange and structural engineer Yoshikatsu Tsuboi designed an open interior space with a seating capacity of 15,000. The immense roof is suspended from cables strung from huge concrete abutments at either end of the building.

In spite of the large size of this structure, there is a sense of *human scale* provided by the proportions of the smaller units of the building to each other and to the entire structure. This is noticeable in the diving platforms, seats, and air conditioning vent pipes on the end wall which become part of the highly sculptural design.

The aerial view shows how the sweeping curves of the buildings unite the two structures and energize the spaces between and around them. The proportions of the many curves, both inside and out, give the complex a sense of graceful motion and balance. Balance here involves bringing actual opposing physical forces into equilibrium.

Although our society is undergoing a period of rapid change, much contemporary architecture is inflexible and permanent. Expen-

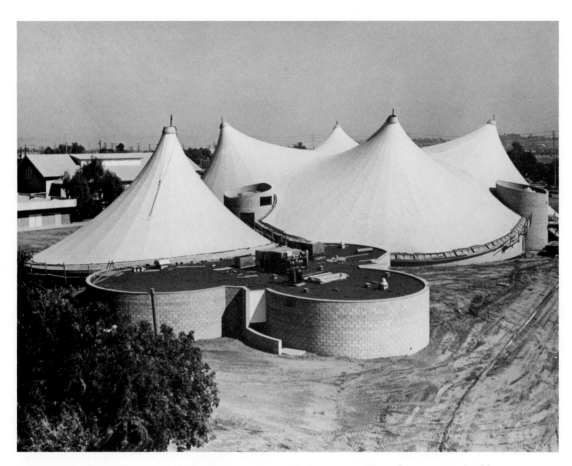

245 The Shaver Partnership and Bob Campbell & Company. TENT STRUCTURE. La Verne College, La Verne, California. 1973.

sive, monumental school buildings, for example, are still being built, many of them of poor design. This results in campus architecture that not only provides centuries of poor visual "education" but is often too rigid to meet the changing needs of education in general. Flexibility and impermanence might be more appropriate to today's changing patterns of use for residential, commercial, and institutional structures.

In the early 1970s, La Verne College badly needed buildings to house classrooms, studios, and a gym. The cost of conventional buildings proved prohibitive, so school officials decided to build two tentlike structures. The roofs are made of Teflon-coated fiberglass, hung from steel poles and cables.

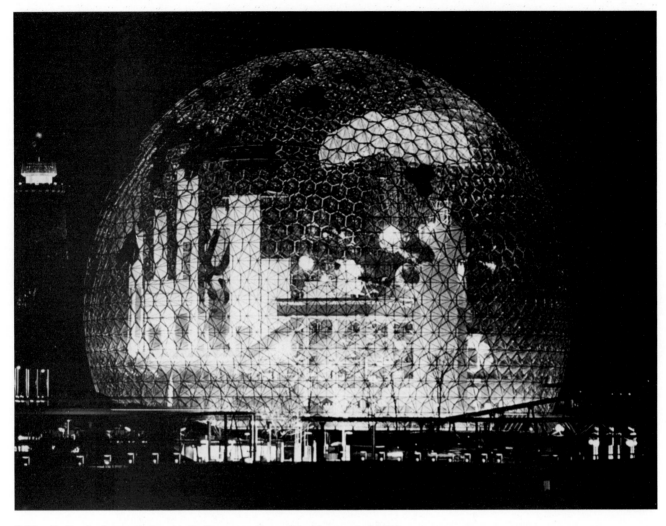

246 R. Buckminster Fuller, U. S. PAVILION, EXPO-67. Montreal. 1967.

Inventor, architect, and structural engineer R. Buckminster Fuller is working for a rapidly emerging new era when humanity will consciously cooperate to preserve and enhance life on Earth. He points out that if we carefully guide our technology, it can provide maximum benefit with minimum cost. Fuller put this concept to work when he developed the principles of the *geodesic dome*, inspired by polyhedrons found in nature. One of Fuller's domes can be erected from lightweight, inexpensive materials in a very short time. Usually a skeleton is constructed of small, modular linear elements joined together to form single planes; these, in turn, join together to form the surface of the dome, as in U.S. PAVILION, EXPO–67. The resulting structure can be covered with a variety of materials to make the enclosed space weatherproof.

Buckminster Fuller is one of the most forward-thinking men of our time. Significantly, the physical projections of his thoughts reach far ahead into the future, yet are in harmony with the structures in nature and in the human past. Fuller believes that all aspects of life can come together in a mutually beneficial pattern if the principles of structural design are applied to society as a whole.

Most human structures have been built without the aid of architects. Structures such as this communal house in Brazil are usually produced without the interference of style or the eccentricities of personal mannerisms. In their purity, such forms are seen by some contemporary architects as inspiration for a style of architecture that is honest, functional, beautiful, and environmentally sound as well.

The Kalapalo Indians build their own domelike structures. The house shown here under construction is in Aifa, a village in central Brazil. The house will hold several families, each with its own hammock space and cooking fire. It has taken months to curve these saplings in an arc fastened to giant posts.

247 KALAPALO INDIANS HOUSE. Aifa, central Brazil, 1967.

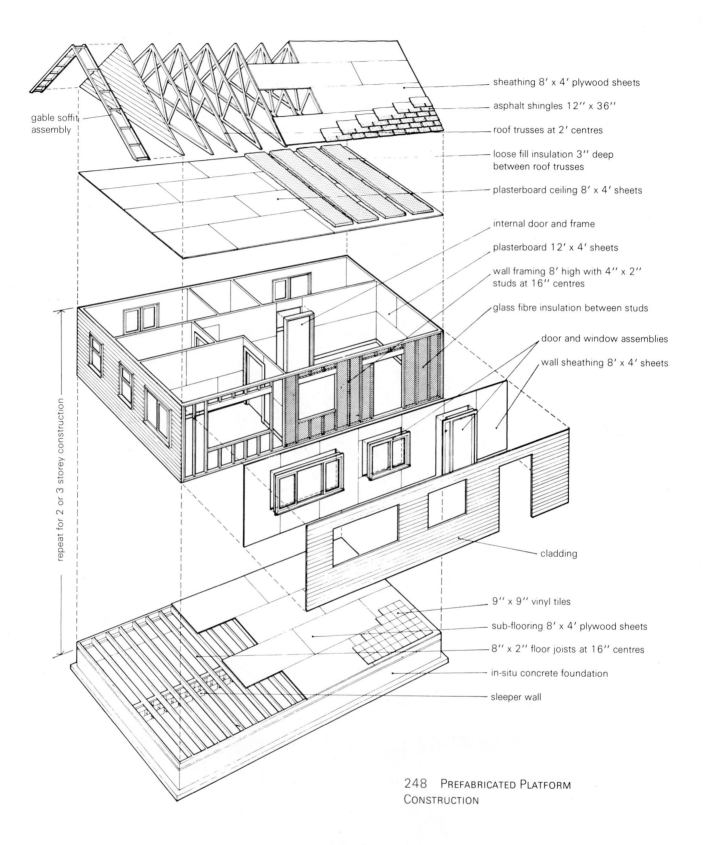

gable soffit
assembly

repeat for 2 or 3 storey construction

sheathing 8' x 4' plywood sheets

asphalt shingles 12'' x 36''

roof trusses at 2' centres

loose fill insulation 3'' deep
between roof trusses

plasterboard ceiling 8' x 4' sheets

internal door and frame

plasterboard 12' x 4' sheets

wall framing 8' high with 4'' x 2''
studs at 16'' centres

glass fibre insulation between studs

door and window assemblies

wall sheathing 8' x 4' sheets

cladding

9'' x 9'' vinyl tiles

sub-flooring 8' x 4' plywood sheets

8'' x 2'' floor joists at 16'' centres

in-situ concrete foundation

sleeper wall

248 PREFABRICATED PLATFORM
CONSTRUCTION

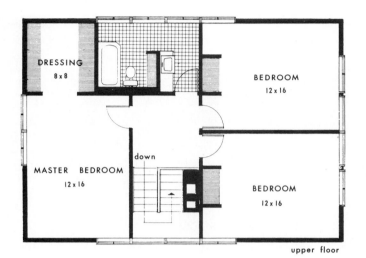

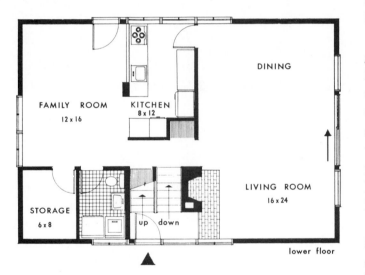

249 Techbuilt Corporation.
PREFABRICATED THREE-BEDROOM
HOUSE. 24 x 36', 1728 sq. ft.

Shelters for individual families are also a concern of architects, although for centuries most homes have been built by the family.

In the mid nineteenth century, when stream power was harnessed to run mills, pre-cut standardized lumber caused a revolution in home building. In the United States, the framed house became in many ways a modular home. We now buy lumber, plywood, wallboard, and window frames in standard sizes. Elements like cabinets, which were once handcrafted on the site, are now often factory produced. Even an architect-designed, custom-built house may contain many standardized components such as ready-made bathrooms.

In this century, a great deal of effort has gone into the development of prefabricated housing. This is a major aspect in the transition of architecture from handcraft to industrial production. Although prefabrication still offers the best hope for combining quality with low cost, poor design has been common in most prefabricated houses. There remains, however, an urgent international need for high-quality, low-cost housing.

Form and function are handsomely joined in the adjustable prefabricated houses produced by Techbuilt Corporation of Cambridge, Massachusetts. Many floor plans are possible because flexibility is built into each model. In the model shown here, the two upper floor bedrooms over the living room can be omitted or added later, and can be removed at any time to accommodate a family that changes in size.

250 Frank Lloyd Wright. TALIESIN EAST. Spring Green, Wisconsin, 1911.

Away from the complexities of urban civilization, human groups have designed simple housing structures to meet their needs for shelter and comfort. These dwellings were and are constructed from available local materials in forms that meet the demands of specific climatic conditions. They grow out of, and therefore blend superbly with, their site. By necessity, the creators of this indigenous architecture followed a principle of building in harmony with nature that Frank Lloyd Wright called *organic architecture.*

TALIESON EAST, Wright's home and studio in Wisconsin, is built of local stone. It honors the hill on which it is placed by its location low on the slope instead of on top in a dominating position.

The growing consciousness of our gross energy consumption set off by the so-called energy crisis of 1974 is forcing us to do what we should have been doing long ago—working *with* nature rather than striving to conquer it. After building up around us a mass of costly technology designed to shield us from climatic changes, we are now beginning to realize that our architecture can be designed both to offer comfortable temperatures year round and to take advantage of free energy sources for all our needs without rapidly consuming Earth's non-renewable resources.

Some architects and engineers are seeking ways to design buildings that conserve energy and utilize infinite resources such as sun and wind. One interesting result of their efforts is new forms of regional architecture, designed for specific climates.

The need to find ways of conserving energy has led to a rediscovery of the logic of earlier regional forms. The traditional adobe brick of the Southwest is a key element in the success of both ancient Pueblo and contemporary solar structures.

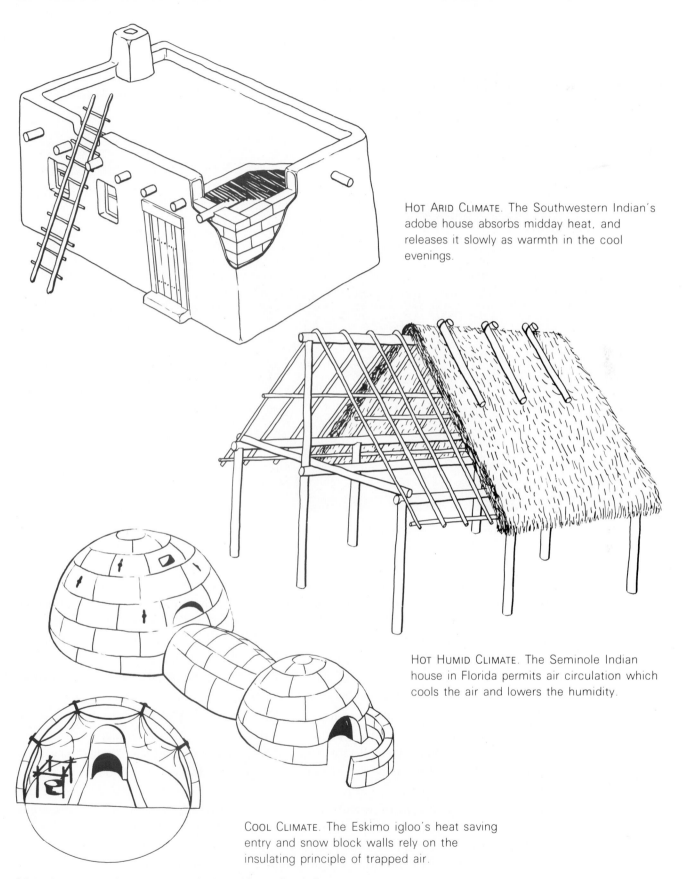

HOT ARID CLIMATE. The Southwestern Indian's adobe house absorbs midday heat, and releases it slowly as warmth in the cool evenings.

HOT HUMID CLIMATE. The Seminole Indian house in Florida permits air circulation which cools the air and lowers the humidity.

COOL CLIMATE. The Eskimo igloo's heat saving entry and snow block walls rely on the insulating principle of trapped air.

251 INDIGENOUS ARCHITECTURE, designed for various climates.

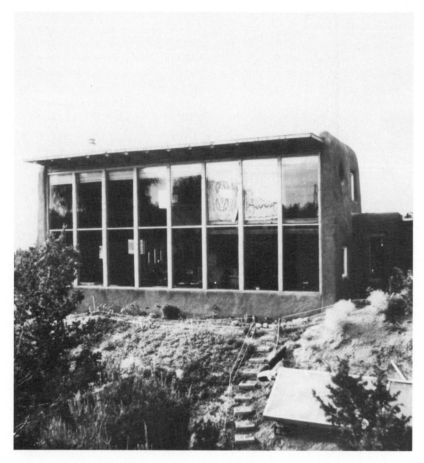

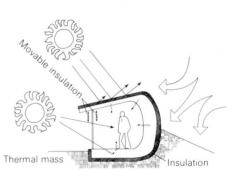

Movable insulation

Thermal mass

Insulation

252 David Wright. WRIGHT RESIDENCE. Santa Fe, New Mexico. 1974.

Architect David Wright designed his residence in Santa Fe for the extreme temperature changes in the arid climate of New Mexico. The desert can be blistering during the day and near freezing at night. The building is a two-story, one-bedroom house with an office, built according to a very simple and open design. It is a "solar house" because the movement of the sun dictated the whole structure. The entire house is the solar collector and heat storage system. Solar energy in the form of heat is collected through the entire south facade of double glass, permitting direct radiation from the two-foot-thick adobe floor in winter. This floor is the primary storage area. Heat comes from the floor and from the sun-heated adobe bricks of the walls. Insulation of

two-inch-thick polyurethane covers the entire outside of the adobe walls and is also used under the floor. The building enclosure is capable of storing enough heat to keep the home comfortable for three or four sunless days. Cooling is provided by good cross ventilation. To reduce heat loss and heat gain through the large double glass windows, an ingenious system of vertical folding insulating shutters of canvas and insulation was installed. These easily adjusted shutters are the only moving elements in the structure. The success of this house is largely due to the complete simplicity of its design.

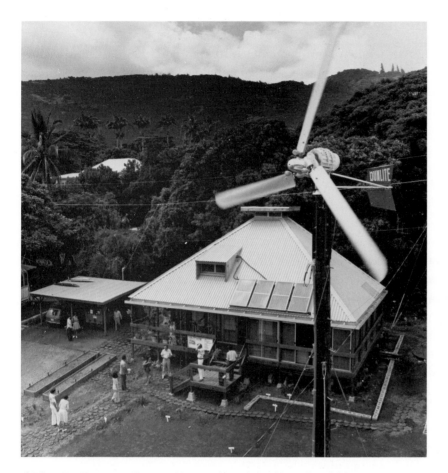

253 Jim Pearson. ENERGY HOUSE. Honolulu, Hawaii. 1976.

Jim Pearson designed and lives in the HA-WAII ENERGY HOUSE. It is a research and demonstration project especially designed for a warm humid climate where heating is not required. A solar hot water heater is, predictably, a major cost saver. Most such systems will pay for themselves in terms of fuel costs saved in a relatively short period of time. A wind generator provides enough power to run all the electric lights in the house, but the cost of the equipment including expensive storage batteries far exceeds the fuel costs saved, even over a period of many years. Significant saving in electric consumption has been achieved through the selection of energy-efficient appliances. Although the house has a full complement of major appliances, including a dishwasher and clothes dryer, the monthly electric bill for the family of four is less than half the average electric bill for a family of this size.

The house is positioned so that the large front slope of the roof faces the noon sun directly. The peaked roof, with its chimneylike cap allows interior warm air to rise and flow out through the vents. A six-foot roof overhang and sliding wall panels provide an open air interior while skylights give ample interior light. Louvers and movable walls permit the control of tradewinds and can be completely closed against inclement weather. The open wall concept for cooling relates this contemporary Hawaiian house to the traditional Seminole dwelling designed to work well with Florida's equally warm and humid climate.

ENVIRONMENTAL DESIGN

As we move outside of buildings, it is apparent that we have generated a man-made environment that frequently demonstrates lack of harmony with itself, with the natural setting, and with Earth's broad ecological systems of which we are a part.

Our environment begins with our attitudes about life, ourselves, and others. This subjective world is the origin of the physical environment consisting of all the objects and places built or shaped by man. As such, it is a composite design—an environmental design that includes indoor and outdoor spaces and the organization of objects within those spaces. We build the larger components of this environment to provide shelter from the elements; privacy; places and facilities for our activities; the manufacture of goods; and the transportation of people, things, and utilities.

The life of the human body depends on fuel, energy, and waste systems. The man-made environment extends these biological systems on an immediate scale in buildings and on a larger scale in communities, cities, states, and countries.

The form of the environment is determined by our size, needs, desires, activities, technologies, cultural values, and life styles, as well as the land on which we build, the climate, the materials with which we build, and our methods of construction.

We continually make changes in our environment by moving from place to place and by adding to or demolishing parts of it. Planned environmental changes must be based on geographical, biological, and sociological information. Most importantly, these changes must relate to real human needs as expressed by those involved.

The new discipline of urban/regional design is a broad category of interdependent disciplines that includes architecture, landscape architecture, transportation design as well as social and physical planning. It deals with the design of subdivisions, new towns, and master plans for cities. Regional and urban design plans must complement each other. Some thinkers like Buckminster Fuller are asking us to think of design in a global sense. This does not mean that we should redesign the world. It means that we must think of our designs as part of a total world harmony that begins with the natural order.

Here, the emphasis is on *urban design.* Urban designer Rolf Preuss has defined this very complex field:

Urban Design can be viewed as an effort to organize all the fundamental elements of the natural and man-made environment into an ordered framework in which the social, economic, cultural and aesthetic functions are arranged to best reflect the needs and values of society.[8]

Without the inclusion of aesthetic concerns, planning is incomplete. The growing complexity of urban fabric must be seen as a whole. The urban design professions try to utilize man's highest sensibilities and applied knowledge to create and interrelate man-made and natural environments and systems in a way that provides a beneficial setting for human life. They may work with others on all phases of the planning, or design, process, from initial policy formulations through development of proposals, to the implementation of final plans. Often the success or failure of the efforts of professional urban designers depends on politics, but public awareness can help change this by providing a broader base of understanding and support.

In the past, because population growth was minimal, urban centers grew slowly to meet

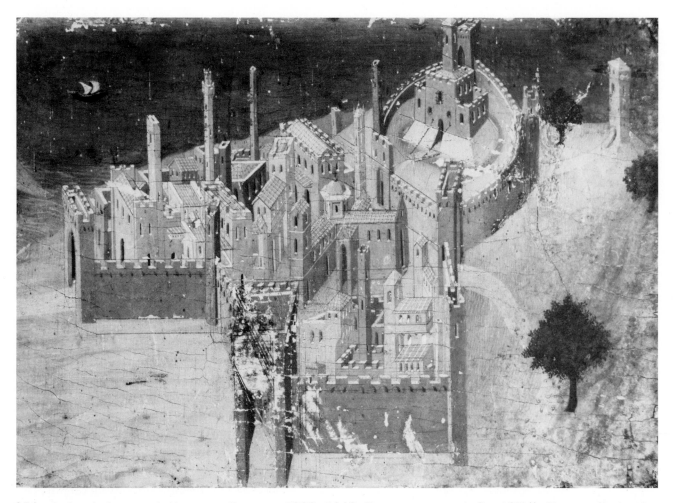

254 Ambrogio Lorenzetti. VIEW OF A TOWN. c. 1338–1340. Tempera on wood. 9 x 13⅛''. Pinoteca Nazionale, Siena, Italy.

needs for protection, trade, and communication. Unchanging life styles and firm traditions created human-scaled environments like the one depicted in the painting, VIEW OF A TOWN, by Ambrogio Lorenzetti.

Now, our urban areas are rapidly changing and growing. Constructed suburban developments are annexed to the city seemingly overnight, creating a ring of residential commuter towns for miles around urban areas. Jammed together in a flattened, treeless landscape, great stretches of identical, stereotyped houses and apartments amalgamate into this pattern of land use known as *urban sprawl.* It is awk-

ward, ugly, distressing, and unnecessary. Better methods of urban development are available, but they are rarely used because population pressures keep land speculators and developers well-supplied with clients who are either too ignorant or too much in need of housing to demand more. Land speculators, acting as land wholesalers, often force land prices to soar far beyond fair value.

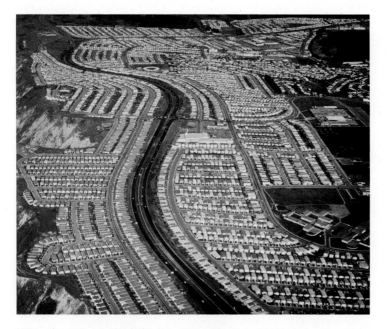

255 DALY CITY. c. 1960. Photograph: Donald W. Aitken.

Daly City, just south of San Francisco along the California coast, is an example of the thousands of places where open space is rapidly being devoured. If any life-enhancing order is to come from this frantic growth, planning must be done and put into effect.

Contemporary needs for protection are very different from those of medieval times. Patterns of commerce and methods of communication have changed radically. New transportation systems must be accommodated in ways that are harmonious with the general urban fabric.

Some environmentalists have suggested that we do not need concentrated urban forms, since they no longer offer protection, are not as necessary for commerce, and are hardly needed at all for communication. Other environmental designers point out that dense urban complexes are necessary to save agricultural, recreational, and wilderness land. Some suggest that the design of urban areas take an even denser form than present zoning laws permit.

The old dream of a single family home outside the city is rapidly becoming impossible for many people. Land and building costs have risen to the point where the average income cannot match the purchase price. The growth pattern resulting from placing one house on one lot consumes enormous amounts of land, our primary finite resource. If the single family house in suburbia is affordable, its location offers housing, but not jobs. Most recent developments are not integrated, planned communities that meet all the major needs of their residents in one location. They are bedroom communities, simply providing a place to sleep and causing huge transportation, air pollution, and energy consumption problems because residents are forced to commute daily to jobs in the city. Commuters spend a substantial portion of their waking hours riding in traffic.

Consumption of open land can be minimized in a variety of ways. All these ways are based on the idea of concentrating people in specific communities capable of meeting all their basic daily needs, including stores, services and job opportunities. With careful planning and design, such forms as townhouses, cluster houses, and the megastructure idea of a whole community in one building can offer not only high density living, but many desirable features that the single family home cannot. Shared open green space and extensive recreational facilities are included in the best community developments.

Architect Moshe Safdie is designing new forms of stacked modular living units as a possible alternative to the present trend toward urban sprawl and high-rise apartments crowded together. He is motivated by the idea that relatively low-cost housing can be designed in ways that minimize land consumption while also providing privacy and a sense of individual living units. This concept is related to traditional community structures in the Southwest

256　Moshe Safdie and David Barott, Boulva Associated Architects. Habitat, Expo-67. Montreal. 1967.

257　North Pueblo. Taos, New Mexico.

that are energy-efficient, climate-related, high density communities surrounded by open space.

Safdie's Habitat-67, built for the World Exposition in Montreal in 1967, was his first demonstration of these concepts. Costs were minimized by prefabricating apartment units in a factory and stacking them on the site. Although the components are standardized, they can be placed in a variety of configurations, thus keeping the total structure from becoming monotonous. The roof of one unit becomes the garden for another. Walkways and covered parking areas are included. The design allows for a dense concentration of people, yet provides many of the advantages of single, unattached dwellings. Much of Safdie's philosophy is summarized in his phrase "For everyone a garden."

213

258 Paolo Soleri. DRAWING OF BABELDIGA. 1965.

259 McMillan, Griffis, and Mileto. A LINEAR CITY FOR LONG
ISLAND, NEW YORK. 1967.

The visionary drawings of Paolo Soleri portray cities as single, self-contained structures. While we might not want to live in a structure such as this, Soleri's ideas help us stretch our perceptions of alternatives to uncontrolled horizontal and vertical growth. Soleri uses the term *arcology* to describe his concept, which combines the ideals of architecture and ecology. His designs for vast self-sufficient communities are a response to the problems of overpopulation and urban decay and they express a utopian architectural vision.

A linear city operating on three levels was proposed for Long Island, New York. In this design, an automobile expressway runs over a subway and is itself covered by a pedestrian mall. Bridges connecting terraced residential units rise above the pedestrian walkway. The idea of building for privacy inside dwellings, and for neighborliness within visual and shouting distance outside is a Mediterranean tradition that goes back at least to Roman times. Immigrants brought this tradition to Brooklyn, Queens, and other first-generation sections of New York. The concept is revived

260 Elliott Erwitt. FREEWAY. 1968. Photograph.

here in a way that could provide new vitality and green openness to old streets crowded with tenements. It would be possible to save both land and time by combining housing units with pollution-free transportation systems. Perhaps one of the reasons this project was not built is that people do not want to live above the present air polluting expressway.

Two mechanical inventions that have had enormous influence on the design of our environment are the elevator and the automobile. The car has made horizontal growth possible. The affluent have been able to escape into the suburbs, leaving in their path unplanned urban sprawl like that in Daly City.

Huge areas of land have also been appropriated for freeways and interchanges. While solving some problems related to the movement of vehicular traffic, freeways become barriers between parts of cities, creating new kinds of ghettos where neighborhoods used to flow naturally into each other.

Henry Ford had little idea of the world his product would help create when he wrote:

I will build a motor car for the great multitude. . . . But it will be so low in price that no man making a good salary will be unable to own one—and enjoy with his family the blessings of hours of pleasure in God's great open spaces.[9]

The automobile industry has grown in a great spiral, passing the point where the birthrate for cars became double that for humans. Urban areas are frequently designed not by urban designers, but by the needs of the automobile. Cars beget highways and highways discourage other means of transportation in a vicious cycle.

We are now seriously questioning our commitment to the automobile and its accompanying freeways and highways as the major means of ground transportation. The city of San Francisco voted to stop all freeway building, turning down millions of dollars in federal and state aid. It is even considering tearing one freeway down.

The search for efficient mass transit almost ended in the mid-twentieth century due to the popularity of the private automobile and the lobbying of the oil and highway construction industries. Now, with our immense energy, air, and traffic problems, the shift is away from highways and back to mass transit. We have much to learn from past and present suc-

261 SUBWAY STATION. New York City.

262 SUBWAY STATION. Montreal.

263 Le Corbusier. DRAWING FOR A CITY OF THREE MILLION. 1922.

264 HYGIENIC APARTMENTS IN THE MAN-MADE DESERT.

cesses and failures. Compare the quality of space in the old New York subway station with the station of the new Montreal system. Each station in Montreal is architect designed to give a unique visual character to that stop.

In 1922 Le Corbusier envisioned that constructing high-rise apartment towers on urban land would open space for continuous park areas. In his plan for a CITY OF THREE MILLION, housing was split between widely spaced tall towers at subway stops, and low-level garden apartments. Industry was banished to the outskirts, and business was to be concentrated in towers at the center. At that time, Le Corbusier saw machine efficiency as the best solution to housing problems. Unfortunately, his ideas led to vast sterile housing projects that have become areas of crime and decay. Individuals and families in these areas are caught in barren wastelands cut off from those elements that give identity and safety to traditional dwellings and neighborhoods. Le Corbusier's vision of contemporary humanity as independent of individual hearths and gardens was at the root of what turned out to be a misconception.

265 a. WAIKIKI, 1961.

265 b. WAIKIKI, 1971.

Carefully planned community development based on sound principles of urban design becomes impossible when independent business and political interests conspire to feed explosive urban growth. Uncontrolled growth in a community can be like its counterpart in the human body—a cancer, destroying life in its path. Rapid unplanned urban development is illustrated by two photographs of Waikiki taken from the same location twenty-one stories off the ground in 1961 and in 1971.

Changing the overall design of existing cities is economically impossible and in many cases undesirable. Relatively small changes within cities are going on all the time with some sensitive blending of old and new. Too often there is no blend, and occasionally incredible confrontations occur between the old and the new. The size of many new buildings tends to dwarf older, smaller structures.

The JOHN HANCOCK BUILDING has been widely publicized because of its past problems with falling glass window panels. Aside from that issue, many people find it offensive because of its dominating size and incompatible style. Others enjoy its monumental scale and the dramatic contrast of its sheer crystalline form with Henry Richardson's nineteenth-century TRINITY CHURCH. The upper part of the Hancock building reflects the sky and seems to dissolve into it, while the lower portion reflects the church.

266 I. M. Pei and Associates. JOHN HANCOCK BUILDING. Boston. 1974.

219

267 Krahô Indians Village. Pedra Branco, central Brazil, 1965.

A city is more than an architectural composition. It is a system within which variety should be able to exist harmoniously.

The *radial plan* has been used as a basis for numerous communities, including early village forms and large cities. Compare the radial patterns of human communities with a magnified cross section of a twig. Both show patterns of movement and growth within which variety can exist.

City Planner Victor Gruen has diagramed a possible future city that would function as a cellular structure, radiating around a central core. Broken lines indicate mass transit leading out from urban centers represented by clusters of black dots. Speckled areas represent park areas.

268 CLEMATIS VIRGINIANA.
Transverse section of
a young stem
showing combination
of hexagonal, radial,
and concentric
symmetries.

269 Victor Gruen and
Associates.
METROCORE AND ITS
TEN CITIES . 1966.

SCALE ⊢————⊣ MILES
0 2 4 6

LEGEND
A Airport
—— Railroad
▮ Industrial Area
------ Rapid Transit

● Urban Centers
CR Connections with National
 Railroad-Network
CH Connections with National
 Highway-Network

▮ Regional Parks ⎫
 City Recreation ⎬ Open Space
 Local Recreation ⎭

221

270

Environmental designer Constantinos Doxiadis is also concerned with the need for housing the world's growing population. In discussing the accompanying photograph, he points out that "the greatest part of humanity lives in conditions similar to these. This is the main architectural problem."[10] It is estimated that 90,000 people live on the sidewalks of Bombay alone. Well over a third of the people in the world's cities are squatters or slum tenants.

There are many ways in which human communities can expand, change, and diminish without causing the kind of destructive chaos that we so often experience today. The rapid, unplanned growth of human centers needs to be replaced with controlled growth designed to meet actual human needs.

Urban design is controlled by zoning laws that determine land use and population density, by open space requirements, and by such restrictions as height limits on buildings and set-back laws establishing the distance a building must be from property lines.

Some of the features urban designers work for include:

- a pattern of development that enhances the preexisting natural features of the site, including land formation, waterways, lakes, and shorelines, if any

- visual contact with memorable natural and man-made features so that residents and visitors can comfortably find their way around, guided by a visual image of the city; this means preserving or creating *view planes* and *view corridors*

- a combination of commercial, residential, industrial, and recreation areas, interrelated as urban functions in healthy, constructive, and exciting ways

- historic preservation—restoring and maintaining the best of the old with planned new elements designed to harmonize with them; preservation of special buildings or natural areas can be achieved by establishing special design districts that protect historic, cultural, and scenic assets

- a defined sense of place, giving the people of the city a feeling of the unique character and rhythm of their particular community

- a harmonious blending and flow in everything from such small elements as signs and street furniture to such huge constructions as freeways and street patterns

- easy accessibility to the best the city has to offer

- plenty of green open spaces interspersed throughout the city, interconnected whenever possible; miniparks make excellent available recreational spaces on small lots; linear parks can include foot and bicycle paths and can follow streams and other enjoyable landscape features

- a definite city limit or boundary so that urban growth does not spread haphazardly into other urban areas in endless sprawl; a boundary or planned stopping point for horizontal urban growth can be set by recrea-

tional parks, farmland, or wilderness areas joined together to form a *green belt,* offering city dwellers access to the country

■ small-scale, attractive neighborhoods blending openly with the larger urban design

■ attractive, lively, well-functioning business districts.

The complexities of contemporary urban life make sophisticated environmental planning an extremely demanding task. An inspiration for that task is provided by an examination of the smallest structures in nature which are quite similar to the largest. In both the microcosm and the macrocosm, nature exhibits three-dimensional structures to which we can turn for clues to the future of environmental design.

During the last decade or so, there has been a growing interest in the methodology of environmental design. This has led to several techniques of programming in which an attempt is made to list and respond to as many functional influences on the form as possible. Environmental planner Ian McHarg has suggested computerizing information on everything from bird sanctuaries to mass transit systems before making plans to change existing urban and regional areas.

Environmental design specialists need the support of a public educated in environmental awareness and ready to become involved in *participatory planning.* Without the benefit of the ideas and feelings of those who inhabit our shared environments, plans become constricting and detrimental to life.

As the chief architect and principal urban designer in the Manhattan office of the New York City Planning Commission, Raquel Ramali accomplishes her goals through teamwork with the various professions that make urban design possible. She loves her work because she can see the results of her efforts. By isolating three major elements Ramali decides if a job has been done to her satisfaction. These criteria are: (1) transforming an idea into a reality while satisfying the various interest groups involved in the process; (2) establishing a dialogue between the professional and the layman; and (3) preserving already existing forms that contribute to the character on an area. She feels her biggest challenge is taking care of the aesthetic and poetic elements that each person needs to survive.

4 WHAT IS THE ART OF THE PAST?

To me there is no past or future in art. If a work of art cannot live always in the present it must not be considered at all. The art of the Greeks, of the Egyptians, of the great painters who lived in other times, is not an art of the past; perhaps it is more alive today than it ever was. Art does not evolve by itself, the ideas of people change and with them their mode of expression.

Pablo Picasso[1]

It is principally through their art that we can know the people of the past—our ancestors. Art history is our history. It is the record of how human beings have lived, felt, and acted in widely separated parts of the world and differing periods of time. Through their works, artists both reflect and affect the age in which they live. Art history differs from other kinds of history because works of art from the past are still with us in the present. If we can openly experience these works, we can put ourselves in touch with those individuals who made them. Basic communication may still occur even when sender and receiver are separated by more than 20,000 years. The artist is the sender, the work is the message, and those who perceived it then and who experience it now are the receivers. This one-to-one communication is what makes our experience of the art of the past so rewarding.

The art of any given period is modern in its time. This is true of the animals painted on rock cliffs in the Sahara in 4000 B.C., and it's true of the cathedrals of medieval

France. We call these cathedrals "Gothic," but those who built them called them *opus modernum* or "modern work."

If numbers of years get in your way when studying art history, consider time in terms of generations. Since the beginning of human life on Earth, the average time interval between the birth of parents and the birth of their offspring has increased from about 18 to 33 years. If we figure that roughly 25 years is the average generation, we can come closer to the people of the past by realizing that most of us have three generations within our own families, and many of us have four. The United States became a country only eight generations ago; the Italian Renaissance occurred just 22 generations ago; Jesus Christ lived 79 generations ago; and Gautama (Siddhartha) Buddha lived only 100 generations ago.

Our awareness of the art of the world grows and changes as contact with other cultures is extended and ancient works are unearthed. Before this century it was not possible to know much about the art of other cultures. Modern techniques of photoreproduction and printing have helped to make this art available to us. Through reproductions we are now able to see more outstanding works of ancient Egyptian and Chinese art, for example, than the people of these cultures were able to see themselves. Of course, we view these works out of context, removed from the life which brought them into being and which gave them their original meaning and purpose. Yet through them, it is still possible for us to share some of the life experiences of those who lived years and centuries ago. All works of art can intensify life, no matter how much they differ in form and intended function.

We are unique among the animals on Earth. More than a million years ago we learned to coordinate our eyes, hands, and brains in the making of rudimentary stonecutting tools. In so doing, we developed our ability to reason and visualize: to remember the past, relate it to the present, and imagine possible futures. As we evolved from primal creature to creative creature, it was this ability to form mental images and the development of hands capable of making those images that set us apart from other animals. Imagination is our special advantage. Coupled with the work of hand and eye, it has made us flexible enough to live on every continent, allowing us to adapt to a wide range of climatic conditions because we can shape our immediate environment. Thus we became conscious participants in nature's design. Art history is a physical record of this ongoing process. All living things leave traces of what they were; but it is humans especially who leave traces of what they created.

A sampling of the creativity of many cultures, as offered in this chapter, helps us see how earlier people expressed themselves. We all tend to be locked into our own beliefs, our own history. The tendency to consider our people, language, and history as THE people, THE language, and THE history is as common now as it ever was, even though our awareness of other cultures is increasing tremendously through the use of communications media. Viewing the art of the past helps us to see beyond these limiting cultural confinements.

There is no one line of development in art history. Within any culture there are progressions toward the perfection of an idea, but these progressions are followed by changes in attitude and circumstance that lead to new forms.

Throughout human history we can observe nonrepresentational art as well as two basic approaches to the depiction of observable objects—representational and abstract. In both sculpture and painting these contrasting concepts have occurred with varying degrees of dominance in cultures of different times all over the world.

225

What we call "art" evidently helped early humans to cope with the power of animals, the energy of natural elements, and the fragility of human life—with the unknown as well as the known. In this sense art is a kind of magic—a form-creating ritual intimately related to what we now call religion.

Painting isn't an aesthetic operation; it's a form of magic designed as a mediator between the strange, hostile world and us, a way of seizing the power by giving form to our terrors as well as our desires. When I came to that realization, I knew I had found my way.

Pablo Picasso[2]

Art still functions in this way for many of Earth's peoples. It serves to fill the gap between what is known and what is felt. Art has physical form, yet it contains spirit. "Man, with his symbol making propensity, unconsciously transforms objects or forms into symbols (thereby endowing them with great psychological importance) and expresses them in both his religion and his visual art" (Carl Jung).[3]

Through the ritual significance of the mask and its accompanying gestures, the man of the Zaire region of West Africa shares a psychic identity with an animal, receiving some of its power in the process. In highly technological cultures we have cut ourselves off from such associations, depriving ourselves of a basic link with the natural world. These psychic associations still persist, however, in our unconscious.

271 HELMET MASK
(Giphogo). Zaire,
West Africa. c. 1950.
Wood. Height 11''.

In the art of some societies, birds appear with human figures to act as guides or messengers between the physical world of the living and the spiritual world of deceased ancestors. In this canoe prow from the Solomon Islands, the bird seems to guide the voyagers, acting as a protective spirit, watching out for shoals and reefs. (See color plate 21.)

The carving is only 6½ inches high, but it looks much larger because of the boldness of its form. The exaggerated nose and jaw help to give the head its forward thrust. The wood is blackened and inlaid with mother-of-pearl, which provides white shapes for the eyes and forms the rhythmically curving linear ZZZ bands that help unify the design.

The sculpture from the Solomons and the Chinese bronze vessel on page 249 express humanity's faith in the power of art to provide safety in a mysterious and threatening world.

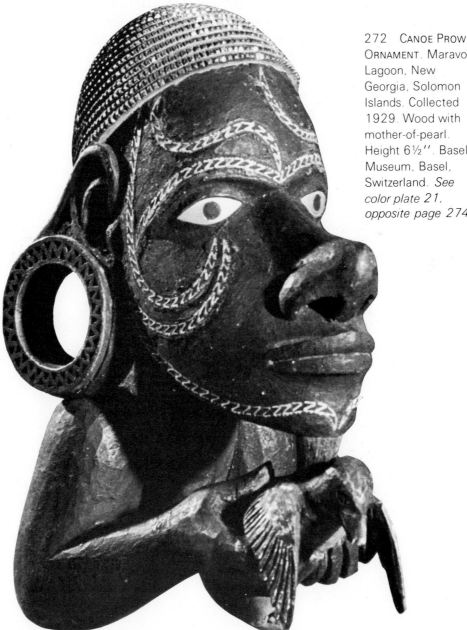

272 CANOE PROW ORNAMENT. Maravo Lagoon, New Georgia, Solomon Islands. Collected 1929. Wood with mother-of-pearl. Height 6½''. Basel Museum, Basel, Switzerland. *See color plate 21, opposite page 274.*

Between 1929 and 1938 an ancient urban settlement was unearthed in the Jordan Valley, southeast of Jericho. Many of the ruined dwellings contain wall paintings in strong colors, including this one with dragonlike animals and geometric designs. Due to the deteriorated condition of both this and the Chumash rock painting, these reproductions are of reconstructions (facsimiles).

A common vocabulary of visual symbols is found in all human cultures. The wall painting from Jordan and the Chumash rock painting from California are from opposite sides of the world and were created about 6000 years apart. Yet they appear to be variations of a shared symbolic language of visual form. As we view them, we need not be troubled by classifications like East or West, ancient or modern. They act as a point of departure for understanding similarity, contrast, sequence, and change in the history of art. Both of them

are highly abstract, and in places, are non-representational.

There are patterns in art history that have been recurring since prehistoric times—stylistic changes that follow one another in cycles. At the same time, a few major themes reappear in different cultures and periods throughout the world. These patterns and themes reveal a rich web of diverse points of view which are held together by the bond of common human experience.

The following discussion is organized chronologically according to major periods and changes in Western cultural history; material from non-Western cultures is brought in chronologically and/or comparatively. Western art history is like the corner of a piece of fabric—many threads weave in and out, each becoming part of the continuing tapestry of human history that is now becoming a worldwide experience.

273 Detail of POLYCHROME WALL PAINTING. From house in Teleilat Gahssul. Valley of the Jordan River, Jordan. c. 4000 B.C.

274 FACSIMILE OF CHUMASH INDIAN ROCK PAINTING. Santa Barbara, California area. c. 1500–1900.

ART OF PRELITERATE SOCIETIES

Nomadic Hunters and Herdsmen

After a long period in human development of which the only remains are stone tools, images of animals and various geometric signs began to appear. Among the earliest indications of the presence of humans on Earth are symbolic marks made with fingers and tools. Recent research shows that some of these marks were systems for keeping track of time. Sometimes hands were imprinted or traced on the walls of caves. The hunter-artist occasionally found inspiration in the cracks and contours of cave walls, and brought out the images through carving and painting.

The richest period of prehistoric art that we are aware of came around the end of the last Ice Age as the lower edge of the European ice sheet slowly retreated northward. It was then that foraging and hunting humans left skillfully made images of the animals on which they depended for life. Only within the last century have we discovered and begun to accurately date prehistoric sites and artifacts throughout the world—at the same time marvelling at the expressions of these peoples.

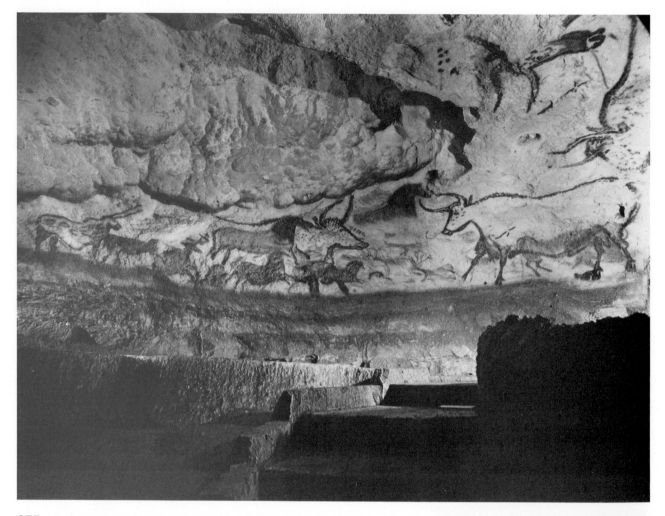

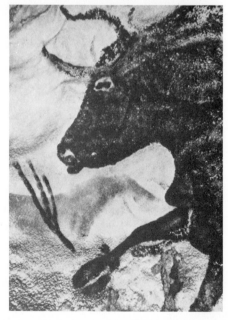

275 a. LEFTHAND WALL, GREAT HALL OF BULLS. Lascaux Caves,
Dordogne, France, c. 15,000–10,000 B.C. Polychrome rock
painting. *See color plate 20, opposite page 274.*
b. FOREQUARTERS OF BULL, PAINTED GALLERY. Lascaux Caves.

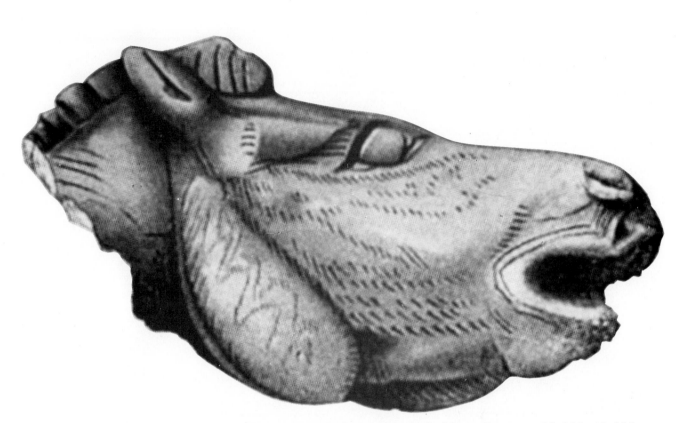

276 HEAD OF NEIGHING PREHISTORIC HORSE. Le Mas d'Azil, Ariège, France. c. 30,000–10,000 B.C. Bone relief. Museum of National Antiquities, Yvelines, France.

The images reproduced here were created on the wall of a deep inner cave chamber at Lascaux in southern France. (See color plate 20.) Animals large and small were painted in a representational style. The images are based on keen observation gained through considerable direct contact with animals. The people who made these paintings had extraordinary visual memory; spontaneous poses are depicted as if caught by a high-speed camera. Earth colors were blown and daubed on the walls, mixed with animal oils as a medium. Some of the bulls at Lascaux are as much as eighteen feet in length. Prehistoric people must have gained confidence by creating images of the creatures that were so crucial to their lives. Human figures rarely appear and, when they do, they tend to be simpler and more abstract than the animals. Geometric signs or symbols are often found with the animal images.

These paintings, generally considered to be magical or ritual art, were probably a way of dealing with the overwhelming struggle to survive and with the sense of helplessness before forces that could neither be controlled nor understood. The hunter and the artist were undoubtedly the same person, with the skills of one enhancing the other.

Many hand-sized carvings have been found at prehistoric sites in Europe. When animals are portrayed, such sculpture has the same expressive naturalism as the animal paintings of this period. HEAD OF A NEIGHING PREHISTORIC HORSE shows that its maker was able to combine skill with careful observation and feeling. The sculptural treatment of the human form during this period, however, lacks this representational quality, and like the depictions of human figures in painting, is more abstract.

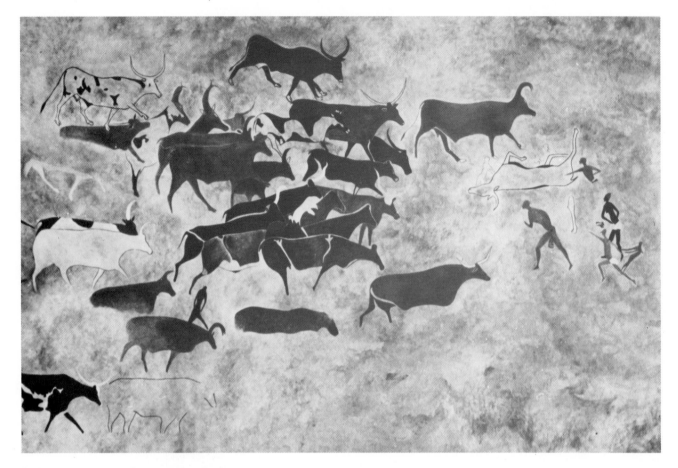

277 FACSIMILE OF POLYCHROME CATTLE. Jabbaren, Tassili-n-Ajjer, Sahara, c. 4000 B.C. Detail of rock painting.

On the surfaces of massive rocks at Tassili Plateau in the high central area of the Sahara of North Africa are numerous paintings done about 4000 B.C. They contain group scenes of people and animals in a flat, semiabstract style. Like other paintings from Tassili, this one is a colorful depiction of daily life, showing sophistication in group composition and in human and animal gestures. This painting and many others of high quality have been discovered within the last 40 years. They were evidently painted by nomadic hunting and herding people who lived in the area before the whole region became the largest desert on Earth. As with many such examples of prehistoric art, we have little except the paintings themselves to tell us about the life and environment of the people who made them.

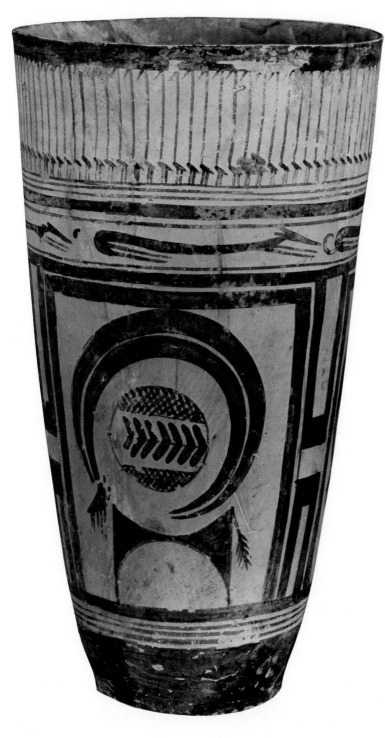

278 EARTHENWARE BEAKER. From Susa.
c. 5000–4000 B.C. Painted
terra-cotta. Height 11¼ ''.
The Louvre, Paris.

Sedentary Peoples

The most dramatic revolution in human history came as people went from nomadic hunting and herding into stable agricultural settlements. Current understanding of prehistory suggests that violent climatic changes from about 10,000 to 8000 B.C. caused wildlife to diminish. Scarcity of game forced hunters to rely on other food sources. Cultivation of crops had been tried before in various parts of the world but never to the extent that it developed in the fertile lands of the Near East about 8000 B.C. There, small groups of people successfully planted crops and domesticated animals. This major shift from nomadic hunting to agricultural communities stabilized human groups, produced early architecture, and brought changes to all the arts. People learned to utilize seasonal rhythms. Because food had to be stored in order to provide a year-round supply, it is not surprising that clay storage pots are often the most significant artifacts made by these Neolithic farmers.

The vigorous naturalism of much representational prehistoric art died out along with the life that produced it. Increasing emphasis was placed on geometric decoration for articles in daily use. These included highly stylized geometric abstractions based on plant and animal forms. Some of the symbols referred to weather gods and other visible and invisible forces of nature. See also the wall painting from Jordan, page 228.

The painted EARTHENWARE BEAKER shown here comes from Susa, the first civilized state of the Iranian plateau. Solid bands define areas of compact decoration. The upper zone consists of a row of highly abstract long-necked birds, followed by a band of dogs (?) running in the opposite direction. The dominant image is an ibex or goat geometrically abstracted into triangular and circular forms. Compare this stylized animal with the bulls of Lascaux and Tassili.

279 BURIEL URN. Kansu type, China. c. 2000 B.C.
Earthenware. Height 14⅛''. Seattle Art Museum.

280 POMO STORAGE BASKET. California, 19th
century. Coiled basketry. Museum of the
American Indian, New York.

Similar abstract and nonrepresentational decorative styles are found on earthenware pots, like the BURIAL URN from ancient China and on the more recent ceramic work of the American Indian cultures of the southwestern United States. An example of the latter is the CEREMONIAL WATER JAR by Maria Chino of Acoma Pueblo on page 171. The now extinct Pomo culture of northern California created

baskets with similar strong geometric designs.

Basket weaving was the major art form developed by the Pomo Indians. Pomo baskets were woven with such incredible tightness that they could hold water. In some baskets one can count sixty stitches to the inch. There was great variety in shape and decoration. Surface designs developed out of the weaving process. No line needs to divide objects or paintings made for a primarily visual function from those in which visual appearance is just one of several functions. The POMO FEATHER BASKET reproduced here shows a characteristic stepped pattern spiraling outward across the surface. Many patterns have names, such as fish teeth, earthworm, or arrowhead. The natural colors and textures of bark, roots, grasses, and other fibers form the design. Sometimes dyes were used to provide a greater range of values.

Women were responsible for the highest artistic achievements in the Pomo culture—the brightly colored feathered baskets. These baskets were highly treasured objects, given as gifts on special occasions. Their primary functions was visual enjoyment.

281 POMO FEATHERED BASKET. California, c. 1945.
1 1/16 x 2⅞''. Los Angeles County Museum of Natural History.

ANCIENT MEDITERRANEAN CIVILIZATIONS

Cycladic

Little is known about the life and traditions of the Bronze Age people who inhabited the Cyclades, a group of islands near Greece in the Aegean Sea, from about 2600 B.C. to 1100 B.C. The only known artifacts from this culture include numerous nude marble figures found in simple stone tombs. These carved figures range in size from a few inches in height to life size. Most of them are female. Both male and female figures were refined to a sophisticated geometric abstraction of human form. The one shown here depicts a man playing a *syrinx* or panpipe. The strong *frontality* in this work is typical of Cycladic sculpture.

282 MAN PLAYING A SYRINX. Cyclades Islands, Greece, c. 2600–2000 B.C. Marble. Height 10½". The Detroit Institute of Arts.

Egyptian

Geometric abstraction is also apparent in this Egyptian sculpture, KING MYCERINUS AND QUEEN, carved about 2500 B.C. The sculptor paid considerable attention to human anatomy, yet stayed within the traditionally prescribed geometric style. Thus, the strength, clarity, and lasting stability which the figures express result from the union of representation and geometric abstraction.

The couple is locked together in the frontal pose that had been established for such royal portraits. The base reveals the shape of the slate block from which the figures were carved; the presence of the original block is still felt in the overall attitude of the figures.

We are living at a time when everything seems to change overnight. Most traditions from our various cultural heritages have been swallowed up. Many of us alive today were born into very rapid cultural and technological change. It is difficult for anyone conditioned by the concept of "new is better" to conceive of cultural traditions, such as that of Egypt, that remained relatively consistent for several thousand years.

283 KING MYCERINUS
AND QUEEN.
c. 2525 B.C. Painted
slate. Height 4'8''.
Museum of
Fine Arts, Boston.

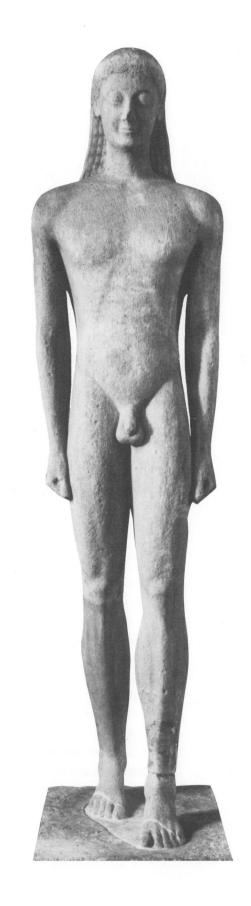

Greek

Art of the Archaic period of Greek civilization (from late seventh to early fifth century B.C.) reveals the assimilation of major influences from Egypt and the Near East. Numerous life-sized nude male and clothed female figures were carved during this era.

Nudity seldom occurred in Egyptian sculpture. In the Greek culture, idealized nudity related to the concept of the supreme athlete and appeared early in male sculpture, possibly to commemorate Olympic victors.

Both male and female figures show Eastern influence. The representation of the male figure, STANDING YOUTH, follows a rigid frontal position that is a direct adaptation of the stance of Egyptian figures. The strict frontal symmetry of prehistoric sculpture was abandoned slowly by all the ancient Mediterranean civilizations. Both the Egyptian sculpture of Mycerinus and this *kouros* (youth) are standing with arms held straight at the side, fingers drawn up, and left leg forward.

In spite of the similarity of stance, however, the character of Egyptian sculpture is quite different from the Greek. The Egyptians were preoccupied with life after death, while the Greeks were primarily concerned with perfecting physical life and the human body. The *kouros* is freestanding, not attached to the back slab of the original block as are the Egyptian figures. The so-called Archaic smile on the face of the Greek figure accentuates an overall aliveness not found in Egyptian sculpture.

284 STANDING YOUTH.
Melos, Greece,
C. 540 B.C.
Marble. National
Museum, Athens.

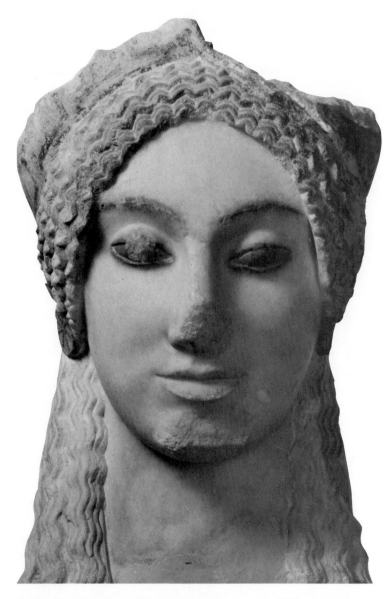

285 Detail of KORE 674. Athens, Greece, c. 500 B.C. Painted marble.

The human face, with its infinite variety of expression, has fascinated sculptors throughout history. We can learn a great deal about the way people of differing cultures saw themselves by looking at their representation of faces.

Sometimes the portraits were individual humans; sometimes they were idealizations of humanity, representing gods. Often they were, like this early Greek *kore* (maiden), ded-

icated to the sanctuary of a god or goddess. Some of the original bright paint with which all Greek sculpture was covered remains on the face of this image of a young girl, found at the Acropolis in Athens, giving her smile an added vitality.

Within one hundred years after the date of the *kouros* figure, Greek sculpture became increasingly active and naturalistic. The bronze SPEAR BEARER by Polyclitus was cast about 450 to 440 B.C. This marble Roman copy demonstrates the full awareness of anatomy and ideal proportions that the sculptor brought to his work. It is an example of the completely developed Classical Greek style. The SPEAR BEARER does not stand at attention with the left leg forward as the Egyptian and early Greek figures did, but tilted so that the hips and shoulders are no longer parallel. This flexible pose created a more relaxed human stance. The major divisions of the body are set off from one another in a form of balance that is known by the Italian word *contrapposto*, meaning "counter posed."

Contrapposto was described by the seventeenth-century sculptor Gian Lorenzo Bernini when he pointed out that people standing in a natural position will seldom rest their weight on both legs unless they are very old. Bernini said that the artist must be careful to reproduce this posture by making the shoulder on the side of whichever leg bears the body's weight lower than the other. He found that good Greek and Roman statues all conformed to this rule.[4] See also Michelangelo's DAVID on page 271.

The statue is balanced asymmetrically so that the central, vertical axis forms a series of graceful curves, whereas the vertical axis of the earlier *kouros* is completely rigid. Geometric abstraction is present in the figure of the SPEAR BEARER, but it structures the work from within rather than from without, as in the earlier Greek and Egyptian works.

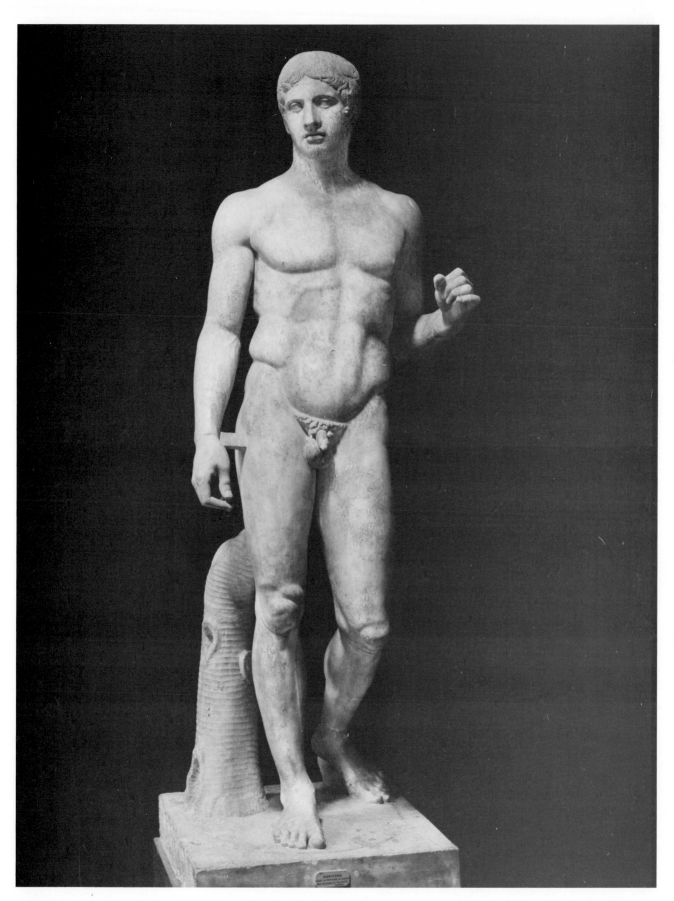

286 Polyclitus. SPEAR BEARER. c. 459–400 B.C. Roman marble copy of the bronze original. Height 6′ 6″.

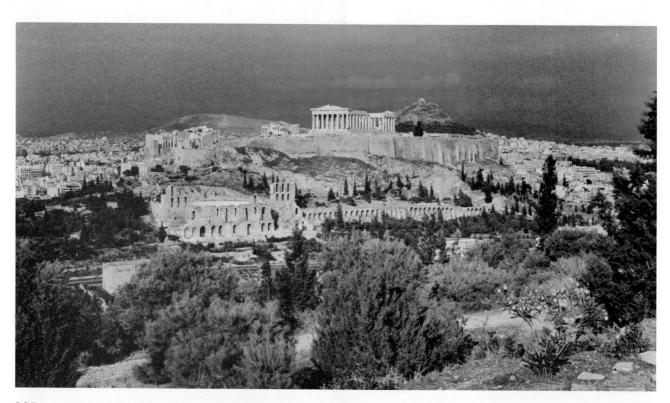

287 ACROPOLIS. View from southwest. Athens, Greece.

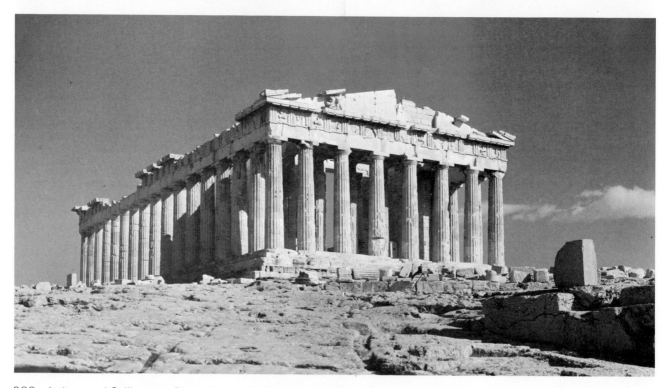

288 Ictinus and Callicrates. PARTHENON. View from northwest. Athens, Greece. 447–432 B.C.

The city-state of Athens was the center of ancient Greek civilization when that culture was at its height. Above the city on a large outcropping of rock called the Acropolis, the Athenians built one of the world's most admired structures. Today, even in its ruined state, the PARTHENON continues to express the high ideals of the people who created it.

This temple, one of several sacred buildings on the Acropolis, was designed and built as a gift to Athena Parthenos, protectress of the Athenian navy, goddess of wisdom, arts, industries, and prudent warfare. It expressed the gratitude of the Athenians for naval and commercial success.

The PARTHENON exhibits the refined clarity, harmony, and simplicity that comes from the heart of the Greek tradition and reflects the Greek ideal of human proportion found in the sculpture of the same period. When Ictinus and Callicrates designed the building, they were following a well-established tradition in temple design which was based on the post and beam system of construction. The basic Greek architectural vocabulary had evolved over many generations. In the PARTHENON, their temple form reached a state of perfection.

The outer form of the temple relates to exterior space. It was located so that it could be seen against the sky, the mountains, or the sea from vantage points around the city. It was the focal point for large outdoor religious festivals. Rites were performed on altars placed in front of the eastern entrance. The interior space was designed to house a forty-foot high statue of Athena. Laymen were permitted to view the magnificent figure through the eastern doorway. Only temple priests were allowed to go inside.

The architects took advantage of natural light in designing the building. The axis of the building was carefully calculated so that on Athena's birthday the rising sun coming through the huge east doorway would fully illuminate the gold-covered statue.

The proportions of the PARTHENON are based on a single mathematical formula and a consistent set of ratios. The ratio of the height to the widths of the east and west ends is 4 to 9. The ratio of the width to the length of the building is also 4 to 9. The diameter of the columns relates to the space between the columns at a ratio of 4 to 9, and so on. None of the major lines of the building are perfectly straight. The columns bulge almost imperceptibly above the center, giving them an elastic quality. Even the steps and the tops of doorways rise slightly in perfect curves. Corner columns, seen against the light, are slightly larger in diameter to counteract the diminishing effect of light in the background. The axis lines of the columns lean in slightly at the top. If extended into space, these lines would converge 5856 feet above the building. The unexpected variations are not consciously seen, but they are strongly felt. They give the building its sense of perfection. The subtle deviations from straight horizontal and vertical lines may correct the optical illusions, but perhaps more importantly, they relate the structure to the site and give it a sense of natural vitality.

Fairly recent analysis of Greek temples shows that exterior surfaces were painted with colors such as pure blues and reds. One can only speculate on what this discovery might have meant to us if it had occurred in the eighteenth century, just before revivalist practices in architecture brought back the Classical Greek style. It is hard to imagine what it would be like if all the Neoclassical architecture of churches, schools, banks, government buildings, and museums still standing in our cities were not unpainted marble as we assumed the Greeks to have used, but were instead brightly painted structures.

In 1687 A.D., the Turks used the PARTHE-NON as a powder magazine during a war with the Venetian Republic. In the fighting, their supplies were blown up, causing great damage to the building. If it had not been for that tragic incident, the building might still look very much the way it did when it was completed. Much of the original sculpture has been moved elsewhere and in some cases replaced with reproductions. In recent years the marble columns and remaining statues have been badly damaged by increasing air pollution. The fuel used in heating apartment houses gives off fumes that are slowly turning the marble to dust, thus threatening the collapse of some of the columns. One recent idea is to build a dome over the Acropolis to protect it from this rapid decay. Imagine one of Buckminster Fuller's domes (see page 202) over the entire Acropolis! What are the historical, philosophical, as well as environmental implications of this?

A valuable comparison can be made between the Greek architecture of the PARTHENON and that of the Japanese SHRINES AT ISE. BAUHAUS architect Walter Gropius once asked, "What are the deep shadows hanging over ISE as against the limitless radiance of the PARTHENON?" The Japanese architect Kenzo Tange answered:

This question . . . touch[es] upon the essence of Japanese culture as compared to Western culture, namely the contrast between an animistic attitude of willing adaption to and absorption in nature and a heroic attitude of seeking to breast and conquer it.[5]

The SHRINES AT ISE were built at least as early as 685 and have been rebuilt every twenty years since then. Wood for the structure is taken from the surrounding forest with gratitude and ceremonial care. As a tree is cut

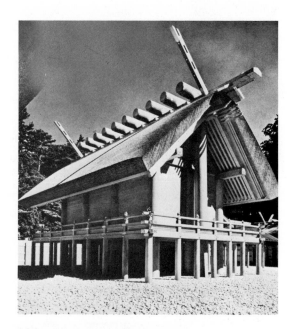

289 SHRINES AT ISE. Main sanctuary from northwest. Ise, Japan. c. 685, rebuilt every 20 years.

into boards, the boards are numbered so that the wood that was united in the tree is together in the building. No nails are used. The wood is fitted and pegged. Surfaces are left unpainted. The main shrine at Ise combines simplicity with rich subtlety. The refined craftsmanship, sculptural proportions, and spatial harmonies are rooted in a seemingly timeless religious and aesthetic discipline. Japanese architecture today reflects this tradition. (See page 200.)

A detail of the head of the Greek god Hermes from HERMES AND THE INFANT DIONYSUS, finished about 330 B.C., shows the famous Greek ideal profile. Its features are essentially the same as those of the SPEAR BEARER, except for an added emphasis on idealized physical beauty and softness of form. The figure does not represent a specific individual, but rather perfected godlike humanity as seen again and again in the features of Greek sculpture. The ideal man and woman were, for the Classical Greeks, the link between themselves and what they believed to

290 Praxiteles. Detail of HERMES AND THE INFANT DIONYSUS. c. 330–320 B.C. Marble. Olympia Museum, Greece.

be the basic order of the universe. They saw the gods in their own images.

In the Hellenistic period (323–100 B.C.), which followed the decline of Classical culture, Greek art became more dynamic and more representational. Everyday activities, historical subjects, and portraiture became more common than the earlier idealized forms. The later Greeks were pleasure-loving people who stressed personal individualism and realism in their art.

According to the myth, Laocoön was a Trojan priest who opposed bringing the Greek wooden horse into Troy. The gods sought to silence him and sent two large serpents that strangled him and his two sons. The mastery of drama and pathos achieved by Hellenistic sculptors is exemplified in the famous marble work known as THE LAOCOÖN GROUP. The rationalism, clarity, and control typical of the Classical period are here given over to writhing movement expressing emotional and physical anguish. When the sculpture was unearthed in Italy in 1506, it had an immediate influence on Michelangelo and many of his contemporaries, and became an inspiration for later Baroque art.

291 Agesander, Athenodorus, and Polydorus of Rhodes. THE LAOCOÖN GROUP. c. 150–30 B.C. Marble. Height 95¼". The Vatican Museums, Rome.

292 FEMALE PORTRAIT. c. 54–117. Marble
Life-size. Museo Profano Lateranese, Rome.

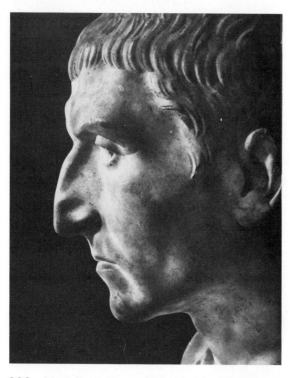

293 MALE PORTRAIT. c. 100. Marble. Life-size.
Capitoline Museums, Rome.

Roman

The change in Greek tradition carried over into Roman art. The Romans were a practical and materialistic people, and their art reflects this. Many pieces of Greek sculpture were brought to Rome as trophies of war, and a process was devised by the inventive Romans to copy them. Greek artists were enslaved to create the ornate and sensual forms demanded by private Roman citizens, as well as to teach Roman artists their techniques.

But not all Roman art was imitative. Roman portraiture achieved a high degree of individuality rarely found in Greek sculpture. This representational style probably grew out of the Roman custom of making wax death masks for the family shrine. Later, these images were re-created in marble to make them more durable. Roman sculptors keenly observed and recorded those physical details and imperfections that give character and individuality to each person's face.

The Romans made few changes in the general style of Greek art, which they admired, collected, and copied. By far their greatest artistic achievement was with civil engineering with which they created utilitarian structures of impressive beauty and grandeur. The outstanding feature of their architecture was the arch, which they mastered as a structural principle and then extended into a variety of forms, including tunnel vaults and domes. See the diagrams on page 189 and the aqueduct at Nîmes on page 193.

In the PANTHEON, a major temple dedicated to all the gods, Roman builders created a domed interior space of breathtaking scale. The walls of the circular concrete and brick building are twenty feet thick, to support the huge dome constructed of horizontal layers of brick set in mortar. These layers are reinforced by a series of arches that converge in the dome's crown, leaving a central opening

called an *oculus* or eye. The oculus, thirty-three feet in diameter, is open to the sky and provides light and ventilation to the interior. On the inside, the coffered ceiling, which was originally covered with gold leaf, arches above the viewer as a symbol of the dome of the heavens. The dome was molded on a huge pile of shaped earth, using an early form of concrete, a material not used again until our own era.

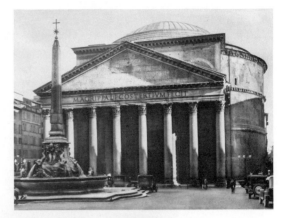

294 PANTHEON. Rome. 118–125. Concrete and marble.

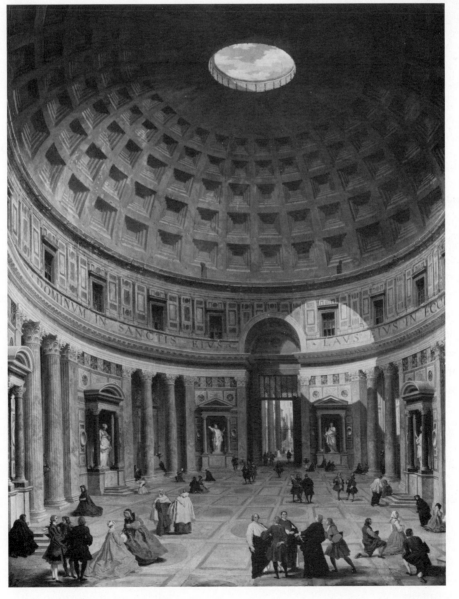

295 Giovanni Paolo Panini. THE INTERIOR OF THE PANTHEON. c. 1750. Oil on canvas. 50½ x 39''. National Gallery of Art, Washington, D.C. Samuel K. Kress Collection.

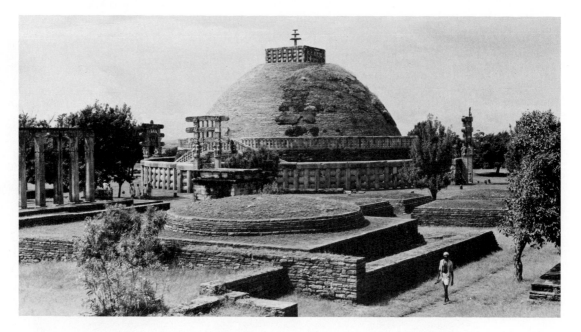

296 THE
GREAT STUPA.
Sanchi, India,
c. 10 B.C. –
15 A.D.

Simplicity of design, coupled with its immensity, makes the PANTHEON a memorable structure. The building is essentially an upright cylinder, capped by a hemispherical dome, with the single entrance framed by a Greek porch or *portico*. This classical porch is reminiscent of the Parthenon. In contrast, however, to the exterior orientation of the Parthenon, the Pantheon has an interior orientation—its most impressive aspect is its immense domed interior space. The Romans developed the ability to build large domed and vaulted interiors to accommodate their preference for gathering inside. The Greeks by contrast congregated outside their temples and did not need large interior spaces.

A Buddhist domelike structure, THE GREAT STUPA at Sanchi, India, is solid, and evolved from earlier burial mounds. Four gates symbolize the directions—North, South, East, and West. The devout individual encircles or circumambulates the stupa in a ritual spiralling path, following the direction of the sun, walking the Path of Life around the World Mountain

TRANSITION TO A WORLD OF MYSTICISM

Early Christian and Byzantine

By the time Emperor Constantine was converted to Christianity, Roman attitudes had changed considerably. The material grandeur of Rome was rapidly declining. As confidence in the material world fell, people turned inward to more spiritual values. The newly recognized Christian religion had been slowly gaining in popularity. This great spiritual change is expressed in the colossal HEAD OF CONSTANTINE, carved in marble in about 312. It was once part of an immense seated figure. The abstract style of this sculpture developed from conflicting attitudes. In its great size, it is definitely heroic, yet its large introspective eyes express an inner spiritual life that is not typically Roman. This is not a realistic portrait of Constantine. It is a symbolic physical manifestation of the transition from Greek and Roman civilization into the Christian era. This is Early Christian sculpture. It seems to have more in common with the later abstract

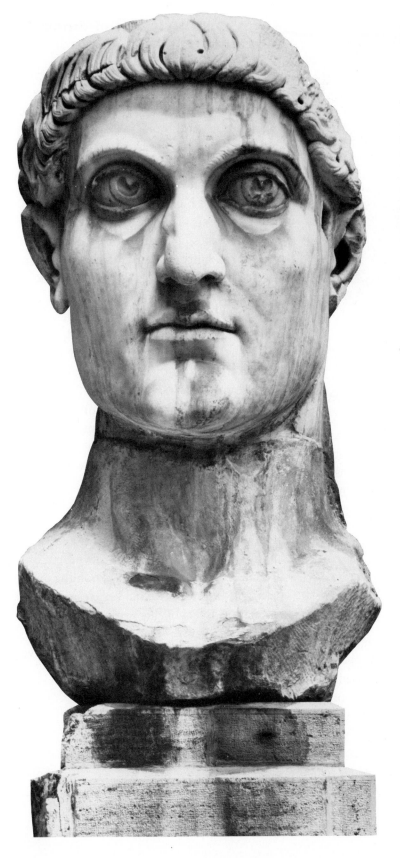

297 HEAD OF
CONSTANTINE. c. 312.
Marble. Height 8'. Museo
dei Conservatori, Rome.

Byzantine images of Christ than with the representational portrait heads of Greece and Rome.

Much Christian art between 300 and 1200 was created in Constantinople (now called Istanbul), the Byzantine capital of the Eastern Roman Empire. There is no sharp dividing line between Early Christian art and Byzantine art. Other art centers were located at Rome, Ravenna, Antioch, and Alexandria.

Iconography, or the study of the meaning of conventional symbolism within a culture, provides needed interpretation of Christian icons. The art forms of the Early Christian period were affected by a controversy between the Iconoclasts, who felt that images were idols, and the Iconophiles, who wanted religious figures. In 726 the Roman emperor issued an edict prohibiting the use of representational images. As a result, many abstract symbols and floral patterns were incorporated into Christian imagery during the next one hundred years. Byzantine Christian abstractions stemmed from associations with Eastern religions, in which flat patterns and nonrepresentational designs were already employed.

Following the Iconoclast period (726–843), the abstract style was integrated with more emotional, figurative imagery. However, Eastern influence continued in the ordered placement of subject matter in Byzantine church decoration, with Christ in Judgment occupying the dome.

298 CHRIST.
Dome mosaic,
Monastery Church,
Daphne, Greece,
c. 1100.

High in the center of the dome of the Monastery Church at Daphne, Greece, there is a Byzantine mosaic depicting Christ as the Ruler of the Universe. This awesome religious work, created in the eleventh century, is one of the most powerful images of Christ in existence. The scale of the figure emphasizes its spiritual importance to the worshipers. Christ appears within a circle against a gold background. The artist has exaggerated the features of His face with bold, black outlines. The large eyes, nose, and mouth work together to form an expression of omnipotence. This flat, linear symbol of Christ as Divine Ruler was designed with such skill and feeling that it has become an image of lasting strength and appeal.

A row of windows circles the base of the dome, giving light to the church. The mosaic surfaces depend on the direction of light from the windows and from artificial sources such as candlelight. Each small *tessera*—or piece of glass or ceramic tile—was placed on the adhesive surface and tilted to catch the light, thus producing a shimmering, luminous quality.

The Animal Style: Art of Eurasia's Migrating Tribes

During the declining years of the Roman Empire, in what has been called the Middle Ages, Germanic tribes entered Western Europe from the East and brought with them an ancient and widespread artistic tradition called the *animal style*. This vigorous style is characterized by intricate, intertwining animal and plant forms in highly abstract linear patterns. Its origin is considered to be the art of ancient nomadic tribes of the Near East. Because of the high mobility of these groups, the style appears to have spread through what is now Russia and into China, carried by migrating peoples back and forth across the Eurasian steppes and into the Mediterranean area and Europe. In China the animal elements of the Near East were combined with geometric patterns of Chinese origin.

A work suggesting an early Chinese source of the animal style is this ancient Shang dynasty bronze container depicting a bear or tiger spirit. Its entire surface is covered with complex animistic designs. The CHINESE SACRAL VESSEL was probably used to hold wine for sacred rites. Because the man's head is almost within the ferocious jaw of the beast, it appears that he is about to be devoured. But his hands are relaxed, and he is holding on to the monster for protection. Perhaps the most fascinating aspect of this work is the contrast between the gentle wonder expressed on the man's face and the aggressive, protective power of the animal.

248

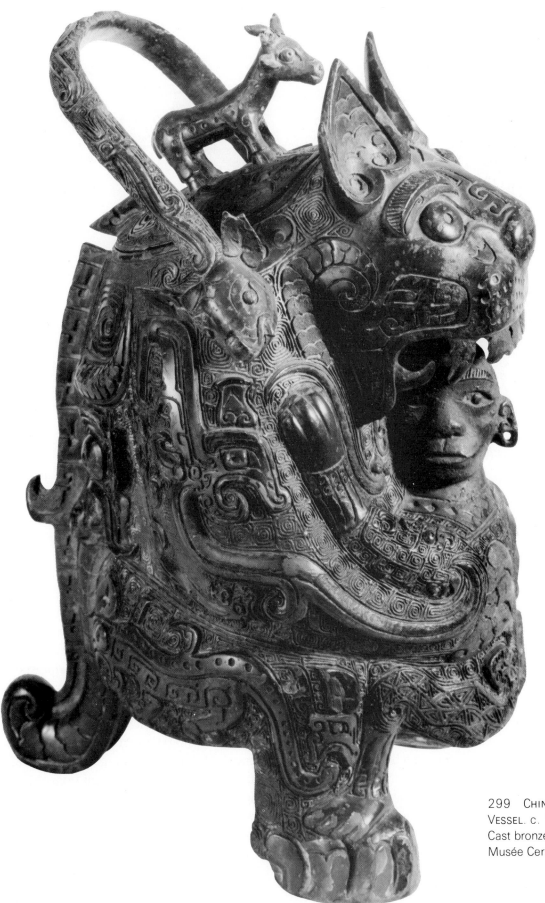

299 CHINESE SACRAL
VESSEL. C. 1500–1059 B.C.
Cast bronze. Height 14″.
Musée Cernuschi, Paris.

300 STAFF FINIAL. Chin–ts'un, China, c. 481—221 B.C. Bronze inlaid with gold and silver. Height 5 ⁵⁄₁₆''. The Cleveland Museum of Art, purchase from the J. H. Wade Fund.

301 BRONZE RING. Luristan, c. 900–700 B.C. Honolulu Academy of Arts, Mr. and Mrs. J. Scott B. Pratt III bequest.

The bronze STAFF FINIAL from China and the later Luristan BRONZE RING were both designed as ornaments. The Chinese staff finial shows a dragon biting, and at the same time being bitten by, a bird seen bending over the top tearing at the dragon's snout. Elaborate gold and silver inlays cover the surface. The total form is a complex of various themes in rhythmic interwoven movement.

The most widely used material for the animal style was metal of various kinds, often exhibiting exceptional craftsmanship. The objects created were small, portable, durable, and much sought after, which accounts for the style's diffusion over larger geographic areas. The technical and aesthetic qualities of the metalworks influenced artistic expression in such other media as wood carving, stone carving, and manuscript illumination.

Most of the wood carving was done in Scandinavia, where the animal style flourished longer than anywhere else in the West. Protective animal spirits like those in both the early CHINESE SACRAL VESSEL and the carving from Norway were felt to have power and symbolic significance far beyond the decorative function we may associate with them. We know that Viking law required that figures such as DRAGON'S HEAD be removed when coming into port so that the spirits of the land would not be frightened.

Christianized Ireland and England developed the most elaborate manuscripts. In the fantastic INHABITED INITIAL on this twelfth-century English manuscript page, a frail human struggles to free himself from a spiraling tangle of beasts, symbolizing the snares of a sinful world. The work is a highly imaginative, rather innocent, illustration of a struggle, similar to that of Laocoön and his sons on page 243. Its vinelike interweaving seems to have come from Asian sources.

302 DRAGON'S HEAD.
Wood carving found at
Oseberg (Norway).
c. 820. Oslo, University
Museum.

303 INHABITED INITIAL, manuscript
illumination. From the beginning of the
Book of Job. Probably done at
Winchester, c. 1150. 5¹¹⁄₁₆ x 5½''.
Copyright Bodleian Library, Oxford.

304 Detail of CHRIST OF THE PENTECOST. Saint Madeleine Cathedral, Vézelay, France. 1125–1150. Stone. Height of tympanum, 35½″.

Major World Religions Revealed Through Art

The vigorous abstract complexity of the animal style is very different from the monumentality of the various styles of art that dominated the major ancient civilizations around the Mediterranean Sea. A lively synthesis of the art of the so-called barbarian peoples and

305 STANDING BUDDHA. 5th century. Red sandstone. Height 5' 3''. National Museum, New Delhi.

the Greco-Roman art tradition occurred at the end of the Middle Ages, about 1000 A.D., and became known as Romanesque art.

CHRIST OF THE PENTECOST from the Romanesque cathedral of St. Madeleine at Vézelay, France (opposite page), combines the complex energetic movement of the animal style with a monumental presence. See also Romanesque architecture, page 194. The mystical spirit and compassion of Christ is given symbolic force in this early twelfth-century relief carving over the central doorway. The linear folds of drapery covering the figure swirl and eddy in rhythmic spirals that are charged with vitality.

Much of Asian art is Buddhist. Both early Buddhism and Christianity opposed the worshipping of human images. As with Christianity, however, religious practice needed icons as support for contemplation, and eventually images of the Buddha appeared. The style of Buddhist sculpture varies according to the culture that produced it. As Buddhism moved from India to Southeast Asia and across Central Asia to China, Korea, and Japan, it influenced, and in turn was influenced by, the indigenous religious and aesthetic traditions with which it came in contact.

This Indian STANDING BUDDHA was carved in red sandstone in the fifth century. The simplified mass of the figure seems to push out from within as though the form was inflated with breath. The rounded form is set off by a sequence of flowing curves that are repeated rhythmically down across the figure. The drapery seems wet as it clings to and accentuates the round softness of the body beneath. In contrast to the intense energy implied by the linear folds of Christ's robes, these lines express feelings of inner peace achieved through calm communion with universal truth. Abstract renderings of the drapery in both of these carvings can be traced back to Greco-Roman origins.

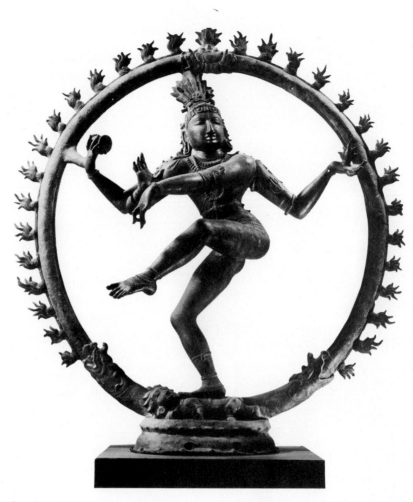

306 SHIVA NĀTARĀJA. 11th century. Bronze. 43⅞ x 40″. The Cleveland Museum of Art, purchase from the J. H. Wade Fund.

In differing ways, the Romanesque Christian, Buddhist, and Hindu images express deep spiritual feelings shared by devout followers. In Hindu belief, Shiva is the Supreme Deity, encompassing all things. For this reason Shiva takes various forms in Hindu sculpture. In this eleventh-century image, Shiva as Nātarāja, Lord of the Dance, performs the cosmic dance within the orb of the sun. As he moves, the universe is reflected as light from his limbs. Movement is implied in such a thorough way that it seems contained in every aspect of the piece. Each part is alive with the rhythms of a dance tradition that has been strong in India for several thousand years. The multiple arms are used expressively to increase the sense of movement.

In his book *The Dance of Shiva*, the great Indian art historian Ananda Coomaraswamy poetically relates the nature of Shiva's dance:

In the night of Brahma, Nature is Inert, and cannot dance till Shiva wills it: He rises from His rapture, and dancing sends through inert matter pulsing waves of awakening sound, and lo! matter also dances appearing as a glory round about Him. Dancing, He sustains its manifold phenomena. In the fullness of time, still dancing, he destroys all forms and names by fire and gives new rest. This is poetry; but none the less, science.[6]

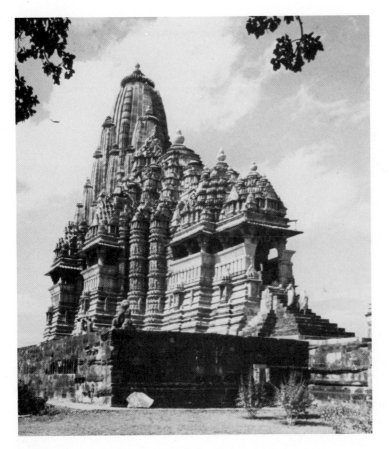

307 KANDARYA MAHADEVA TEMPLE. Khajuraho, India, 10th–11th centuries.

These forms seem to celebrate the procreative energy found in all of nature and felt or experienced within ourselves. In contrast to Chartres, Kandarya has no large interior space intended to function as a sanctuary. This temple can be compared to the totally solid mass of THE GREAT STUPA at Sanchi, see page 246. Indian temples tend to be more sculptural than architectural in this sense.

Shown here is one of the many erotic scenes portrayed in the abundant sculpture at Kandarya temple. Its design indicated to the worshipper that heaven or union with God is filled with a joy that can be suggested or symbolically expressed by reference to the sensual pleasures of erotic love. The natural beauty of the human figure is heightened by the symbolic emphasis on maleness and femaleness. Fullness seems to come from within the rounded forms, heightening their sense of physical presence. The couple's intertwining form symbolizes oneness. They are symbols of divine love in human form, an allegory of ultimate spiritual unity or oneness.

Both the religious architecture and the sculpture of the Hindu KANDARYA MAHADEVA TEMPLE at Khajuraho in north central India, make interesting comparisons with the Gothic European counterparts of CHARTRES CATHEDRAL. Kandarya was completed about one hundred years before CHARTRES was begun. Like CHARTRES, its design emphasizes a vertical thrust. Both are complex, mystical forms appearing to rise effortlessly from the horizontal countryside as if they were organic and continuing to grow. On the Indian temple a series of small towers builds to a climax in a single large tower. The rounded projecting forms are symbolic of both male and female sexuality, expressing a growth quality linked to the unifying concept of creation and love.

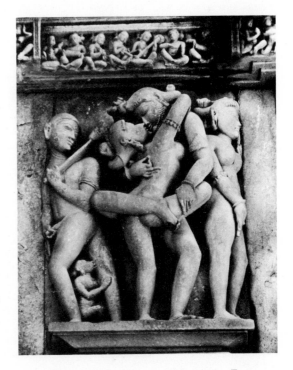

308 SCENE FROM KANDARYA MAHADEVA TEMPLE.

309 a. NOTRE DAME DE CHARTRES. View from southeast. Chartres, France. 1145–1513. Cathedral length, 427'; facade height, 157'; south tower height, 344'; north tower height, 377'.

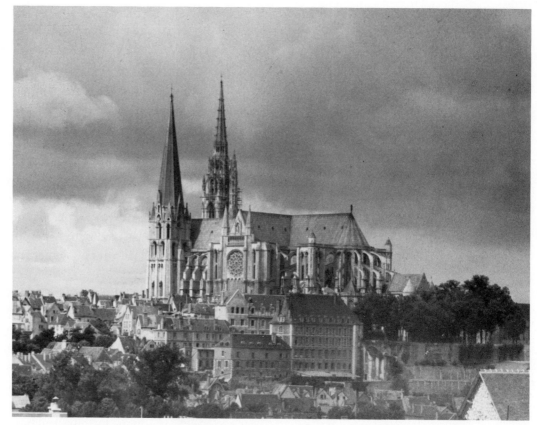

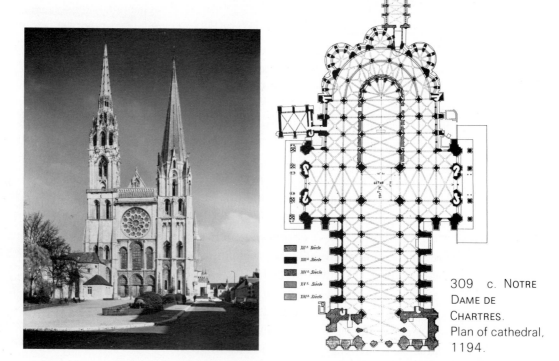

309 b. NOTRE DAME DE CHARTRES. West front.

309 c. NOTRE DAME DE CHARTRES. Plan of cathedral, 1194.

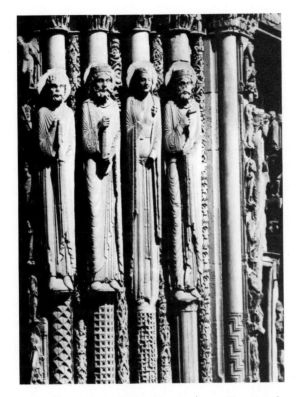

310 SAINTS AND ROYAL PERSONAGES. Facade of West Portal, Notre Dame de Chartres, Chartres, France, c. 1145–1170.

One of the major differences between the cultures of the East and the West is the restless searching of Europeans, which has resulted in frequent changes in attitude that are clearly seen in their art. The Romanesque had lasted barely one hundred years when the Gothic style began to replace it in about 1145. The shift is seen most clearly in architecture, as the Romanesque round arch was superseded by the pointed Gothic arch that developed in the late twelfth century. (See page 195.)

In one sense the change from Romanesque to Gothic architecture is simply a change in the method of vaulting. Yet this tremendous human achievement was motivated by, and is expressive of, the communal faith of the people of that time and place. The cathedrals were enthusiastic expressions of a new age of faith that was growing out of medieval Christian theology. Their immense reaching form

takes us beyond the petty concerns of this world, expressing a sense of joyous spiritual elation not found in earlier Christian architecture. They are made of stones carved and assembled to form thin ribs and pillars; the result is a seemingly weightless network supporting luminous colored-glass windows. Inside, the faithful must have felt they had actually arrived at the visionary Heavenly City.

The second Romanesque design for the CATHEDRAL OF NOTRE DAME DE CHARTRES was begun in 1145 after the first Romanesque building was destroyed by fire in 1134. It was partially destroyed again by fire in 1194 and then rebuilt in the High Gothic style. See the plan. This, the third structure was the first cathedral based on the full Gothic system, and set the standard for Gothic architecture in Europe. In its west facade, Chartres reveals the transition between late Romanesque and High Gothic architecture. The massive lower walls and round arch portals were built in the mid-twelfth century. The Gothic tendency toward greater verticality is apparent in the upper levels built by later generations in the style of their time. The north tower, on the left as one approaches the facade, was rebuilt with intricate flamelike or flamboyant curves of the late Gothic style early in the sixteenth century after the original tower collapsed in 1506.

Gothic cathedrals, such as Chartres, were the center of community life. They were used as meeting places for people doing business, for lovers, for lectures, and for concerts—apart from their continuous sacred role.

The entire community worked on Notre Dame de Chartres (Our Lady of Chartres). Its form rises above the flat countryside on the site of a pre-Christian sacred spring. The people who began its construction never saw it in its present form. It continued to change and grow for more than three hundred years. There is no quarrel here between art and engineering—in Gothic cathedrals they are one.

What would the architects of the Parthenon have thought of this complex and seemingly irrational structure? The plan of the building is based on the Latin Cross. It follows a rational geometry, yet from the outside this scheme cannot be seen or grasped mentally as a total logical image in the same way as the design of the Parthenon. Chartres appears to reach beyond the earth and human scale. The changing light of day activates the rich color of its stained-glass windows.

The Romanesque depictions of SAINTS AND ROYAL PERSONAGES on the west portal of Chartres Cathedral are symbolic portraits of idealized historic Christian figures. The abstract elegance of their elongated forms calls attention to spiritual concerns by a denial of the physical body. A faint smile on the woman's face suggests inner peace.

These sculptured figures echo the cylindrical columns behind them, bringing about a fine blend of architecture and sculpture. The figures from Chartres stand before their columns almost completely detached. Their gentle human heads show a new trend toward naturalism, which eventually leads to the first portraiture and freestanding figures since the beginning of the Christian era.

In spite of the great differences in form and content between Hindu and Christian architecture and sculpture, their basic purposes are similar. They relate to an idea expressed in 1200 by Abbot Suger, the man responsible for starting the Gothic style of architecture in France. Suger was an abbot, statesman, historian, and advisor to both Louis VI and Louis VII. He planned and supervised the construction of the new Abbey of Saint-Denis near Paris. Here the use of tall slender forms and extensive areas of stained glass were the first expression of Gothic architecture. Suger believed that we could come to understand God only through the effect of beautiful things on our senses. He said, "The dull mind rises to truth through that which is material."

BEYOND MEDIEVAL EUROPE

Africa

The traditional art of black Africa is more varied from culture to culture than the traditional art of other continents. The variety of styles ranges from extremely abstract (see page 318) to naturalistic.

As the Gothic era was beginning in twelfth-century Europe, a sophisticated culture began to flourish around the royal court of Ife, the sacred Yoruba city in southwestern Nigeria. There, a naturalistic style of courtly portraiture developed that was unlike anything to be found in Europe at the time and was equally unique among the inventive abstract forms created by most African cultures. MALE PORTRAIT HEAD shown here is a representational portrayal of an individual. The work demonstrates great skill in the difficult art of lost wax bronze casting. Scarification lines follow contours across the face. Rows of small holes held hair and beard, adding to the realism.

In the thirteenth century a master sculptor from Ife brought bronze casting to the neighboring Nigerian kingdom of Benin (see page 163).

The semiabstract IVORY MASK from Benin was carved in the sixteenth century, but modern versions of it are still worn at the oba's (king's) waist during important ceremonies. The crown consists of a row of heads inspired by the strange appearance of Portuguese men. "Civilized" Europeans were amazed when they saw Benin sculptures, palaces, and city plans because they could not imagine how such refined art could come from people they had considered "naked savages," living in mud and straw huts. Europeans believed that these were "tribal" peoples caught in a stage of human development low on the evolutionary scale. Their feelings of superiority can be put in perspective by realizing that the art of Gothic cathedrals was created by the hands of people who also lived in simple huts and had been looked upon as barbaric tribesmen by the "civilized" peoples of the Mediterranean only a few centuries before.

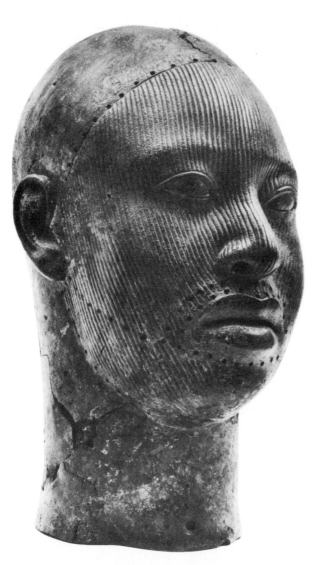

311 MALE PORTRAIT HEAD. Ife, Nigeria, 12th century. Bronze. Height 13½''. Collection the Oni of Ife.

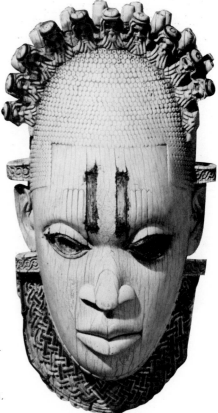

312 IVORY MASK. Benin district, Nigeria. 16th century. Height 9''. British Museum, London.

China

A monumental style of landscape painting developed in China beginning in the tenth century, several centuries before the West began developing its own ways for handling such subject matter. Traditional Chinese painting is based on values which have been upheld for centuries. This contrasts with Western painting, which has been based on changing values since the Renaissance.

According to tradition, young Chinese painters spend several years copying the works of earlier artists in order to fully assimilate the long tradition they inherit. Artists are also interested in adding their individual interpretation to traditional themes. Subject matter is secondary to form. Poetry is frequently written on the surface. Brush techniques are highly developed, both for the written characters and for the painted subject. The quality of each stroke is considered as important as the total design. Landscape strokes and their rhythms have names such as "raveled rope," "raindrops," "ax cuts," "nailhead," and "wrinkles on a devil's face." Timing and speed add to the unrepeatable quality of each stroke. In order to paint a landscape the artist spends time in quiet meditation outdoors, thus becoming one with the subject. The painting is then done from memory. It is also common to base a composition on the work of an earlier painter.

The three basic forms of portable paintings firmly established by the Sung Dynasty (960–1279) are the hanging scroll, hand scroll, and album leaf.

In Fan K'uan's monumental hanging scroll TRAVELERS ON A MOUNTAIN PATH, the intricate brushwork suggests trees with textured shapes which emphasize the structure of the mountain. With humility, human travelers traverse the almost horizontal road, while behind them, mountain cliffs rise vertically to-

313 Fan K'uan. TRAVELERS ON A MOUNTAIN PATH.
c. 990–1030. Hanging scroll, ink on silk. Height 81¼". National Palace Museum, Taipei, Taiwan.

314 Yü–Chien. MOUNTAIN VILLAGE IN A MIST. 13th century. Ink on paper. Private collection.

ward heaven. The stylized waterfall is an accent in the design.

The painting is considerably more than a pleasant scene. It symbolizes major philosophical attitudes rooted in Taoism and Confucianism. According to Chinese tradition, humanity is only a small part of the universe. Nature is seen as alternating positive and negative forces that are vast and powerful. When humans are humble, they fit comfortably within these universal forces. They are one with nature.

In the thirteenth century, Yü-Chien painted MOUNTAIN VILLAGE IN A MIST with ink in a highly abstract and sophisticated spontaneous style reflecting the values of Ch'an (Zen) Buddhism. Again the man/nature relationship is expressed with tiny figures and barely suggested roof lines of houses blending with nature's free forms.

Japan

Japanese portraiture of the twelfth and thirteenth centuries shows contrasting abstract and representational styles. The power of the abstract PORTRAIT OF MINAMOTO YORITOMO, done in the twelfth century by Fujiwara Takanobu, has much in common with the design quality found in Japanese woodcuts of the eighteenth century. In this painting, Yoritomo is shown seated, dressed in the ceremonial robes of a senior court official. His light face accents the dominant angular shape of his garments. The black hairpiece rising from the back of his head repeats the shape and direction of his white sceptre.

Japanese artists have long respected the flat character of a two-dimensional picture surface. In traditional Japanese art there has never been a lasting break from this value though there have been many changes of style.

In the three dimensions of sculpture, representational form is less of an illusion. When the refinements of court life in the Fujiwara

315 Fujiwara Takanobu. PORTRAIT OF MINAMOTO YORITOMO. 1142–1205. Ink and color on silk. 55½ x 44¼". Jingo–ji Temple, Kyoto, Japan.

316 Unkei. Detail of MUCHAKU. c. 1208. Wood. Height 75''. Kofuku–ji Temple, Nara, Japan.

317 Gibon Sengai. THE FIST THAT STRIKES THE MASTER. c. 1800. Ink on paper. Idemitsu Art Gallery, Tokyo.

period (897–1185) gave way to the aggressive soldiers of the Kamakura period (1185–1333), a new style of art emerged that emphasized realism. One of the greatest artists of the time was the sculptor Unkei. His portraits are made of thin pieces of wood that have been joined, carved, and painted. They are some of the first portraits known in Asia in which careful depiction of an individual's personality appears in natural detail.

Toward the end of the eighteenth century, Zen Buddhist monk Sengai became known for his rugged visual epigrams of Zen thought. Each hit of the brush against the paper produced a stroke conveying power and significance. In THE FIST THAT STRIKES THE MASTER, he illustrates the story of a great Chinese Zen priest, Rinzai, who found enlightenment and struck his teacher with his fist. His images are graphic in every sense of the word.

318 Detail of BURNING OF THE SANJO PALACE. Kamakura period. 1185–1333. Handscroll, ink on colored paper. Height 16¾''. Museum of Fine Arts, Boston.

The portable handscroll was developed in China as a format for sequences of single images. Later the handscroll was adapted in Japan as a continuous composition. The BURNING OF THE SANJO PALACE is an excellent example of the storytelling potential of this format. It is one of a series of three scrolls describing the Heiji insurrection of 1159. As the scroll or *makimono* was unrolled from right to left, the viewer was pulled along in a succession of events expertly designed into a continuous narrative composition. The horrors and excitement of the action are connected through effective visual transitions. The story builds from simple to complex events, reaching a dramatic climax in the scene of the burning palace. This is one of the most effective depictions of fire in the history of art. The color of the flames emphasizes the excitement of this historic struggle. Such epic drama is now presented through the media of film and television.

DISCOVERY OF THE WORLD AND OF MANKIND

The Renaissance in Italy

In Italy during the fourteenth and fifteenth centuries, art and architecture reflected a developing humanistic philosophy. *Renaissance* means "rebirth" and describes the period of the great revival of interest in the art and ideas of ancient Greece and Rome. It was a time of discovery—discovery of the world and of humanity.

In Europe, a major shift in attitude occurred as the spiritual mysticism of the Gothic era was increasingly challenged by logical thought and the new humanism. The beginnings of this transition became apparent in the late thirteenth century.

Giotto di Bondone was part of the changing attitude toward religion developing in Italy in the early fourteenth century. Gothic art had been dominated by a belief in a heaven-centered religion. New interest in Greek and Roman thought led to a more human-centered vision of the world. Giotto turned away from the flat, stylized symbolism of medieval painting to a three-dimensional naturalism, a style that reached full maturity in the Renaissance.

319 Giotto di Bondone. THE DESCENT FROM THE CROSS. c.
1305. Fresco. 78¾ x 78¾''. Cappela deli Scrovegni,
Padova, Italy.

In THE DESCENT FROM THE CROSS, Giotto's people appear as solid forms in a shallow stage-like space that seems continuous with the space we occupy. Their expressions show personal responses to the death of Christ. From Giotto's work came the tradition of making a painting as if it were a window looking out onto nature. This treatment was not radically challenged until the development of Cubism in the early twentieth century.

The Italian artist Filippo Brunelleschi studied Roman ruins and medieval, Byzantine, and Italian architecture. He then developed a new architecture expressing the dignity of humanity rather than the omnipotence of God. His design for the Pazzi family chapel became the model for an architectural style that spread throughout Europe. Its balanced horizontal and vertical forms are in contrast to the soaring vertical thrusts of Gothic cathedrals. With it, Brunelleschi brought rational clarity and a more human scale back to architecture.

The main interior space of the chapel is rectangular, with the altar placed in a niche opposite the entry. A Roman dome caps the central space. Dark stone pilasters and mouldings divide the walls and vaults into geometrically distinct zones that accent the spatial clarity.

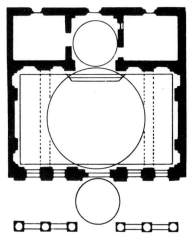

320 a. Filippo Brunelleschi. PAZZI CHAPEL.
Florence, 1429–1430. b. Pazzi Chapel, plan.

265

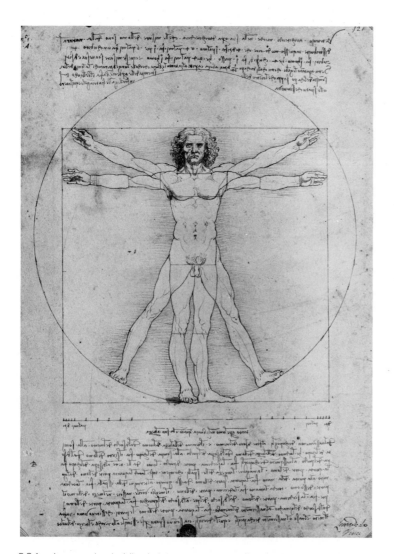

321 Leonardo da Vinci. ILLUSTRATION OF PROPORTIONS OF THE
HUMAN FIGURE. c. 1485–1490. Pen and ink. 13½ x 9¾''.
Academy of Fine Arts, Venice.

The symbolic use of the circle and the square goes back to prehistoric times. In the Renaissance the square symbolized the earth and the circle stood for the cosmos. Leonardo da Vinci's famous ILLUSTRATION OF PROPORTIONS OF THE HUMAN FIGURE (1485–1490) symbolizes the dual nature of humanity by showing how human proportions work with both of these geometric forms. It is curious how one drawing can be seen as a religious symbol, a scientific study, and a work of art.

The new spirit of Renaissance humanism is revealed by comparing THE LAST SUPPER by Leonardo da Vinci with the Byzantine mosaic of Christ (see page 248). The Byzantine Christ is high in a dome; Leonardo's Christ is sitting across the table at eye-level. The Byzantine mosaic is an abstract icon. Leonardo, however, wanted to paint a likeness of Christ in an earthly setting, so he placed THE LAST SUPPER in a Renaissance interior. In his painting, the natural world of everyday appearances becomes one with the supernatural world of divine harmony. The style of the work could be defined as representational on the surface, but as geometric abstraction within. The painting relates to classical Greek art in which representational naturalism is organized according to rules of proportion, based on geometric harmonies. Geometry similar to that which is so apparent in Leonardo's drawing of human proportions is hidden here.

The interior space is based on a one-point linear perspective system, with the single vanishing point, infinity, exactly in the middle of the composition, behind the head of Christ. Leonardo placed Christ not only in the center of the two-dimensional picture plane, but also in the center of the implied spatial depth. Christ's head is directly in front of the point of greatest implied depth, relating Him to infinity. Over Christ's head an architectural pediment suggests a halo, further setting Him off from the shapes of the figures on either side.

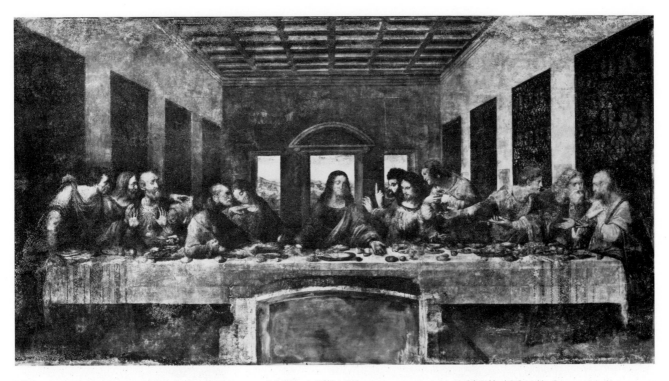

322 Leonardo da Vinci. THE LAST SUPPER. c. 1495–1498. Oil–tempera mural. 14′ 5″ x 28¼″. Santa Maria della Grazie, Milan.

We find ourselves looking into the image of a real room, as if we were sitting on the opposite side of the table, just as Christ declares, "One among you will betray me." The Apostles are deeply shaken by this accusation, yet, in spite of their agitation, the feeling of the painting remains calm. This calm seems to emanate from the quiet figure of Christ, but it is the geometric design that contributes to it.

In his "Treatise on Painting," Leonardo wrote that the "figure is most praiseworthy which by its action best expresses the passions of the soul."[8] In contrast to the distraught figures surrounding Him, Christ is shown with arms outstretched in a gesture of submission which makes His image a stable triangular shape expressing eternal calm.

THE LAST SUPPER began to deteriorate soon after it was completed because Leonardo tried an oil-tempera medium that did not adhere permanently to the wall. We can only imagine its original visual quality.

Leonardo was one of the first to give a clear description of the *camera obscura* (dark room), an optical device that captures light images in much the same way as the human eye. This later developed into what we know today as the camera. It was a valuable tool for anyone trying to create representational images of the visual world. Leonardo described the principle:

Light entering a minute hole in the wall of a darkened room forms on the opposite wall an inverted image of whatever lies outside.[9]

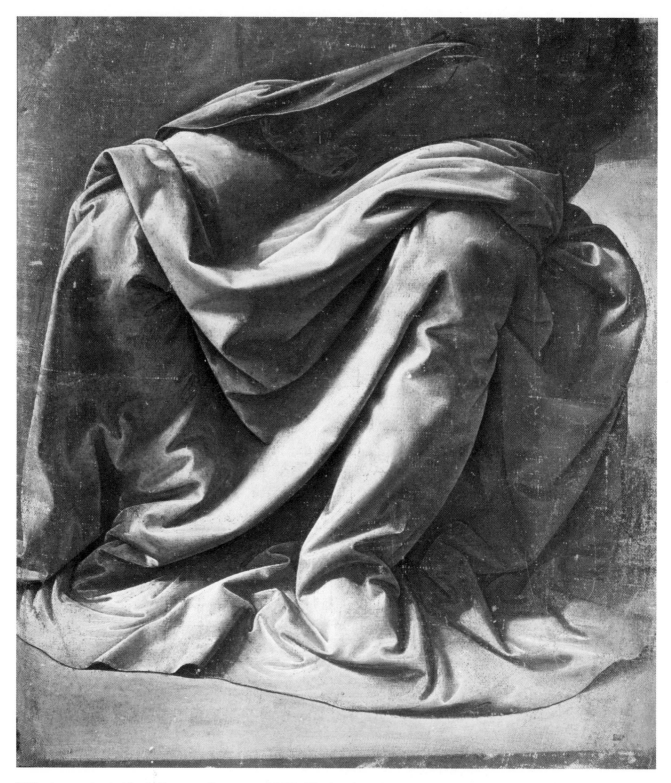

323 Leonardo da Vinci. DRAPERY STUDY. c. 1475. Black and white brush drawing on linen canvas.
26.6 x 23.4 cm. The Louvre, Paris.

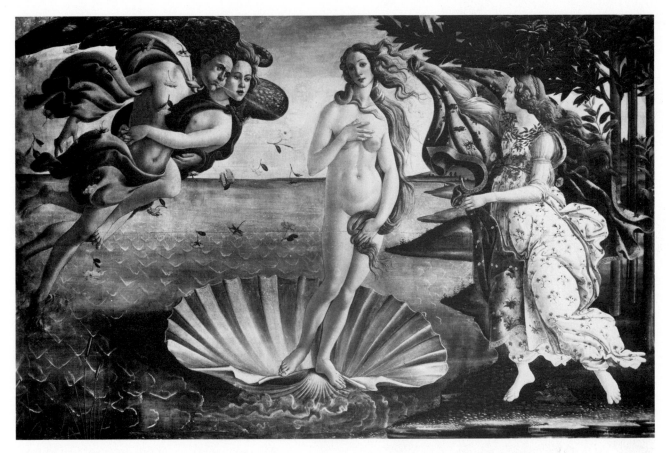

324 Sandro Botticelli. BIRTH OF VENUS. c. 1490. Oil on canvas. 5' 8⅞'' x 9' 1⅞''. Uffizi Gallery, Florence. *See also detail, color plate 23, near page 275.*

This study of drapery was rendered with a brush by Leonardo as a black and white value study, using the concept of *chiaroscuro* as he had developed it. The image represents the manner in which light has revealed the subject.

A major Renaissance painting completed in Italy in the late fifteenth century is Sandro Botticelli's BIRTH OF VENUS. Gothic and Greek styles are brought together here in a new synthesis. In this painting, Venus, the Roman goddess of love, known to the Greeks as Aphrodite, is gently blown to shore in a large shell, propelled by two zephyrs. By centering the figure of Venus, Botticelli placed her in the position of importance held for centuries by the Virgin Mary. Church patronage was still im-

portant, but many patrons such as the Medici, who commissioned this painting, hired artists to sculpt and paint for their homes. These patrons were influential people of politics and commerce who were not interested solely in sacred subjects.

We are more enchanted with the vitality and lyrical beauty of Venus than by the details of the myth about her. Botticelli understood anatomy, light, and color. He also understood how to give the whole design lasting interest by keeping the background relatively flat and by slightly abstracting the figures to emphasize their grace. The many flowing lines add life and movement to the painting, while the vertically curving figure of Venus contrasts with the horizontal line of the sea.

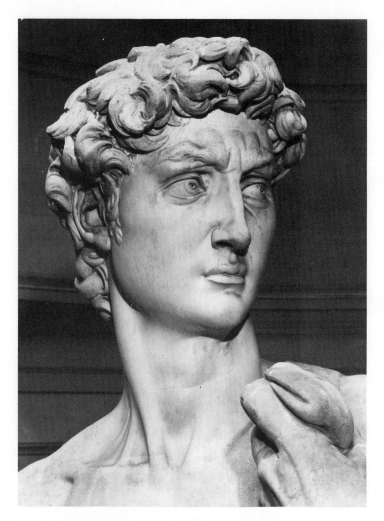

325 a. Michelangelo Buonarroti. Detail of DAVID.

The artist expressed the Renaissance spirit in his humanistic treatment of "pagan" subject matter. The human body became the true subject, painted with sensuous delight.

The detail of the head of Venus (see color plate 23) from Botticelli's work shows how a master uses a whole range of visual elements in order to create an image of great elegance. The rhythmic grouping of lines for the hair is particularly effective. Venus's head, neck, and shoulders are simplified shapes. Some shading indicates the three-dimensional qualities of the figure. But it would be difficult to imagine reaching around this figure because Botticelli has emphasized the outlines or edge lines and underplayed the shading. Venus appears as a half-round rather than a fully three-dimensional mass. This is not a problem; it is simply a different concept. Everything in the painting flows together in a shallow, decorative space.

The Old Testament story of David and Goliath is both a myth or allegory and a sacred story. It has had strong appeal for centuries. Michelangelo carved the image of David from a single block of marble. The sculpture is about eighteen feet tall. We could expect this scale for Goliath rather than David.

DAVID represents humanity—humanity as it rediscovered itself in the Renaissance. Imagine looking up and identifying with this tremendous figure. Legend has it that when Michelangelo revealed the sculpture, the people of Florence were so pleased that they pulled it through the streets in a great procession that lasted for three days.

The influence of Greek sculpture is apparent, but this is not an idealized Greek figure. The face reveals an inner struggle, perhaps anxiety, based on the new and sometimes painful self-awareness that followed close behind the new humanism. Michelangelo may have intended this expression to portray David's concern as he confronted the giant, Goliath. How different this head is in feeling from Praxiteles's head of Hermes (see page 243).

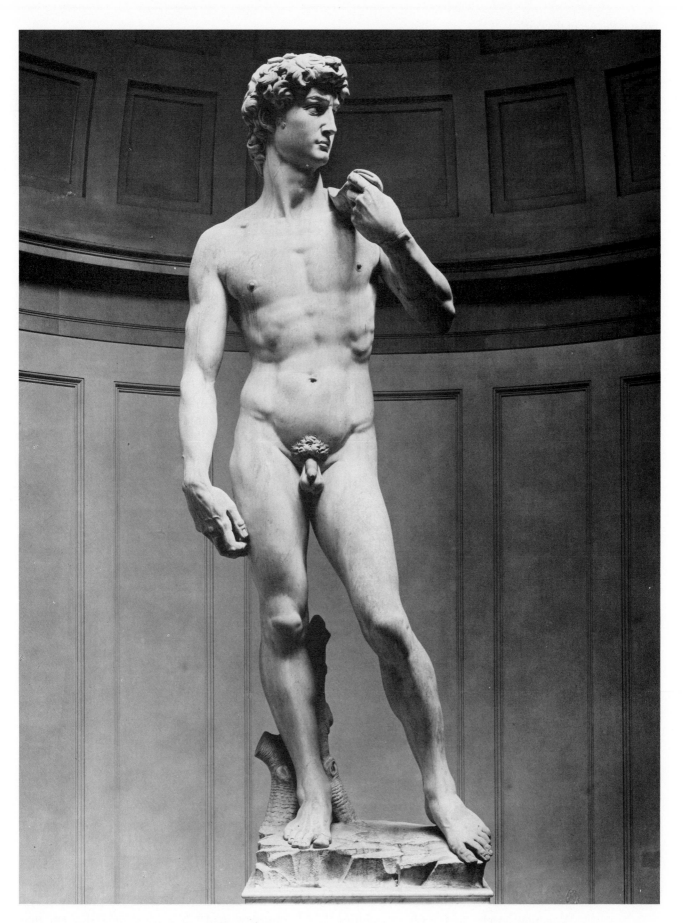

325 b. Michelangelo Buonarroti. DAVID. 1501–1504. Marble. Height 18'. Academy Gallery, Florence.

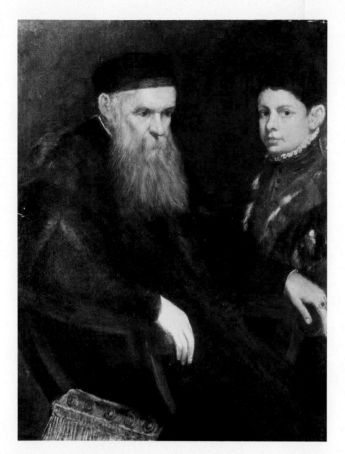

326 Marietta Tintoretto. PORTRAIT OF AN OLD MAN AND A BOY. c. 1585. Oil on canvas. Kunsthistorisches Museum, Vienna.

The art of portraiture developed with and contributed to the humanism of the Renaissance. By the late sixteenth century, portraits and other secular subjects had become at least as important as sacred themes. This portrait of her grandfather, PORTRAIT OF AN OLD MAN AND A BOY, was painted by Marietta Tintoretto, daughter of the painter Jacopo Tintoretto. It was long believed to have been painted by her father, but in 1920 her initial was found on it. She was taught by her father and worked on the backgrounds of his huge canvases. Later, she was much in demand as a portraitist and was invited to the French and Spanish courts. Her father would not let her go away, however, and reportedly married her off to a Venetian jeweler to keep her near him.

The Renaissance in Northern Europe

During the fifteenth century, new, highly representational styles of painting in Europe revealed a growing interest in the everyday secular world as seen by human eyes. This depiction of earthly reality began and developed in different ways, however, in Italy and in the North.

In the Northern Low Countries of Belgium, Holland, and Luxembourg, the leading artist was Jan van Eyck, known today as the "Father of Flemish painting." He was one of the first to paint with linseed oil instead of egg yolk or other protein, which was used in the traditional tempera paintings of the time. The fine consistency and flexibility of the new medium made it possible to achieve a brilliance and transparency unattainable until then. With oil, artists could make changes as they worked. On the same type of small wooden panels previously used for tempera painting, images were painted in minute detail, showing deep space, directional light, illusion of mass, rich implied textures, and the physical likenesses of particular people. Human figures and their interior settings took on a unique believable presence.

Often, as in van Eyck's GIOVANNI ARNOLFINI AND HIS BRIDE, the artist would include numerous commonplace objects, each of which had been vested with a special religious meaning. (See color plate 22.) Christian iconography had flourished during the Middle Ages, providing fifteenth-century culture with a rich symbolic heritage.

At the time the painting of the Arnolfini wedding was commissioned, the Church did not require the presence of the clergy for a valid marriage contract. All that was necessary was a *fides manuales* (joining of hands) and *fides levata* (raising right forearm) on the part of the man. Since it was easy to deny that a marriage had taken place, it is thought that

van Eyck's painting is a testament to the oath of marriage between Giovanni Arnolfini and Jeanne Cenami. As witness to the event, Jan van Eyck's signature and the date, 1494, are boldly written directly above the mirror.

Today the painting's complex Christian symbolism, well understood in the fifteenth century, must be explained. Many of the ordinary objects portrayed with great care have sacred significance. The lone, lighted candle in the chandelier represents the presence of Christ. The convex mirror, which reflects the images of the couple and the artist, is compared to the eye of God watching over all. The crystal beads and the sunlight are symbols of purity. The dog represents marital fidelity. Also, in a symbolic action, the wooden shoes of the bride and the groom were removed. God had commanded Moses on Mt. Sinai to take off his shoes when he stood on holy ground. Aside from the Christian symbolism it was stylish for a young woman to appear to be pregnant as an indication of her willingness to bear children.

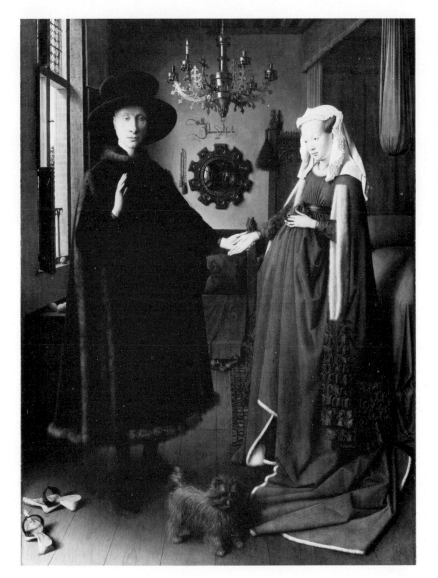

327 Jan van Eyck. GIOVANNI ARNOLFINI AND HIS BRIDE. 1434. Tempera and oil on panel. 33 x 22½". National Gallery, London. _See color plate 22, near page 274._

328 Joachim Patinir. REST ON THE FLIGHT INTO EGYPT. 1515–1524. Oil on wood. 6¾ x 8⁵⁄₁₆″.
Koninklijk Museum, Antwerp.

Almost one hundred years after van Eyck, another Flemish painter, Joachim Patinir, helped develop landscape painting as an art form in its own right. Earlier, landscape had been merely background for religious scenes. Patinir's subject in REST ON THE FLIGHT INTO EGYPT is still religious, but the landscape becomes more important than the figures of the Holy Family or the abduction of infants from the village.

Patinir emphasized the small scale of people in the natural world in a way that is similar to the earlier Chinese landscape tradition. In the foreground, rock formations tower above the Holy Family; in the middle ground, a village fits comfortably into the land; in the background, sky and water meet in infinity behind the distant hills. The deep space and apparent curvature of the earth express the excitement of the new age of exploration. Atmospheric perspective, heightened by the transparent glazes of the oil medium, helps to create a sense of space by gradually turning the warm greens and earth tones of the foreground into the light cool haze of the distant hills. By developing existing trends, Patinir helped to establish a tradition of landscape painting that has continued into this century.

Color plate 20 LEFTHAND
WALL, GREAT HALL OF
BULLS. Lascaux Caves,
Dordogne, France.
c.15,000–10,000 B.C.
Polychrome rock painting.

Color plate 21 CANOE
PROW ORNAMENT. Maravo
Lagoon, New Georgia,
Solomon Islands.
Collected 1929. Wood
with mother-of-pearl.
Height 6½''. Basel
Museum, Basel,
Switzerland.

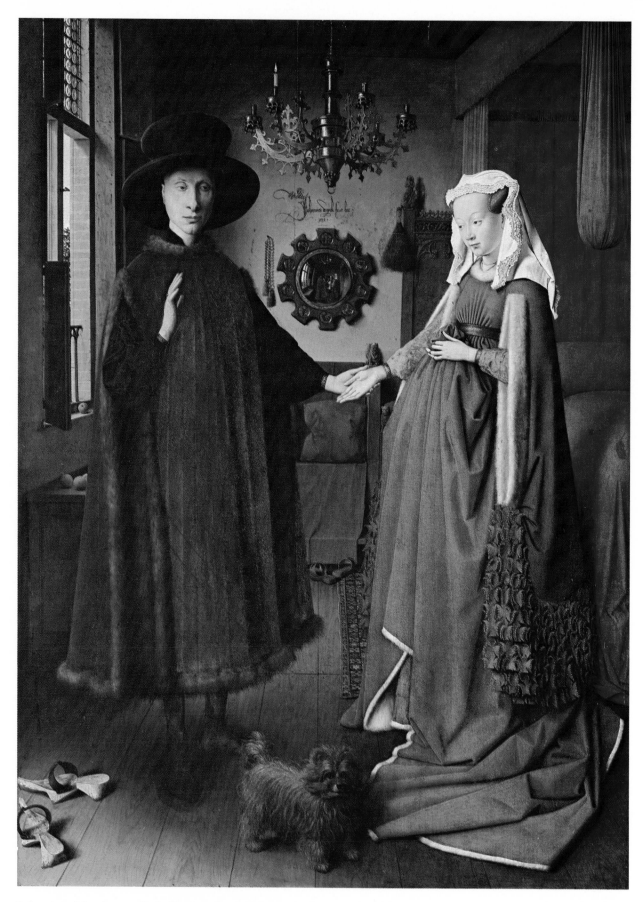

Color plate 22 Jan van Eyck. GIOVANNI ARNOLFINI AND HIS BRIDE. 1434. Tempera and oil
on panel. 33 x 22½''. National Gallery, London.

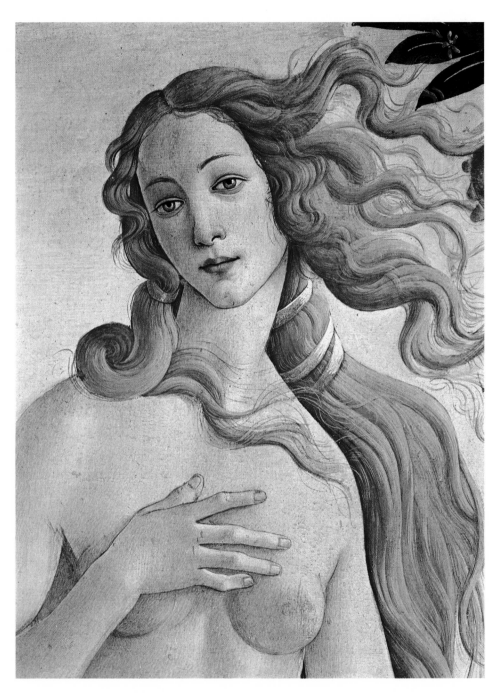

Color plate 23 Sandro Botticelli. Detail of BIRTH OF VENUS. c. 1490. Oil on canvas. Full painting 5'8⅞'' x 9'1⅞''. Uffizi Gallery, Florence.

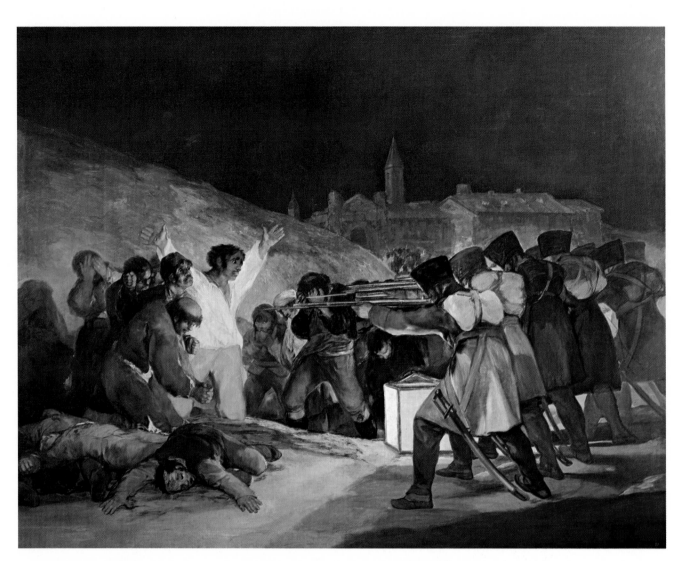

Color plate 24 Francisco Goya. THE THIRD OF MAY 1808. 1814. Oil on canvas. 8'9'' x
13'4''. The Prado Museum, Madrid.

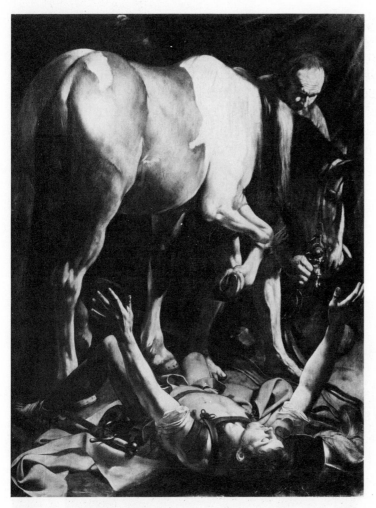

329 Michelangelo Merisi da Caravaggio. THE CONVERSION OF
SAINT PAUL. 1600–1601. Oil on canvas. 100 ⁹⁄₁₆ x 68 ¹⁵⁄₁₆ ''.
Santa Maria del Popolo, Rome.

The Baroque Age

Michelangelo Merisi da Caravaggio was one of the foremost painters of the *Baroque* style, which dominated late sixteenth- and seventeenth-century Italian and Spanish art and spread north with the Counter-Reformation. Baroque painting, sculpture, and architecture is typically dynamic, emotional, realistic, and often heavily ornate. Caravaggio brought to the stories of the Bible the vivid emotional intensity that he experienced in his own life. He wanted his paintings to be accessible and self-explanatory. The clergy for whom he painted rejected his style. His dramatic realism was too direct for people accustomed to aristocratic images demonstrating little more than insincere piety.

Caravaggio developed the use of light as a key element, directing the attention of the viewer and unifying and intensifying the subject matter. The strong contrast between light and dark areas and the highly developed chiaroscuro, as seen in THE CONVERSION OF SAINT PAUL, are characteristic of Baroque art. (See Zurbaran's ST. SERAPION, page 58.) It is no accident that Caravaggio chose to depict the conversion of Saint Paul: "And suddenly there shined round about him a light from heaven: and he fell to the earth."[10] Light from an unknown source creates a blinding flash, dramatizing the evangelist's enlightenment. The stabilizing inner geometry of Renaissance painting is replaced with a scene in which the major figure is foreshortened and pushed into the foreground, presenting such a close view that we feel we are there witnessing the event. Although the subject matter is sacred, the style is robust and reflects street life. The gestures and surfaces of the figures seem natural, in spite of the supernatural character of the event. Caravaggio gives a mystical feeling to ordinary things.

One of the most individual artists of the late sixteenth and early seventeenth centuries was Domenikos Theotokopoulos, known as El Greco (the Greek). He was born in Crete and studied in Italy where he absorbed a variety of influences. He finally settled in Spain where he evolved a highly personal style in which the calm grandeur of Renaissance imagery was transformed into new visions of great spiritual strength. El Greco achieved mystical and emotional intensity by abstracting religious subject matter into flamelike sinuous forms compressed in ambiguous space. His figures are both sculptural and intangible, embedded in a flickering chiaroscuro that covers the entire surface of the painting. Figures, drapery, and background are of almost equal importance and merge together in elongated vertical shapes. THE VISION OF SAINT JOHN THE DIVINE reflects a blending of Venetian color, Spanish mysticism, and Byzantine abstract tradition.

The most typically Baroque artist of the seventeenth century was the Italian sculptor and architect Gian Lorenzo Bernini. His THE ECSTASY OF SAINT TERESA, including a life-sized

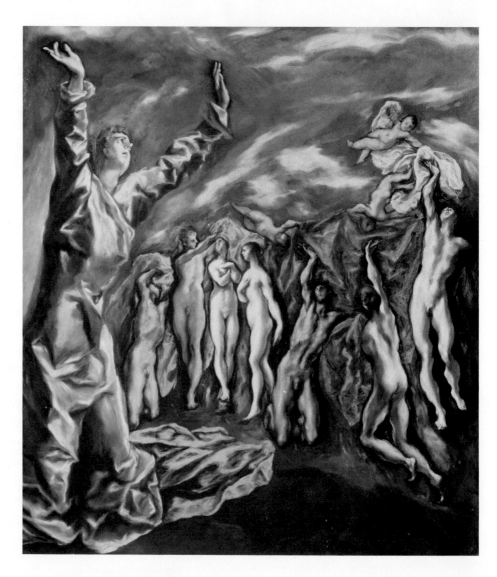

330 El Greco (Domenicos Theotocopoulos). THE VISION OF SAINT JOHN THE DIVINE. c. 1605. Oil on canvas. 88½ x 76''. Metropolitan Museum of Art, New York, Rogers Fund.

figure of the saint, is an amazing work representing one of Saint Teresa's visions as she recorded it. In this vision, she saw an angel who seemed to pierce her heart with a flaming arrow of gold, giving her great pain as well as pleasure and leaving her "all on fire with a great love of God."[11] Bernini makes the experience visionary, yet as vivid as possible, by choosing to portray the moment of greatest feeling. The turbulent drapery heightens the expression of ecstasy on Saint Teresa's face, suggesting strong spiritual energy within.

Both Saint Teresa and Bernini were part of the Counter-Reformation, a movement within the Roman Catholic Church that tried to offset the effects of increasing secularism, scientific investigation and the Protestant Reformation of the sixteenth century. The dramatic realism of Baroque painting and sculpture was part of the Catholic effort to revitalize the church. Bernini's THE ECSTASY OF SAINT TERESA is a major example. In it, Bernini symbolizes spiritual ecstasy by showing physical ecstasy. In this sense, this work has something in common with the Indian sacred sculpture on page 255.

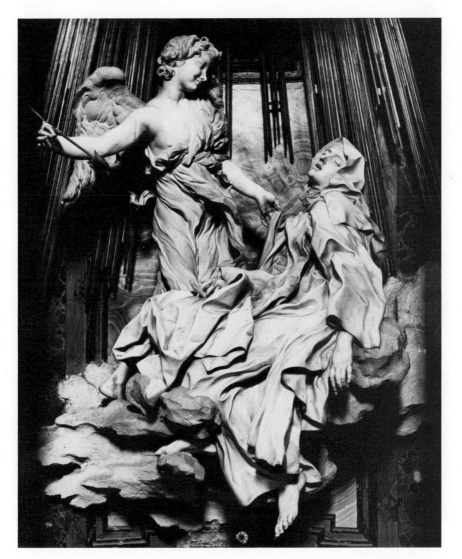

331 Gian Lorenzo Bernini. THE ECSTASY OF SAINT TERESA. 1645–1652. Marble. Life-size. Cornaro Chapel, Santa Maria della Vittoria, Rome.

332 Gian Lorenzo Bernini. CORNARO CHAPEL. 1645–1652. (18th century painting by an unknown artist. Staatliches Museum, Schwerin, Germany.)

If form is thought of as the total of a work's perceivable characteristics, then the environment in which a given work was intended to be seen must be considered since it modifies the form of the work. Bernini designed not only the figure of St. Teresa and the angel, but their altar setting and the entire Cornaro Chapel. The chapel is a monument of Baroque art that has many of the qualities of opera, which came into being during the seventeenth century. Opera was a major musical art form of the Baroque period, combining all the arts in elaborate dramas. An operatic quality is found in much Catholic Baroque art. In Bernini's Cornaro Chapel, architecture, painting, and sculpture work together to enliven the drama of the central figures above the altar.

This elaborate theatrical setting established a background underscoring the celestial qualities of Saint Teresa's dream. Above the saint and her heavenly messenger actual sunlight filters through a hidden window illuminating the work in such a way that it appears to dematerialize the figures.

In box seats on either side of the altar, sculptured figures of the Cornaro family witness the event, making symbolic contact between sacred and secular experience. Bernini intentionally broke the lines usually drawn between architecture, painting, and sculpture, as well as those between illusion and actuality.

In the Low Countries, Vermeer and Rembrandt (see color plate 3 and page 24) painted portraits of the wealthy, and views of the rich interiors of merchant homes. Velázquez, in Spain, was painter to the royal family and excelled in his renderings of them in their silk and satins. (See page 26.) There was, of course, some religious art in these countries: Rembrandt's etchings of the life of Christ, for example, were strong religious statements. (See page 140.) But art no longer relied wholly on the church for its support. In fact, most art was commissioned by the rising middle-class merchants and bankers and by the aristocracy.

The Dutch seventeenth-century painter Jan Vermeer had a great love for the way light reveals surfaces. Recent research shows that he used a table-model camera obscura in order to see this quality more accurately.

GIRL WITH A RED HAT is one of the painter's early works. It was painted on a small wooden panel about the same size as the frosted glass on which the image would appear in one type of camera obscura then in use. Vermeer evidently taught himself to see with photographic accuracy by copying images from the ground glass. In GIRL WITH A RED HAT the focus has a narrow range. Only part of the girl's collar and the left edge of her cheek are in sharp focus. Everything in front of and behind that narrow band becomes increasingly blurred. The carved lion's head on the arm of the chair in the foreground looks like shimmering light, just as it would appear in an out-of-focus photograph.

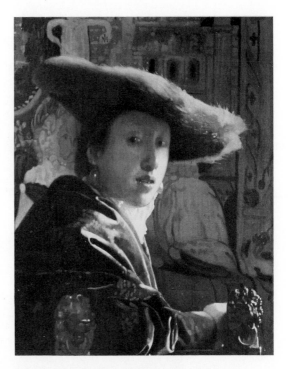

333 Jan Vermeer. GIRL WITH A RED HAT. c. 1660. Oil on panel. 9⅓ x 7⅛''. National Gallery of Art, Washington, D.C., Andrew Mellon Collection.

For Vermeer the camera obscura was a point of departure, not a crutch. With it he was able to develop his perceptive powers and to give form to his excitement over optical reality as revealed by light. He did not stop at the imitation of surfaces. His own deep sense of design was behind each brush stroke. The personal sense of order that he gave to the composition of his subjects contributes to the lasting strength of his paintings.

The camera obscura in the drawing on page 145 dates from the eighteenth century. It is a slightly more advanced model than the one Vermeer must have used. The principle of the camera obscura was first described by Leonardo da Vinci and was discussed in connection with his works. (See page 267.)

Also during the seventeenth century two imperial villas were constructed on opposite sides of the world. Both were surrounded by extensive gardens.

The supremacy of the French Sun King, Louis XIV, was symbolized by the elaborate Baroque architecture and gardens of VERSAILLES. The architecture is projected outward across the landscape in vast, formal gardens symbolizing the king's authority. Louis XIV organized nature in this way as a grand gesture of his power. Long straight avenues eventually lead out from the main parade ground in front of the palace. The longest of these connects Versailles with Paris and runs down the center of the entire plan. Strong symmetry is quite apparent here.

Versailles has one of the largest formal gardens ever conceived. Its terraces, reflective pools, and clipped hedges were planned to provide an appropriate setting for the king's public

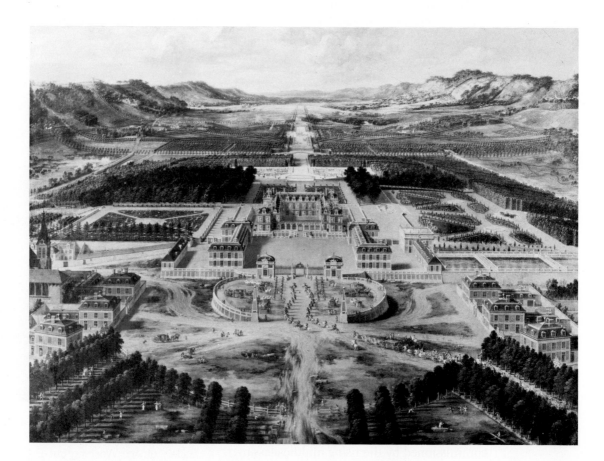

334 VERSAILLES. c. 1665. (Painting by Pierre Patel. The Louvre, Paris.)

335 a. AERIAL VIEW OF KATSURA. 17th century.

335 b. GARDENS AND TEA HOUSE AT KATSURA.

appearances and a playground for the gentlemen and ladies of the court who, with the king, enjoyed festivals in these outdoor spaces.

KATSURA, another seventeenth-century imperial villa, contrasts strongly with the form and content of Versailles. This Japanese palace near Kyoto was built under the direction of Prince Toshihito and his son Prince Toshitada. It occupies sixteen acres near the Katsura River, whose waters were diverted into the garden to form ponds. Land, water, rocks, and plants are masterfully interwoven with one another and with the buildings in a flow of man-made and natural things. The walls of the palace support no weight. They are sliding screens, which can be opened to allow interior and exterior space to blend.

When Katsura was constructed, the imperial family did not have much political power. The palace acted as a kind of retreat, in contrast to the imposing authoritarian character of Versailles.

By avoiding symmetry and maintaining simplicity, the builders of Katsura were able to give form to their attitude toward nature. Unlike Versailles, the palace complex was planned with no grand entrances either to the grounds or to the buildings. The palace is approached along garden paths. As one proceeds along these paths, unexpected views open up, designed to symbolize the seasons of the year. One of these is the view across a pond to the tea house. It has been carefully planned to look unplanned. The tea house has much in common with the traditional Japanese farm house. Natural materials and humble design provide a perfect setting for the building where the _cha-no-yu_, or tea ceremony, is performed. The ceremony embodies the same attitudes of simplicity, naturalness, and humility that permeate the entire palace grounds. The dominant feeling of the palace is one of timeless serenity. Katsura is a major work in a long Japanese tradition of respect for those factors that bring humanity and nature together in harmony.

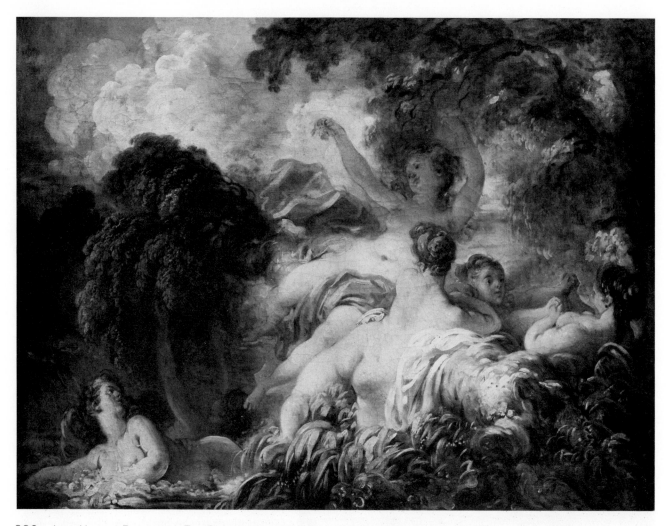

336 Jean-Honoré Fragonard. THE BATHERS. c. 1765. Oil on canvas. 25¼ x 31½''. The Louvre, Paris.

The heavy, theatrical qualities of Baroque art gave way to the *Rococo* style in France early in the eighteenth century. Rococo paintings are light and airy. Some of the movement, light, and gesture of the Baroque style is still present, but the total effect is quite different. The arts moved out of the marble halls of Versailles into the fashionable town houses.

The light, airy colors of the Rococo style in France were particularly suited to the escapist life of the court. Elegantly paneled interiors of palaces and wealthy homes were decorated with golden shells, garlands of flowers, and gay paintings. The word *Rococo* comes from the French *rocaille,* which refers to the shells and rocks used for ornament in garden grottos. The curved shapes of the shells were copied in architectural ornament and furniture, and influenced the billowing shapes in paintings.

THE BATHERS by Jean-Honoré Fragonard is one of the finest Rococo paintings. There is not a straight line in the entire composition. There are no hints of horizontal or vertical edges that might tie things down a bit. Everything flows in a pastel world. Compositions during this period were often as visually loose as the subjects were morally loose. It was part of the endless game-playing that centered in the French court.

THE DAWN OF A NEW AGE

Art for Political and Social Change

The luxurious life of the aristocracy ended abruptly with the French Revolution in 1789. French society and economy were disrupted and transformed, and tastes changed radically. One of the men who led the way to revolution was the painter Jacques-Louis David. When he painted the OATH OF THE HORATII, David intentionally used a classical approach. The resulting Neoclassical style was rational and controlled, and aimed at calling a halt to what David saw as the frivolous immorality associated with the Rococo.

The subject is a story of virtue and a readiness to die for liberty, in which the sons pledge to take the swords offered by their father to avenge the enemies of Rome. The heroic sense of duty to defend the homeland had great appeal to the French people. This painting acquired political meaning and was one of many factors that helped precipitate the French Revolution.

David's Neoclassicism emphasized a geometric structuring of the composition, creating an atmosphere of rational clarity in the painting. The three arches set on columns give strength to the design and provide a proper setting for the Roman figures. The two center columns separate the three major parts of the subject. The stable verticals and horizontals are aligned with the edges of the picture plane. Dramatic use of light emphasizes the figures against the shadowed areas behind the arches.

337 Jacques-Louis David. OATH OF THE HORATII . 1784. Oil on canvas. 10' 10'' x 14'. The Louvre, Paris.

338 Francisco Goya. THE THIRD OF MAY 1808. 1814. Oil on canvas. 8′ 9″ x 13′ 4″. The Prado Museum, Madrid. *See color plate 24, opposite page 275.*

Many of the freedoms won by the French Revolution were soon lost, either to dictators or counter-revolutionaries. Spanish painter Francisco Goya was a contemporary of David's. He was aware of the Revolution, and personally experienced some of its aftermath.

From his youth, Goya felt strongly about the liberal ideas of the Enlightenment. Throughout the later part of his life he was able to give form to these feelings, even though he held the position of painter to the degenerate Spanish royal family.

Because his sympathies were with the French Revolution, Goya welcomed Napoleon's invading army. He soon discovered that this army of occupation was destroying rather than defending the ideals he had associated with the Revolution. Madrid was occupied by Napoleon's troops in 1808. On May 2, a riot occurred against the French in the Puerto del Sol. Officers fired from a nearby hill and the cavalry was ordered to cut down the crowds. The following night a firing squad was set up to shoot anyone who appeared in the streets.

339 Paul Revere after Henry Pelham. THE BLOODY MASSACRE.
1770. Metal engraving. 9⅞ x 8¾''.

These brutalities were vividly and bitterly expressed by Goya in his powerful indictment of organized murder, THE THIRD OF MAY 1808, painted in February 1814. (See color plate 24.)

The painting is large and yet it is so well conceived in every detail that it delivers its meaning in a single, visual flash. Throughout the long hours necessary to complete such a work, Goya maintained the intensity of his original feelings. The essence of the scene is organized and given impact by bold patterns of light and dark. A wedge of middle value is formed by the edge of the hill and the edge of the lighted area on the ground. This wedge takes our glance immediately to the soldiers. From their dark shapes we are led by the light and the lines of the rifle barrels to the man in white. The entire picture is focused on this man. As more people are forced into the light for execution, he raises his arms in a final gesture of defiance. The irregular shape of his

shirt is illuminated by the hard, white cube of the soldier's lantern. Cold regularity marks the faceless firing squad, in contrast with the ragged group forming the target.

Goya was appalled at the massacre. Although it is not known whether he saw this particular incident, he did see many similar brutalities. His visual sensitivity, magnified by deafness, made war experience all the more vivid. The painting is neither an heroic reconstruction of history, nor a glorified press photograph. It is history—clarified, intensified, and given lasting form through art.

THE THIRD OF MAY 1808 is a symbol of real events that has become universal in its significance. This universality becomes even more apparent when Goya's work is compared to Paul Revere's record of the Boston Massacre. The subject of both pictures is the same, but what a difference! The engraving has historic interest to Americans because it was done by a famous patriot, and because of the significance of the event. The direct nature of its naive drawing adds quaintness to the scene. But Revere's work has little of the lasting impact of the Goya. Actually, Revere was an engraver. In the interest of delivering an important news picture to the public, he copied this design from an engraving of the same incident by Henry Pelham.

Eighteenth-century architects as well as painters, returned to classical concepts from ancient Greece and Rome as extended by the Renaissance.

In the eighteenth and nineteenth centuries, most architects adapted and combined ideas from earlier traditions. The practice of borrowing and combining the best from diverse sources is called *eclecticism*. By the nineteenth century, historic styles had been carefully catalogued so that architects could borrow freely. In church design, the Byzantine, Romanesque, and Gothic styles dominated. For public and commercial buildings, Renaissance, Greek, and Roman designs were preferred, and often mixed. This approach lasted well into the twentieth century.

Thomas Jefferson, American statesman and architect, designed his own home, Monticello. It was begun in 1770, completed about 1775, and remodeled to its present appearance between 1795 and 1809. The initial building was derived from a sixteenth-century interpretation of Roman country-style houses. Jefferson went to Europe as Minister to France between 1784 and 1789 and was strongly influenced by surviving examples of Roman architecture. When his home was rebuilt, the second story was removed from the center of the building and replaced by a dome on an octagonal drum. A large Greco-Roman portico was added, making the whole design reminiscent of the Pantheon (see page 245). In comparison with the first Monticello, the second version has a monumental quality reflecting Jefferson's increasingly classical conception of architecture. Jefferson designed the University of Virginia, which was built shortly before his death. Both Monticello and the University of Virginia are examples of the Roman phase of postcolonial architecture which is often called the Federal Style. The city of Washington is dominated by this eclectic style of architecture, which can also be found in practically every city in the United States. Jefferson's architecture has an originality in its application of Greek, Roman and Renaissance forms, causing his work to stand above the more imitative works of other Neoclassical architects.

340 Thomas Jefferson.
MONTICELLO. 1796–1806.
Charlottesville, Virginia.

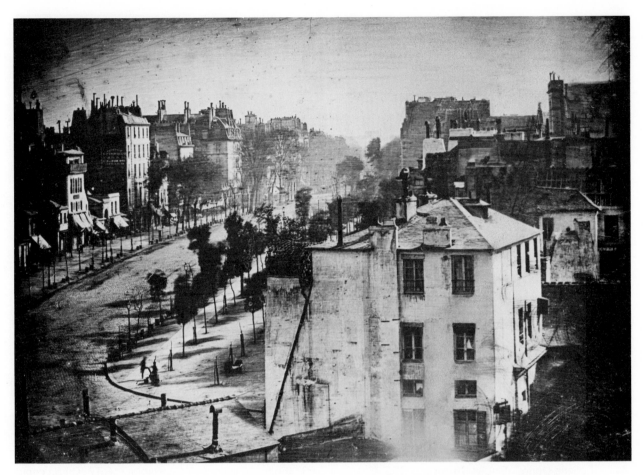

341 Louis Jacques Mandé Daguerre. LE
BOULEVARD DU TEMPLE. Paris, 1839.
Daguerreotype. International Museum of
Photography at George Eastman House,
Rochester, New York.

The Dichotomy of Vision and Emotion: Photography and Romanticism

During the third decade of the nineteenth century, the painter Louis Jacques Mandé Daguerre perfected a system for fixing a light-created image on a flat surface. The images produced by this process became known as *daguerreotypes*. The first true photograph had been produced in 1826 by Joseph Nicéphore Niépce by recording and fixing on a sheet of pewter an image made with light.

At first, photography could only be used to catch images of stationary objects. Then exposure time went from hours down to minutes. In this view of Paris in 1839, the streets appear deserted because moving figures made no last-ing light impressions on the plate. However, one man, having his shoes shined, stayed still long enough to become part of the image. You can see him in the lower left, the first human to appear in a photograph. It was a great moment in history. Now images of actual things could be recorded without the skillful hand of an artist. Artists were in this way freed from the role of recording visual appearances. Although some of them at the time felt the new medium constituted unfair competition that spelled the end of art, it actually marked the beginning of a period when art would once again become accessible to all.

342 Eugène Durieu. FIGURE STUDY. c. 1855.
Photograph.

343 Eugène Delacroix . ODALISQUE. 1857. Oil on canvas.
Collection Stavos S. Niarchos, London.

Photography freed the artist from being only an illustrator or storyteller. The realistic portrayal of subject matter could now be handled by the new medium, giving artists the opportunity to explore dimensions of inner experience scarcely considered previously. At the same time, photography offered the possibility of seeing the outer world of physical reality in new ways.

The French Romantic painter Eugène Delacroix was one of the first to recognize the difference between camera vision and human vision. He understood the unique qualities of each. For him the camera and the photographic process developed by Daguerre were of great benefit to art and artists: ". . . let a man of genius make use of the daguerreotype as it is to be used, and he will raise himself to a height that we do not know."[12]

Delacroix drew and painted from daguerreotypes and paper prints. He would set up a painter's composition with a model, and then with the help of the photographer Durieu, make a photograph. In an essay for students, he wrote:

A daguerreotype is a mirror of the object, certain details almost always overlooked in drawing from nature take on in it characteristic importance, and thus introduce the artist to complete knowledge of construction as light and shade are found in their true character.[13]

Thus, a photograph rather than a drawing became the basis for a painting.

Delacroix disliked most inventions of his day, such as the steamboat, and felt man was driven by the devil. He expressed himself strongly and with a good deal of foresight:

Here is another American invention that will let people go faster, always faster. When they have got travelers comfortably lodged in a cannon, so that the cannon can make them travel as fast as bullets . . . civilization will doubtless have taken a long step. . . . it will have conquered space but not boredom.[14]

The values that formed the basis of Romanticism did not produce a unified style. Yet this fact does not diminish the importance of this movement, which dominated French art between 1830 and 1850. The leading Romantic painter was Delacroix. Both Goya and Delacroix used Baroque lighting to heighten the dramatic impact of their work. Delacroix's painting THE DEATH OF SARDANAPALUS exhibits the many qualities distinguishing Romanticism from the Neoclassicism of David and his followers.

The frantic sensuality of this painting is based on Byron's poem wherein the legendary Assyrian ruler watches from his deathbed after ordering that his palace and all its contents be destroyed. The romantic ideal stresses passionate involvement, color, and spontaneous movement, in contrast to the cool, detached, formal linear qualities of Neoclassicism. Delacroix's rich color and rapid painterly execution was greatly admired by later painters, particularly the Dutch expressionist Vincent van Gogh.

344 Eugène Delacroix. THE DEATH OF SARDANAPALUS. 1827. Oil on canvas. 12′ 1½″ x 16′ 2⅞″. The Louvre, Paris.

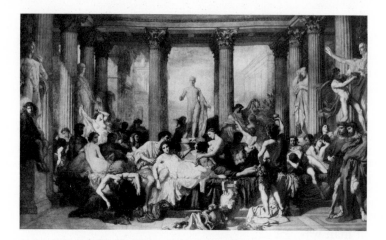

345 Thomas Couture. ROMANS OF THE DECADENCE. 1847. Oil on canvas. 15'1" x 25'4". The Louvre, Paris.

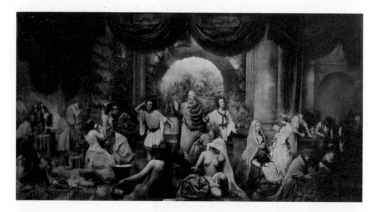

346 O. G. Rejlander. THE TWO WAYS OF LIFE. 1857. Photograph. 16 x 31". The Royal Photographic Society Collection, London.

Both Neoclassical and Romantic painters of the period enjoyed portraying historical, literary, mythical, and exotic subjects. The French School of Fine Arts, *L'Ecole des Beaux Arts*, gave official sanction to this approach to painting.

Thomas Couture's huge painting ROMANS OF THE DECADENCE is a romantic subject in a neoclassical setting typical of nineteenth-century French academic art. Academic art follows formulas laid down by an academy or school. This painting represents the dying gasp of concepts that had been worked and reworked since the Renaissance. Couture was a success because he fed the sexual needs produced by restrictive Victorian society. As they looked at the painting, they could allow themselves to enjoy it sensuously because it was clearly intended as a moralizing picture. But vast changes in art were about to topple the influence of the Academy.

Even photography, the medium so suited to staying in touch with the actual world, was pulled into service in the academic manner. With exceeding care, painter and photographer O.G. Rejlander combined over thirty negatives to achieve his ambitious THE TWO WAYS OF LIFE. The moral content is blatantly apparent: Which way does one choose?

Rejlander was devoted to the new medium of photography and sought to prove that it was possible to create photographs equal in importance to paintings. His opportunity came when he entered this print in the Manchester Art Treasures Exhibition of 1857. Queen Victoria, who was an amateur photographer, purchased the work.

Color plate 25
Claude Monet.
IMPRESSION:
SUNRISE. 1872. Oil
on canvas. 19½ x
25½". Museé
Marmottan, Paris.

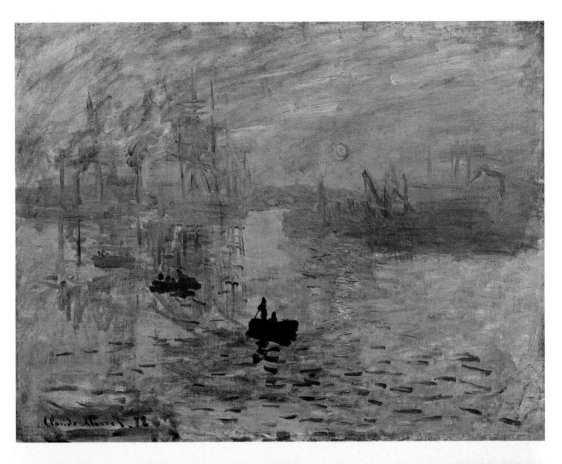

Color plate 26
Pierre-Auguste
Renoir. THE
LUNCHEON OF THE
BOATING PARTY.
1881. Oil on
canvas. 51 x 68".
The Phillips
Collection,
Washington, D.C.

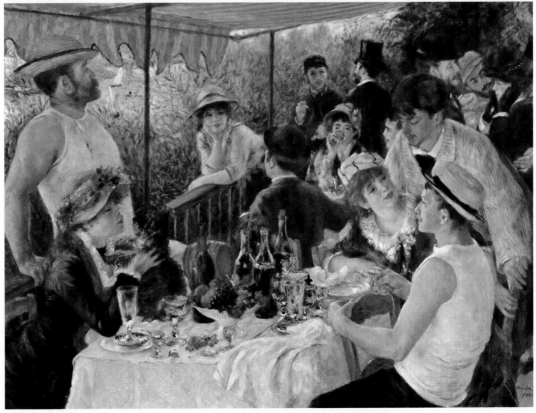

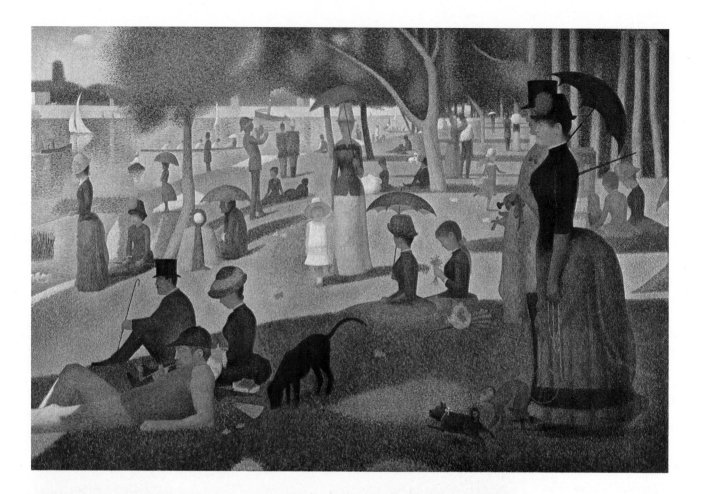

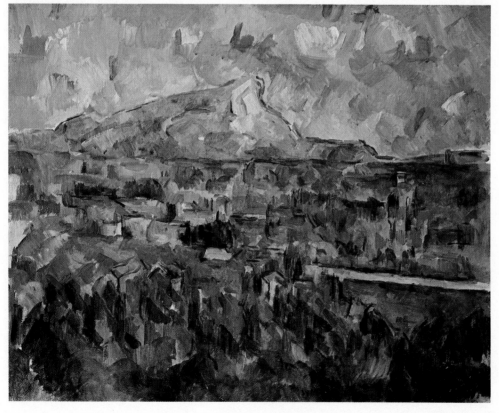

Color plate 27 Georges Seurat. SUNDAY AFTERNOON ON THE ISLAND OF LA GRANDE JATTE. 1884–1886. Oil on canvas. 81 x 120⅜". The Art Institute of Chicago.

Color plate 28 Paul Cézanne. MONT SAINTE-VICTOIRE. 1904–1906. Oil on canvas. 25⅝ x 31⅞". Private collection.

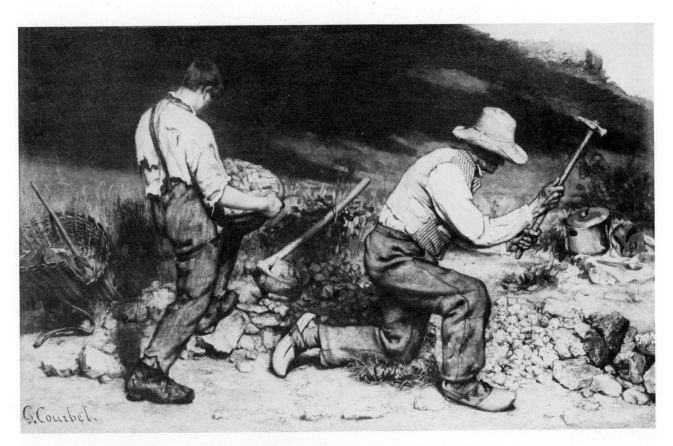

347 Gustave Courbet. THE STONE BREAKERS. 1849. Oil on canvas. 5′ 5″ x 7′ 10″. Destroyed during World War II. Formerly in State Picture Gallery, Dresden.

The Break: Realism and the New Architecture

The term *realism* is often used to describe a style that seeks to represent an equivalent of the retinal image. This approach was used before the nineteenth century, notably in Roman, Flemish, and Dutch painting. In the 1850s Gustave Courbet reinstated the concept with new vigor by employing a direct painterly technique and objective vision to represent images of contemporary life. By doing this, he broke with the artificial grandeur and exoticism of the popular and academically acceptable styles of his day and paved the way for a new way of seeing. Manet fused this realism with his own concepts and, in turn, sparked the enthusiasm for everyday reality so basic to Impressionism. In America, Eakins (see page 28) developed his own powerful realism based on Manet, Courbet, and Velázquez. The new technique of photography began to find itself in the mid-nineteenth century, making its own contribution to this reawakening of direct vision.

Courbet's THE STONEBREAKERS shows the painter's total rejection of Romantic and Neoclassic formulas. Courbet neither idealized the work of breaking stones, nor dramatized the struggle for existence. He simply said, "Look at this."

291

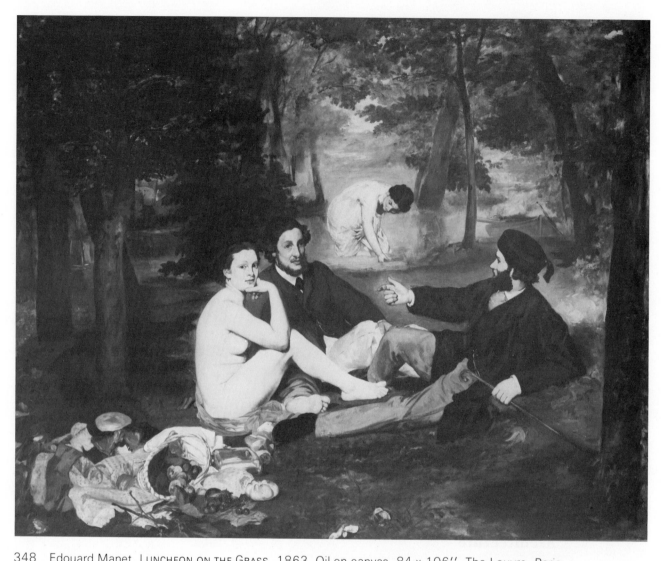

348 Edouard Manet. LUNCHEON ON THE GRASS. 1863. Oil on canvas. 84 x 106''. The Louvre, Paris.

Portable, slow-drying oil colors became available in 1841 with the invention of the collapsible tin tube. This made it possible for artists to paint outdoors without preliminary drawings or preconceived plans. Courbet was one of the first to work outdoors directly from nature. He looked at the physical reality of the immediate everyday world, choosing his subjects to fit his visual realism and his enjoyment in painting textures. His figures are contemporary, ordinary people. Strong feeling would only detract from the immediacy of the painting. When THE STONEBREAKERS was hung in Paris in 1850, it was attacked as unartistic, crude, and socialistic.

The revolution that occurred in painting in the 1860s and 1870s has sometimes been referred to as the Manet Revolution. Edouard Manet was a student of Couture. Compare Couture's ROMANS OF THE DECADENCE with Manet's LUNCHEON ON THE GRASS. It is difficult to believe that the paintings were done at about the same time. Manet rejected most of the artistic ideals of his teacher. His study

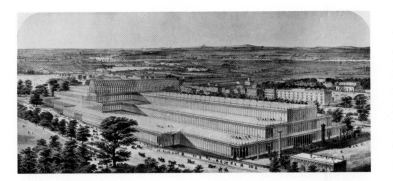

349 a. Joseph Paxton. CRYSTAL PALACE. London, 1850–1851. Cast iron and glass. Width 408', length 1,851'. (Etching. Victoria and Albert Museum, London.)

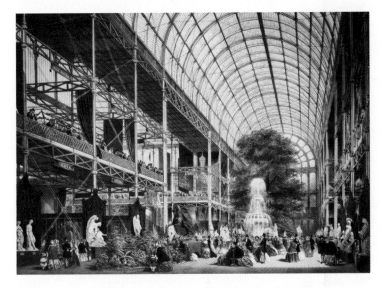

349 b. Joseph Paxton. CRYSTAL PALACE. Interior view. (Etching by Lothar Buchar. Victoria and Albert Museum, London.)

of the refined, flat shapes of Japanese art (see page 301) helped him to create paintings based on a new concept of the importance of the picture plane. Manet minimized illusionary space, giving full power to value and shape. His direct brushwork and choice of commonplace subjects reflect Courbet's influence. If Courbet painted the present, Manet painted *in* the present. He was an independent, who, through his interest in light, in everyday visual experience, and the fresh use of visual form, led the way into Impressionism.

Manet's depiction of a leisurely picnic in the woods scandalized French critics and the public because a French woman is represented in the nude accompanied by two men in contemporary Parisian dress. There is no hint of allegory, history, or mythology. It seemed that no one could get beyond the subject matter, which actually derives from a long tradition of figures in a landscape going back to Renaissance and Roman compositions. What is revolutionary about Manet's painting is his new attention to visual form independent of subject. We find ourselves beginning to look *at* rather than through or into his paintings.

New inventions of the Industrial Age, which led to a revolution in architecture, came at the same time as the rejection of the Academic style by Realist painters. In September 1850, construction began on Joseph Paxton's CRYSTAL PALACE, a large exposition hall designed for the Great Exhibition of the Works of Industry of All Nations, held in London in 1851. There is no eclecticism in this building. Paxton used the new methods of the Industrial Age, prefabricating iron, glass, and wooden sections to be assembled at the building site. Paxton's successful innovation helped lead to the concept that the function of a building should be expressed in its form. The light, decorative quality of the glass and cast iron units was created, not by applied ornamentation, but by the structure itself.

In its design, the Crystal Palace reveals concepts closer to the ideals of Buckminster Fuller than to the works of Paxton's contemporaries or even to Fuller's contemporaries. (See page 202.) Most significant of these concepts is the use of relatively lightweight, preformed *modules* or standard-sized structural units repeated throughout the building. This provided enough flexibility that the entire building could be assembled on the site right over existing trees and later disassembled and moved across town.

293

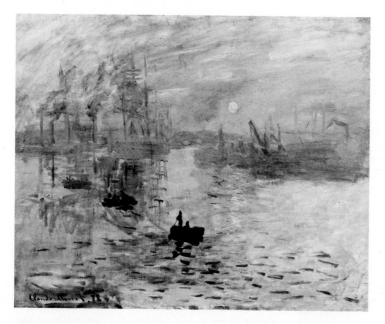

350 Claude Monet. IMPRESSION: SUNRISE. 1872. Oil on canvas. 19½ x 25½". Musée Marmottan, Paris. *See color plate 25, opposite page 290.*

Impressionism

In 1874 a group of young artists who were denied the right to show in the official French Academy exhibit hung their work in a photographer's studio. They were primarily interested in the momentary effect of light playing over the natural world. Landscape and ordinary scenes painted in varying atmospheric conditions and times of day were their main subjects. They were dubbed "Impressionists" by a critic who objected to the sketchy quality of their paintings, exemplified by Claude Monet's IMPRESSION: SUNRISE. (See color plate 25.) Their work came to be known as *Impressionism.*

Monet was the leader of the Impressionists. They called themselves "illuminists," and found the scintillating effect of light particularly beautiful. The group and their style were strongest between 1870 and 1880. After 1880 it was Monet who continued for more than thirty years to be true to Impressionism's original ideals. Instead of painting from sketches, he painted outdoors. To capture the momentary visual experience of a particular time of day Monet returned again and again to the same subject with different canvases in order to record the qualities of light and mood of each changing hour.

Since Monet painted with touches of pure color placed next to each other on the picture surface, rather than with colors premixed and then applied to the canvas, the viewer experienced a form of "optical mixing." In his paintings, a violet area may be made of violet, blue-purple, and touches of pure red. As the viewer's eye mixes the colors, a vibrancy results that cannot be achieved with paint mixed on the palette. The effect was startling to eyes used to the muted colors of academic painting.

Monet continued to paint in the Impressionist manner after others of the group such as Renoir, Degas, and Cézanne had moved on to develop individual styles. From about 1890 to his death in 1926, he painted the water lilies in his garden, making the reflective light and color on the pond and the lilies a basis for paintings of lyrical richness. WATER LILIES, shown here, is from this period. The free use of color and the vigorous brush strokes of the Impressionists were to influence the Abstract Expressionist painters of the mid-twentieth century.

Pierre-Auguste Renoir's THE LUNCHEON OF THE BOATING PARTY is a fine example of Impressionist concerns. (See color plate 26.) A group of friends are seen finishing their lunch at a small café situated on the bank of the river Seine a few miles from Paris. By 1881 Renoir had begun to move away from the lighter, more difuse, imagery of the 1870s toward solid forms and more structured composition. His distortion of true linear perspective, as seen in the railing and table top, reflects the declining interest in depicting depth noticed earlier in the works of Manet and Monet. As in the works of Monet, pure hues vibrate across the surface in delightfully exuberant brushwork.

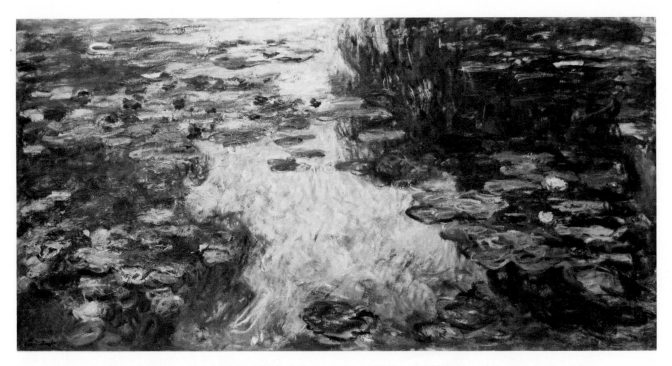

351 Claude Monet. WATER LILIES. 1919–1922. Oil on canvas. 29½ x 78¾". Honolulu Academy of Arts, purchased in memory of Robert Allerton.

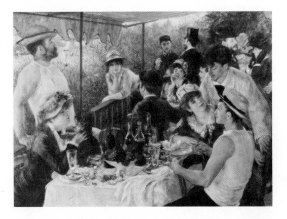

352 Pierre-Auguste Renoir. THE LUNCHEON OF THE BOATING PARTY. 1881. Oil on canvas. 51 x 68". The Phillips Collection, Washington, D.C. *See color plate 26, opposite page 290.*

The young men and women in the painting are conversing, sipping wine, dancing, and otherwise enjoying themselves at the open-air café. The Industrial Revolution had created a new leisure for the middle class; people were free on Sundays, and had the opportunity to gather together for pleasure. These images of joyous people savoring the delights of a moment encourage us to live fully in the present.

Painters like Manet, Monet, Renoir, and Degas were interested in seeing directly the spontaneous life happening around them. They rejected the artificial poses and limited color prescribed by the Academy. Because they rebelled against acceptable styles, they made few sales in their early years. Critics blasted their work with degrading remarks. Many of the painters whom we now consider the key masters of nineteenth-century art were outsiders, cut off from the traditional patronage of church and state and set apart from the acceptable art of their time. Men like Goya, and later Daumier, Courbet, Manet, Monet, Gauguin, and van Gogh gave birth to the idea of the artist as an isolated figure, starving in a garret. Today they are the ones whose works give us lasting pleasure. The painters of the academic school are largely forgotten.

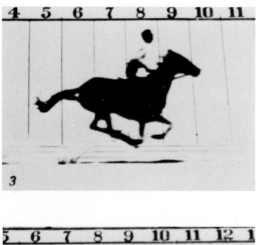

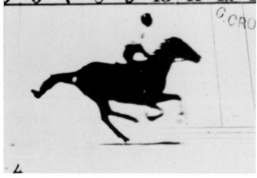

353 Eadweard Muybridge. GALLOPING HORSE. 1878. See illustration 181.

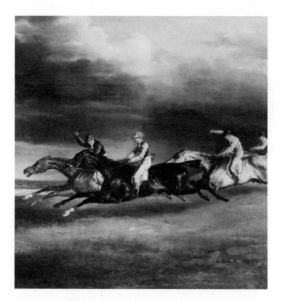

354 Théodore Géricault. Detail of HORSE-RACING AT EPSOM. c. 1819. Oil on canvas. 34⅝ x 47¼″. The Louvre, Paris.

The Impressionists' new sense of perceiving life as it happened in the everyday world was carried into paintings of people and horses in motion and is related to pioneering studies of motion that were being done with photography at that time.

Eadweard Muybridge was the first photographer to make elaborate studies of animals and people in action. His stop-action stills of a galloping horse made it possible to see how a horse actually moves. Muybridge's photographs proved that a horse's feet leave the ground in a rolling sequence rather than in pairs. A comparison between the photograph by Muybridge and a painting of racing horses by Théodore Géricault is a clear example of how photography has given us new ways of seeing. Géricault had a great knowledge of horses and of painting, but he could not see how horses really moved. The photographic process had not been invented when he painted HORSE-RACING AT EPSOM.

Edgar Degas and other Impressionist painters were strongly influenced by the new ways of seeing and imagemaking suggested by Japanese prints and by photography. Both of these sources depicted figures in candid poses often cut off by the edge of the picture plane in sharp contrast with standard European compositions at the time.

The tipped-up floor planes and bold asymmetry of Japanese prints led Degas to create superbly designed paintings full of intriguing visual tensions such as those seen in THE BALLET CLASS of 1880.

Degas depicted classes in ballet in ways that revealed their true unglamorous character. Often, as here, he was able to turn his great ability to the task of defining human character and mood in a given situation.

355 Edgar Degas. THE BALLET CLASS. c. 1880. Oil on canvas. 32⅛ x 30⅛". Philadelphia Museum of Art. Purchased: The W. P. Wilstash Collection.

356　Georges Seurat. SUNDAY AFTERNOON ON THE ISLAND OF LA GRANDE JATTE. 1884–1886. Oil on canvas. 81 x 120⅜". The Art Institute of Chicago. *See color plate 27, opposite page 291.*

Degas's painting builds from the quiet disinterested grandmother in the foreground up to the right, then across to the cluster of dancing girls following the implied line of sight of the ballet master. The fairly calm stability of the combined group on the right sets off the smaller, highly irregular composite shape of the girls struggling before the mirror. Degas has managed to hold in balance spatial tensions between near and far, and to shape tensions between stable and unstable, large and small.

Notice how Degas emphasizes the line in the floor, which he brings together with the top of the old lady's newspaper in order to guide the viewer's eye movement within the painting. The angle of the old lady's foot brings us back around to begin again.

The Post-Impressionist Period

Post-Impressionism refers to the composite of styles that followed Impressionism between 1885 and the turn of the century. Painters who tried Impressionism early in their careers came to feel that solidity of form and composition had been sacrificed for the sake of fleeting impressions of light and color. They sought a new balance. *Post-Impressionism* is a confusing term because it refers to a complex of reactions to Impressionism, rather than to a single style. There were two dominant tendencies during the period: expressionism and formalism.

Four men stand out in retrospect: Paul Gauguin, Vincent van Gogh, Georges Seurat, and Paul Cézanne.

Gauguin and van Gogh brought emotional intensity and spontaneity to their work. They used bold color contrasts, shapes with abruptly changing contours, and, in van Gogh's case, swirling brush strokes. They were the romantics, the expressionists. From them developed the twentieth-century styles of _Expressionism._

Seurat and Cézanne were more interested in _formalism,_ in structure and rational clarity. They were the classicists or formalists. Both organized visual form in order to achieve a new clarity of design.

Seurat's large painting SUNDAY AFTERNOON ON THE ISLAND OF LA GRANDE JATTE has the subject matter, the broken brushwork, and the light and color qualities of Impressionism. But this painting is not of a fleeting glimpse; it is a structural design worked out with great precision. Seurat set out to systematize the optical color mixing of Impressionism and to create a more rigid organization with clearly edged, simplified forms. His system was called _pointillism._ With it, Seurat tried to develop and apply a scientific painting method that would make the intuitive approach obsolete. He arrived at his method by studying the principles of color optics that were being discovered at the time. He applied his paint in tiny dots of color to achieve optical mixture. This method had a direct influence on modern color printing, in which tiny yellow, red (magenta), blue (cyan), and black dots give the appearance of full color. (See color plates 27 and 6.)

A large number of drawn, photographed, and painted studies of the subject preceded his masterpiece. With them, Seurat studied carefully the horizontal and vertical relationships, the character of each shape, and the patterns of light, shade, and color.

The final painting shows the total control that Seurat sought through the application of his method. The frozen formality of the figures seems surprising, considering the casual nature of the subject matter. Can you imagine how Renoir would have handled this? But it is precisely its calm, formal grandeur that gives the painting its lasting appeal.

Of the many great painters working in France during the last twenty years of the nineteenth century, it is said that Cézanne had the most lasting effect on the course of painting. Because of this, he is referred to as the "Father of Modern Art."

Cézanne, like Seurat, was more interested in the structural or formal aspects of painting than in its ability to convey emotions. He shared the Impressionists' practice of working directly from nature. But in his later work he wished to achieve a lasting formal image. "My aim," he said, "was to make Impressionism into something solid and enduring like the art of the museums."[15] He worked for a new synthesis of nature and the approaches used in masterworks of the past, particularly the paintings by Nicolas Poussin. Cézanne said, "I want to do Poussin over again from nature."[16]

Cézanne shared with Seurat the desire to make something lasting out of the discoveries of the effects of light and color. They both based their work on direct observation of nature and they both used visibly separate strokes of color to build their richly woven surfaces of paint. Seurat's highly demanding method was not popular among younger artists. Cézanne's open strokes, however, were part of an open-ended system of geometric structuring that offered a whole range of possibilities to those who studied his work.

Cézanne achieved a method of designing the picture's space by carefully developing exactly the right relationships between separate strokes of color. His approach gave a new life to the surfaces of his own paintings and influenced the works of many later painters.

357 Paul Cézanne. MONT SAINTE-VICTOIRE. 1904–1906.
Oil on canvas. 25⅝ x 31⅞″. Private collection. *See color plate 28, opposite page 291.*

358 Nicholas Poussin. SAINT JOHN ON PATMOS.
1645–1650. Oil on canvas. 40 x 52½″.
The Art Institute of Chicago.

Cézanne also gave new importance to the compositional problems that the Impressionists had tended to ignore. Landscape was one of his main interests, but unlike the Impressionists, his subjects were merely a point of departure. He went beyond the reality of nature, organizing it in his own way to create a new reality on the picture surface. In MONT SAINTE-VICTOIRE, we can see how he flattened space. The dark edge lines around the distant mountain stop our eyes and return them to the foreground. He simplified the houses and tree masses into almost geometric planes. (See color plate 28.) Compare this painting with Monet's IMPRESSION: SUNRISE opposite page 290 to see how Cézanne moved away from Impressionism.

The young painters who were coming to study in Paris at the turn of the century looked to Cézanne to help them develop new ways of seeing, new ways of organizing form. Out of these experiments and Cézanne's analytical approach to painting would grow the new twentieth-century style of Cubism.

Japanese prints were an important influence on European and American painters beginning with Manet and continuing into the twentieth century. In the mid-seventeenth century, Japanese woodcut printing evolved from a way of reproducing paintings to a way of producing original prints. For the next two hundred years, hundreds of thousands of such prints were produced for the popular market. They are called *Ukiyo-e* (which means "floating world") woodblock prints because they depict transient scenes of daily life, particularly as it was lived in the entertainment centers of the time.

Utamaro's woodcut of a woman looking at herself in a mirror is subtly abstract. The ordinary subject is transformed into a memorable image based on bold curving outlines defining flat shapes. The center of interest is the reflected face of the woman, set off by the strong, simple curve representing the mirror's edge. No shadows are indicated. The figure is thrust in from the right and cut off by the edge of the picture plane rather than presented completely within the frame as in traditional European painting.

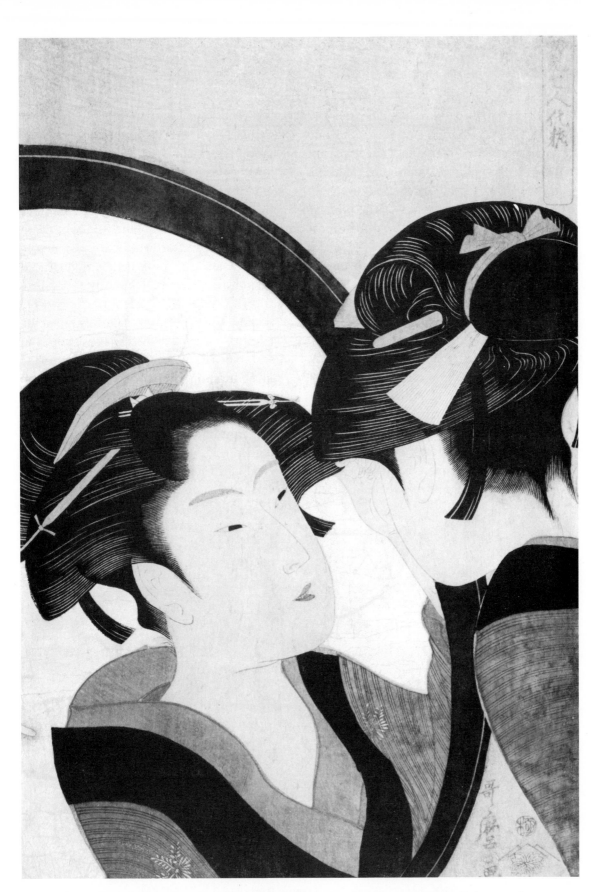

359 Kitagawa Utamaro. ONE OF SEVEN WOMEN SEEN IN A MIRROR. c. 1790. Color woodcut. Museum of Fine Arts, Boston. Spaulding Collection.

The depiction of everyday life and the strong sense of design in prints like this one inspired Western painters like Manet (see page 292) to break with the Renaissance tradition. Japanese *Ukiyo-e* prints, in their often superb design, were fine realizations of the primary expressive nature of the two-dimensional properties of the picture surface.

The influence of Japanese prints is readily apparent in the simplicity and bold design of Mary Cassatt's THE BOATING PARTY. The painting is Impressionist in subject matter, and post-Impressionist in form.

With van Gogh, late nineteeth-century painting moved from an outer *impression* of what the eye sees to an inner *expression* of what the heart feels and the mind knows. Vincent van Gogh's deep feeling for life's essential truths and his early interest in literature and religion led him to work as a lay preacher for poverty-stricken coal miners, where he fought against the often inhuman values of an industrial society. Dissatisfied with his inability to change the social injustice he saw, van Gogh turned instead to art. With financial support from his brother Theo, he began working as an artist in 1880 when he was 27 and continued to develop his abilities until his death ten years later. During these few years he overcame an early clumsiness and produced works of great emotional intensity and spiritual insight.

From Impressionism, van Gogh learned the expressive potential of divided brushwork and pure color, but the style did not provide enough freedom to satisfy the desire to express his emotions. Without departing from "natural color," van Gogh intensified the surface of his paintings with textural brushwork that recorded each gesture of his hand.

Van Gogh used startling color in an effort to express his emotions. He wrote:

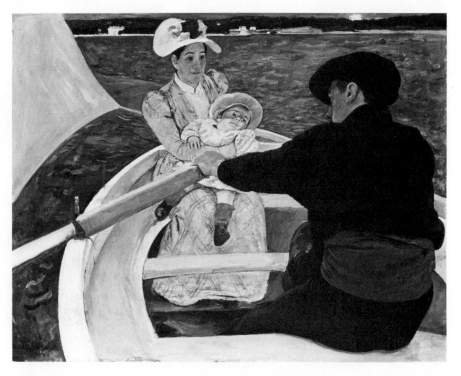

360 Mary Cassatt. THE BOATING PARTY. 1893–1894. Oil on canvas. 35½ x 46⅛". The National Gallery of Art, Washington, D.C., Chester Dale Collection.

361 Vincent van Gogh after Hiroshige. PLUM TREES IN BLOSSOM . 1888. Oil on canvas. 55 x 46 cm. National Museum Vincent van Gogh, Amsterdam.

362 Vincent van Gogh. THE SOWER. 1888. Oil on canvas. 17⅜ x 22⅛''. National Museum Vincent van Gogh, Amsterdam.

Instead of trying to reproduce exactly what I have before my eyes, I use color more arbitrarily so as to express myself forcibly. . . . I am always in hope of making a discovery there to express the love of two lovers by a marriage of two complementary colors, their mingling and their opposition, the mysterious vibrations of kindred tones. To express the thought of a brow by the radiance of a light tone against a sombre background.[17]

Van Gogh found inspiration for his new sense of design by copying the work of Japanese printmaker Ando Hiroshige. Van Gogh's copy of Hiroshige's PLUM TREES IN BLOSSOM is quite accurate. In THE SOWER, van Gogh demonstrates his newly acquired sense of bold, simple shapes and flat color areas. The wide band of a tree trunk cuts diagonally across the composition as a major shape, its strength balancing the sun and its energy coming toward us with the movement of the sower.

It is not necessary for an artist to work with a conscious knowledge of all the visual elements and how they interact. These interactions can be intellectually formulated most thoroughly after the creative work is completed. A strong desire to share personal experience motivated van Gogh. After tremendous struggle with materials and techniques, he finally reached the point at which he was able to put his intensity on paper and canvas. "The artist does not draw what he sees but what he must make others see."[18]

303

In THE STARRY NIGHT van Gogh's observation of human life within landscape becomes the point of departure for an invented symbolic image of great magnitude. Hills seem to undulate in rhythm to tremendous cosmic forces of the sky. The limited scale of human life is presented in the town nestled into the dark forms of the ground plane. The church's spire reaches toward the heavens echoed by the larger more dynamic upward thrust of the cyprus trees in the left foreground. Cyprus is traditionally planted beside graveyards in Europe as a symbol of eternal life. All these elements are bound together by the surging lines that cover the surface and express van Gogh's passionate feelings for the creative force that animates all life. (See color plate 29.)

Paul Gauguin began painting on Sundays, working in an Impressionist manner while making a good living as a stockbroker. He decided to quit his job and leave his family to devote himself full time to art. What he sought was a style that went beyond the confines of Renaissance imagery to reveal something more of mind and spirit.

In 1888 Gauguin completed THE VISION AFTER THE SERMON (see color plate 30), a large carefully designed painting that was the

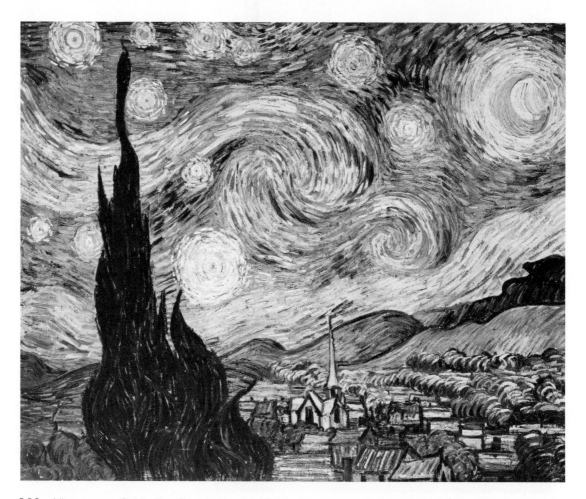

363 Vincent van Gogh. THE STARRY NIGHT. 1889. Oil on canvas. 29 x 36¼''. The Museum of Modern Art, New York. Lillie P. Bliss Bequest. *See color plate 29, opposite page 306.*

364 Paul Gauguin. THE VISION AFTER THE SERMON (JACOB WRESTLING WITH THE ANGEL). 1888. Oil on canvas. 28¾ x 36½''. National Gallery of Scotland, Edinburgh. *See color plate 30, opposite page 306.*

first major work in his new style. It is an image originating in the mind rather than the eye. With it, Gauguin took a major step beyond Impressionism. In order to avoid what he considered the distraction of implied deep space, he tipped up the simplified background plane and painted it an intense "unnatural" vermilion. The entire composition is divided diagonally by the trunk of the apple tree, in the manner of Japanese prints. Shapes have been reduced to flat curvilinear areas outlined in black, with shadows minimized or eliminated. Jacob and the angel appear to the group in a vision inspired by the sermon in their village church.

Gauguin's use of color had an important influence on twentieth-century painting. His views on color were prophetic. The subject, as he said, was only a pretext for symphonies of line and color.

In painting, one must search rather for suggestion than for description, as is done in music. . . . (T)hink of the highly important musical role which colour will henceforth play in modern painting.[19]

365 Paul Gauguin. TWO NUDES ON A TAHITIAN BEACH. 1892. Oil on canvas. 35¾ x 25½''. Honolulu
Academy of Arts. Gift of Mr. and Mrs. Charles M. Cooke.

Color plate 29
Vincent van Gogh.
THE STARRY NIGHT.
1889. Oil on canvas.
29 x 36¼''. The
Museum of Modern
Art, New York.
Acquired through the
Lillie P. Bliss
Bequest.

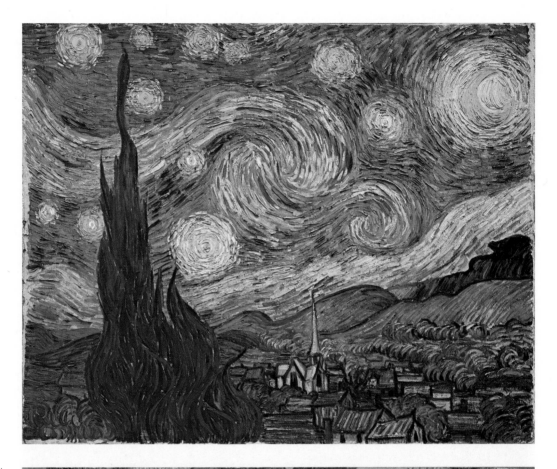

Color plate 30 Paul
Gauguin. THE VISION
AFTER THE SERMON
(JACOB WRESTLING
WITH THE ANGEL).
1888. Oil on canvas.
28¾ x 36½''.
National Gallery of
Scotland, Edinburgh.

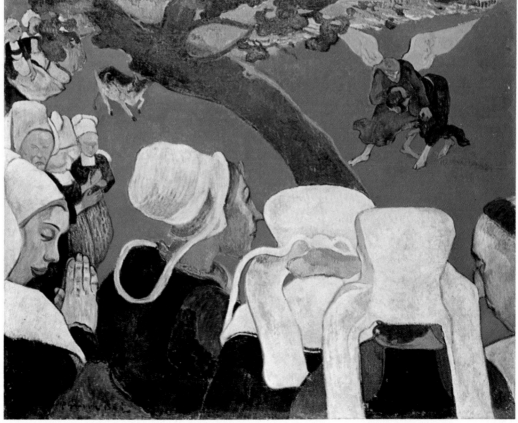

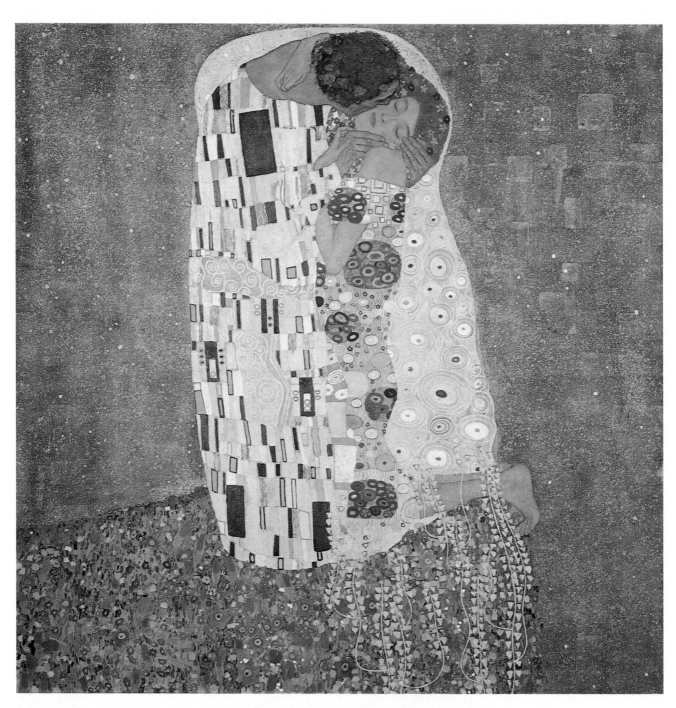

Color plate 31 Gustav Klimt. THE KISS. 1908. Oil on canvas. 71 x 71''. Galerie Welz
Salzburg, Salzburg, Austria.

Like his colleague van Gogh, Gauguin was highly critical of the materialism and artificiality of industrial society that caused people to neglect true feelings. This attitude led him to admire the honest life of the Brittany peasants of western France and then to try to break with European civilization by going to Tahiti.

Gauguin's painting TWO NUDES ON A TAHITIAN BEACH has a shallow spatial feeling, in spite of the fact that the subject suggests a background of infinite space. Within the large areas of color, there are subtle variations, but the values are close enough so that the areas read as flat shapes. The figures are solid, yet the black lines around them keep them on the surface of the picture plane.

Gauguin escaped the industrialized world of Europe by fleeing to the romantic South Seas in an attempt to return to a more natural life. Other artists found their subjects in less pleasant aspects of city life.

Jacob Riis armed himself with a camera in order to record the misery of a world at which no one really wanted to look . For Riis, art was a way of calling attention to and thereby helping to change conditions of suffering that appalled him. In holding this attitude he was unique among many of the prominent photographers of the day, who sought merely to imitate the artistic effects of painters. Riis realized that the photographic medium would enable him to produce strong images of the living environment of New York slum dwellers.

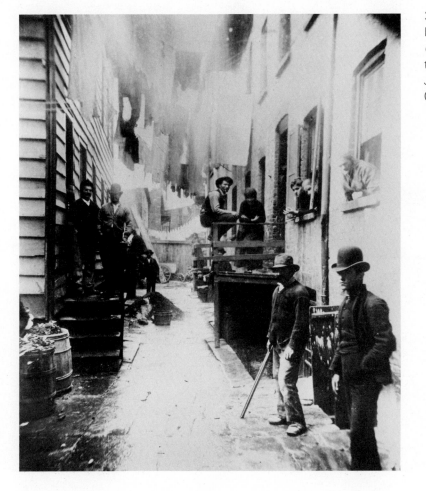

366 Jacob Riis.
BANDIT'S ROOST.
c.1888. Museum of
the City of New York,
Jacob A. Riis
Collection.

Henri de Toulouse-Lautrec painted in the gaslit interiors of Parisian nightclubs and brothels, frequently catching their atmosphere in moments of deep human drama. His quick, long strokes of color define a world of sordid gaiety. In his painting AT THE MOULIN ROUGE, he used unusual angles, photographic cropping of images, such as the face on the right, and vivid color to heighten our feelings about the people he painted. He, like Gauguin and van Gogh, influenced the later Expressionists.

Edvard Munch, a Norwegian, traveled to Paris to study and view the works of his comtemporaries, especially Gauguin, van Gogh, and Toulouse-Lautrec. What he learned from them, particularly from Gauguin, enabled him to carry *Expressionism* to an even greater level of intensity.

His great work, THE SHRIEK, completed as a painting and as a lithograph, is far from the pleasant delights of Impressionism and even takes van Gogh's emotionalism one step further. It is difficult to imagine a more powerful image of anxiety. The major human figure could be anyone caught in complete isolation, fear, and loneliness. Despair reverberates throughout the picture, carried by continuous linear rhythms.

367 Henri de Toulouse-Lautrec. AT THE MOULIN ROUGE. 1892. Oil on canvas. 48⅜ x 55¼". The Art Institute of Chicago.

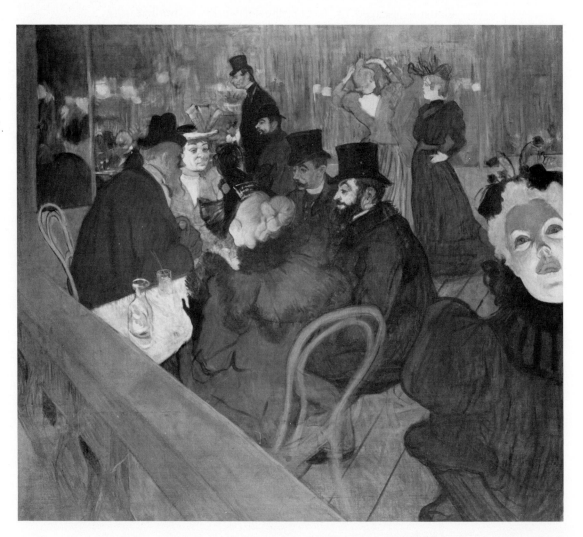

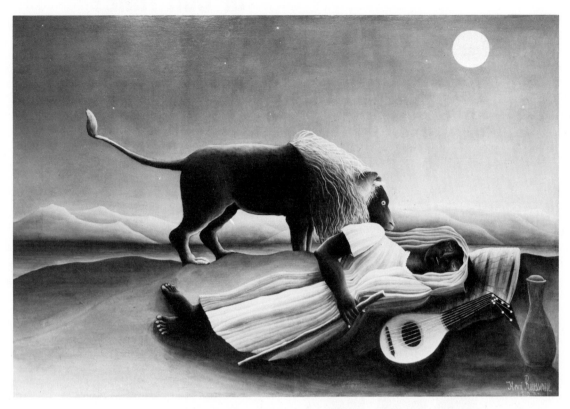

369 Henri Rousseau. THE SLEEPING GYPSY.
1897. Oil on canvas. 51 x 79''. The Museum
of Modern Art, New York. Gift of Mrs. Simon
Guggenheim.

368 Edvard Munch. THE SHRIEK. 1896.
Lithograph. $20^{11}/_{16}$ x $15^{13}/_{16}$''. The Museum
of Modern Art. New York. Matthew T. Mellon
Foundation Fund.

As the nineteenth century came to an end,
several artists became precursors of the twen-
tieth century's exploration of human inner ex-
perience. Of these, the works of Munch and
the "naive" French painter Henri Rousseau
show differing personal expressions of the
mysterious psychic world of dream and night-
mare. Rousseau's THE SLEEPING GYPSY is a
painted dream, relating to Surrealism of the
1920s. (See page 343.) Its purity, mystery, and
rich abstract power keep us endlessly fasci-
nated. Rousseau's lack of formal art educa-
tion freed him from academic convention
and permitted his instinct and imagination
to have full reign.

5 WHAT IS THE ART OF OUR TIME?

Now that we are approaching the end of the twentieth century, it is fairly easy to identify certain dominant concerns among artists and to see characteristics in their work that reveal the unique features of our age. These features include rapid change, diversity, individualism, and exploration followed by abundant new discoveries. All of these have challenged and transformed the assumptions of the past, while expanding the limits of what we know to be true and possible. The veritable explosion of new styles in this century follows this continuous challenge and reexamination of traditions. Yet the art we call modern today has roots in many cultures going far back in time.

It may seem that "isms" soon become "wasms" as styles replace one another in rapid succession. The "isms" of art are terms for movements or individual styles that have been particularly significant. Such classifications help to define the concepts and characteristics of important art movements. The goal of this chapter is to extend what we know is possible, not merely to classify art forms.

The great diversity today of group and individual styles in painting and sculpture makes meaningful generalizations quite difficult, and at times misleading. The perspective of time is needed before future historians can select what they feel are the outstanding trends and styles of the twentieth century—ignoring the rest as we do when we discuss the art of earlier times. We are too close to the art of today to know which of it will have meaning for future generations. But some terms and classifications are becoming well established and, as in the past, some names applied to significant trends at their inception will remain.

370 Francois Auguste René Rodin. THE KISS. 1886–1898. Marble. Height 5′ 11¼″. Musee de Luxembourg, Paris.

time and space with his theory of relativity, published in 1905. In 1908 the Wright brothers began modern aviation history by flying the first power-driven aircraft. With these new concepts regarding the essential nature of reality, matter became fields of energy, and the space frame of Renaissance perspective dissolved into a dynamic, nonlinear, omnidirectional flow. New styles came forward in rapid profusion and artists began to break down visual preconceptions inherited from earlier periods.

In 1913 the Russian artist Wassily Kandinsky described how deeply he was affected by the discovery of subatomic particles.

A scientific event cleared my way of one of the greatest impediments. This was the further division of the atom. The crumbling of the atom was to my soul like the crumbling of the whole world.[1]

Art does not illustrate science but is a parallel concern dedicated to investigating and revealing what we know of the true nature of reality.

There is no meaningful way to present art history of the twentieth century in a single, chronological sequence. In any period, art and the life that goes with it are more like a collage than a line, particularly in a complex, contradictory time like ours.

One of the greatest transitions that occurred in early twentieth-century art was the move from representational to abstract and non-representational.

THE KISS by Auguste Rodin and THE KISS by Constantin Brancusi represent this transition. Rodin's work is representational; Brancusi's is abstract. Rodin was the great master of sculpture in the second half of the nineteenth century; Brancusi held the same position for the first half of the twentieth.

The rich variety of styles is a large part of what makes today's art so exciting. Artists themselves are extending the concept of art.

During the first decade of this century, major changes were taking place in the way people looked at the world. Revolutionary scientific discoveries shattered prevailing assumptions about the solidity of objects. The work of several physicists led to the discovery of subatomic particles within the nucleus of the atom. Einstein changed the concepts of

311

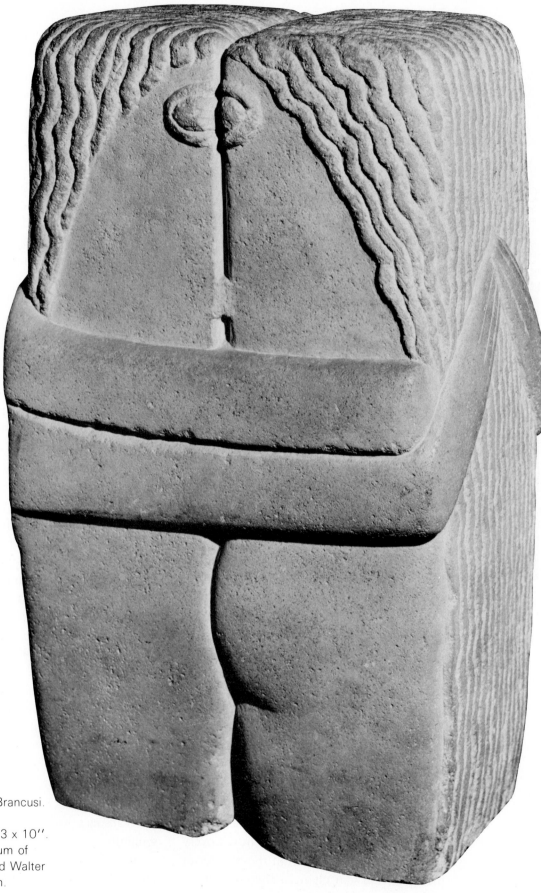

371 Constantin Brancusi.
THE KISS. 1908.
Limestone. 23 x 13 x 10''.
Philadelphia Museum of
Art. The Louise and Walter
Arnsberg Collection.

385 Pablo Pica
canvas. 42 x 26½

rial
sion
qui
was
ture
part
imp
and

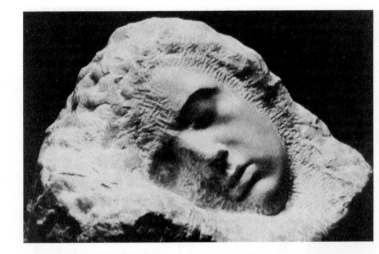

372 Constantin Brancusi. SLEEPING MUSE. 1906. Marble.
6½ x 12''. National Gallery, Bucharest.

373 Constantin Brancusi. SLEEPING MUSE. 1909–1911.
Marble. Height 11½''. Hirshhorn Museum and Sculpture
Garden. Smithsonian Institution, Washington, D.C.

376
Meri

377
190
Solo
See

French sculptor Auguste Rodin became known as one of the most important artists of the late nineteenth century. His work is part of a long tradition of sculpture based on the human figure. His best known works are THE THINKER and·THE KISS. In THE KISS, the life-sized human figures represent ideals of masculine and feminine form. Their implied natural softness is accentuated by the roughness of the uncarved marble on which they sit.

Brancusi carved two figures kissing in a solid embrace. Through minimal cutting of the block, he symbolized the concept of two becoming one. The work was originally commissioned as a tombstone by a couple who must have loved each other very much. This is not a portrait of erotic love, but a personal symbol of the inner union that occurs when two people love each other in such a continuing and unselfish way that they achieve oneness.

Brancusi's SLEEPING MUSE of 1906 has a quality similar to Rodin's romantic naturalism. In 1908 he completed THE KISS and in 1911 he finished a second version of the SLEEPING MUSE. THE NEWBORN, finished in 1915, has the refined simplicity of a powerful conception stripped to its essentials. Brancusi said, "Simplicity is not an end in art, but one arrives at simplicity in spite of oneself; in approaching the real sense of things...."[2]

These four works span ten years of Brancusi's evolution toward the kind of elemental form for which he is known. Seen together they illustrate the transition from representational to abstract and nonrepresentational art within the work of one individual.

374 Constantin Brancusi. THE NEWBORN.
1915. Marble. 6 x 8½''. Philadelphia
Museum of Art. The Louise and Walter
Arnsberg Collection.

313

375 Gustav Klin
Galerie Welz Salzl
opposite page 30

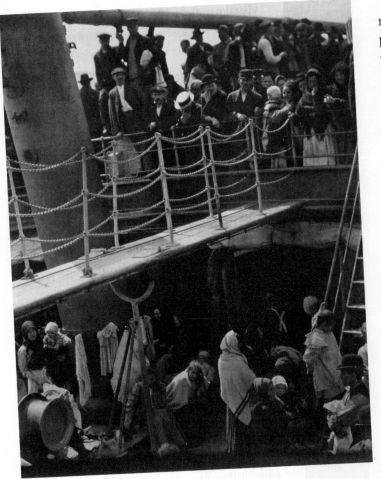

386 Alfred Stieglitz. THE STEERAGE. 1907. Photograph. Reproduced from ''Camera Work''. The Museum of Modern Art. New York.

Alfred Stieglitz, an American photographer, reconsidered the geometry of design on the picture plane as Picasso began taking the steps that led to Cubism. When Picasso saw Stieglitz's photograph THE STEERAGE he said, ''This photographer is working in the same spirit as I am.''[7]

THE STEERAGE looked chopped up to many people. Some of the artist's friends felt that it should have been two photographs, rather than one. But Stieglitz saw the complex scene as a pattern of interacting forces of light, shade, shape, and direction. Aboard a liner headed for Europe, he saw the composition of this photograph as ''a round straw hat, the funnel leaning left, the stairway leaning right, the white drawbridge with its railings made of circular chains, white suspenders crossing on the back of a man on the steerage below, round shapes of iron machinery, a mast cutting into the sky, making a triangular shape. . . . I saw a picture of shapes and underlying that the feeling I had about life.''[8] He rushed back to his cabin to get his camera hoping the composition would remain. It had, and he made the photograph, which he considered to be his best.

Stieglitz made his own move toward realizing the potential of an overall picture-plane geometry, freed from the continuous, linear flow of Renaissance perspective.

Color plate 32 Wassily Kandinsky. Blue Mountain. 1908. Oil on canvas. 42 x 38½''. The
Solomon R. Guggenheim Museum, New York.

Color plate 33 Pablo Picasso. THREE MUSICIANS. 1921. Oil on canvas. 6'7"
x 7'¾". The Museum of Modern Art, New York. Mrs. Simon Guggenheim
Fund.

Color plate 34 Paul Klee. BATTLE
SCENE FROM THE COMIC OPERA "THE
SEAFARER". 1923. Colored sheet,
watercolor, and oil drawings. 15 x
20¼". Collection Frau T. Dürst
Haass, Muttenz, Switzerland.

Color plate 35 Kasimir Malevich.
YELLOW QUADRILATERAL ON WHITE.
1916–1917. Oil on canvas. 43¾ x
27¾". Stedelijk Museum,
Amsterdam.

Color plate 36 Piet Mondrian. COMPOSITION WITH RED, YELLOW AND BLUE. 1930. Oil on
canvas. 19 x 19''. Private collection.

Color plate 37 Willem de Kooning. WOMAN AND BICYCLE. 1952–1953. Oil on canvas. 76½ x 49″ Whitney Museum of American Art, New York.

Color plate 38 Helen Frankenthaler. INTERIOR LANDSCAPE. 1964. Acrylic on canvas. 104¾ x 92¾''. San Francisco Museum of Modern Art. Gift of the Women's Board.

Color plate 39
Thomas Wilfred.
LUMIA SUITE, OP.
158 (two stages).
1963–1964. Light
composition
projected against a
screen. 6 x 8'.
Commissioned by
the Museum of
Modern Art, New
York.

Color plate 40 Isamu Noguchi. RED CUBE. 1969. Painted welded steel and aluminum. Height 28'. 140 Broadway, New York City.

Color plate 41 Ben Cunningham. CORNER PAINTING. 1948–1950. Oil on canvas. 25½
x 36½''. 25½ x 21½''. Collection Mrs. Ben Cunningham.

Color plate 42 Richard Estes. HORN AND HARDART AUTOMAT. 1967. Oil on masonite. 48 x 60". Collection Mr. and Mrs. Stephen D. Paine, Boston.

387 Frank Lloyd Wright. ROBIE HOUSE. Chicago, 1909.

At the same time that Cubism was developing in painting, the American architect Frank Lloyd Wright was designing prairie houses in which the rigid boundaries between interior and exterior space give way to a spatial flow and interaction that has much in common with Cubism. In the ROBIE HOUSE of 1909, Wright created long, horizontal lines that end in exaggerated, overhanging roofs. These lines repeat an irregular pattern throughout the building, keeping the structure in tune with the flat land that surrounds it. Long cantilevered eaves reach out into exterior space and work with the diagonally placed window walls and open plan, allowing interior and exterior space to flow together. The simple purity of interpenetrating geometric masses and spaces became a basic tenet of contemporary architecture. To get a feeling of how far ahead of his time Wright was, imagine the new 1909 horseless carriage that could have been parked in front of the house the year it was completed.

388 Pablo Picasso. SHEET OF MUSIC AND GUITAR. 1912–1913. Gummed paper with paste. 21½ x 23″. Collection George Salles, Paris.

389 Pablo Picasso. GUITAR. 1911–1912. Sheet metal and wire. 30½ x 13⅛ x 7⅝″. The Museum of Modern Art, New York. Gift of the artist.

In 1912, Analytical Cubism gave way to greater interest in textural surfaces, bold cut-out shapes, and use of richer color. This style was later called *Synthetic Cubism*. As well as representing surfaces with paint, actual two-dimensional objects were often used. Pieces of newspaper, sheet music, wallpaper, and similar items came into the work, not represented, but actually presented as in SHEET OF MUSIC AND GUITAR. These painted and pasted paper compositions were called *papier collé* by the French and later became known in English as *collage*.

When Picasso constructed his GUITAR out of sheet metal and wire in 1911 or 1912, he began what has become a dominant trend in twentieth-century sculpture. Before Picasso's Cubist GUITAR, most sculpture was modeled or carved. Now much of contemporary sculpture is created by assembling methods. Ac-

390 Fernand Legér. THE CITY. 1919. Oil on canvas. 7'7'' x 9'9''. Philadelphia Museum of Art. The A. E. Gallatin Collection.

cording to Picasso, this sculpture was completed before he did any work with collage.

In one sense, Cubism is a way of seeing, as well as a way of depicting forms in space. Cubism has been for the twentieth century what the development of linear perspective was for the fifteenth. After the original analytical phase of Cubism, many painters adopted its basic spatial concept. One of them was Fernand Léger. In his painting called THE CITY, he used Cubist overlapping planes in compact, shallow space to create a complex symbol of city rhythms and intensities. (See REFLECTIONS, next page.)

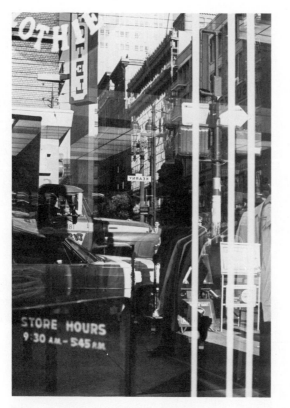

391 REFLECTIONS. 1972. Photograph.

In today's cities, the buildings, signs, people, and traffic crowd together between reflective surfaces, in a giant assemblage of overlapping, disjointed forms. To the eye, these phenomena join in a collage experience that is part of the same spatial awareness explored by Cubism. Cubism has given us a relevant way of experiencing the world we live in. The Cubist approach also led to further abstractions and to nonrepresentational painting.

The American painter Lyonel Feininger's painting of sailboats racing on open water, THE GLORIOUS VICTORY OF THE SLOOP "MARIA", is Cubist in design. Geometric shapes, mostly triangles, move over the surface, woven into strong unity by straight lines of force that run from edge to edge across the picture plane. Size difference in the sails adds to the illusion of depth.

THE THREE MUSICIANS by Picasso is created in the flat, decorative style of Synthetic Cubism. (See color plate 33.) The painting acts as a culmination of Cubism. Its form is heavily in-

392 Lyonel Feininger. THE GLORIOUS VICTORY OF THE SLOOP "MARIA". 1926. Oil on canvas. 21½ x 33½". The St. Louis Art Museum. Purchase: Eliza McMillan Trust Fund.

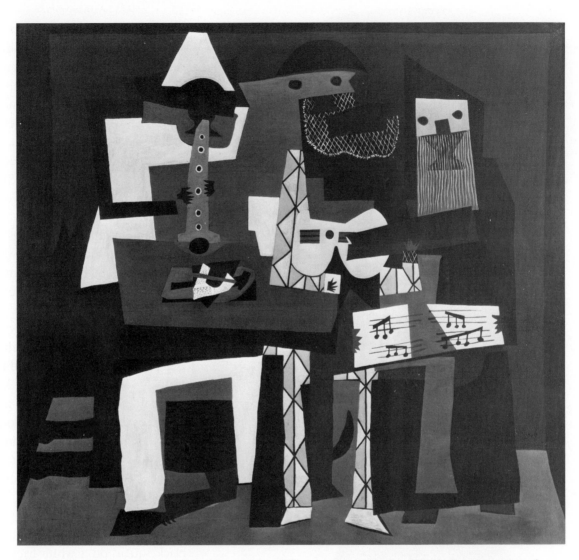

393 Pablo Picasso. THREE MUSICIANS. 1921. Oil on canvas. 6'7'' x 7'¾''. The Museum of Modern Art, New York. Mrs. Simon Guggenheim Fund. *See color plate 33, near page 322.*

fluenced by the cutout shapes of Cubist collages. Two of the life-size figures are the traditional characters of French comedy—Pierrot, in white, playing a recorder, and brightly costumed Harlequin in the center, playing a guitar. The third figure wears a black monk's habit and a veiled mask, and sings from the sheet of music he holds. Behind the trio a black dog lies with tail raised. Although abstract, the figures have a real presence. The work is solemn, yet filled with an air of whimsey.

Many historians find Picasso's work difficult to deal with because he shifted from style to style, using one approach, and then another. THE THREE MUSICIANS was painted by Picasso at the same time he was working with the style and subject matter of Greco-Roman antiquity, creating figures with the solid appearance of classical sculpture. (See YOUNG MAN'S HEAD, page 76.) Yet now, as we look back over his career, the dramatic shifts in attitude all seem part of Picasso's fantastic inventive ability.

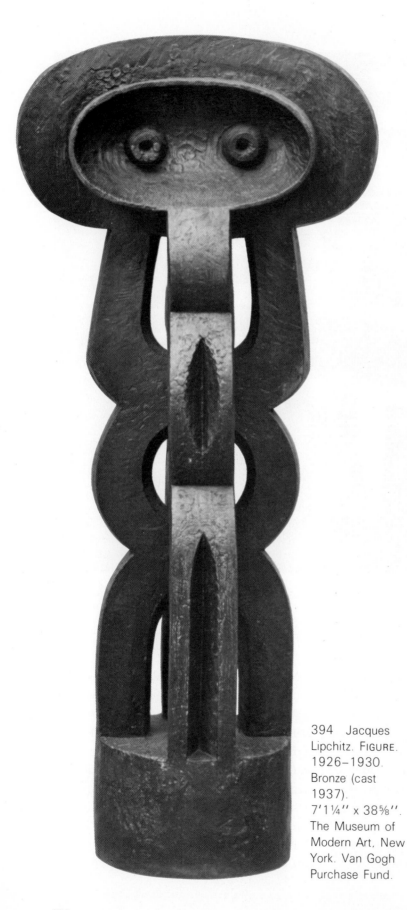

For the sculptor Jacques Lipchitz, "Cubism was essentially a search for a new syntax."[9] He came to Paris from Poland just as the style was developing. His larger than life-sized FIGURE of the late 1920s, however, is not simply Cubist. The figure's symmetry seems to have an organic as well as a geometric basis. But the sculpture could not have existed without Cubism, just as van Gogh's THE STARRY NIGHT (see page 304) could not have been created without Impressionism.

This monumental piece has an awe-inspiring presence. It has the power we might expect to find in a votive figure from Africa or the South Pacific. Here the power comes from Lipchitz's sense of his own time. The figure appears as a symbol of humanity in the twentieth century. Compare Munch's THE SHRIEK (see page 309). A viewer asked Lipchitz to explain his work. "It wouldn't help you," the sculptor answered. "If I were to explain it in Chinese, you would tell me you didn't know Chinese, and I would tell you to learn Chinese and you will understand. Art is harder than Chinese. Anyone can look—you have to learn to see."[10]

In 1913 the Russian painter Kasimir Malevich exhibited "nothing more or less than a black square on a white background. . . . It was not just a square I had exhibited," he ex-

394 Jacques Lipchitz. FIGURE. 1926–1930. Bronze (cast 1937). 7'1¼" x 38⅝". The Museum of Modern Art, New York. Van Gogh Purchase Fund.

395 Kasimir Malevich. YELLOW QUADRILATERAL ON WHITE. 1916–1917. Oil on canvas. 43¾ x 27¾". Stedelijk Museum, Amsterdam. *See color plate 35, near page 322.*

plained, "but rather the expression of nonobjectivity."[11] Malevich conceived this work as the touchstone of a new movement which he christened "Suprematism," based on a system of "totally pure" geometric abstraction. The name *Suprematism* comes from Malevich's attitudes toward the supremacy of pure feeling as generated by the most elemental relationships of visual form. He based his work on geometric form and made the painting itself the subject before Mondrian reached that point. In later works such as YELLOW QUADRILATERAL ON WHITE (see color plate 35), he made significant visual statements relying on minimal means.

By 1922 the Suprematist movement and De Stijl, which had developed at the same time, began to have a strong influence on European art. Malevich visited the Bauhaus School in 1926, and his book *The Non-Objective World* was published by the Bauhaus in 1927. Through the Bauhaus these new ideas influenced modern architecture and nearly all areas of design, including graphic, interior, and fabric design.

The Cubists caused a radical change in re-

cent Western art by shifting the basis for image making from natural appearances to abstract geometric order. The Dutch painter Piet Mondrian took the next step. Inspired by Cubism's inner logic, he gradually went beyond Cubist references to subject matter until he arrived at an austere personal style based on the beauty of basic visual relationships, independent of references to objects in the external world. (See pages 38 and 39.) Between 1910 and 1916 Mondrian did his paintings in sequence, starting with sketches of trees and landscapes, then gradually transforming them into abstract, formal relationships in his studio. His personal philosophy of life led him to search for an art that was collective, anti-individualistic, and objective. In this, his search for absolute form was the rational opposite of Kandinsky's personal expressionism.

When he painted HORIZONTAL TREE, Mondrian concentrated on the rhythmic curves of the branches and on the patterns of the spaces between the branches. He became more aware of the strong expressive character of simple horizontal and vertical lines, defining two-dimensional rectilinear shapes.

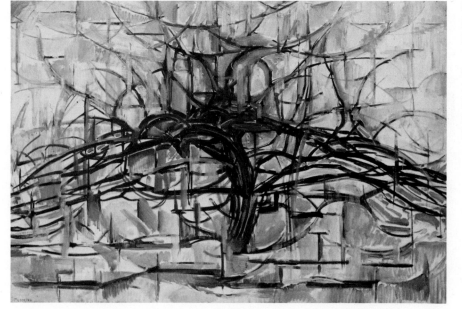

396 Piet Mondrian. HORIZONTAL TREE. 1911. Oil on canvas. 29⅝ x 43⅞". Munson-Williams-Proctor Institute, Utica, New York.

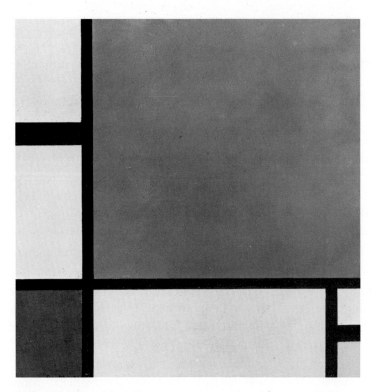

397 Piet Mondrian. COMPOSITION WITH RED, YELLOW AND BLUE. 1930. Oil on canvas. 19 x 19''. Private collection. *See color plate 36, near page 322.*

From 1917 until his death in 1944, Mondrian was a leading spokesman for a pure art reflecting universal order.

The new art has continued and culminated the art of the past in such a way that the new painting, by employing "neutral," or universal forms, expresses itself only through the relationships of line and color.[12]

For Mondrian, these universal elements were straight lines and primary colors. Mondrian was able to create major works using only black horizontal and vertical lines of varying width and the three primary colors, red, yellow, and blue, against a white background. One of these is COMPOSITION WITH RED, YELLOW AND BLUE, completed in 1930. It exemplifies his most mature style, in which three simplified elements—line, shape, and color—combine to create images of strong visual interest. (See color plate 36.)

Mondrian's style was shared by his circle of friends. In 1917 they founded a magazine called *De Stijl* (the style). The group and their work have since been known by this name.

Mondrian distilled his sense of design from the complex relationships of daily visual experience. His style was a way of getting at the universal core of our intuitive experience of form. Mondrian felt that he was expanding the possibilities of visual expression by using elements which in themselves would evoke responses deeper than those coming from representations of specific objects. In his search, he reached for new ways to express human nature and its place in the cosmos.

His great spiritual mind took him beyond the contradictions of modern life which he

398 Piet Mondrian. BROADWAY BOOGIE WOOGIE. 1942–1943. Oil on canvas. 50 x 50''. The Museum of Modern Art, New York.

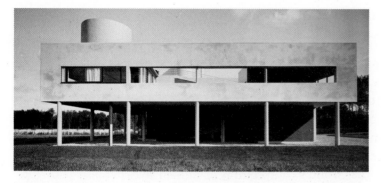

399 a. Le Corbusier. VILLA SAVOYE. 1928–1930. Poissy, France.

399 b. Le Corbusier. VILLA SAVOYE. Interior view of living room toward terrace.

dance to boogie-woogie, and this enthusiasm plus his new environment gave his final paintings, such as BROADWAY BOOGIE-WOOGIE, a pulsing rhythmic energy unlike the monumental simplicity of his earlier works.

The search for a language of visual form stripped to its essentials was carried on by architects as well as painters from 1910. Concepts of geometric form growing out of Cubism and De Stijl were combined with new structural possibilities resulting from technological advances.

About 1918 this new style began to emerge simultaneously in France, Germany, and the Netherlands. For this reason it became known as the *International Style*. Part of this movement, and clearly reflecting the concepts of the De Stijl group, are the buildings of the German school of art called the Bauhaus, which were designed by Walter Gropius in 1925. (See page 197.)

In France the principles of the International Style of architecture were basic to the early work of leading architect, city planner, and painter Charles-Edouard Jeanneret, known by the pseudonym Le Corbusier. He was an artist equal in stature to Frank Lloyd Wright, a major figure in the development of twentieth-century architecture. His most significant early work is the VILLA SAVOYE at Poissy, France, built in 1928–1930. The second-floor living area seems to float on slender reinforced concrete columns above a smaller, deeply recessed entrance and service area on the ground. A private interior terrace opens to the sky on the upper level, joined to the living room by revolutionary floor-to-ceiling panels of glass plate. Such walls of glass are now common in contemporary homes. Le Corbusier called the houses he designed "machines for living," and tended to celebrate human constructions as set apart from nature. In this attitude his approach contrasts to that of Frank Lloyd Wright. (See TALIESIN EAST, page 206.)

seemed to embrace. His paintings are icons of elemental harmony, designed to encourage awareness of universal truth.

In 1940 Mondrian left France for New York, where he spent the last four years of his life. New York was a joy to him because it seemed a celebration of human achievement. He was fascinated by this geometric, technological world, its neon lights, and especially the staccato rhythms of American jazz. He loved to

Futurism and the Conquest of Motion

The Italian Futurists added motion to the ideas of Cubism. They were excited by the beauty of speed made possible by technology. In multiplying the image of a moving object, *Futurism* expanded the Cubist concepts of simultaneity of vision and metamorphosis. In 1909, Marinetti, a poet, proclaimed in the *Initial Manifesto of Futurism:* "The world's splendor has been enriched by a new beauty; the beauty of speed . . . a roaring motorcar . . . is more beautiful than the VICTORY OF SAMOTHRACE."[13]

In spite of such statements about the beauty of the new technology, much of their work is based on the dynamics of human figures, animals, and still life objects. The treatment of these traditional subjects was influenced by the new sense of speed in modern life and the motion underlying all matter, as revealed by science. See Balla's DYNAMISM OF A DOG ON A LEASH, page 95.

In 1912, at the age of sixteen, French photographer Jacques Lartigue took one of many excellent photographs of his father and friends participating in the excitement of the new technological age. Lartigue's enthusiastic observation of the world around him led him to capture bold images of life in motion, accelerated by the new technology. His technique and attitude made him a forerunner of the approach to photography used by later small camera masters such as Cartier-Bresson who lifted "decisive moments" out of the broad spectrum of human lives.

French artist Marcel Duchamp and the Futurist painters of Italy independently brought the dimension of motion to Cubism. Many artists of this century have continued to create a sense of energy, movement, and rhythm expressive of the dynamism of the age.

Although the new media of film and television are better suited to showing motion than is painting, Duchamp's NUDE DESCENDING A STAIRCASE works well in a way that film cannot. Utilizing sequential, diagonally placed, Cubist images of the same figure, the painting presents the movement of a figure through space, seen all at once, in a single rhythmic progression. Because of our sense of gravity, the diagonal placement of the major sequence and the minor elements intensifies the overall feeling of movement.

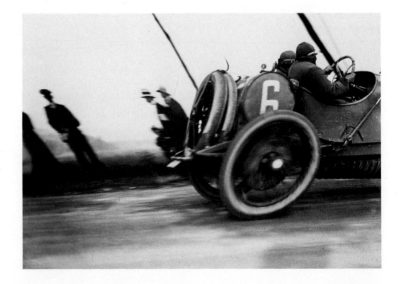

400 Jacques Henri Lartigue.
GRAND PRIX OF THE
AUTOMOBILE CLUB OF FRANCE.
Dieppe, France, 1912.
Photograph.

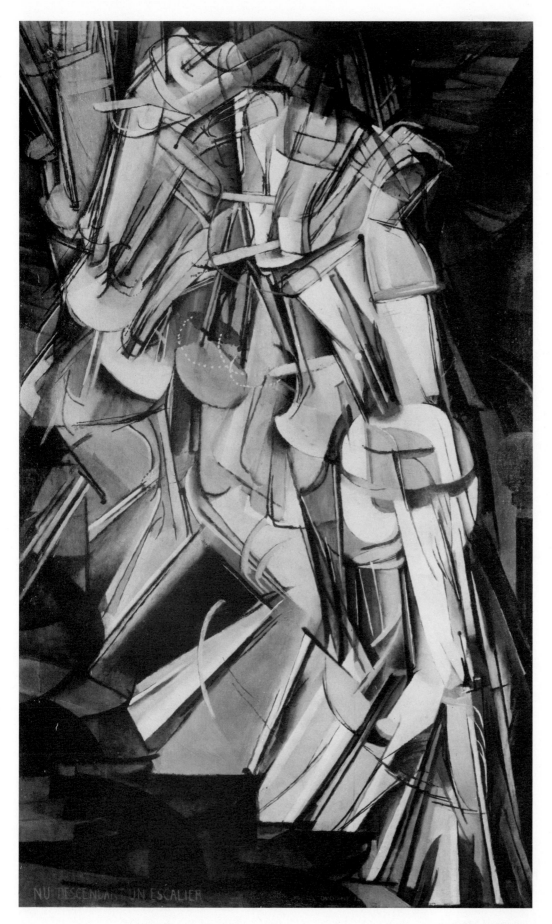

NU DESCENDANT UN ESCALIER

401 Marcel
Duchamp. NUDE
DESCENDING A
STAIRCASE, #2. Oil
on canvas.
58 x 35".
Philadelphia
Museum of Art.
The Louise and
Walter Arnsberg
Collection.

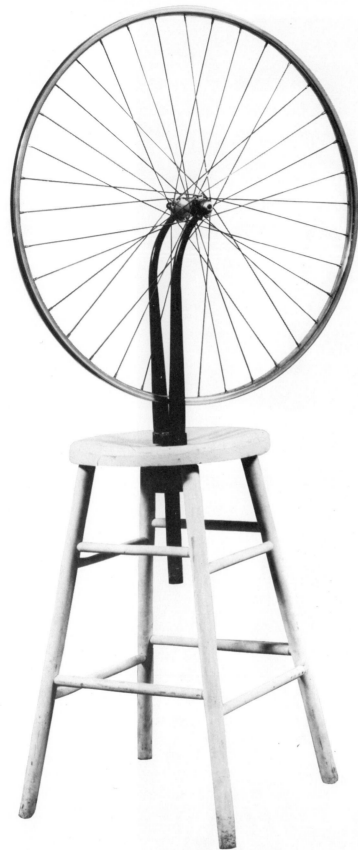

402 Marcel Duchamp. BICYCLE WHEEL. 1951 (third version after lost original of 1913). Assemblage: metal wheel, diameter, 25½″, mounted on painted wood stool, 24¾″ high, overall height 50½″. The Sidney and Harriet Janis Collection, Gift to The Museum of Modern Art, New York.

ILLUSIONS SHATTERED: WORLD WAR I AND ITS AFTERMATH

Dada

Dada is a word that identifies an attitude toward art and life that began to emerge during the nineteenth century and was finally christened in 1916. This attitude is different from the rational search for absolute or pure form. It is not a style.

Dada was not a school of artists, but an alarm signal against declining values, routine and speculation, a desperate appeal on behalf of all forms of art, for a creative basis on which to build a new and universal consciousness of art.
Marcel Janco[14]

After Duchamp painted the NUDE DESCENDING A STAIRCASE in 1912, he became increasingly dissatisfied with the accepted framework for art. He said, "I have forced myself to contradict myself in order to avoid conforming to my own taste."[15] Duchamp was not alone. As European society moved inexorably into World War I, many people felt compelled to react. As the actual fighting began, artists counterattacked with their art.

While the thunder of guns rolled in the distance, we sang, painted, glued, and composed for all our worth. We are seeking an art that would heal mankind from the madness of the age.
Jean Arp[16]

Dada began in poetry and painting, then carried into sculpture, architecture, photography, film, music, and graphic design. But more than an art form, "Dada was a metaphysical attitude . . . a sort of nihilism . . . a way to get out of a state of mind—to avoid being influenced by one's immediate environment, or by the past; to get away from clichés—to get free." (Marcel Duchamp.)[17]

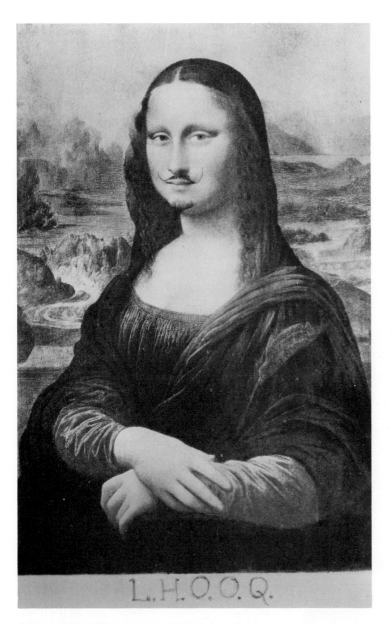

403 MARCEL DUCHAMP. L.H.O.O.Q. 1919. "Corrected ready-made." Private collection.

One of the outstanding contributions Duchamp made to the history of art was the *ready-made*—an ordinary manufactured object selected more or less at random and exhibited as art. In his effort to free himself from the past, Duchamp declared all art a swindle, and before Dada had become a group effort, he exhibited his first non-art ready-made, BICYCLE WHEEL.

Duchamp felt that you cannot separate art from other man-made things. He recognized selection as the primary ingredient of art. In his BICYCLE WHEEL assemblage of 1913, he applied both of these ideas to produce a work that has caused much controversy and has stirred considerable thought. Its components are simply a bicycle wheel and a kitchen stool. It is a conceptual work from Duchamp's fertile imagination. It took only a simple operation to join the wheel frame to the stool. The stool provides a static base for the movable wheel. This is the first mobile of the twentieth century, incorporating motion that is actual, rather than implied as in his painting NUDE DESCENDING A STAIRCASE.

The wheel and the stool still say whatever they said before, by themselves. Yet this expression is now subordinate to what they communicate as a combined form. Through their new association and by the placement of this work in galleries and museums as an art object, a strong change has occurred in the way we perceive them. Preconceptions related to function have been cleared away. We now see the form itself.

For Duchamp, mechanically produced things were a reservoir of potentially un-self-conscious art objects. In this view, a reproduction of the MONA LISA is a ready-made object, in the same class as bicycle wheels, kitchen stools, and bottle racks.

L.H.O.O.Q. is a "corrected" ready-made by Duchamp. It is art or graffito? Corrections took the form of a moustache and goatee done in pencil, and a new title. The unusual title given it provides us with a possible clue as to why the MONA LISA has been smiling all these years. It is a pun in French, comprehensible only to those who can say the letters in a flowing sentence with perfect French pronunciation. Translated into English, it reads, "She has a hot tail." Duchamp's irreverence towards art helps get art, and therefore life itself, off to a fresh start.

404 Man Ray. THE GIFT. c.1958 (replica after 1921 original). Flatiron with metal tacks. 6⅛ x 3⅝ x 4½''. The Museum of Modern Art, New York. James Thrall Soby Fund.

Man Ray, an American, was a friend of Duchamp's. His Dada works include paintings, photographs, and assembled objects. In 1921, in Paris, Man Ray saw a flatiron displayed in front of a shop selling housewares. He purchased the iron, a box of tacks, and a tube of glue. He glued a row of tacks to the smooth face of the iron and entitled it THE GIFT. This particular Dada assemblage tweaks the viewer's mind in a unique way. Utilitarian objects are transformed into useless irony.

In the past, the major subjects for art were gods (or God), nature, and mankind and the interrelationships among them. It was not until the twentieth century that man-made things became a frequent subject for art.

It is not surprising that this shift in emphasis has occurred in art during an age when we have surrounded ourselves with objects of our own making, even objects that go on making objects. Today we have spent more time, thought, and energy on the acquisition, use, and maintenance of manufactured things than we have on God, nature, or ourselves.

The twentieth-century emphasis on things has been apparent in art in two ways. First, as noted before, artists have ceased using traditional subjects that hold little meaning for them or for their public, and in some cases have even stopped using recognizable subjects altogether. To some, the appearance of the visual world has become either not to their liking or uninteresting, compared to the possibilities of independent visual form. Secondly, artists have confronted the most unlikely sources of inspiration. They have gone to man-made things, to the most common artifacts of mass production, and have found in them symbols of crass materialism in some cases, and universal continuity and spirit in others. These attitudes have formed what has been called "the art of things."

Paradoxically, the art of things has developed concurrently with the concept of a work

of art as an independent thing, free to express itself without reference to external subject matter.

When Picasso and Braque put actual pre-existing things, such as pieces of rope and scraps of newspapers, into their work, they began one development in the art of things, which includes works of collage and assemblage (see page 164). Things are not represented, but are themselves presented, in a new context.

Another direction moves from collage into photomontage. In THE MULTI-MILLIONAIRE, by the Dadaist Hannah Höch, man, the artifact-making industrialist, stands as a fractured giant among the things he has produced.

405 Hannah Höch. THE MULTI-MILLIONAIRE. 1920. Photomontage.

406 Kurt Schwitters. CONSTRUCTION FOR NOBLE LADIES. 1919. Mixed media assemblage of wood, metal and paint. 40½ x 33″. Los Angeles County Museum of Art.

Kurt Schwitters was a master of Dada collage. From 1917 until his death in 1948, he created images, like this CONSTRUCTION FOR NOBLE LADIES, out of timeworn objects discarded by society. His assembled junk was designed to destroy the sacred standards of art. He asked us to look again at these cast-off objects. They are familiar old things returned to us, freed from their past functions and associations, and, therefore, visible again in a different context. Schwitters made his attitude clear in the following statement:

I could not, in fact, see any reason why one should not use the old tickets, driftwood, cloakroom numbers, wires and parts of wheels, buttons, and old lumber out of junk rooms and rubbish heaps as materials for paintings as well as the colors that were produced in factories.[18]

The Development of Surrealism

Paul Klee intentionally freed himself from the accumulation of history by digging deeply into his own being in an effort to begin all over again. The self-portrait that he drew in 1919 goes well with this statement, written in his diary in June 1902:

It is a great difficulty and great necessity to have to start with the smallest. I want to be as though new-born, knowing nothing, absolutely nothing, about Europe; ignoring poets and fashions, to be almost primitive. Then I want to do something very modest; to work out by myself a tiny formal motive, one that my pencil will be able to hold without any technique.[19]

Paul Klee remained an independent artist all his life. He was able to tap the resources of his own unconscious, creating fantastic images years before Surrealism became a group style.

. . . everything vanishes round me and good works rise from me of their own accord. My hand is entirely the implement of a distant sphere. It is not my head that functions but something else, something higher, something more remote. I must have great friends there, dark as well as bright. . . . They are all very kind to me.[20]

In Klee's painting of the BATTLE SCENE FROM THE COMIC OPERA "THE SEAFARER," Sinbad the Sailor fights three monsters of the unknown in a battle that has universal human implications. The marvelous line patterns and distinctive use of color are common to Klee's small paintings.

407 Paul Klee.
SELF-PORTRAIT. 1919.
Colored sheet, pen and
wash. 9 x 5¼''.

408 Paul Klee. BATTLE SCENE FROM THE COMIC OPERA ''THE SEAFARER''. 1923. Colored sheet,
watercolor, and oil drawings. 15 x 20¼''. Collection Frau T. Dürst Haass, Muttenz, Switzerland.
See color plate 34, near page 322.

409 Giorgio de Chirico. THE MYSTERY AND MELANCHOLY OF A STREET. 1914. Oil on canvas. 34¼ x 28⅛''.
Private collection.

410 René Magritte. PORTRAIT. 1935. Oil on canvas. 28⅞ x 19⅞''. The Museum of Modern Art, New York. Gift of Kay Sange Tanguy.

The Italian metaphysical painter Giorgio de Chirico is another artist who, on his own, anticipated surrealism. The playwright and critic Apollinaire used the world *Surrealism* to describe de Chirico's works, which were shown in Paris in 1911 and 1912.

THE MYSTERY AND MELANCHOLY OF A STREET, 1914, is one of his finest works. De Chirico used distorted linear perspective to create an eerie space peopled by faceless shad-

ows. The painting speaks the symbolic language of dreams, mystery, and ominous silence. According to the artist:

Everything has two aspects: the current aspect, which we see nearly always and which ordinary men see, and the ghostly and metaphysical aspect, which only rare individuals may see in moments of clairvoyance and metaphysical abstraction.[21]

In the 1920s a group of writers and painters gathered to proclaim the omnipotence of the unconscious mind, thought to be a higher reality than the conscious mind. Their goal was to make this aspect of the mind visible. The group was indebted to the irrationality of Dadaism and the incredible creations of Chagall, Klee, and de Chirico. Surrealism was officially launched in Paris in 1924 by the publication of its first manifesto, written by the poet-painter André Breton.

Among the prominent members of the Surrealist group were Salvador Dali and Joan Miró. Picasso took part in the first exhibit, but did not remain in the style long. Although Dali is perhaps the best known of these men, he joined the group late and was considered by many Surrealists to be too flamboyant to be taken seriously.

Belgian Surrealist René Magritte based his work on an illogical form of magical realism, similar to Salvadore Dali's in surface appearance, but quite different in content. In Magritte's paintings the macabre quality found in Dali's work is replaced by wit and playfulness. Everything depicted in PORTRAIT is ordinary. The impact of the painting comes from the strange combination of everyday objects causing an extraordinary result.

411 Hieronymus van Aeken Bosch. THE GARDEN OF WORLDLY DELIGHTS. (a) Detail of center panel. (b) Detail of right panel. c. 1500. Oil on wood. The Prado Museum, Madrid.

As Surrealism expanded the horizons of the present, it found important ancestors in the past. One of the most imaginative of these was the Flemish artist Hieronymus Bosch, active between 1488 and 1516. In one three panel altarpiece, Bosch painted with equal care an imaginary garden of sensory delights and the horrors of hell. In his depictions of hell, he made clear references to his own society, wracked by devastating plagues and the terrors of the Inquisition. What fascinated the Surrealists was Bosch's ability to operate on several levels at once. In one sense his pictures are Christian allegories, in another they present seemingly endless symbolic events loaded with psychological overtones. This juxtaposition may occur only in the world of fantasy and dreams. It is common today to explain our actions by referring to these subconscious forces. Many artists of the past and present have drawn their images from this inner world.

In PERSISTENCE OF MEMORY Dali evokes the eerie quality of dream experience. Mechanical time wilts in a deserted landscape of infinite space. The warped, headlike image in the foreground may be the last remnant of a vanished humanity. It may also be a self-portrait.

Miró and Dali, both Spaniards, represent two opposite tendencies operating in Surrealism. Dali uses illusionary deep space and representational techniques to create near "photographic" dream images that make the impossible seem possible. This approach has been called *Representational Surrealism.* In contrast, Miró uses more abstract, suggestive elements, giving the widest possible play to the viewer's imagination. This style has been called *Abstract Surrealism.*

To reach deep into the unconscious, Miró and others used automatic processes in which chance was a key factor. This approach influenced later Abstract Expressionists.

Miró often refers just enough to monsters

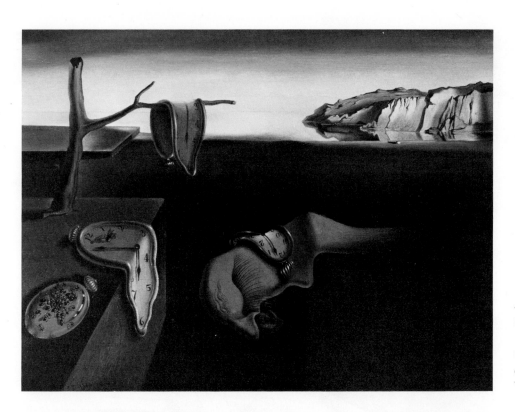

412 Salvador Dali.
PERSISTENCE OF MEMORY.
1931. Oil on canvas.
9½ x 13''. The Museum
of Modern Art, New
York.

413 Joan Miro. WOMAN HAUNTED BY THE PASSAGE OF THE DRAGON- FLY, BIRD OF BAD OMEN (also called NURSERY DECORATION). 1938. Oil on canvas. 2'7½'' x 10'6''. Collection Mr. and Mrs. Richard K. Weil, St. Louis.

to evoke memories of the universal fears of childhood. Children respond easily to his paintings. The bold organic shapes in WOMAN HAUNTED BY THE PASSAGE OF THE DRAGON-FLY, BIRD OF BAD OMEN are typical of his mature work. The wild, tormented quality, however, is unusual for Miró, and reflects his reaction to the times. This painting was completed within a year of Picasso's GUERNICA. (See following section.) Miró has pointed out that his painting was done at the time of the Munich Crisis, which helped precipitate World War II. The work is commonly known as NURSERY DECORATION which Miró seems to have used as a facetious working title, but now feels is inappropriate.

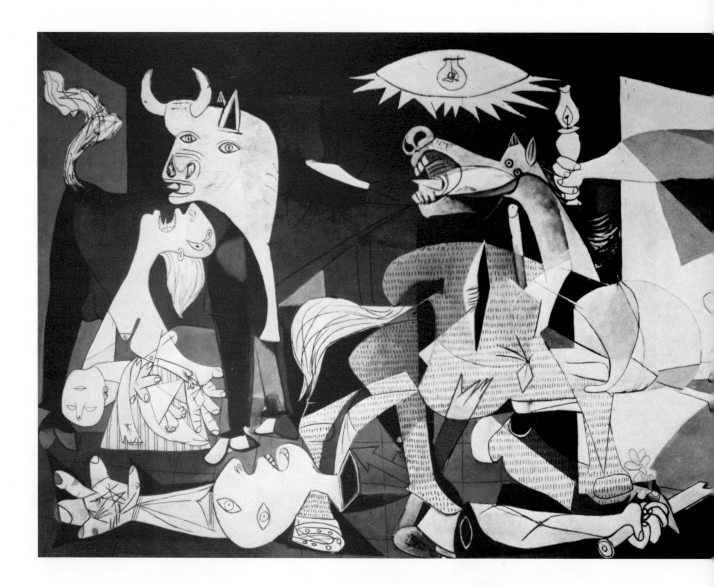

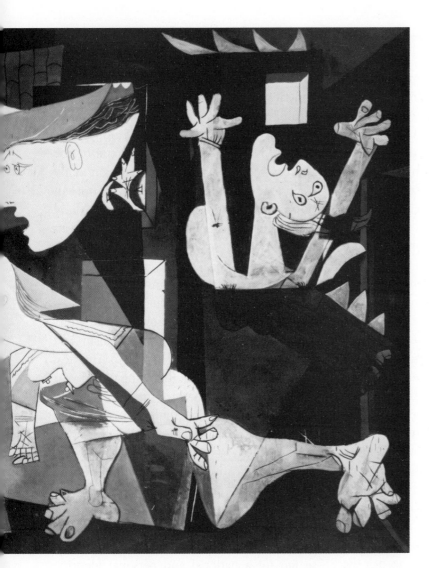

414 Pablo Picasso. GUERNICA. 1937. Oil on canvas. 11'5½''x 25'5¼''. On extended loan to The Museum of Modern Art, New York, from the artist's estate.

Guernica: Art As a Weapon

Picasso continued to produce a great volume of innovative drawings, paintings, prints, posters, and sculptures throughout the 1920s and into the early 1930s. Many of these works were filled with distortions and metamorphoses. In 1937, while the Spanish Revolution was in progress, Picasso was commissioned by the Spanish democratic government to paint a mural for the Spanish government building at the Paris Exposition. For several months he was unable to start work. Suddenly, on April 26, 1937, he was shocked into action by the experimental mass bombing of the defenseless Basque town of Guernica. To aid his bid for power, General Franco allowed Hitler to use his war machinery on the town of Guernica as a demonstration of military power. It was the first incidence of saturation bombing in the history of warfare. The bombing occurred at night. According to witnesses, one out of every seven people in the town was killed.

Picasso was appalled by this brutal act against the people of his native country. In retaliation, he called upon all his powers to create the mural GUERNICA as a protest against the senseless atrocities of war.

Although GUERNICA stems from a specific incident, it has universal significance, and is viewed today as a work of tremendous spiritual importance. It is a powerful visual statement of protest against man's inhumanity to man.

The painting covers a huge canvas measuring twenty-five feet, eight inches in length and eleven feet, six inches in height. It occupies an entire wall in the Museum of Modern Art in New York City, where it has been on extended loan from Picasso and is now on loan from his estate.

GUERNICA is painted in somber blacks, whites, and grays, stark symbols of death and mourning. A large triangle is embedded under the smaller shapes, holding the whole scene of chaotic destruction together as a unified composition. The predominantly triangular shapes and the shallow space are Cubistic. Some of the textural patterns are reminiscent of newsprint.

For Picasso, Cubism was a tool, not a master. He took the Cubist concept from the early intellectual phase through its synthetic period, and here used it to create a symbol of great emotional intensity.

During the 1940s, while the Nazis occupied France, Picasso maintained his studio in Paris. For some reason, he was allowed to paint, even though his art was considered highly degenerate by the Nazis. The German soldiers harassed him, of course. One day they came to his door with a small reproduction of Guernica. They asked, "Did you do this?" Picasso replied, "No, you did."[22]

During the same war years, Picasso made this statement: "No, painting is not done to decorate apartments. It is an instrument of war for a means of attack and defense against the enemy."[23]

Social and Regional Concerns in the Art of the New World

At the turn of the century it was common for American artists to go to Europe to study, returning afterward to work in styles influenced by European art. Additionally, European art came to New York in 1913, provided by the Armory Show. This exhibition brought many important examples of the new European styles to America for the first time. Many Americans and especially young American artists were able to see key works by the Impressionists, post-Impressionists, and Fauves, particularly Matisse who was much maligned by the critics. Also shown were paintings by Picasso, Braque, Léger, and Duchamp, and sculpture by Brancusi. As a result, Cubism and other forms of abstract art spread to America.

Growing isolationism following World War I, and the Depression of the thirties, led Americans to develop their own art forms. The Mexican mural school of the 1920s, led by Diego Rivera and José Clemente Orozco (see pages 134 and 102), influenced American artists as both countries turned to their own cultures and countries for subject matter.

The political and economic crisis of the thirties helped motivate artists in America to search for a national and personal identity. American artists were caught between a largely indifferent public at home and a feeling in foreign circles that American art was merely provincial. In this atmosphere of cultural inferiority a native American *regionalism* developed, based on the idea that artists in America could find their own identity by focusing attention on subject matter that was uniquely their own. For these artists subject matter was important as a way of making their art relevant to themselves and their culture.

The American painter and photographer, Charles Sheeler worked both abstractly and in a highly representational photographic style, based on his own photographs. In drawings,

paintings, and photographs he created images with great precision of design. See his drawing of a cat, page 124. He shared with Léger an enthusiasm for the machine age, but, unlike abstractionist Léger, who enjoyed the clunky vulgarity of the urban scene, Sheeler loved and representationally portrayed mechanical precision. Compare Sheeler's CITY INTERIOR with Léger's THE CITY on page 325.

Another painting of the city environment is Edward Hopper's EARLY SUNDAY MORNING. Its variation on a basic rectilinear grid laid out parallel to the picture plane suggests a representational variation of Mondrian. Hopper, however, is fascinated by painting the visual mood—indescribable in words—of a particular place at a particular time. The Impressionists were interested in this, but their paintings seem to be dissolved by light, rather than structured by it as in Hopper's work.

415 Charles Sheeler. CITY INTERIOR. 1936. Painting on fiberboard. 22⅛ x 27''. Worcester Art Museum, Worcester, Massachusetts.

416 Edward Hopper. EARLY SUNDAY MORNING. 1930. Oil on canvas. 35 x 60''. Whitney Museum of American Art, New York.

Georgia O'Keeffe's personal abstract style is seen in her majestic and monumental paintings of the American Southwest. Although her style developed during her early years in New York, she rejected the superficial materialism of the city and moved to New Mexico in 1929 where she continues to find abundant inspiration for her haunting images. In BLACK CROSS, NEW MEXICO the viewer is confronted by the bold impact of the single dominant shape of the cross pushing forward from the infinite vista of subtle glowing landscape behind it. Here, as in much of her work, there is a powerful simplicity achieved through subtle shading, careful design, and placement of large masses.

Grant Wood revolted against what he and others of the American regional group considered the cultural insignificance of modern art. He sought to participate in the reality of American life in order to develop an art with which people could identify, even though the agrarian farm life shown in his paintings was becoming a phenomenon of the past for most

417 Georgia O'Keeffe. BLACK CROSS, NEW MEXICO. 1929. Oil on canvas. 39 x 30". The Art Institute of Chicago.

people. The dry precision of his painting relates to Sheeler's work, but Sheeler sought to capture the urban industrial age rather than agrarian farm life. Wood was at his best when commenting on the special character of people and their place in a slowly disappearing American scene, as in his superbly designed painting titled AMERICAN GOTHIC, page 3. He is also noted for picturesque landscapes with an element of contrived simplicity.

During the Depression years of the 1930s, the United States government maintained an active program of subsidy for the arts. The Works Progress Administration commissioned painters to paint murals in public buildings, and the Farm Security Administration hired photographers to record the eroding dustbowl and its work-worn inhabitants. One of these photographers, Dorothea Lange, also documented the helplessness and hopelessness of the urban unemployed in such sensitive photographs as A DEPRESSION BREADLINE, SAN FRANCISCO.

418 Dorothea Lange. A DEPRESSION BREADLINE, SAN FRANCISCO. 1933. Photograph. The Oakland Museum. Dorothea Lange Collection.

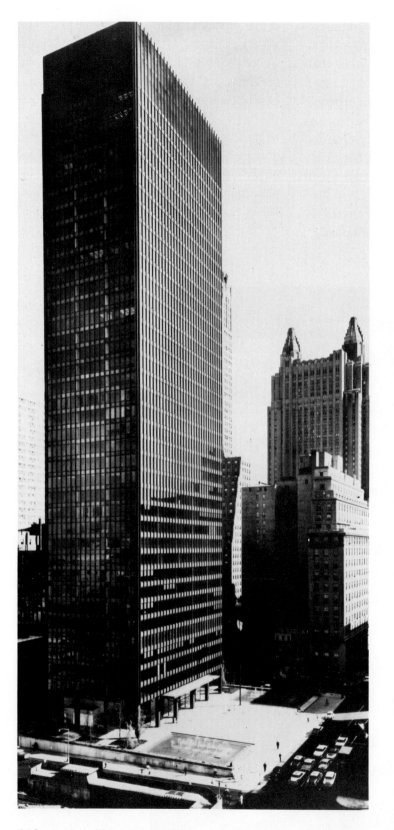

419 Ludwig Mies van der Rohe and Philip Johnson. SEAGRAM BUILDING. New York City, 1957.

ACCELERATED CHANGE: ART SINCE WORLD WAR II

Architecture: Rational and Emotional

Much of twentieth-century architecture has lost almost all personal or locational identity in the quest for pure structural beauty. A major work built in the classical International Style is the SEAGRAM BUILDING in New York, designed by Ludwig Mies van der Rohe and Philip Johnson. Interior floor space gained by the height of the building allowed the architects to leave a large, open area at the base. The vertical lines emphasize the feeling of height and provide a strong pattern, ending with a top planned to give a sense of completion without suppressing the soaring verticality. Mies van der Rohe's famous statement, "Less is more"[24] is given classical form in this elegant yet austere structure.

The International Style's ideal for a new architecture based on the honest beauty of purely functional forms was not widely put into practice until the late 1950s. In the 1960s the style too often went from an ideal to a boring formula for low-cost standardized buildings. These were erected with speed and efficiency, yet were devoid of imagination and exhibited nothing more than the regimented sameness of orderbook construction.

Now we have discovered that we can scarcely afford the tremendous drain on energy resources caused by heating, cooling, and ventilating these numerous thin-skinned glass and metal constructions.

In the late 1940s, Le Corbusier helped to reverse the trend toward the cold geometric functionality of the International Style, which he had helped to develop. (See page 331.) The bold, yet soft and organic free form of NOTRE-DAME-DU-HAUT, his chapel at Ronchamp, has some of the expressive character of the prehistoric dolmen, also believed to be a religious structure.

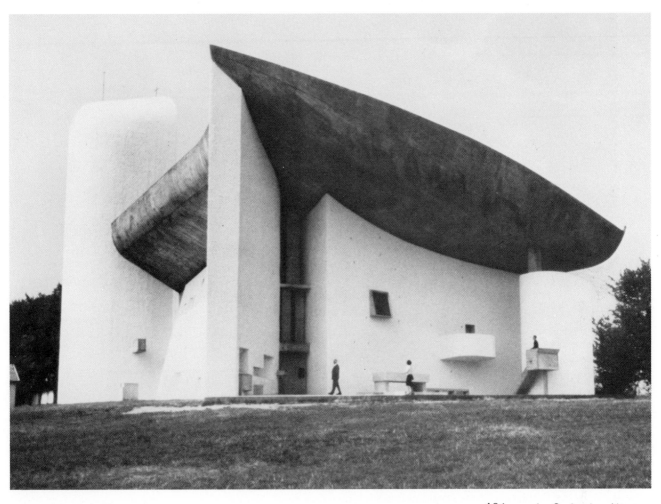

421 a. Le Corbusier. NOTRE-
DAME-DU-HAUT. Exterior,
Ronchamp, France.
1950–1955.

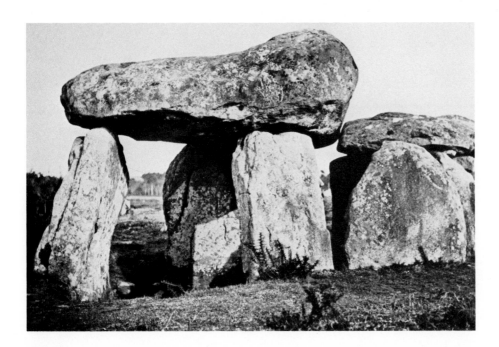

420 DOLMEN OF MANÉ-
KERIONED. Carnac, Morbihan,
France, 3000–2000 B.C.

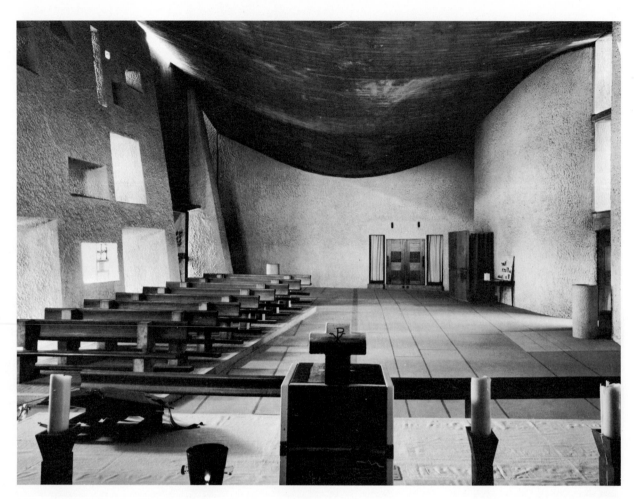

421 b. Le Corbusier. Notre-Dame-du-Haut. Interior.

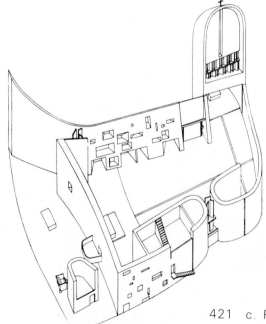

421 c. Perspective Diagram.

He was inspired by the shell of a crab as he began to develop a form that would fit the beauty of the site and the purpose of the building. The structure was built between 1950 and 1955 out of reinforced concrete, wood, and plaster. The walls are massive. Natural wood, rough concrete, and plaster are contrasted with bright accents of color. Light enters through corner slits and through stained glass windows set in funnel-like openings that emphasize the thickness of the massive concrete walls. The side altars are illuminated dramatically by sunlight slanting through tower openings.

Ideally, architecture is functional sculpture. A primary function of churches and other public buildings is to celebrate an idea. Because the Ronchamp chapel is a pilgrimage site, the building is used for both outdoor and indoor services. Inside and out, in every detail, Le Corbusier has provided a structure of expressive strength. It is one of the most revolutionary and influential pieces of architecture of the last thirty years.

Le Corbusier's highly sculptural building renews and celebrates the human spirit, putting emotion back into contemporary architecture. The International style is classical in its rational clarity, while NOTRE-DAME-DU HAUT is romantic, mystical, and emotional in its expressive irregularity. However, NOTRE-DAME-DU HAUT, by incorporating some classical qualities within the overall form, also retains a sense of the controlled geometric abstraction and essential purity of form found in Corbusier's earlier work.

Abstract Expressionism

Nonrepresentational art came into its own in the United States during the 1940s. The expressive strength of van Gogh, the spontaneous brushwork and luminous color surfaces of Monet's late canvases, and, particularly, Kandinsky's rejection of representational subject matter and his expressive freedom, all formed part of the background against which *Abstract Expressionism* grew. A parallel but independent movement occurred at the same time in France.

The evocative shapes of Miró's Abstract Surrealism and Surrealist attitudes toward chance, accident, and spontaneity were most important sources.

By 1912 Kandinsky had already painted Abstract Expressionist paintings long before the style had a group name. The artists who began to realize fully the potential of this mode came together in New York about 1943. Few young painters were as attracted to the austere, hard-edge abstractions of Mondrian and others of his age as they were to this more personal, intuitive, and spontaneous approach which gave them a greater opportunity for individual variations.

Abstract Expressionism grew out of two disasters—the Depression and World War II. Through the WPA, the Depression provided new opportunities for artists, and the war brought many of the leading European avant-garde artists to America. During the hard years of the late thirties and early forties the developing art was marked by signs of emotional stress, anxiety, and despair.

With the outbreak of World War II, the center of artistic activity shifted abruptly from Paris to New York as many European artists fled their native countries to find refuge in the United States. One of these, the German artist Hans Hofmann, made a major contribution to the new American art through both his painting and his teaching.

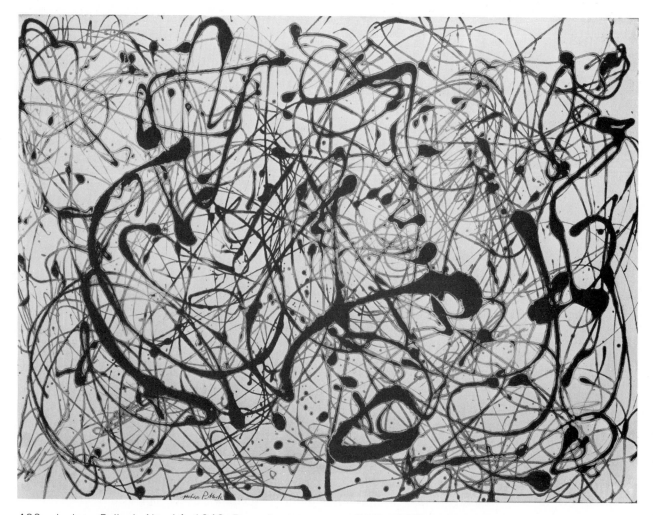

422 Jackson Pollock. No. 14. 1948. Enamel on wet gesso. 23¾ x 31''. Private collection.

Hofmann was one of the leading forces behind the American phenomenon of Abstract Expressionism. In the early 1940s he began to apply his paint in free gestures, sometimes dripping and pouring it, using bold, often pure color, in combinations of geometric and freeform shapes. THE GOLDEN WALL, painted in 1961 when Hofmann was eighty-one years olds, shows the strength of his later works. (See color plate 12.) The canvas glows with warm color set off by cool accents. Rectangles are played off against irregular shapes.

Jackson Pollock was a principal innovator of Abstract Expressionism. He picked up Hofmann's early drip and pour techniques and made them the basis for painted surfaces moving in overall patterns of continuous energy. His large paintings often go beyond the viewer's peripheral vision as did Monet's late works. Pollock studied the ideas of psychologist Carl Jung, as well as primitive rituals and ancient myths, searching for ways to express man's primal nature. The subject of Pollock's paintings became the act of painting itself. A similar emphasis in the work of many of his colleagues led to the term *action painting*. Pollock's painting, NO. 14, was done by flinging paint onto the canvas rather than brushing it on. Because Pollock dripped, poured, and flung his paint, many people felt that he had no con-

trol. Actually, he exercised control and selection by the rhythmical, dancing movement of his body. Many of Pollock's followers did not do as well.

Whether it happens in a rapid series of dramatic changes or in a very slow, almost imperceptible, evolution, each young artist develops ways of working based on the concepts and perceptions handed on from preceding generations. Even Pollock's radical break from the past has roots in the serpentine rhythms of the work of his teacher, Thomas Hart Benton; in the use of intuition, accident, and chance by the Surrealists; and in the tradition of spontaneous calligraphy in China and Japan.

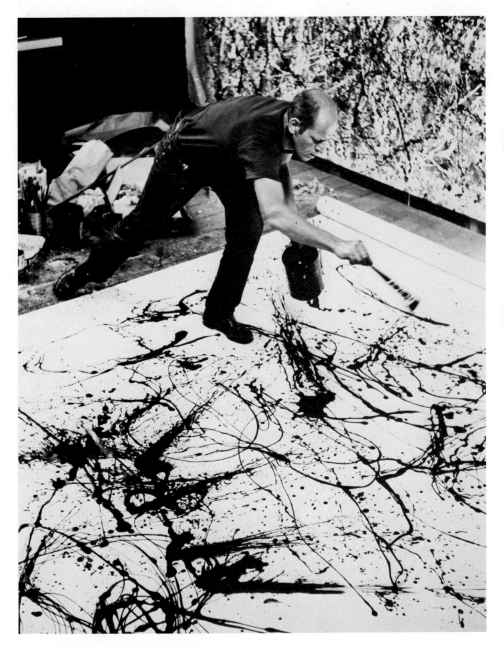

423 Jackson Pollock at work. Photograph by Hans Namuth.

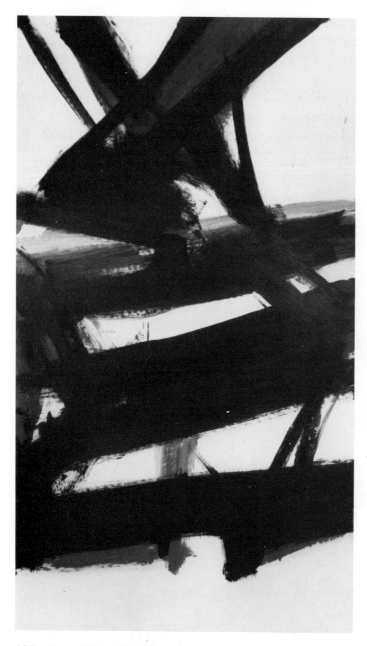

424 Franz Kline. HORIZONTAL RUST. 1960. Oil on canvas.
86½ X 49''. Private collection.

pressionism is the expression of the artist's inner life through bold, free use of calligraphic line. In this sense many of their paintings are like giant signatures. This attitude toward line, which is apparent in the painting by Frank Kline, HORIZONTAL RUST, has been basic to Chinese and Japanese writing, or calligraphy, for over a thousand years.

Many contemporary painters in Japan developed their own expressive visual language based on this ancient art and were influenced as well by the action painting of New York. This work of Yuichi Inoue, CALLIGRAPHY BUDDHA, is an example.

The Japanese Buddhist scholar and master calligrapher Kazuaki Tanahashi traveled through the United States in the 1960s and felt particularly attracted to the paintings of Franz Kline.

There is a mutual influence between Asia and the West that has been of great benefit to both cultures. The result is a growing international style based on shared beliefs, yet rich in its own variety.

Helen Frankenthaler's work evolved during the height of Abstract Expressionism. In 1952 she pioneered staining technique as an extension of Jackson Pollock's poured paint. She spread liquid oil colors out across unprimed canvas, where they soaked in—in fluid, often amorphous, soft shapes, becoming part of the fabric. Her main concern was the interaction of colors and shapes. The new acrylic paints made it possible for her to cover huge canvases with thin layers of intense color and avoid the problem of eventually rotting the raw canvas through contact with oil. Today Frankenthaler is a leader in a direction called *color field painting*, in which large areas of paint provide an environment of color for the viewer (see page 131 and color plate 38).

De Kooning felt no compulsion to banish recognizable images from his work. After several years of working without explicit subject

Several of the New York painters were fascinated by their own discoveries of Asian art and religion; Zen Buddhism with its philosophy of spontaneous awareness of ''self'' through contemplation and intuition was particularly influential in their development. A dominant element in much of Abstract Ex-

425 Yuichi Inoue. CALLIGRAPHY BUDDHA. 1957. Ink on paper. Collection J. Bijtebier, Brussels.

matter, he began a long series of paintings in which rather ferocious female figures appear.

His paintings are overpowering because of their size, their design, and the obviously slashing attacks by which they were painted. De Kooning began one of these woman paintings by cutting a gleaming artificial smile from an advertisment and attaching it to the canvas for the mouth of the figure. In WOMAN AND BICYCLE, the toothy smile is repeated in a savage necklace capping a pair of tremendous breasts. Everything in the painting is consistently outrageous. (See color plate 37.)

427 Willem de Kooning. WOMAN AND BICYCLE. 1952–1953. Oil on canvas. 76½ x 49''. Whitney Museum of American Art, New York. *See color plate 37, near page 322.*

426 Kazuaki Tanahashi. HEKI. 1965. Ink on paper. 36 x 28''. East-West Center, Honolulu.

Recent Diversity: From Object to No Object and Beyond

In the mid-1950s some young artists became dissatisfied by Abstract Expressionism's retreat from the actual visual reality of the everyday world. Robert Rauschenberg began incorporating preexisting objects in paintings that were otherwise Abstract Expressionist in style. By calling attention to the aesthetic capacity of mundane things, he led the way toward *Pop Art*. His collage/paintings recall the work of Kurt Schwitters. (See page 338.) About 1962 Rauschenberg began to reproduce borrowed images from art and life with the aid of the new technique of photographic silk-screen printing. These he combined with brushwork on large canvases. His TRACER of 1964 is a key work of this type.

428 Robert Rauschenberg. TRACER. 1964. Mixed media. 84 x 60''. Private collection.

429 Jasper Johns. TARGET WITH FOUR FACES. 1955.
Encaustic and newspaper on canvas with plaster casts.
33⅝ x 26″. The Museum of Modern Art, New York.
Gift of Mr. and Mrs. Robert C. Scull.

Jasper Johns shared ideas with Rauschenberg and began to create large paintings that were based on common, flat symbols, such as targets, maps, flags, and numbers that could be presented, but not represented. (See color plate 7.) His TARGET WITH FOUR FACES seems to emphasize the loss of individual self in an increasingly man-made world. Johns' sense of irony relates back to Duchamp and forward to Conceptual Art. Both Johns and Rauschenberg remain outstanding individual artists of our time.

Soon others demonstrated their dissatisfactions with Abstract Expressionism, rejecting the personal emotionalsim of the Abstract Expressionists, and turning instead to the cold impersonal banality of the mass-produced urban environment.

Ideas directly influencing the American Pop Art style of the 1960s first appeared in a 1956 collage by English artist Richard Hamilton called JUST WHAT IS IT THAT MAKES TODAY'S HOMES SO DIFFERENT, SO APPEALING? In spite of its small format, the work is a major comment on the degenerate cultural values of the time as determined by the advertising media environment. In Hamilton's collage we see inspiration for the name as well as the attitude behind the Pop style. Quite appropriately, this collage was made for an exhibition called "This Is Tomorrow."

430 Richard Hamilton. JUST WHAT IS IT THAT MAKES TODAY'S HOMES SO DIFFERENT, SO APPEALING? 1956. Collage. 10¼ x 9¾″. Kunsthalle Tubingen, Philosophenweg, Germany.

431 Bernie Kemnitz. Mrs. Karl's Bread Sign. 1964. Billboard. 60 x 150'.

Pop Art's media sources include the comic strip, the advertising blowup, the branded package, and the visual clichés of billboard, newspaper, movie house, and television.

The artifacts that are the dominant subject matter of Pop Art still take a central position in many people's lives—a position similar to that held by Christian iconography through the Renaissance. The difference is that Michelangelo was intensifying faith in God, while artists like Tom Wesselmann are exposing the shallowness which occurs when people look for happiness in newer and "better" material possessions.

432 Tom Wesselmann. STILL LIFE No. 33. 1963. Paint and collage. 11 x 15'. Collection of the artist.

The size of the paintings and the boldness of single visual components within them have carried over from Abstract Expressionism. Yet, in contrast to the personal emotional warmth of Abstract Expressionism, Pop painters such as Warhol and Wesselman use their skill to create cool, mechanical images that hide all evidence of their personal touch. They often use photographic silk-screen stencils and airbrush techniques to achieve the surface character of machine-made images. This impersonality links their work to the uniformity and banality of the mass media world in which they live.

Ever since humans began to create art, artists have employed their sensitivity, awareness, and image-making skills to give form to their experience. By so doing, they have added to the experience and awareness of others. Bernie Kemnitz's billboard, MRS. KARL'S BREAD SIGN is an element of the media environment to which Tom Wesselmann has responded with his STILL LIFE No. 33. In the past, when the environment was predominantly natural, art helped people to describe, understand, and gain a sense of control over their surroundings. Today, with our largely man-made environment, art answers a similar need.

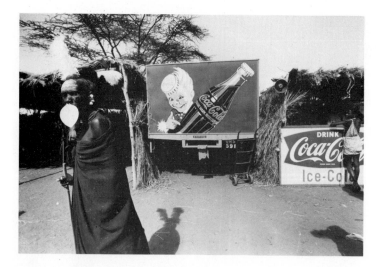

433 Ivan Massar. THE PAUSE THAT REFRESHES. Kenya, 1964. Photograph.

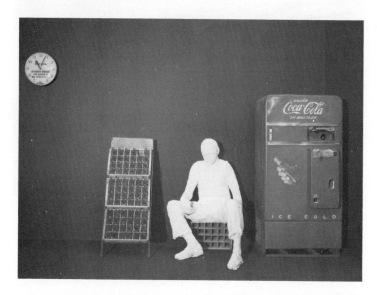

435 George Segal. Detail of THE GAS STATION. 1963 Plaster and mixed media. 8'6'' x 24' x 4'. The National Gallery of Canada, Ottawa.

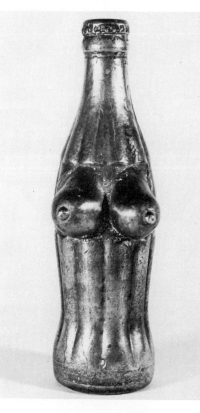

434 Charles Frazier. AMERICAN NUDE. 1963. Bronze. Height 7¾''. Kornblee Gallery, New York.

436 Marisol. LOVE. 1962. Plaster. Life-size. The Museum of Modern Art, New York. Gift of Claire and Tom Wesselmann.

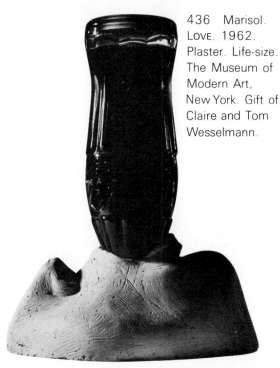

The Coke bottle is a most commonplace object in the world today. An archaeologist of the future who digs up the remains of our present civilization will find so many Coke bottles that he or she may assume they were used in some sort of common fertility ritual! Marisol used an actual bottle in her assemblage, LOVE. Others have commented on the Coke culture in photographs, paintings, and sculpture.

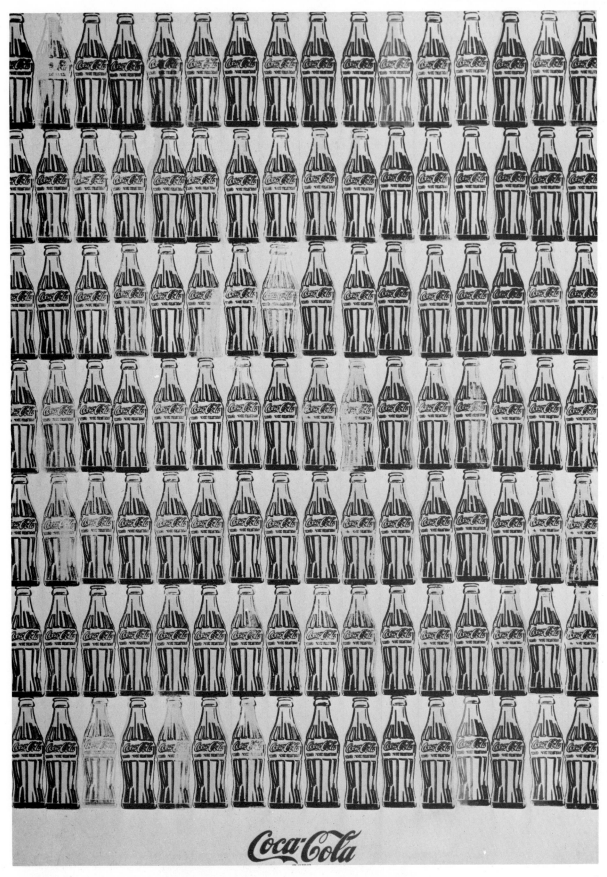

437 Andy Warhol. GREEN COCA COLA BOTTLES. 1962. Oil on canvas. 82¼ x 57''. Whitney Museum of American Art, New York.

It is fairly easy to divide artists into stylistic groups, but the practice is valuable only up to a point. Ultimately each person gives form to individual experience. Claes Oldenburg can be called a Pop sculptor, but that label merely suggests his point of view.

Oldenburg calls our attention to the amazing character of ordinary man-made things by taking them out of context and changing their scale or transforming them from hard to soft. In this way, a garden tool becomes a monument in his SCULPTURE IN THE FORM OF A TROWEL STUCK IN THE GROUND, overwhelming us with its exaggerated scale in an outdoor setting. Duchamp began such confrontation of ordinary manufactured objects with his bicycle wheel and kitchen stool in 1913. (See page 334.)

438 Claes Oldenburg. SCULPTURE IN THE FORM OF A TROWEL STUCK IN THE GROUND. 1971. Height 40'.

439 Tony Smith. DIE. 1962. Steel. 6' x 6' x 6'. Collection of the artist.

Styles in the arts are frequently reactions to the style that precedes them. In this way the new style expresses the changing character of the times.

In the late 1950s and 1960s a number of painters and sculptors reduced the complexity of their designs to a minimum, concentrating on cool nonsensual, impersonal geometric structures presented without interpretation as neutral objects. The approach is called *minimal*.

Former architect and sculptor Tony Smith was one of the first to explore the possibilities of large inert objects. Smith challenged another preconception about the nature of art by removing himself completely from the process. He ordered a six-foot steel cube by telephone. The size, mass, material, and method produce a heavy visual statement.

Al Held cuts off his shapes at the edge of the picture plane in such a way that they seem even more gigantic than they actually are. The figure in this photograph shows the scale of his painting, GREEK GARDEN.

440 Al Held. GREEK GARDEN. 1966. Acrylic on canvas. 12 x 56'. Collection of the artist.

441 Frank Stella. HIRAQLA 1. 1968. Polymer and fluorescent polymer paint on canvas. 10 x 20′. Private collection.

Ever since Cubism broke with the Renaissance concept of illusionary deep space, some painters have tried to push the limits of flatness rather than depth. Almost any mark on a flat surface will begin to give the appearance of depth. Frank Stella has built up painted surfaces that are made entirely of parallel line patterns. More recently, in HIRAQLA I., he has interwoven bands of intense day-glo color, which pull together into a tight spatial sandwich. Although most of the colors tend naturally to appear to either advance or recede, each is pulled to the surface because of its placement in the overlapping visual weave.

My painting is based on the fact that only what can be seen there *is* there. It really is an object. . . . All I want anyone to get out of my paintings, and all that I ever get out of them, is the fact that you can see the whole idea without any confusion. . . . What you see is what you see.

Frank Stella[25]

Other painters in recent years have sought maximum effectiveness with minimum means. There are infinite ways to make a surface come to life. The style called *Op Art* is also in strong contrast to the ideas of personal emotional involvement recorded on the lively surfaces of Abstract Expressionist paintings. Op painters pushed surface movement even further by developing images based on optical illusions. The dynamic tension of their images exists only in the eye of the beholder. A primary aim is to stretch vision by producing involuntary visual sensations.

The Op artist's emphasis is on scientific exploration of optical phenomena. Painters like Vasarely (see color plate 15) and Bridget Riley explore the field of pure optical experience with the cool precision and anonymity of engineers. In CREST Riley combines the movement of the diagonal edges of the picture plane with the dynamic energy of the linear surface rhythms. Compare her precise impersonal painting with the expressive effect of the

similar wavelike pattern in the WAVE UNDER THE MOON, painted in twelfth-century China (see page 49).

Light shows presented with rock and other forms of contemporary music became popular in the mid-1960s. The drug culture produced a vibrant, emotional style of art that appeared most frequently in posters advertising rock music concerts and accompanying light shows. The flamelike curvilinear forms of turn-of-the-century art provided inspiration. Eye-teasing _psychedelic art_ was the popular informal partner of Op. (See page 136.)

Since Edison invented the electric light bulb in 1879, it has been easier to control light. Light is a medium, not a style. Its use in art is not a new idea. Twenty-five centuries ago Pythagoras visualized the silent motion of the heavenly bodies as visual music and called it "the music of the spheres." Isaac Newton speculated on a possible connection between the vibrations of sound and light in an art of "Color Music."

Thomas Wilfred was one of the first to conceive of light art as an independent aesthetic language. He called it "lumia." His experiments in 1905 led to the development of the "Clavilux Lumia," an instrument on which he played the first public recitals in 1922 in New York City, and later throughout the United States, Canada, and Europe. The Clavilux is a silent keyboard that rear-projects moving light forms through reflectors and filters onto a screen. His recorded compositions, such as LUMIA SUITE, OP. 158, are now exhibited in museums and art collections. (See color plate 39).

Wilfred's late works have achieved rare quality. He has worked out a system for reflecting light from moving mirrors onto a translucent screen. From the front of the screen a continuously changing pattern of colored light appears. Light art has come into its own since 1960.

442 Bridget Riley. CREST. 1964. Emulsion on board. 65½ x 65½". Private collection.

443 Thomas Wilfred. LUMIA SUITE, OP. 158 (two stages). 1963–1964. Light composition projected against a screen. 6 x 8'. Commissioned by the Museum of Modern Art, New York. _See color plate 39, near page 323._

444 Chryssa. FRAGMENT FOR THE "GATES TO TIMES SQUARE". 1966. Neon and plexiglass. 81 x 34½ x 27½". Whitney Museum of American Art. Gift of Howard and Jean Lipman.

About 1967 a few artists began experimenting with laser light. The laser beam consists of a straight, narrow band of light, organized in direction and totally pure in hue. Because of its coherent nature the laser beam remains narrow indefinitely. A variety of pure light sculpture pieces have been produced with this new medium.

Contemporary American signs and symbols are the basis for Chryssa's art. She translates neon advertisements into objects for contemplation. In FRAGMENT TO THE "GATES TO TIMES SQUARE", blinking and repeating lines and shapes add depth, and contribute to the artist's use of light, space, and proportion.

Kinetic art is art that changes as you look at it or touch it. The term *kinetic* applies to a wide range of styles in which motion is an important element. Form and content in contemporary kinetic art range from cool precision to the happy absurdity of Jean Tinguely's mechanical junk sculpture.

The Swiss sculptor Tinguely creates machines that do just about everything except work in the manner expected of machines. In 1960 Tinguely built a large piece of mechanized sculpture that he put together from materials gathered from junkyards and stores around New York City. The result was a giant assemblage designed to destroy itself at the turn of a switch—which it did in the courtyard of the Museum of Modern Art in New York on March 17, 1960. The sculpture was appropriately called HOMAGE TO NEW YORK: A SELF-CONSTRUCTING, SELF-DESTROYING WORK OF ART.

Another mixed-media art form that came into prominence in the early 1960s was the "happening." Artists, who saw easel painting and fixed-object sculpture as irrelevant, found they could involve their audience in works that can best be described as experimental participatory theater. The resulting dramas had Dada and Surrealist overtones.

445 Jean Tinguely. HOMAGE TO NEW YORK: A SELF-CONSTRUCTING, SELF-DESTROYING WORK OF ART. 1960. Photograph by David Gahr.

446 ANTI-AUTO POLLUTION DEMONSTRATION. New York, 1971. Photograph by Horst Schafer.

The term *happening* was first used in the United States by Allan Kaprow. Like Duchamp, the creators of happenings wanted to force the viewer to be involved with the environment. No help is given to the viewer, who is expected to find his or her own answers. Strictly speaking, happenings are drama with "structure but no plot, words but no dialogue, actors but no characters, and above all, nothing logical or continuous."[26] Unlike Dada and Surrealist events, the first happenings were frequently nihilistic without a relieving sense of humor.

Festivals of all kinds can be considered happenings. In a broad sense, if they contribute to human experience, they act as art. Street protests can work as happenings. If the participants in the event have a sense of symbolic drama, the effect can be very effective communication.

447 Lee Bontecou. UNTITLED. 1961. Pencil and soot on muslin with copper wire and steel. 72 x 66¼ x 26''. Whitney Museum of American Art, New York.

448 Lee Bontecou at work. Photograph by Giulia Niccolai.

Lee Bontecou's welded steel, wire, and canvas constructions are strong images. She aims to give the viewer a glimpse of some of the beauty, ugliness, mystery, fear, and hope that exists in all of us. This untitled work of 1961 is one of many hanging relief sculptures, rectangular and shaped, that contain ominous craterlike openings and huge sets of fierce teeth.

Once during an art festival a little girl holding the string of a helium-filled balloon was forced by the crowd to stand close to a similarly ferocious work by Bontecou. Suddenly there was a loud BANG! The girl looked up, wide-eyed, at the work and wailed, "It bit my balloon!"

The American sculptor David Smith was a leading proponent of assembled metal sculpture as conceived by Picasso. With the contemporary medium of welded steel, he evolved a way of working that combined the psychological, symbolic content of Surrealism with the abstract geometric structuring of Cubism. His late work included the monumental stainless steel "Cubi" series based on cubic masses and planes balanced dynamically above the viewer's head. In CUBI XVII, the scoured surfaces of the steel form reflect light in ways that tend to dissolve their solidity. Smith intended the sculpture to be viewed outdoors in strong light, and set off by landscaping. There is a relationship here to Frank Lloyd Wright's romantic use of geometric planes in space, as well as to the work of the New York Abstract Expressionists who were Smith's friends.

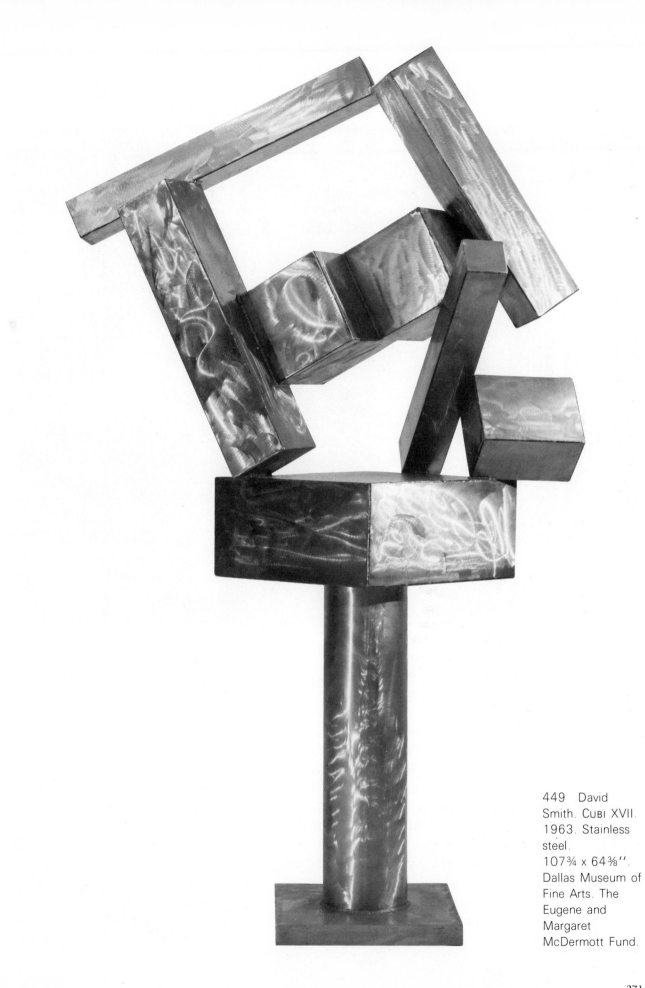

449 David
Smith. CUBI XVII.
1963. Stainless
steel.
107¾ x 64⅜''.
Dallas Museum of
Fine Arts. The
Eugene and
Margaret
McDermott Fund.

371

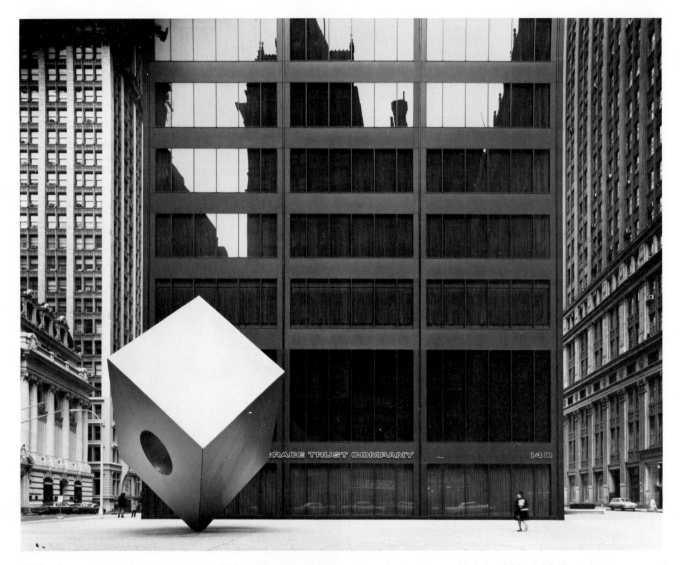

450 Isamu Noguchi. RED CUBE. 1969. Painted welded steel and aluminum. Height 28'. 140 Broadway, New York City. *See color plate 40, near page 323.*

Isamu Noguchi's RED CUBE relates to the minimal trend, but immediately the viewer is engaged in the dynamics of balance, bold color, and shaped space. The piece is a distorted rather than actual cube. Emphasis is on the huge, simple, geometric mass strong enough to interact with the architecture behind it. The scale and character of such sculpture make it involve its surroundings, thus relating it to even larger environmental sculptures. (See color plate 40.)

As paintings have become objects themselves, rather than reflections of objects, they have begun to function as environments, instead of as representations of environments already existing.

In the late 1940s independent painter Ben Cunningham went beyond the usual rectangular format in his first CORNER PAINTING (see color plate 41). The image is a forerunner of Op art and anticipates the shaped canvases of later decades. His manipulation of color re-

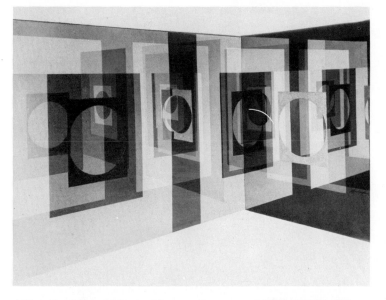

451 Ben Cunningham. CORNER PAINTING. 1948–1950. Oil on canvas. 25½ x 36½''. 25½ x 21½''. Collection Mrs. Ben Cunningham. *See color plate 41, near page 323.*

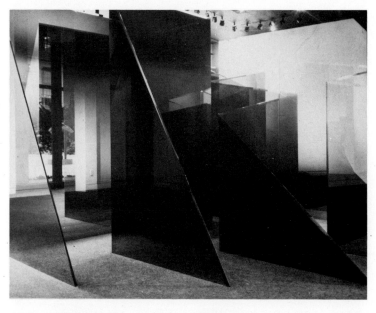

452 Larry Bell. Detail of THE ICEBERG AND ITS SHADOW. 1975. Plate glass, 56 sections. Varying heights x 60 x ⅜''. Collection of the artist.

lationships in precise perspective planes gives a fascinating illusion of depth. Cunningham mastered in one painting the spatial effects of color as transparent film, as hollow volume, and as impenetrable surface.

Years before Op art was singled out as an identifiable style, Cunningham began searching out the dimensions of color form. He sought to dematerialize color, as Renaissance painting had dematerialized the picture planes, and Cubism had dematerialized mass. Unlike most Op artists who played upon one or two perceptual phenomena, Cunningham's color explorations employed a variety of themes—simultaneous contrast of colors, afterimages, depth illusion created with color rather than linear perspective, the illusion of light coming from within the painting, color as temperature, and colors that do not exist except by implication. One can look at, through, and into Cunningham's paintings.

Larry Bell's THE ICEBERG AND ITS SHADOW is comprised of fifty-six panels of clear and dark glass that can be installed in endless combinations, using the entire work, or part of it. The sculpture has been presented in different ways in various museums and galleries.

The large translucent shapes transform exhibition space into a three-dimensional environment that reflects and merges with itself in transparent overlays. The spectator becomes a part of this reflective, luminous maze. As one moves around within the work, the kaleidoscopic reflections of the panels absorb the viewer in a disorienting interweaving of spaces that suggest cubist influence.

453 Dennis Oppenheim. CANCELLED CROP. 1968.

454 Robert Smithson. SPIRAL JETTY. Great Salt Lake, Utah. 1970. Length 1500', width 15'.

In the late 1960s many serious artists tried to abandon the established circuit of galleries, dealers, patrons, and museums by creating works that could not be bought, sold, or collected. The cult of the "precious object" was attacked. Permanence, long a major concern in the visual arts, had been losing importance for some time. In Dada and Surrealist works, chance frequently played a major role in determining composition. The process of creating art thus became as important as the product. This attitude was central to Abstract Expressionism and seems to have culminated in *Conceptual Art.*

If ideas produce art forms, and if the idea of art iself has been corrupted by overemphasis on art products, then why not cut back to the essence of art: art-as-idea or concept?

A notable Conceptual work was ICE by Rafael Ferrer. In the fall of 1969 Ferrer put together an assemblage of ice blocks and au-

tumn leaves on the Whitney Museum's entry ramp. When collectors complained about the ephemeral nature of his creation, Ferrer suggested that the iceman's bill might do as a kind of drawing.

Conceptual Art is part of a recent tendency to conceive works that relate to interior and exterior spaces, not as isolated pieces, but as environmentally inclusive forms. Such thinking is illustrated by one form of noncollectable work known as *Earth Art.* For Dennis Oppenheim art, as in CANCELED CROP, is idea and process, calling our attention to a new awareness of the extraordinary quality of ordinary events.

Robert Smithson's earthwork SPIRAL JETTY completed at Great Salt Lake in 1970 is a major work of contemporary sculpture. Its out of the way location adds to its unity with the whole Earth setting.

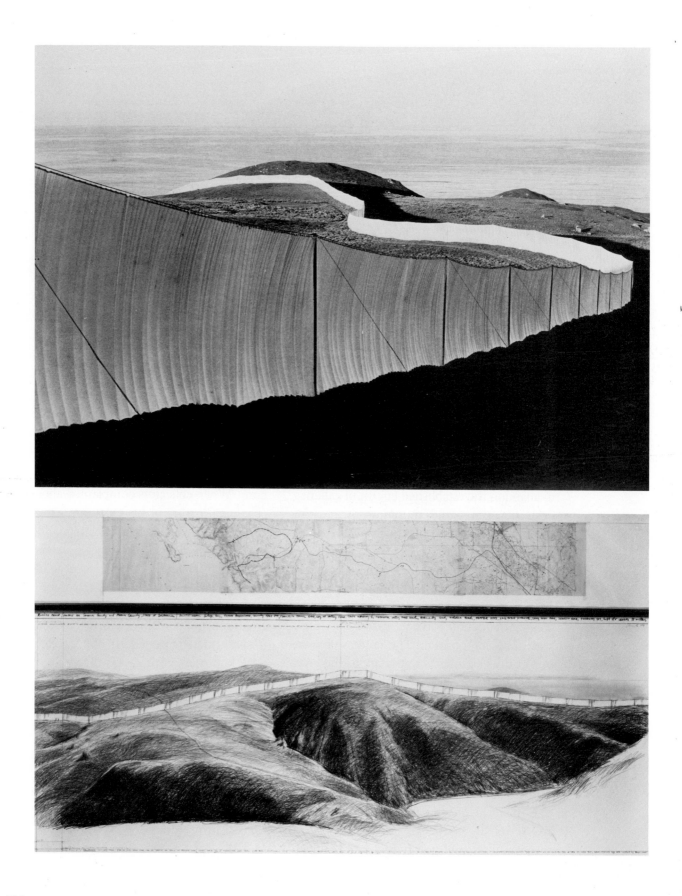

RUNNING FENCE, a temporary environmental art work designed by Christo, was a process and an event as well as a form. The eighteen foot high white nylon fence ran from the ocean at Bodega Bay in Marin County, California, through 24½ miles of agricultural and dairy country, and a small residential subdivision, in Marin and Sonoma counties. It was installed in September, 1976 and remained on view for two weeks. The owners of the forty-eight parcels of land involved gave their consent prior to construction. When the viewing period was completed, all materials were removed and presented to the ranchers on whose land it had been erected.

In its fullest dimensions RUNNING FENCE was a complex process leading to a unique environmental event, directly involving thousands of people. Christo raised the huge sum of money necessary to complete the project by selling drawings and collages of his visualization of the final appearance of the work.

The seemingly endless ribbon of white stretched across the softly rolling hills, appearing and disappearing on the horizon. Seeing the great white fence accenting the landscape was not very different from experiencing more traditional art forms.

Christo's work is conceptual in the way it calls attention to the fact that art is experience before and after it is anything else. As an idea, RUNNING FENCE may help preserve not only the land it temporarily graced, but other landscapes as well. Christo's ideas may make people more aware of the beauty and character of open countryside. RUNNING FENCE celebrates landscape.

In a capsule history of the visual arts we can only mention the most popular public arts of our time: photography, cinematography, and television. These arts play a major role in contemporary life, yet to weave them into this tapestry of painting, sculpture, and architecture would be confusing and inadequate. Their format does not translate into single book reproductions. While the camera arts are the dominant popular forms of our time, their quantity makes it difficult to find those works that are of sufficient quality to be called art in the full sense of the word. Both film and television are kinetic forms that respond to the demands of mechanized urban life. Their transitory character fits with the complex technology that supports them. What will be their significance to future man?

The quality of impersonal neutrality found in many camera images has been the basis for the recent style of painting descriptively labeled *Photorealism*. This style, which began in California, is represented here by Don Eddy and Richard Estes. (See next page.)

It seemed inevitable that after all the different movements rejecting subject matter in favor of "pure" nonrepresentational form, art would eventually return to some aspect of its role as recorder of appearances. There is a major difference, however, between the works of most Photorealists and most earlier representational painters. The Photorealists are not telling stories. Their subjects are often as insignificant as possible. The cool banality is related to earlier Pop subject matter, yet it is translated into imagery without the influence of mass media.

455 a. Christo. RUNNING FENCE.
1972–1976. Nylon fabric and steel poles.
18' x 24½ miles. Installed in Sonoma and Marin Counties, California for two weeks, Fall 1976.

455 b. Christo. RUNNING FENCE PROJECT.
1972–1976. Drawing in two parts. Pencil and map. 14 x 96'', 36 x 96''.

456 Don Eddy.
PRIVATE PARKING X.
1971. Acrylic on
canvas. 66 x 95".
Collection Mr. and Mrs.
Monroe Myerson, New
York.

457 Richard Estes.
HORN AND HARDART
AUTOMAT. 1967. Oil on
masonite. 48 x 60"
Collection Mr. and Mrs.
Stephen D. Paine,
Boston. *See color plate
42, opposite page 323.*

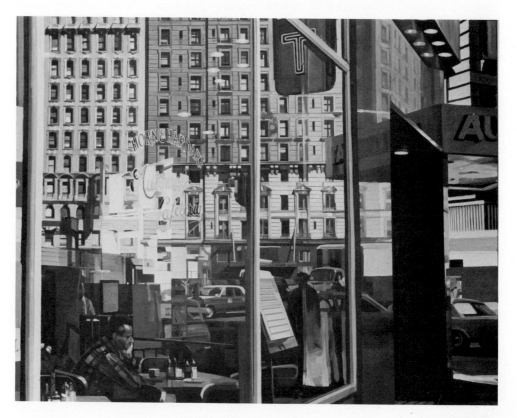

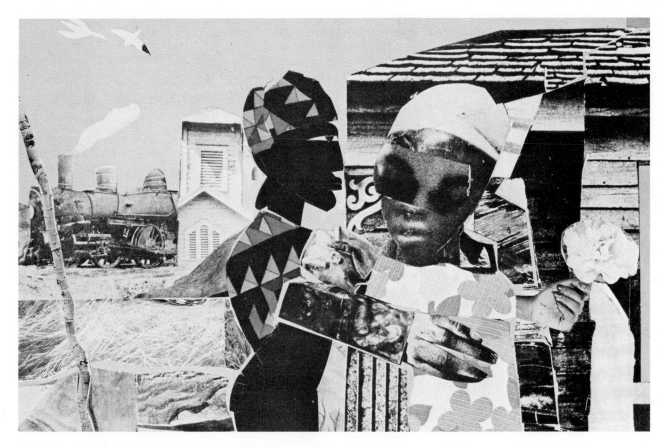

458 Romare Bearden, TIDINGS #2. 1975. Collage.

Don Eddy's images are developed on large canvases with faultless airbrush technique. He works from black-and-white photographs using a grid pattern and sketching in the image with charcoal before he starts to paint with an airbrush. The subject matter recalls his past experience working in his father's car painting shop, and the color is often inspired by works of other artists, particularly Hans Hofmann. Eddy is excited about what he can discover and make happen in terms of unique spatial tensions. On the flat painted surface, these tensions couple with ambiguous reflections, creating rich sensations for the eye.

Richard Estes photographs and then paints detailed images of common cityscapes, often devoid of people but full of the artifacts of contemporary life. In contrast to the impersonal quality of Eddy's airbrush work, Este's HORN AND HARDART AUTOMAT was painted with a traditional brush, giving the surface a rich and personal paint quality when viewed at close range. (See color plate 42).

Romare Bearden's subjective visual poetry is in contrast to the cool neutrality of Photorealism. His photo-collages are alive with references to his own heritage, yet they go considerably beyond that to communicate experiences we all share. TIDINGS #2 contains a variety of symbols. The left figure appears to be a messenger spirit or angel who is making incomplete contact with the sad, unseeing person. A flower is held just beyond the reach of an outstretched hand. The train accents a melancholy feeling caused by loneliness or separation.

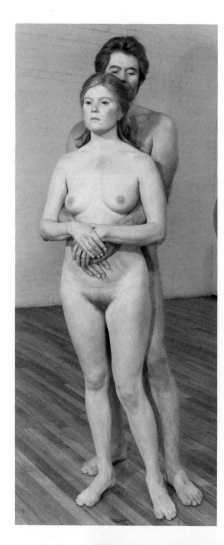

459 John
DeAndrea. MAN WITH
ARMS AROUND
WOMAN. 1976. Vinyl
polychromed.
Life-size. Collection of
the artist.

460 John DeAndrea. Several
works, including CLOTHED ARTIST
WITH MODEL, and live viewer.
Photographed in storeroom of
OK Harris Gallery, New York.

Parallel to Photorealism in painting, a style of highly detailed, superrepresentational sculpture also came into being about 1970 following the lead of pop sculptor George Segal. (See page 362.) The cast and painted fiberglass and polyester life-sized figures of John DeAndrea are unsettling when experienced face to face. They are so incredibly realistic in every detail that their stillness is disturbing.

Variety of image, concept, and materials has been characteristic of figurative sculpture, as well as figurative painting, since 1950. The poignant personal feelings expressed in the SLEEPWALKER by Marianna Pineda contrast strongly with the total neutrality of cast-from-life sculpture such as DeAndrea's and George Segal's works. The cool blank anonymity of Segal's unpainted plaster boy in a service station is also in strong contrast to the Pop-related plastic color of Luis Jiménez's sculpture. The slick surfaced epoxy resin of THE AMERICAN DREAM emphasizes Pop culture's media-created sex-object woman and America's love affair with the automobile.

As we approach the last two decades of the

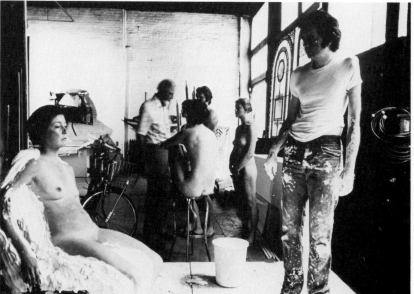

twentieth century, artists continue to find ways to challenge and augment our experience. The gold frame and the pedestal that set art apart from the viewer are things of the past. Increased viewer participation is a major characteristic of contemporary art. Some artists, whose works would traditionally be found in galleries, museums, and the homes of wealthy collectors, are creating works designed for public indoor and outdoor spaces and for the homes of people with moderate incomes. This move away from exclusive art circles has been helped by the growing patronage of corporations and by the production of multiples, which can be sold at prices many people can afford. Rapidly growing interest in the crafts has increased involvement in the visual arts.

461 Marianna Pineda. SLEEPWALKER. 1950. Bronze, unique. Height 38''. Private collection.

462 Luis Jiménez. THE AMERICAN DREAM. 1967–1969. Fiberglass resin epoxy coating, first of five castings. Height 3'. Collection David Anderson, Roswell, New Mexico.

463 a.

It is only logical that the rarified upper atmosphere of the art world should sometimes fail to sustain life and thereby open a gap for a bit of fresh air. RUCKUS MANHATTAN, a refreshing, wildly humorous construction, was a show put together by Red Grooms, his wife Mimi, and a group called the Ruckus Construction Company. This giant assemblage of Pop sculpture features caricatures of many of the most famous landmarks of New York City, including a thirty-foot high version of the world trade center, a subway train, the Woolworth Building, a Times Square porno shop, a Staten Island ferry one can "ride" on, and the Statue of Liberty in red platform shoes, holding a cigar in her raised hand. The show was a marvelous mix of theater, circus, carnival, parade, and amusement park. Realistic details were everywhere—even steam puffing out of manholes.

The viewers became participants as they mingled with papier-mâché and cutout figures and other viewers in a complex of walk-in buildings, shops, roads, and bridges—all constructed in Manhattan's Marborough Gallery in the summer of 1976. As the live people and the papier-mâché people blended in the chaos of the mini-city, one began to wonder if all Manhattan and all the world were really just a giant cartoon.

Beyond the dazzling excitement of new forms, much contemporary art and life is harsh, mechanical, uncompromising, confusing, and just plain ugly. It is natural to feel more comfortable with the art of the past; it has been around long enough to be understandable, and therefore enjoyable. It is often difficult to look the present in the eye!

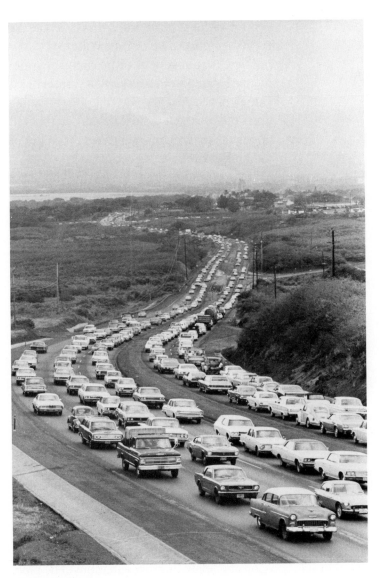

464 AUTOSCAPE.

All the arts are environmental in the sense that they help to determine the quality of our living areas. The discussion on environmental design in Chapter 3 shows some of the ways professionals affect the environment on a large scale. These professionals include: architects, who are responsible for the design of buildings and groups of buildings; landscape architects, who plan open green spaces; industrial designers, who are responsible for the appearance of manufactured objects ranging from street furniture to transportation systems; and urban and regional designers, who plan ordered relationships between each of these diverse physical elements.

Even the best professionals cannot solve environmental problems alone. Their efforts are outweighed by the force of the economic, political, and social values of the culture as a whole—in other words, YOU and ME—all of us, whether we work together or apart. In the sense that what we do changes our surroundings, we are all environmental designers.

Your environment is your self-portrait. It begins with your attitudes about life. Simply by being alive, you make a difference. You are part of the problem *and* can also be part of the solution.

How we care for or neglect our own bodies is a starting point. A healthy man or woman complements and is a part of the beauty of nature. Our smallest acts change how we live. Eating, washing, combing our hair, deciding what to wear—all have an effect on our environment, which begins with the individual.

The way we organize the interior spaces in our lives also makes a difference in how we feel about ourselves and what we project into the outer environment. Outside the home or work environment, we affect community design when we move from place to place. The patterns of footpaths, sidewalks, streets, and bus or train routes are generated by our travel. As we change these habits, the transportation corridors of the city and region will eventually reflect these changes for better or worse.

From room to region, from small decisions about personal health and appearance to large physical and political decisions affecting entire continents and oceans, we shape our surroundings and they in turn shape us.

465 Linda Wiig. ARTIFICIAL FORMULA. 1968. Photograph.

The material culture of nonindustrialized people is created by craftsmen whose work reflects shared values and feelings. Within such a community each person knows that every thing not made by nature was made and can be made again by people like themselves. (See pages 178, 203, and 234.) In the manufactured world most of us live in now, this is not true. Anonymous people working with machines make our major buildings, our furniture, and our utensils. The touch of their hands can rarely be seen or felt. Living in this kind of setting, it is easy to feel that the built environment is just *there*, that it cannot be changed. This feeling we have of not being in control of our surroundings is one of the causes of today's environmental crisis.

There is an urgent need to extend environmental awareness to larger and less specialized groups of people. We are not simply facing questions of which picture to hang on the wall or what color to paint public buildings, but of life and death. It is all connected.

Since primitive times the environment has been both natural and man-made. Today the man-made factors have become increasingly dominant and out of harmony with the natural order. Once we understand the interdependence of all things, we can understand why cooperation is more essential than competition. A dynamic, yet balanced relationship between the various environmental elements is crucial to our well-being and ultimately to our survival.

For humans, mere survival is not enough, but even to achieve *that* requires the survival of complete ecological systems, not merely the survival of one species. No ecosystem, no human existence. Now, near the end of the twentieth century, the problem is not only physiological survival, which humans have always been faced with, but also survival of a life with personal and social fulfillment.

Necessity encouraged early humans to develop and apply their imaginations. The problem was survival. They began to make things in order to meet the need for food, shelter, and protection. From these beginnings we have gone on inventing and constructing at an ever-increasing rate, building up around ourselves an accumulation of artifacts that has set us apart from what Walt Whitman called "the primal sanities of nature."[2] This proliferation of material goods has become so dominant in the world that it has caused the extinction of over three hundred species of animals, and now threatens many more, including mankind. "Only within the moment of time represented by the present century has one spe-

466 Herbert Loebel. AVENUE U. 1961. Photograph.

cies—man—acquired significant power to alter the nature of his world." (Rachel Carson)[3]

A major force working against the unification of man and nature, and art and life, is the set of values that has developed in today's industrial nations to perpetuate economic growth based on technology. Regardless of political ideologies, these values include: (1) setting the highest priority on production itself, with emphasis on technical efficiency—this is often at the expense of more human consider-ations, including concern for the aesthetic aspects of life; and (2) the assumption that we must "tame" the environment so that it will provide us with immediate "necessary" re-sources. These values produce a life style that appears strikingly rich in every aspect except that of cultivation of the human person.[4] Are we destroying both ourselves and our environ-ment with the so-called economic imperatives of modern civilization?

We are now at a crossroads between natural evolution and technological progress. Human-centered attitudes and values have created an explosive growth in technology and an accompanying emphasis on material wealth and physical security. The changes accompanying this growth have led to a reexamination of basic human values. A major struggle is going on between those who believe that the highest quality of life will be obtained by continuing the drive toward greater control over the physical world and those who would like to abandon this direction in order to move toward a more spiritual and natural style of life. A possible solution appears to be *not* simply to abandon the mental and physical environments produced by industrial technologies, but to select technologies with great care. Selections should be based on the ideal of bringing human endeavor into equilibrium with the natural order.

Art is concerned with the quality of life. What we call *life* is an interaction between ourselves and our surroundings. It is a *relationship*. The quality of that relationship determines whether there will be life or death, and if there is life, whether it will be worth living.

The most basic relationship is between ourselves and the land. Our current abuse of the land is largely the result of our attitude that land is a commodity to be owned, bought, sold, and consumed. We must recognize that land is part of the total ecological system of which we are but a small part and use it with greater respect. We must learn an attitude of humility toward, and rapport with, the natural world from such native peoples as those of North America and the Pacific whose land we have appropriated. This is the only way our land and all who live on it can survive the impact of modern egotistical man. We must design *with* nature.

With the timeless dignity of an ancient chant, this poem expresses the American Indian's idea of self in relation to Earth and the Universe:

You see, I am alive.
You see, I stand in good relation to the earth.
You see, I stand in good relation to the gods.
You see, I stand in good relation to all that is beautiful.
You see, I stand in good relation to you.
You see, I am alive, I am alive.

<div align="right">N. Scott Momaday[5]</div>

The ability of earlier generations to identify with the environment and to act out the drama of life in drawing, carving, mime, and song, calmed their fears and hungers and intensified their joys. Creating art called for intuition, imagination, memory, skill, and the imitation of natural forms. Today we have the same human needs.

Tools extend our power. Today's tools give us the awesome power to transform the world, greatly magnifying the impact of our choices. As human beings we are more responsible for our choices than other species because we are *conscious*. Our consciousness makes it possible for us to select the wrong choices as well as the right ones, to be awkward as well as graceful. The price of consciousness is responsibility for choices.

Our next step is to use this power to make our man-made environment a work of art—a work of harmony and delight, capable of promoting rather than destroying the health and well-being of all who share it. Not as one above or against the other, but *for one another*.

Chaos and ugliness are the symptoms and causes of cultural disease. Given the growing array of environmental problems facing us today, it is no wonder that many of us feel despair. Yet when despair interferes with posi-

467 George Tooker. THE SUBWAY. 1950. Egg tempera on composition board. 18⅛ x 36⅛''. Whitney Museum of American Art. Juliana Force Purchase.

tive action it magnifies the crisis. Perhaps worse than despair is the illusion that we can escape the crisis by abandoning our wasted places for fresh ones. Another form of escape is the withdrawal that can occur when the environment becomes so bad that it pollutes our senses and anaesthetizes our perception. Without sensitivity we cannot recognize the changes that are needed. Our ability to adapt can work against us. We become increasingly withdrawn from and tolerant of surroundings that deny our basic human needs.

One of the most dangerous aspects of concentrated urban environments is the lack of confirmation of the worthwhile self. Living in a dingy apartment in a crowded neighborhood can convey the message that a person is not worth much. A low opinion of oneself may ultimately result in destructive behavior. This opinion, spread through a city's population, can produce what anthropologist Edward T. Hall described as "a series of destructive sinks more lethal than the hydrogen bomb."[6]

468 Bernice Abbott.
EXCHANGE PLACE.
1933.

New York City is the epitome of environments made by industrial man. Because it brings together in one place much of the best and the worst of human life it can be both exhilarating and depressing. Much of Manhattan is now crowded with tall buildings and improved spacing is almost impossible. The demands of a growth economy designed this incredible human construction.

Rockefeller Center, begun in 1931, was an early demonstration of the fact that tall buildings can be designed to interrelate with shorter buildings and open areas to create pleasant spaces, even when population density is extremely high. In this project open space became the unifying concept, enhancing the buildings. Rockefeller Center was an exceptional venture that remained just that. Midtown Manhattan is a colossal concentration of almost uncontrolled vertical growth.

The tremendous urban growth in America since 1950 has given cities a variety of pressing problems. Many people wished to live near the city, but not in it. As new shopping and business centers grew around the central city, the old city centers decayed.

Urban renewal projects have ranged from very successful to total failure. At best they meet the needs of the occupants, providing pleasant places to live at low cost. At worst, they compound social and environmental problems by providing costly sterile environments out of human scale. (See page 217.)

Recent years have seen a reexamination of the urban renewal concept. Economic factors, as well as social concerns, have led to a new trend of recycling old buildings in older sections of cities. This is more than historic preservation. Federal, state, and city agencies, often in cooperation with one another, have found that in many cases it is cheaper to rebuild the insides of old buildings than to tear them down and start over. And the results are likely to be more attractive to residents.

469 Bruce Davidson.
MANHATTAN. 1966.

470 ROCKEFELLER
CENTER. Original
buildings completed in
1937. Later buildings
added since 1960.

ART HELPS FORM THE SOLUTION

Art can be a tool to encourage equilibrium between human efforts and the order of natural systems. In the past, art has brought humanity and nature together. Art refers to human creations (acts, ideas, constructions) that fuse matter with spirit. The artist and other aesthetically aware individuals use their abilities to create something, as nature does; that is, not to do what nature has done, in the sense of a replica, but to move with nature.

How can art help transform society into a social structure whose values and physical forms are rooted in the biological requirements for survival? One obvious approach might be simply to make things and places prettier. But environmentally we are dealing with cancer and not acne. If the human values behind environmental forms are destructive or false, no amount of "beautification" will help. As in other forms of illness, it is the disease, not the symptoms, that must be stopped, and pollution, noise, ugliness, and related conditions are but symptoms. Application of a concealing cosmetic will only delay the process of solving the deeper problems.

If beautification is skin deep, art may contribute to survival in two less superficial ways: by training perceptions and by guiding the process of form making. Sensory experience can provide the awareness and imagination necessary for value changes. Intense aesthetic experiences break the habit of taking things for granted, and thus are an important tool for the nurturing of new perceptions.

Changed values result in changed actions. If we learn how to design *with* and not *against* the natural order, our actions in the physical world will be markedly different from what they are now. Translating new values into new actions entails design problems of two types: design of new life styles and the design of physical environments for human use.

As you become aware of how your surroundings and your relationships to them affect your day-to-day feelings and even your health, you can begin to take a more active conscious role in shaping your place of living. It is becoming increasingly clear that environmental factors play a major part in determining our mental health and our physical well being.

If we are to stand the stresses of urban life, some direct contact with wilderness may be vital to us. The need for protected areas was understood as early as 1898 by John Muir, naturalist, conservationist, pioneer spokesman for the national parks, and founder of the Sierra Club.

Thousands of tired, nerve-shaken, over-civilized people are beginning to find out that going to the mountains is going home; that wildness is a necessity; and that mountain parks and reservations are useful not only as fountains of timber and irrigating rivers, but as fountains of life.[7]

But nature must also be close to us. Maintaining wilderness mountain areas is vital, but it does not help people who, for economic or physical reasons, cannot go to it. We need nature where it can be enjoyed each day. The regular occurrence of open space combined with vegetation can help meet the city dweller's need for relief from pollution of the senses.

Generations ago towns were built around an open area known as a village square or common. Most of our cities have sizable parks, established generations ago by planners who recognized the need for open space within a metropolitan area.

471 Ansel Adams. MOON AND HALF DOME, YOSEMITE NATIONAL PARK, CALIFORNIA. c. 1960.

472 M. Paul Friedberg and Associates. VEST POCKET PLAYGROUND AND NATURE STUDY CENTER. 29th St. New York City, 1968.

473 WILLIAM S. PALEY PARK. East 53rd St., New York City.

475 Kevin Roach and Associates. OAKLAND MUSEUM. 1969.

474 Tom Wells, architect. VINE COVERED APARTMENT BUILDING.

As cities become increasingly populated, the need for park space increases, yet land becomes less and less available and more expensive. The concept of vest-pocket parks has evolved to meet this need in a practical way. Small parks can be liberally sprinkled throughout the city. When an old building is torn down, a tiny park can be built on one lot. In business districts such parks provide a haven for workers and tired shoppers. In residential areas they provide recreation and play areas easily accessible to nearby residents.

Plant life cools and refreshes the air, relaxes the eyes, and gives the country much of its beauty. Green areas can be made between and even on city buildings. Some high-rise structures have been designed to be covered with vines, and other buildings have elaborate roof gardens. Parking garages can have parks on their roofs. The Oakland Museum in California is roofed with a series of garden terraces that provide space for outdoor sculpture and pleasant places to sit and rest or eat.

476 RIVER WALK. San Antonio, Texas. 1969.

477 Lawrence Halprin and Associates (Angela Danadjieva Tzvetin, Project Designer). AUDITORIUM FORECOURT CASCADE (PEOPLE'S FOUNTAIN). Portland, Oregon. 1972.

San Antonio, Texas, decided to develop its river for people use. There was much argument about how to deal with the San Antonio River, which flowed through the heart of the city. Some said it should be encased in concrete, and built over in order to provide more commercial space. Others wanted to take advantage of its inherent charm by providing park space, a continuous walkway, boating facilities, and restaurants along the river's edge. Fortunately for the city, the people who believed in the river's potential won the argument. In San Antonio, the river is now a delight to all those who live there.

The residents of Portland, Oregon, are thoroughly enjoying their new AUDITORIUM FORECOURT CASCADE (PEOPLE'S FOUNTAIN) by the urban design firm of Lawrence Halprin and Associates. Angela Danadjieva Tzvetin was the principal designer on the project, which is the result of design professionals working together, to blend sculpture, engineering, landscape architecture, and urban design.

The eighty-foot-wide cascade began with the idea of a wilderness cascade, with still and churning water ponds and rough water falls. What look like massive white water falls are actually flows of only one to three inches deep—an impressive effect at low cost. The falls vary in size; the tallest is eighteen feet. In warm weather people of all ages enjoy cooling off in the pools and falls.

478 a. BEFORE UNDERGROUND TELEPHONE AND POWER LINES.

478 b. AFTER UNDERGROUND TELEPHONE AND POWER LINES.

Through art we can come back to our senses. We can again be in touch with feelings, while avoiding total despair or the need for escape

While art keeps us in touch with what is and what can be, it also enriches our experience and gives a quality of rightness to the things we make. In creating art we produce forms that are the human extension of nature within us. We need to bring back to life our collective sense of design, which has become dulled through many generations of progressive disuse.

With greater understanding of the visual arts and their possibilities, you can consciously improve the quality of your immediate surroundings and the larger community environment that you share with others. This action will affirm and strengthen the best in you. It will begin a constructive cycle that grows into a self-generating give-and-take between yourself and your surroundings.

What kind of positive action can you take to improve the environment you look at and live in? Possibilities range from small, specific actions to broad, large-scale involvement. These are a few examples of actions others have taken to save the best and change the worst.

■ Make decisions and take action regarding the parts of your surroundings that you would like to preserve or restore and those you would like to see discarded and changed. You could start with your personal possessions and home surroundings and perhaps carry the process into a cooperative effort in your community, county, or state. Some national and global awareness is also needed.

■ Strive to eliminate visual and environmental pollution. This can involve simply not littering or perhaps picking up litter left by others or it can involve active support of

479 C. W. Felix, coordinator. WALL, ESTRADA COURTS HOUSING PROJECT. 1973.

education and legislation related to aesthetics and environmental quality.

■ Get involved in the art process. This can mean doing a little solitary sketching or stitchery, or participating in or even organizing large-scale projects such as painting a public mural, designing or building a park or playground, or starting a community arts center.

■ Support existing organizations and groups involved in art or environmental activities. You can simply join, adding your name to a membership list, or you can participate in educational programs, community improvement projects, or other activities.

■ Be aware of who makes art decisions and find out how you and others can influence the decision-making process. Many environmental decisions, including some related to art education and commissions of art works, are made by various branches of government. Cast a vote, or become directly involved in organizing group support for or against specific plans or ideas.

480 THE WORLD.

■ Lend your support and patronage to businesses whose practices and products you find beneficial to the quality of life, and withhold your support from those you don't. The process of buying things involves selection. In a free society, taste and public demand play a large part in determining how products are designed. Everything we wear or use, from toasters to transportation systems, is designed with the consumer in mind. By deciding *not* to buy a product because it is unattractive or is environmentally unsound, you are affecting its design and even its future existence. Those with money to invest make a major impact on our shared environment by their investment choices.

■ Be aware of your environmental impact. Whether you occasionally walk instead of drive, or become involved in planning or lobbying for improved transportation systems, you are affecting the environment.

Our aesthetic awareness can be developed to such an extent that there is no line between the art of everyday life and the art of museums. When we surround ourselves with the elements of a life style we have consciously chosen as enjoyable, the best in us is reaffirmed. As we experience our decision-making capacity, our critical sensibilities are strengthened.

To act effectively as agents in our own survival we must first see and feel. Vision is our most important link to the environment. To be aware of only that which is immediate and proven is not enough. More than the practical details of working in various media, art provides the tools for going beyond the basic facts of the world. If understood and employed by many, the ideas, values, and approaches that constitute the basis of the visual arts could *help* to transform our man-made surroundings into something viable and satisfying. Art verifies and encourages our expanding awareness. As the creatures with the most advanced consciousness, we have been described as nature becoming aware of itself. We form art. Art forms us.

GLOSSARY

These terms are defined according to their usage in the visual arts.

abstract art Art based on objects in the physical world in which the usual form of the object is modified or changed in order to emphasize *content* not otherwise apparent. Recognizable references to original appearances may be very slight. Abstract art is often confused with *nonrepresentational art.*

Abstract Expressionism A style (or styles) of painting originating primarily in America during the last years of World War I; characterized by spontaneous action recorded in free *calligraphic* forms, exploitation of the accident, and strong color value patterns that express personal intuitive awareness. Large canvases give environmental impact to these images.

Abstract Surrealism See *Surrealism.*

academy An official school of art, primarily found in Italy during the sixteenth century and in France from the seventeenth through nineteenth centuries. By the late nineteenth century, the conservatism of the French Academy made it the center of opposition to all new ideas in art. The term *academic* has come to mean conservative and traditional. "Academic" also refers to a style sanctioned or promoted by an official institution, academy, or school.

achromatic Without color, or color with no *saturation*—black, white, and neutral grays, for example.

acrylic A clear plastic used as a binder in paint and as a casing material in sculpture.

Action Painting See *Abstract Expressionism.*

additive color mixture Mixture of colored light (light colors).

additive sculpture Sculptural form produced by adding, combining, or building up material from a core or *armature.* Modeling in clay and welding steel are additive processes.

aesthetic Pertaining to the sense of the beautiful and to heightened sensory perception in general.

afterimage A visual image that persists after the initial stimulus is removed.

air brush A small-scale paint sprayer that can project a fine controllable mist of paint.

analogous color A color scheme consisting of or limited to adjacent hues on the color wheel, usually within the scope of a primary through one of its related secondaries such as blue, blue-green, and green.

Analytical Cubism See *Cubism.*

aperture In photography, the camera lens opening and its relative diameter. Measured in "F stops," such as 5.6, 8, and 16. As the numbers increase, the size of the aperture decreases, thereby reducing the amount of light passing through the lens.

aquatint An *intaglio* print process in which rosin dust sprinkled on the plate is used to resist the biting action of acid; used to produce value areas, rather than lines on a print. Also, a print made by this process.

arcade A series of arches supported by columns or piers.

armature A rigid framework serving as a supporting inner core for clay or other soft modeling material.

assemblage Sculpture using preexisting, recognizable objects that contribute their original identity to the total content of the work.

asymmetrical Not symmetrical.

atmospheric perspective See *perspective.*

axis An implied straight line in the center of a form along its dominant direction.

balance An arrangement of parts achieving a state of equilibrium between opposing forces or influences. Major types are symmetrical, asymmetrical, and radial.

Baroque A style or period in European arts dominant during the seventeenth century; characterized in the visual arts by dramatic light and shade, turbulent composition, and exaggerated emotional expression.

barrel vault See *vault.*

bas relief See *relief sculpture.*

batik A process for dying cloth that involves applying wax to parts of the fabric to prevent them from absorbing dye. When the cloth is immersed in the dye, the waxed areas remain the original color. The wax is then removed. This process may be repeated many times using different dyes on the same piece of cloth.

binder The material used in paint that causes pigment particles to adhere to one another and to the support.

buttress A support, usually exterior, for a wall, arch, or vault that opposes the lateral forces of these structures. A *flying buttress* consists of a strut or segment of an arch carrying the thrust of a vault to a vertical pier positioned away from the main portion of the building. An important element in Gothic cathedrals.

Byzantine art Styles of painting, design, and architecture developed from the fifth century A.D. in Constantinople, formerly Byzantium now Istanbul; characterized in architecture by round arches, massive domes, and extensive use of mosaic; characterized in painting by formal design, frontal and stylized figures, and rich use of color, especially gold, in generally religious subject matter.

calligraphy The art of beautiful writing. Broadly, a controlled flowing use of line referred to as "calligraphic."

camera A mechanical device for taking photographs that generally consists of a light-proof enclosure with an *aperture* that allows a controlled light image to pass through a shuttered *lens* and be focused on a photosensitive material.

camera obscura A dark room (or box) with a small hole in one side through which an inverted image of the view outside is projected onto the opposite wall, screen, or mirror.

cantilever A beam or slab projecting a substantial distance from a post or wall; supported only at one end.

capital In architecture, the top part, cap stone, or head of a column or pillar.

caricature A distorted representation in which the subject's distinctive features are exaggerated to produce a comic or grotesque effect.

cartoon A humorous or satirical drawing. Also a drawing completed as a full-scale working drawing for a painting, mural, tapestry, or the like.

carving A subtractive process in which a sculpture is formed by removing material from a block or mass of wood, stone, or other material using sharpened tools.

casein A white tasteless, odorless milk and cheese protein used in making paint as well as plastics, adhesives, and foods.

casting A process that involves pouring liquid material such as resin, metal, clay, wax or plaster into a mold. When the liquid hardens, the mold is removed, leaving a hollow form in the shape of the mold.

ceramic An object made of clay that is hardened by firing or baking it into a relatively permanent material.

chiaroscuro The treatment (and use of) light and dark areas, patterns, and gradations in two-dimensional works of art, especially gradations of light and dark that produce the effect of *modeling*.

cinematography The art of making motion pictures, or pictures that appear to be in motion. Also called filmmaking.

Classical The art of ancient Greece and Rome. In particular, the style of Greek art that flourished during the fifth century B.C. Classical can also mean any art based on a clear, rational, and regular structure, emphasizing horizontal and vertical directions, and organizing its parts with special emphasis on balance and proportion. *Classic* is used to indicate recognized excellence.

closed form A form whose contour is regular and continuous; having a resolved balance of tensions, a sense of calm completeness implying a totality within itself.

cluster houses Housing units placed close together in order to maximize usable exterior space in the surrounding area, within the concept of single family dwellings.

coffer In architecture, a decorative sunken panel on the underside of a ceiling.

collage From the French *papiers collés*, or pasted papers. A work made by pasting various materials, such as paper scraps, photographs, and cloth on a flat surface.

colonnade A row of columns usually spanned or connected by beams.

Color Field painting A trend that grew out of Abstract Expressionism that uses large stained or painted areas to provide the viewer with an environment of color. Paint is sometimes poured on an unprimed canvas.

complementary colors Two hues directly opposite one another on the color wheel. The complement of each primary can be produced by mixing the other two primaries.

composite shape A single shape composed of two or more interlocking smaller shapes.

composition The combining of parts or elements to form a whole. The structure, organization, or total form of a work of art. See also *design*.

Conceptual Art An event or work of art conceived in the mind of an artist. Conceptual works are sometimes produced in visible form, but often presented only as a mental concept or idea. A trend developing in the late 1960s partially as a way of avoiding the commercialization of art.

content Meaning contained and communicated by form.

contour The edge of a mass or shape or group of masses or shapes.

contrapposto The counterpositioning of parts of the human figure about a central vertical axis, as when the weight is placed naturally on one foot causing the hip and shoulder lines to counterbalance each other in opposite directions.

cool colors Colors whose relative visual temperature makes them seem cool. Cool colors generally include green, blue-green, blue, blue-violet, and violet.

Counter Reformation The Roman Catholic Church's response to the Protestant Reformation and the growing impact of science occurring during the sixteenth and first half of the seventeenth centuries.

crosshatching See *hatching*.

Cubism A major development and style of early twentieth-century art that began in 1907 with the work of Picasso and Braque. The early mature phase of the style, called Analytical Cubism, lasted from 1909 through 1911 and was based on limited color, shifting points of observation, disintegration, and geometric reconstruction of the subject in flatted, ambiguous pictorial space. Figure–ground relationships merge into one interwoven surface of shifting planes. By 1912, the later, more decorative phase called Synthetic or Collage Cubism began to appear; this was characterized by fewer, more solid forms, conceptual rather than observed subject matter, and richer color and texture.

curtain wall A non-load-bearing wall.

curvilinear Formed or characterized by curving lines or edges.

Cyclades A group of Greek islands in the Southern Aegean Sea.

Dada A movement in art and literature founded in Switzerland in the early twentieth century that ridiculed contemporary culture and conventional art. The Dadaists shared an antimilitaristic and antiaesthetic attitude, generated in part by the horrors of World War I and in part by a rejection of accepted canons of morals and taste. The anarchic spirit of Dada can be seen in the works of Duchamp, Arp, Miró, and Picasso. Many Dadaists later became Surrealists.

design. Both the process and the result of structuring the elements of visual form.

De Stijl A Dutch purist art movement begun during World War I by Mondrian. It involved painters, sculptors, designers, and architects whose works and ideas were expressed in *De Stijl* magazine. De Stijl, Dutch for "the style," was a movement aimed at creating a universal form language that would be independent of individual emotion. Visual form was pared down to primary colors plus black and white and rectangular shapes.

dome A generally hemispherical roof or vault. Theoretically, an arch rotated 360° on its vertical axis.

drypoint An *intaglio* printmaking process in which lines are scratched directly into a metal plate with a steel needle. Also the resulting print.

earthwork Large-scale sculpture that involves moving quantities of earth in order to shape a site into a particular form.

eclecticism The practice of selecting or borrowing from earlier styles and combining the borrowed elements, rather than originating new forms. Frequently used in architecture until the mid-twentieth century.

ecology The science of the relationships between organisms and their environments.

edition In printmaking, the total number of prints made and approved by the artist, usually numbered consecutively. Also a limited number of multiple originals of a single design in any medium.

elevation In architecture, a scale drawing of any vertical side of a given structure.

encaustic A painting medium in which pigment is suspended in a binder of hot wax.

engraving An *intaglio* printmaking process in which grooves are cut into a metal or wood surface with a sharp cutting tool called a burin or graver. Also the resulting print.

etching An *intaglio* printmaking process in which a metal plate is coated with acid-resistant wax, then scratched to expose the metal to the bite of the acid where lines are desired. Also the resulting print.

expressionism The broad term that describes emotional art, most often boldly executed and making free use of distortion and arbitrary color. When used more specifically, Expressionism refers to individual and group styles originating in Europe in the late nineteenth and early twentieth centuries.

eye level The height of the viewer's eyes above the ground plane.

facade In architecture, used to refer to the front exterior of a building, but also to other exterior sides when they are emphasized architecturally.

Fauvism A style of painting introduced in Paris in the early twentieth century, characterized by areas of brilliant, contrasting color, and simplified shapes. The name *les Fauves* is French for "the wild beasts."

figure Separate shape(s) distinguishable from a background or ground.

flamboyant In architecture, having complex, flamelike forms, characteristic of fifteenth and sixteenth century Gothic architecture. Highly ornate or elaborate.

flying buttress See *buttress*.

foreshortening The representation of forms on a two-dimensional surface so that the long axis(es) appears to project toward the viewer.

form In the broadest sense, the total physical characteristics of an object, event, or situation.

format Basic layout or proportions of a work being presented.

fresco A painting technique in which pigments suspended in water are applied to a damp lime-plaster surface. The pigments dry to become part of the plaster wall or surface.

frontal An adjective describing an object that faces the viewer directly, rather than being set at an angle or foreshortened.

Futurism A style of art that originated in Italy in the early twentieth century that represented and interpreted a dynamic, modern, machine-powered world. Futurists endeavored to represent movement and speed. Also *futurism*, a current movement attracting support from many disciplines including the arts, based on the goal of developing "future consciousness" by anticipating change.

geodesic A geometric form basic to structures using short sections of lightweight material joined into interlocking polygons. Also a structural system developed by R. Buckminster Fuller to create domes using the above principle.

gesso A mixture of glue and either chalk or plaster of Paris applied as a *ground* or coating to surfaces in order to give them the correct properties to receive paint. Gesso can also be built up or modeled into relief designs, or carved.

glaze In ceramics, a vitreous or glassy coating applied to ceramicware to seal and decorate the surface. Glaze may be colored, transparent, or opaque. In oil painting, a thin transparent or translucent layer brushed over another layer of paint, allowing the first layer to show through but altering its color slightly.

Gothic Primarily an architectural style that prevailed in Western Europe from the twelfth through the fifteenth centuries, characterized by *pointed arches*, *rib vaults*, and *flying buttresses* which enabled buildings to reach great heights.

gouache An opaque water-soluble paint.

green belt An encircling strip or belt of planned or protected open green space, consisting of recreational parks, farm land, or uncultivated land, surrounding a community and controlling its size.

ground The background in two-dimensional works—the area around and between figure(s). Also, the surface onto which paint is applied.

happening An event conceived by artists and performed by artists and others, usually unrehearsed and without a specific script or stage.

hatching A technique used in drawing and linear forms of printmaking in which lines are placed in parallel series to darken the value of an area. *Crosshatching* is drawing one set of hatchings over another in a different direction so the lines cross. *Contour hatching* uses curving parallel lines that follow and define the changing surfaces of three-dimensional forms.

high key Exclusive use of pale or light values within a given area or surface.

holography The technique of producing images using laser beams to record on a photographic plate a diffraction pattern from which a three-dimensional image can be seen or projected.

horizon line In linear perspective, the implied or actual line or edge placed on a two-dimensional surface to represent the point in nature where the sky meets the horizontal land or water plane. The horizon line matches the eye level on a two-dimensional surface. Lines or edges parallel to the ground plane and "moving away" from the viewer appear to converge at vanishing points on the horizon line.

hue That property of a color identifying a specific, named wavelength of light such as green, red, violet, and so on.

humanism A cultural and intellectual movement that occurred during the Renaissance following the rediscovery of art and literature of ancient Greece and Rome. A philosophy or attitude that is concerned with the interests, achievements, and capabilities of human beings rather than with the abstract concepts and problems of theology or science.

icon An image or symbolic representation (often with sacred significance).

iconography Visual images or symbols used by a given culture.

impasto In painting, thick paint applied to a surface in a heavy manner, having the appearance and consistency of buttery paste.

Impressionism A style of painting that originated in France about 1870. (The first Impressionist exhibit was held in 1874.) Paintings of casual subjects were executed outdoors using theories of optical color mixture and divided brush strokes to capture the light and mood of the fleeting moment.

intaglio A printmaking technique in which lines and areas to be inked and transferred to paper are recessed below the surface of the printing plate. The plate is coated with ink, then wiped clean, leaving ink only in the cuts. The ink is transferred to damp paper by pressure, using a printing press. Etching, engraving, drypoint, and aquatint are all intaglio processes.

intermediate color A hue between a primary and a secondary on the color wheel such as yellow-green, a mixture of yellow and green.

International Style An architectural style that emerged in several European countries between 1910 and 1920. It was related to purism and De Stijl in painting; it joined structure and exterior design into a non-eclectic form based on rectangular geometry and growing out of the basic function and structure of the building.

kiln A large oven in which pottery or ceramic ware is fired (baked).

kinetic art Art that incorporates actual movement as part of the composition.

kore Greek for "maiden." An archaic Greek statue of a standing clothed maiden.

kouros Greek for "youth." An archaic Greek statue of a standing nude young male.

lens The part of a camera that concentrates light and focuses the image.

linear perspective See *perspective*.

lithography A planographic printmaking technique based on the antipathy of oil and water. The image is drawn with a grease crayon or painted with *tusche* on a stone or grained aluminum plate. The surface is then chemically treated so that it will accept ink only where the crayon or tusche has been used. The surface is inked, and the image transferred to damp paper using pressure.

local color The actual color as distinguished from the apparent color of objects and surfaces; true color, without shadows or reflections.

loom A device for producing cloth by interweaving fibers at right angles.

low key Consistent use of dark values within a given area or surface.

lumia The use of actual light as an art medium.

mass Three-dimensional form having physical bulk. Also, the illusion of such a form on a two-dimensional surface.

mat Border of cardboard or similar material placed around a picture as a neutral area between the frame and the picture.

matte (mat) A dull finish or surface, especially in painting, photography, and ceramics.

medium (*pl.* media) A particular material along with its accompanying technique. A specific type of artistic technique or means of expression determined by the use of specific materials. Also, in paint, the fluid in which pigment is suspended allowing it to spread and adhere to the surface.

megastructure A very large building complex combining many functions in a single structure.

Minimal Art A style of twentieth-century sculpture and painting, usually severely restricted in the use of visual elements and often producing relatively simple geometric structures.

mobile A type of sculpture in which parts are moved by air currents or motors. See also *kinetic art*.

modeling Working pliable material such as clay or wax into three-dimensional forms. A type of additive sculpture. In drawing or painting, the effect of light falling on a three-dimensional object so that the image of its mass is revealed and defined by value gradations.

module A standard unit of measure in architecture. The part of a structure used as a standard by which the rest is proportioned.

monochromatic A color scheme limited to variations of one hue. A hue with its tints and/or shades.

montage A composition of pictures or parts of pictures previously drawn, painted, or photographed. In motion pictures, the combining of separate bits of film of a single event.

mosaic An art medium in which small pieces of colored glass, stone, or ceramic tile are embedded in a background material such as plaster or mortar. Also works made using this technique.

mural A painting executed directly on a wall, usually large in size. *Fresco* is a medium often used for mural paintings.

naturalism In the visual arts, the doctrine that art should resemble as closely as possible the appearance of the natural world. A work created with this intention is called naturalistic. See also *representational art*.

nave The tall central space of a church or cathedral, usually flanked by side aisles.

negative shape A background or ground shape produced by its interaction with foreground or figure shape(s).

neoclassicism A revival of classical Greek and Roman forms in art, music, and literature, particularly during the eighteenth and nineteenth centuries in Europe and America. It was part of a reaction against the excesses of *Baroque* and *Rococo*.

neutral color A color not associated with any single hue. A neutral can be made by mixing complementary hues. Neutrals are low in *saturation*.

nonobjective See *nonrepresentational*.

nonrepresentational art Visual form without reference to anything outside itself.

oil paint Paint in which the pigment is held together with a binder of oil, usually linseed oil.

opaque Impenetrable by light. Not transparent or translucent.

Op Art (optical art) A style of two-dimensional art that uses lines or shapes of contrasting color to generate optical sensations not actually present in the initial image.

open form A form whose contour is irregular or broken, having a sense of unfinished growth, change, or unresolved tension. Form in a state of becoming.

optical color mixture Apparent rather than actual color mixture produced by interspersing brush strokes or dots of the hues to be "mixed" instead of physically mixing them. The implied mixing occurs in the eye of the viewer and produces a lively color sensation.

perspective The depiction of three-dimensional space on a two-dimensional surface or picture plane in order to produce the same or similar impression of distance and relative size as is received by the human eye when observing the natural world. *Linear perspective* is the most consistent system for portraying an illusion of the three-dimensional world on a two-dimensional surface. Linear perspective is based on the fact that parallel lines or edges appear to converge and objects appear to grow smaller as they recede into the distance. *Atmospheric perspective* (aerial perspective) creates the illusion of distance by reducing color saturation, value contrast, and detail in order to imply the hazy effect of atmosphere on distant objects.

perspective rendering A view of an architectural structure drawn in linear perspective, usually from a ¾ view or similar vantage point that shows two sides of the structure in great detail.

Photorealism A style of painting based on the cool, detached objectivity of photographs as records of subjects.

pictorial space The implied or illusionary space in a painting or other two-dimensional work as it appears to recede backward from the *picture plane*.

picture plane The two-dimensional picture surface.

pigment A coloring agent in powder form used in paints, crayons, and chalks.

plan In architecture, a scale drawing in diagrammatic form showing the basic layout of the interior and exterior spaces of a structure as if seen in a cutaway view from above.

plastic In the visual arts, capable of being formed. Pertaining to shaping or modeling.

pointillism A system of painting using tiny dots of color; developed by French artist Georges Seurat in the 1880s. Seurat systematized the divided brushwork and optical color mixture of the Impressionists.

polychromatic Having many colors; random or intuitive use of color combinations as opposed to color selection based on a specific color scheme.

Pop Art A style of painting and sculpture that developed in the late 1950s, primarily in the United States; based on the visual clichés and subject matter of mass media.

positive shape A *figure* or foreground shape, as opposed to a negative ground or background shape.

post and beam system (also called "post and lintel") In architecture, a structural system that uses two uprights or posts supporting a member called either a beam or lintel which spans the space between them.

post-Impressionism A general term applied to various styles of painting that developed from 1880 to 1900 in reaction to the Impressionists' formlessness and indifference to subject matter. Post-Impressionist painters were concerned with the significance of form, symbols, expressiveness, and psychological intensity. These concerns have continued to engross twentieth-century artists. The post-Impressionists were broadly separated into two groups—the *expressionists* such as Gauguin and van Gogh and the *formalists* such as Cézanne and Seurat.

prehistoric art Art created before written history. Often the only record of early cultures.

primary colors Those hues that cannot be produced by mixing other hues. *Pigment primaries* are red, yellow, and blue; *light primaries* are red, green, and blue. Theoretically, primaries can be mixed together to form all the other hues in the spectrum.

prime In painting, a primary layer of paint or sizing applied to a surface that is to be painted.

print (artist's print) A multiple original impression made from a plate, stone, wood block or silk screen by an artist or made under the artist's supervision. Prints are usually made in *editions*, with each print numbered and signed by the artist.

proportion The size relationship of parts to a whole and to one another.

Realism A mid-nineteenth century style of painting and sculpture based on the belief that subject matter and representation in art should be true to appearance without idealizing or stylization. The style grew out of a rejection of the artificial grandeur and exoticism of the academically accepted art of the time.

reinforced concrete (ferroconcrete) Concrete with steel mesh or bars embedded in it to increase its tensile strength.

relief printing A printing technique in which the parts of the printing surface meant to carry the ink are left raised while the remaining areas are cut away, resulting in a surface design. The raised surface is inked and the ink transferred to paper. Wood cuts and linoleum prints (linocuts) are relief prints.

relief sculpture Sculpture in which three-dimensional forms project from the flat background of which they are a part. The degree of projection can vary and is described by the terms *high relief* and *low relief* or *bas relief*.

Renaissance Period in Europe from the fourteenth through the sixteenth centuries that was characterized by a renewed interest in human centered Classical art, literature, and learning.

representational art Art in which it is the artist's intention to present again or *re-present* a particular subject as closely as possible to the way it is seen by the human eye.

reproduction A mechanically produced copy of an original work of art.

rhythm In the visual arts, the regular or ordered repetition of elements or units within a design.

rib In architecture, a slender arch or projecting arched member of a vault.

ribbed vault See *vault*.

Rococo From the French *rocaille* meaning "rock work." It was a late Baroque (c. 1715–1775) style used in interior decoration and painting. The style was characteristically light hearted, pretty, and morally and visually loose; based on the use of pastel colors and the asymmetrical arrangement of curves. Rococo existed primarily in France and southern Germany.

Romanesque A style of European architecture prevalent from the ninth to the twelfth centuries, influenced by Roman architecture and vaulting systems.

Romanticism A literary and artistic movement originating in Europe in the late eighteenth century, aimed at asserting the validity of subjective experience as a countermovement to the often cold formulas of Neoclassicism.

CHRONOLOGICAL GUIDE

30,000 B.C. HEAD OF NEIGHING PREHISTORIC HORSE. France. c. 30,000–10,000 B.C. p. 231.

15,000 B.C. LEFTHAND WALL, GREAT HALL OF BULLS. Lascaux, France. 15,000–10,000 B.C. p. 230, color plate 20, opposite page 274.

5,000 B.C. BEAKER. Susa (now Iran). 5000–4000 B.C. p. 233.

FACSIMILE OF POLYCHROME CATTLE. Tassili, North Africa. c. 4000 B.C. p. 232.

POLYCHROME WALL PAINTING. Jordan River. c. 4000 B.C. p. 228.

3,000 B.C. DOLMEN OF MANE-KERIONED. France. 3000–2000 B.C. p. 351.

MAN PLAYING A SYRINX. Cycladic Islands, Mediterranean. 2600–2000 B.C. p. 235.

KING MYCERINUS AND QUEEN. Egypt. c. 2525 B.C. p. 236.

2000 B.C. CHINESE SACRAL VESSEL. c. 1500–1059 B.C. p. 249.

QENNEFER, STEWARD OF THE PALACE. Egypt. c. 1450 B.C. p. 72.

A POND IN A GARDEN. Egypt. c. 1400 B.C. p. 82.

1000 B.C. STANDING YOUTH. Greece. c. 540 B.C. p. 237.

500 B.C. KORE 674. Greece. c. 500 B.C. p. 238.

STAFF FINIAL. China. c. 481–221 B.C. p. 250.

Polyclitus, SPEAR BEARER. Greece. c. 450–400 B.C. p. 239.

Ictinus and Callicrates, PARTHENON. Greece. 447–432 B.C. p. 192.

Praxiteles, HERMES AND THE INFANT DIONYSUS. Greece. c. 330–320 B.C. p. 243.

Agesander, Athenodorus, and Polydorus of Rhodes, THE LAOCOÖN GROUP. Greece. c. 150–30 B.C. p. 243.

B.C./A.D. THE GREAT STUPA. India. c. 10 B.C.–15 A.D. p. 246.

LE PONT DU GARD. Roman Empire (now France). c. 15. p. 193.

PANTHEON. Rome. 118–125. p. 245.

CONSTANTINE. Rome. c. 312. p. 247.

500 A.D. STANDING BUDDHA. India. 5th century. p. 253.

SHRINES AT ISE. Japan. c. 685. p. 242.

DRAGON'S HEAD. Norway. c. 820. p. 251.

Fan K'uan, TRAVELERS ON A MOUNTAIN PATH. China. c. 990–1030. p. 106.

1000 SHIVA NĀTARĀJA. India. 11th century. p. 254.

KANDARYA TEMPLE. India. c. 1000. p. 255.

1100 MALE PORTRAIT HEAD. Ife, Nigeria. 12th century. p. 259.

Unknown Chinese artist, A WAVE UNDER THE MOON. 12th century. p. 49.

CHRIST, dome mosaic. Byzantium (now Greece). c. 1100. p. 248.

CHRIST OF THE PENTECOST. France. 1125–1150. p. 252.

Fujiwara Takanobu, PORTRAIT OF MINAMOTO YORITOMO. Japan. 1142–1205. p. 262.

NOTRE DAME DE CHARTRES. France. 1145–1513. p. 256.

INHABITED INITIAL, manuscript illumination. England. c. 1150. p. 251.

1200 BURNING OF THE SANJO PALACE. Japan. c. 1185–1333. p. 264.

Yü-Chien, MOUNTAIN VILLAGE IN A MIST. China. 13th century. p. 261.

ENTHRONED MADONNA AND CHILD. Byzantium (now Turkey). 1200. p. 43.

Unkei, MUCHAKU. Japan. c. 1208. p. 263.

REIMS CATHEDRAL. France. 1225–1299. p. 79.

Mu Ch'i, SIX PERSIMMONS. China. c. 1269. p. 81.

1300 Giotto di Bondone, THE DESCENT FROM THE CROSS. Italy. c. 1305. p. 265.

Ambrogio Lorenzetti, VIEW OF A TOWN. Italy. c. 1338–1340. p. 211.

Angelo Puccinelli, TOBIT BLESSING HIS SON. Italy. c. 1350–1399. p. 83.

1400 Filippo Brunelleschi, PAZZI CHAPEL. Italy. 1429–1430. p. 265.

Jan van Eyck, GIOVANNI ARNOLFINI AND HIS BRIDE. Flanders (now France and Belgium). 1434. p. 273, color plate 22, near page 274.

Fra Filippo Lippi, MADONNA AND CHILD. Italy. c. 1440–1445. p. 44.

Andrea Mantegna, THE MADONNA AND CHILD. Italy. c. 1445. p. 44.

1450 Leonardo da Vinci, ILLUSTRATION OF PROPORTIONS OF THE HUMAN FIGURE. Italy. c. 1485–1490. p. 266.

Sandro Botticelli, BIRTH OF VENUS. Italy. c. 1490. p. 269. Detail of, color plate 23, near page 274.

Georges Seurat, SUNDAY AFTERNOON ON THE ISLAND OF LA GRANDE JATTE. France. 1884–1886. p. 64, color plate 27, opposite page 291.

Henry Hobson Richardson, MARSHALL FIELD WHOLESALE STORE. U.S. 1885–1887. p. 195.

François Auguste René Rodin, THE KISS. France. 1886–1898. p. 311.

Jacob Riis, BANDIT'S ROOST. U.S. c. 1888. p. 307.

Paul Gauguin, THE VISION AFTER THE SERMON. France. 1888. p. 305, color plate 30, opposite page 306.

Vincent van Gogh, THE STARRY NIGHT. France. 1889. p. 304, color plate 29, opposite page 306.

1890 Louis Sullivan, WAINWRIGHT BUILDING. U.S. 1890–1891. p. 196.

Henri de Toulouse-Lautrec, AT THE MOULIN ROUGE. France. 1892. p. 308.

Edvard Munch, THE SHRIEK. Norway. 1896. p. 309.

1900 Edwin S. Porter, THE GREAT TRAIN ROBBERY. U.S. 1903. p. 154.

Paul Cézanne, MONT SAINTE-VICTOIRE. France. 1904–1906. p. 300, color plate 28, opposite page 291.

Henri Matisse, JOY OF LIFE. France. 1905–1906. p. 315.

Paula Modersohn-Becker, MOTHER AND CHILD. Germany. 1907. p. 75.

Pablo Picasso, LES DEMOISELLES D'AVIGNON. France. 1907. p. 319.

Alfred Stieglitz, THE STEERAGE. U.S. 1907. p. 322.

Constantin Brancusi, THE KISS. France. 1908. p. 312.

Georges Braque, HOUSES AT L'ESTAQUE. France. 1908. p. 90.

Wassily Kandinsky, BLUE MOUNTAIN. Russia. 1908. p. 315, color plate 32, opposite page 322.

Gustav Klimt, THE KISS. Austria. 1908. p. 314, color plate 31, opposite page 307.

Frank Lloyd Wright, ROBIE HOUSE. U.S. 1909. p. 323.

1910 Pablo Picasso, GUITAR. France. 1911–1912. p. 324.

Marc Chagall, I AND MY VILLAGE. Russia. 1911. p. 50.

Piet Mondrian, HORIZONTAL TREE. Holland. 1911. p. 329.

Pablo Picasso, THE CLARINET PLAYER. France. 1911. p. 321.

Pablo Picasso, SHEET OF MUSIC AND GUITAR. France. 1912–1913. p. 324.

Giacomo Balla, DYNAMISM OF A DOG ON A LEASH. Italy. 1912. p. 95.

Jacques Henri Lartigue, GRAND PRIX OF THE AUTOMOBILE CLUB OF FRANCE. France. 1912. p. 322.

Marcel Duchamp, NUDE DESCENDING A STAIRCASE, #2. France. 1912. p. 333.

Henri Matisse, NASTURTIUMS AND THE DANCE. France. 1912. p. 29, color plate 4, opposite page 19.

Wassily Kandinsky, LIGHT FORM NO. 166. Russia. 1913. p. 316.

Marcel Duchamp, BICYCLE WHEEL. France. 1913. p. 334.

Le Corbusier, DOMINO CONSTRUCTIONAL SYSTEM. France. 1914–1915. p. 196.

Giorgio de Chirico, THE MYSTERY AND MELANCHOLY OF A STREET. Italy. 1914. p. 340.

1915 D. W. Griffith, THE BIRTH OF A NATION. U.S. 1915. p. 155.

Kasimir Malevich, SUPREMATIST COMPOSITION: WHITE ON WHITE. Russia. 1918. p. 59.

Fernand Léger, THE CITY. France. 1919. p. 325.

Kurt Schwitters, CONSTRUCTION FOR NOBLE LADIES. Germany. 1919. p. 338.

Claude Monet, WATER LILIES. France. c. 1920. p. 295.

1920 Hannah Höch, THE MULTI-MILLIONAIRE. Germany. 1920. p. 337.

Simon Rodia, WATTS TOWERS. U.S. 1921–1954. p. 14.

Pablo Picasso, THREE MUSICIANS. France. 1921. p. 327, color plate 33, near page 322.

Man Ray, THE GIFT. U.S. 1921. p. 336.

Le Corbusier, DRAWING FOR A CITY OF THREE MILLION. France. 1922. p. 217.

Paul Klee, BATTLE SCENE FROM THE COMIC OPERA "THE SEAFARER." Switzerland. 1923. p. 339, color plate 34, near text page 322.

1925 Walter Gropius, THE BAUHAUS. Germany. 1925. p. 197.

Jacques Lipchitz, FIGURE. U.S. 1926–1930. p. 328.

Constantin Brancusi, BIRD IN SPACE. France. 1928. p. 74.

Ludwig Mies van der Rohe, BARCELONA CHAIR. Germany. 1929. p. 183.

Georgia O'Keeffe, BLACK CROSS, NEW MEXICO. U.S. 1929. p. 348.

Diego Rivera, ENSLAVEMENT OF THE INDIANS. Mexico. 1929–1930. p. 134.

1930 Pierre Bonnard, THE BREAKFAST ROOM. France. 1930. p. 66, color plate 10, near page 67.

Piet Mondrian, COMPOSITION WITH RED, YELLOW AND BLUE. Holland. 1930. p. 330, color plate 36, near page 322.

Edward Weston, PEPPER #30. U.S. 1930. p. 37.

Grant Wood, AMERICAN GOTHIC. U.S. 1930. p. 3.

Salvador Dali, PERSISTENCE OF MEMORY. Spain. 1931. p. 343.

José Clemente Orozco, ZAPATISTAS. Mexico. 1931. p. 102.

Bernice Abbott, EXCHANGE PLACE. U.S. 1933. p. 390.

Dorothea Lange, A DEPRESSION BREADLINE, SAN FRANCISCO. U.S. 1933. p. 349.

1935 Käthe Kollwitz, DEATH SEIZING A WOMAN. Germany. 1935. p. 33.

René Magritte, PORTRAIT. Belgium. 1935. p. 341.

Margaret Bourke-White, AT THE TIME OF THE LOUISVILLE FLOOD. U.S. 1937. p. 148.

Pablo Picasso, GUERNICA. France. 1937. pp. 344–345.

Joan Miró, WOMAN HAUNTED BY THE PASSAGE OF THE DRAGONFLY, BIRD OF BAD OMEN. Spain. 1938. p. 343.

Henry Moore, RECUMBENT FIGURE. England. 1938. p. 75.

1940 Pablo Picasso, BULL'S HEAD. France. 1943. p. 164.

1945 Alberto Giacometti, MAN POINTING. Switzerland. 1947. p. 73.

Jackson Pollock, No. 14. U.S. 1948. p. 354.

Ben Cunningham, CORNER PAINTING. U.S. 1948–1950. p. 373, color plate 41, near page 322.

1950 Le Corbusier, NOTRE-DAME-DU-HAUT. Ronchamp, France. 1950–1955. p. 351.

Gordon Bunshaft of Skidmore, Owings and Merrill, LEVER HOUSE. U.S. 1950. p. 198.

Werner Bischof, HUNGER IN INDIA. U.S. 1951. p. 34.

Willem de Kooning, WOMAN AND BICYCLE. U.S. 1952–1953. p. 357, color plate 37, near page 322.

Richard Lippold, VARIATION WITHIN A SPHERE, NO. 10: THE SUN. U.S. 1953–1956. p. 165.

Margaret Bourke-White, CONTOUR PLOWING. U.S. 1954. p. 149.

1955 Jasper Johns, TARGET WITH FOUR FACES. U.S. 1955. p. 359.

Richard Hamilton, JUST WHAT IS IT THAT MAKES TODAY'S HOMES SO DIFFERENT, SO APPEALING? England. 1956. p. 359.

Yuichi Inoue, CALLIGRAPHY BUDDHA. Japan. 1957. p. 357.

1960 Franz Kline, HORIZONTAL RUST. U.S. 1960. p. 356.

Jean Tinguely, HOMAGE TO NEW YORK: A SELF-CONSTRUCTING, SELF-DESTROYING WORK OF ART. U.S. 1960. p. 369.

Hans Hofmann, THE GOLDEN WALL. U.S. 1961. p. 130, color plate 12, opposite page 130.

Eero Saarinen, TWA TERMINAL. U.S. Completed 1962. p. 78.

David Smith, CUBI XVII. U.S. 1963. p. 371.

Tom Wesselmann, STILL LIFE No. 33. U.S. 1963. p. 361.

Richard Anuszkiewicz, INJURED BY GREEN. U.S. 1963. p. 66, color plate 8, near page 66.

Thomas Wilfred, LUMIA SUITE, OP. 158. U.S. 1963–1964. p. 367, color plate 39, near page 322.

Helen Frankenthaler, INTERIOR LANDSCAPE. U.S. 1964. p. 131, color plate 38, near page 322.

Robert Rauschenberg, TRACER. U.S. 1964. p. 358.

Kenzo Tange, OLYMPIC STADIUMS. Japan. 1964. p. 200.

Bridget Riley, CREST. England. 1964. p. 49.

1965 Paolo Soleri, DRAWINGS OF BABELDIGA. U.S. 1965. p. 214.

Nam June Paik, ELECTROMAGNETIC DISTORTIONS OF THE VIDEO IMAGE. U.S. c. 1965. p. 158.

Robert Breer, FLOATS. U.S. 1966. p. 95.

Richard Estes, HORN AND HARDART AUTOMAT. U.S. 1967. p. 378, color plate 42, opposite page 323.

R. Buckminster Fuller, U.S. PAVILION, EXPO-67. U.S. 1967. p. 202.

Moshe Safdie and David Barott, HABITAT, EXPO-67. Canada. 1967. p. 213.

Frank Stella, HIRAQLA I. U.S. 1968. p. 366.

M. Paul Friedberg and Associates, VEST POCKET PLAYGROUND AND NATURE STUDY CENTER. U.S. 1968. p. 394.

Isamu Noguchi, RED CUBE. U.S. 1969. p. 372.

Kevin Roach and Associates, OAKLAND MUSEUM. U.S. 1969. p. 395.

1970 Marvin Lipofsky, LEERDAM GLASVORMCENTRUM COLOR SERIES. U.S. 1970. p. 174, color plate 18, opposite page 179.

Ed Emshwiller, SCAPE-MATES. U.S. 1973. p. 159, color plate 14, opposite page 131.

The Shaver Partnership and Bob Campbell & Company, TENT STRUCTURE. U.S. 1973. p. 201.

Lawrence Halprin and Associates, AUDITORIUM FORECOURT CASCADE (PEOPLE'S FOUNTAIN). U.S. 1973. p. 397.

David Wright, WRIGHT RESIDENCE. U.S. 1974. p. 208.

1975 Romare Bearden, TIDINGS #2. U.S. 1975. p. 379.

Larry Bell, THE ICEBERG AND ITS SHADOW. U.S. 1975. p. 373.

John DeAndrea, CLOTHED ARTIST WITH MODEL. U.S. 1975. p. 380.

Christo, RUNNING FENCE. U.S. 1976. p. 376.

Red Grooms, RUCKUS MANHATTAN. U.S. 1976. pp. 382–383.

NOTES

FRONT MATTER AND INTRODUCTION

1 Ralph Graves, ed., "The Master of the Soft Touch," *Life*, November 21, 1969, p.64c.

2 Caroline Thomas Harnsberger, ed., *Treasury of Presidential Quotations* (Chicago: Follett, 1964), p.22.

CHAPTER 1

1 Reid Hastie and Christian Schmidt, *Encounter with Art* (New York: McGraw-Hill, 1969), p.314.

2 C. L. Barnhart and Jess Stein, eds., *The American College Dictionary* (New York: Random House, 1963), p.70.

3 Copyright by Elizabeth-Ellen Long. *Arizona Highways* (August 1958).

4 Don Fabun, *The Dynamics of Change* (Englewood Cliffs, N.J.: Prentice-Hall, 1968), p.9.

5 Carroll Quigley, "Needed: A Revolution in Thinking," *The Journal of the National Education Association* 57, no. 5 (May 1968): 9.

6 Henri Matisse, "The Nature of Creative Activity," in *Education and Art*, ed. Edwin Ziegfeld (New York: UNESCO, 1953), p.21.

7 Mike Samuels, M.D., and Nancy Samuels, *Seeing with the Mind's Eye* (New York: Random House and Berkeley, Calif.: The Bookworks, 1975), pp.5-6.

8 Rev. Paul Osumi, *Honolulu Advertiser*, November 26, 1976. p.F-11.

9 Douglas Davis, "New Architecture: Building for Man," *Newsweek* 77, no. 16 (April 19, 1971): 80.

10 Abraham H. Maslow, *Toward a Psychology of Being* (New York: Van Nostrand Reinhold, 1968), p.136.

11 Bergen Evans, *Dictionary of Quotations* (New York: Delacorte Press, 1968), p.340.

12 Samuels and Samuels, *Seeing with the Mind's Eye*, p.239.

13 Courtesy of the Committee for Simon Rodia's Towers in Watts.

14 John Holt, *How Children Fail* (New York: Pitman, 1964), p.167. Reprinted with permission.

15 Susumu Hani, director, *Children Who Draw Pictures* (New York: Brandon films). 1953.

16 Carl G. Jung et al., *Man and His Symbols* (New York: Doubleday, 1964), p.20.

17 Henri Matisse, "Notes of a Painter," trans. Alfred H. Barr, Jr., in *Problems of Aesthetics*, ed. Elised Vivas and Murray Krieger (New York: Holt, Rinehart & Winston, 1953), p.256; originally printed as "Notes d'un peintre," *La Grands Revue* (Paris, 1908).

18 Ibid., p.260.

19 Ibid., pp.259–260.

20 Edward Weston, *Edward Weston, Photographer: The Flame of Recognition*, ed. Nancy Newhall (New York: Aperture Monograph, Crossman Publishers, 1965), p.39.

21 Ibid., p.34.

22 Piet Mondrian, *Artists on Art*, ed. Robert Goldwater and Marco Treves (New York: Pantheon Books, 1945), p.428.

CHAPTER 2

1 Gene Youngblood, *Expanded Cinema* (New York: E. P. Dutton, 1970), p.347.

2 John Cage, *A Year from Monday: New Lectures and Writings* (Middletown, Conn.: Wesleyan University Press, 1969).

3 D. T. Suzuki, "Sengai, Zen and Art," *Art News Annual* 27, pt. 2, no. 7 (November 1957): 118.

4 Faber Birren, *Color Psychology and Color Therapy*. (New Hyde Park, N. Y.: University Books, 1961), p.20.

5 Edgar Cayce, *Auras* (Virginia Beach, Va.: A.R.E. Press, 1945), pp.11–13.

6 Wassily Kandinsky, *Concerning the Spiritual in Art*, original trans. Michael Sadleir, retrans. Francis Golffing, Michael Harrison, and Ferdinand Ostertag (New York: George Wittenborn, 1955), p.58.

7 Albert E. Elsen, *Purposes of Art* (New York: Holt, Rinehart & Winston, 1967), p.437.

8 Ray Bethers, *Composition in Pictures* (New York: Pitman, 1949), p.163; originally printed in the *Manifesto of the Futurist Painters*, Italy, 1910.

9 Henri Cartier-Bresson, *The Decisive Moment* (New York: Simon and Schuster, 1952), p.6.

10 Yvonne Baby, "Henri Cartier-Bresson," *Harper's Magazine*, November 1961, p.74.

11 Henri Matisse, "Notes of a Painter," trans. Alfred H. Barr, Jr., in *Problems of Aesthetics*, ed. Elised Vivas and Murray Krieger (New York: Holt, Rinehart & Winston, 1953) p.259; originally printed as "Notes d'un peintre," *La Grands Revue* (Paris, 1908).

CHAPTER 3

1 Anthony Blunt, *Picasso's Guernica* (New York: Oxford University Press, 1969), p.28.

2 Ichitaro Kondo and Elsie Grilli, *Katsushika Hokusai* (Rutland, Vt.: Charles E. Tuttle, 1955), p.13.

3 André Malraux, *Museum Without Walls*, trans. Stuart Gilbert and Francis Price (Garden City, N. Y.: Doubleday & Co., 1967), p.12.

4 Henri Cartier-Bresson, *The Decisive Moment* (New York: Simon & Schuster, 1952), p.1.

5 Ibid., p.14.

6 Andrew Sarrif, ed., *Interviews with Film Directors*, trans. Alice Turner (New York: Avon Books, 1969), p.35.

7 John Coyne, "Handcrafts," *Today's Education*, November–December 1976, p.75.

8 Rolf Preuss, "What Is Urban Design?", in *Hawaii Architect*, July 1977, p.9.

9 Peter Blake, "The Ugly American," *Horizon* 3, no. 5 (May 1961): 6.

10 Constantinos A. Doxiadis, *Architecture in Transition* (New York: Oxford University Press, 1968), p.35.

CHAPTER 4

1 Marius de Zayas, "Pablo Picasso, An Interview," in *Artists on Art*, ed. Robert Goldwater and Marco Treves (New York: Pantheon Books, 1958), p.418; originally printed in *The Arts* (New York, May 1923).

2 From the film *The Eye of Picasso*, written and produced by Nelly Kaplan, Cythere Films, Paris, 1969.

3 Carl G. Jung et al., *Man and His Symbols* (New York: Doubleday, 1964), p.232.

4 Robert Goldwater and Marco Treves, eds., *Artists on Art* (New York: Pantheon Books, 1958), p.137; originally printed in *The Arts* (New York, May 1923).

5 Kenzo Tange and Noboro Kawazoe, *Ise: Prototype of Japanese Architecture* (Cambridge, Mass.: M.I.T. Press, 1965), p.18.

6 Ananda Coomaraswamy, *Dance of Shiva* (New York: Noonday Press, 1965), p.78.

7 Kenneth Clark, *Civilisation* (New York: Harper and Row, 1969), p.50.

8 Helmut Wol, *Leonardo da Vinci* (New York: McGraw-Hill, 1967), p.45.

9 Beaumont Newhall, *The History of Photography* (New York: The Museum of Modern Art, 1964), p.11.

10 *Holy Bible*, Acts 9:3–4.

11 Albert E. Elsen, *Purposes of Art* (New York: Holt, Rinehart & Winston, 1967), p.183.

12 Eugène Delacroix, *The Journal of Eugène Delacroix*, trans. Walter Pach (New York: Covici-Friede Publishers, 1973), p.314.

13 Beaumont Newhall, "Delacroix and Photography," *Magazine of Art* 45, no. 7 (November 1952): 300.

14 Tom Prideaux, *The World of Delacroix*, eds. of Time-Life Books (New York: Time, Inc., 1966), p.168.

15 *Cezanne and the Post-Impressionists*, McCall's Collection of Modern Art (New York: McCall Books, 1970), p.5.

16 Ibid.

17 Vincent van Gogh, "To His Brother Theo," in *Artists on Art*, ed. Goldwater and Treves, pp.383–384.

18 Vincent van Gogh in John Rewald, *Post-Impressionism—From Van Gogh to Gauguin* (New York: Museum of Modern Art, 1958).

19 Ronald Alley, *Gauguin*, The Color Library of Art (Middlesex, Eng.: Hamlyn Publishing Group, 1968), p.8.

CHAPTER 5

1 Wassily Kandinsky, "Reminiscences," in *Modern Artists on Art*, ed. Robert L. Herbert (Englewood Cliffs, N.J.: Prentice-Hall, 1964), p.27.

2 Alfred H. Barr, Jr., ed., *Masters of Modern Art* (New York: The Museum of Modern Art, 1955), p.124.

3 William Fleming, *Art, Music and Ideas* (New York: Holt, Rinehart & Winston, 1970), p.342.

4 Ibid.

5 Ibid.

6 Georges Braque in Roland Penrose, *Picasso: His Life and Work* (New York: Schocken Books, 1966), p.125.

7 Nathan Lyons, ed., *Photographers on Photography* (Englewood Cliffs, New Jersey: Prentice Hall, Inc., 1966), p.133.

8 Beaumont Newhall, *The History of Photography* (New York: The Museum of Modern Art, 1964), p.111.

9 Barr, *Masters of Modern Art*, p.86.

10 "Venerable Giant of Modern Sculpture Bares Views," *Honolulu Star-Bulletin*, August 24, 1971, p.F-2.

11 Barr, *Masters of Modern Art*, p.121.

12 Robert Goldwater and Marco Treves, eds., *Artists on Art* (New York: Pantheon Books, 1958), p.427.

13 Calven Tomkins, *The World of Marcel Duchamp*, eds. of Time-Life Books (New York: Time, Inc., 1966), p.12.

14 Hans Richter, *Dada 1916-1966* (Munich: Goethe Institut, 1966), p.22.

15 Barr, *Masters of Modern Art*, p.137.

16 Hans Arp in Paride Accetti, Raffaele De Grada, and Arturo Schwarz, *Cinquant'annia Dada—Dada in Italia 1916-1966* (Milano: Galleria Schwarz, 1966), p.39.

17 Barr, *Masters of Modern Art*, p.137.

18 Kurt Schwitters in Accenti et al., *Cinquant'annia Dada*, p.25.

19 Paul Klee, "Notes from His Diary," in *Artists on Art*, ed. Goldwater and Treves, p.442.

20 Barr, *Masters of Modern Art*, p.131.

21 Fleming, *Art, Music and Ideas*, p.346.

22 Lael Wertenbaker, *The World of Picasso*, eds. of Time-Life Books (New York: Time, Inc., 1967), p.130.

23 Herbert Read, *A Concise History of Modern Painting* (New York: Praeger, 1959), p.160.

24 Siegfried Giedion, *Space, Time and Architecture* (Cambridge, Mass.: Harvard University Press, 1967), p.617.

25 Bruce Glaser, "Questions to Stella and Judd," *Art News*, vol. 65, no. 5 (Sept. 1966): p.59.

26 Tomkins, *The World of Marcel Duchamp*, p.162.

27 Ibid., p.171.

CHAPTER 6

1 Richard Neutra, *Survival Through Design* (New York: Oxford University Press, 1954), p.6.

2 Walt Whitman in Charles A. Lindbergh, "The Wisdom of Wilderness," *Life* 63, no. 25 (December 22, 1967): 8.

3 Rachel Carson, *Silent Spring* (Boston: Houghton Mifflin Co., 1962), p.5.

4 Robert L. Heilbroner, *An Inquiry into the Human Prospect* (New York: W. W. Norton & Company, Inc., 1974), p.77.

5 *The World of the American Indian*, eds. of National Geographic Society (Washington, D.C.: National Geographic Society, 1974), p.14. Reprinted with permission of the author.

6 Tom Wolfe, *The Pump House Gang* (New York: Farrar, Strauss & Giroux, 1968), p.240.

7 Sunset eds., *National Parks of the West* (Menlo Park, Calif.: Lane Magazine and Book Co., 1965), p.11.

LIST OF COLOR PLATES

CREDITS

The publisher wishes to thank artists, owners, museums, galleries, and other institutions for supplying photographs and permission to reproduce them. In addition to those named in the captions, we would like to acknowledge the following:

Alinari-Art Reference Bureau, Ancram, N.Y.: 117, 119, 132, 191, 286, 290, 294, 319, 320, 322, 324, 325 a and b, 329, 331, 370;

Wayne Andrews, Grosse Pointe, Mich.: 340;

Archives Photographiques, Paris: 93, 237, 309c, 310, 420;

Photograph by Irving W. Bailey (dec.), Professor of Botany, Harvard University. Reproduced by permission of E. S. Barghoorn, Harvard University, Cambridge, Mass.: 268;

Baltimore Museum of Fine Art: 130;

Bibliotheque Nationale, Paris: 342;

Big Red: 452;

Black Star, New York City: 275;

Photograph by Francis Breer, The Bonino Gallery, New York City: 113;

F. Bruckmann KG Bildarchiv, Munich: 347;

Camerafoto, Venice: 321;

Photograph by C. K. Eaton. From **The Arts in the Classroom** by Natalie Robinson Cole, Copyright © 1940 and 1968 by Natalie Robinson Cole, published by The John Day Co., Inc. Reproduced by permission of the Thomas Y. Crowell Company, Inc.: 45;

Margaret French Cresson: 67;

Derse Advertising Company, Milwaukee, Wis.: 432;

H. Ubbelohde Doering: 233;

From **Architecture in Transition** by Constantinos A. Doxiadis, published 1968 by Oxford University Press, New York. Reproduced by permission of Doxiadis Associates International, Athens, Greece: 270;

Durand-Ruel, Paris: 129;

George Eastman House, Rochester, N.Y.: 174;

Edita S.A., Lausanne, Switzerland: 169, 170;

Editions Arthaud, Paris / Grenable. Photograph by G. Franceschi, from ''The Discovery of the Frescoes of Tassili,'' by H. Lhote: 277;

Editions Denise René: pl. 15;

From **French Drawing of the 20th Century** edited by Ed. Mermod-Lausanne, published 1955 by Vanguard Press, New York City: 133;

Editorial Photocolor Archives: 235, pl. 23;

The estate of Eliott Elisofon, photographer: 44, 311;

Andre Emmerich Gallery, New York City: 440;

From **Art Today: An Introduction to the Visual Arts**, 5th edition, by Ray Faulkner and Edwin Ziegfeld. Copyright 1941, 1949 © 1956, 1963 by Holt, Rinehart & Winston, Inc. Reprinted by permission of Holt, Rinehart & Winston.: 68, 176b;

Gerome Feldman, Honolulu: pl. 40;

Fogg Art Museum, Harvard University: 98;

Fototeca Unione Roma-Art Reference Bureau, Ancram, N.Y.: 291;

Fourcade, Droll, Inc., New York City: 439;

Allison Frantz, Princeton, N.J.: 234, 284, 285, 288;

Laura Gilpin, Santa Fe, N.M.: 257;

Courtesy of George F. Goodyear and the Buffalo Fine Arts Academy: 114;

Gianfranco Gorgoni, New York City: 454;

From **Rock Paintings of the Chumash** by Campbell Grant, published 1965 by University of California Press, Berkeley. Reproduced by permission of the author: 274;

O.K. Harris Gallery, New York City: 459;

Hedrich Blessing Ltd., Chicago: 239, 243, 387;

Lucien Hervé, Paris: 399 a and b;

Grant Hicks: 206;

Hans Hinz, Basel, Switzerland: 275 a and b, 408, pl. 21, pl. 34;

Hirmer Photoarchiv, Munich: 190, 297;

Hoa-Qui, Paris: 271;

Nancy Hoffman Gallery, New York City: 456;

From **Who Designs America** by Laurence B. Holland. Copyright © 1966 by the Trustees of Princeton University for the Program in American Civilization at Princeton University. Reprinted by permission of Doubleday & Company, Inc.: 264, 269;

Holle Bildarchiv, Baden-Baden, Germany: 308;

Honolulu Advertiser, 1972: 207, 215, 218;

Honolulu Star Bulletin, 1977: 115b;

Claude Horan, Honolulu: 201;

Hans Huber Publishers, Berne, Switzerland: 57;

From **The Great Architecture of Japan** by Drahomir Illik, published 1970 by Hamlyn Publishing Group, London. Reproduced by permission of the author-photographer: 335 b;

Government of India, Archaeological Survey of India, New Delhi: 296;

Phokion Karas, Cambridge, Mass.: 90;

From **The Psychology of Children's Art** by Rhoda Kellog with Scott O'Dell, published 1967 by CRM Books, Del Mar, Calif. Reproduced by permission of the author: 20;

A. F. Kersting, London: 287, 309 b;

Kornblee Gallery, New York City: 111 a;

Reproduced with permission of Florian Kupferberg Verlag, Mainz, from Laszlo Moholy-Nagy, **Malerei Fotografie Film**: 405;

Basil Langton, New York City: 111 b;

Mrs. Albert Lasker, New York City: 424;

Library of Congress, Washington, D.C.: 182;

Permission granted by Liggett Group Inc. to use the EVE advertisement. All rights reserved: 226;

From **Creative and Mental Growth** by Victor Lowenfeld and W. Lambert Brittain, © 1970 by the Macmillan Company. Reprinted with permission of the Macmillan Company: 16, 19;

BIBLIOGRAPHY

FOR GENERAL REFERENCE

Art and Illusion by E.H. Gombrich. New York: Pantheon Books, 1960.

Art in America. Published bimonthly, New York.

Craft Horizons. Published bimonthly, New York: Museum of Contemporary Crafts.

Domus: architecttura, arredamento, arte. Published monthly, Milano.

Great Museums of the World, editorial director, Carlo Ludovico Ragghianti, translated and edited by editors of **Art News.** 15 vols. New York: Newsweek, Inc., 1968–1971.

Horizon. Published bimonthly, New York.

McGraw-Hill Dictionary of Art edited by Bernard S. Myers. 5 vols. New York: McGraw-Hill Book Co., 1969.

The World Museums Guide edited by Barbara Cooper and Maureen Matheson. London: Threshold Books, 1973.

Chapter 1
WHY ART?

Art and Visual Perception by Rudolf Arnheim. Berkeley: University of California Press, 1954.

Arts and the Man by Irwin Edman. New York: W. W. Norton & Co., 1939.

Creativity and Personal Freedom by Frank Barron. Rev. ed. New York: Van Nostrand Reinhold Co., 1968.

Creativity in the Arts edited by Vincent Tomas. Englewood Cliffs, N.J.: Prentice-Hall, 1964.

Experiences in Visual Thinking by Robert McKim. Monterey, Calif.: Brooks/Cole Publishing Company, 1972.

Eye and Brain by R. L. Gregory. New York: McGraw-Hill Book Co., 1966.

Growing with Children Through Art by Aida C. Snow. New York: Van Nostrand Reinhold Co., 1968.

Influence of Culture on Visual Perception by Marshall H. Segall, Donald T. Campbell, and Melville J. Herskovits. Indianapolis: Bobbs-Merrill Co., 1966.

Kaethe Kollwitz Drawings by Herbert Bittner. Cranbury, N.J.: A. S. Barnes & Co., 1959.

Man and His Symbols by Carl G. Jung et al. Garden City, N.Y.: Doubleday & Co., 1964.

Purposes of Art by Albert E. Elsen. 3d ed. New York: Holt, Rinehart & Winston, 1972.

Seeing with the Mind's Eye: The History, Techniques and Uses of Visualization by Mike Samuels, M.D., and Nancy Samuels. New York and Berkeley: Random House, Inc. and the Bookworks, 1975.

Silent Language by Edward T. Hall. New York: Fawcett World Library, 1969.

The Arts and Man by UNESCO. Englewood Cliffs, N.J.: Prentice-Hall, 1969.

The Arts in the Classroom by Natalie Robinson Cole. New York: John Day Co., 1940.

The Creative Process edited by Brewster Ghiselin. New York: New American Library, 1952.

The Family of Man by Edward Steichen. New York: Simon & Schuster, 1967.

The Necessity of Art: A Marxist Approach by Ernest Fischer. Baltimore: Penguin Books, 1964.

The Psychology of Children's Art by Rhoda Kellogg with Scott O'Dell. Del Mar, Calif.: CRM Books, 1967.

Chapter 2
WHAT DO WE RESPOND TO IN A WORK OF ART?

A Color Notation by Albert Henry Munsell. Baltimore: Munsell Color Co., 1946.

Art Fundamentals: Theory and Practice by Otto G. Ocvirk et al. Dubuque, Iowa: William C. Brown Co., Publishers, 1968.

Basic Design: The Dynamics of Visual Form by Maurice de Sausmarez. New York: Reinhold Publishing Corp., 1964.

Color: Basic Principles and New Directions by Patricia Sloane. New York: Reinhold Publishing Corp., 1968.

Color Psychology and Color Therapy by Faber Bitren. New Hyde Park, N.Y.: University Books, 1961.

Composition in Pictures by Ray Bethers. New York: Pitman Publishing Corp., 1962.

Design as Art by Bruno Munari, translated by Patrick Creagh. Baltimore: Penguin Books, Inc., 1971.

Interaction of Color by Josef Albers. New Haven: Yale University Press, 1963.

Persian Painting by Stuart Cary Welch. New York: George Braziller, 1976.

Perspective: Space and Design by Louise Bowen Ballinger. New York: Reinhold Publishing Corp., 1969.

The Art of Color by Johannes Itten. New York: Reinhold Publishing Corp., 1961.

Chapter 3
WHAT ARE THE VISUAL ARTS?

A Concise History of Photography by Helmut and Allison Gernsheim. New York: Grosset & Dunlap, 1965.

African Crafts and Craftsmen by René Gardi. New York: Van Nostrand Reinhold Co., 1970.

Architecture without Architects by Bernard Rudofsky. Garden City, N.Y.: Doubleday & Co., 1964.

Art Career Guide edited by Donald Holden. 2d ed. New York: Watson-Guptill Publications, 1967.

Art from Found Materials: Discarded and Natural: Techniques, Design Inspiration by Mary L. Stribling. New York: Crown Publishers, 1966.

Ceramics: A Potter's Handbook by Glenn C. Nelson. New York: Holt, Rinehart & Winston, 1966.

Cities by Lawrence Halprin. New York: Reinhold Publishing Corp., 1963.

Design through Discovery by Margorie Elliott Bevlin. 3d ed. New York: Holt, Rinehart & Winston, 1977.

Drawing by Daniel M. Mendelowitz. New York: Holt, Rinehart & Winston, 1967. Has companion study guide.

Elements of the Art of Architecture by William Muschenheim. New York: Viking Press, 1964.

Expanded Cinema by Gene Youngblood. New York: E.P. Dutton & Co., 1970.

Experiencing Architecture by Steen E. Rasmussen. Cambridge, Mass.: M.I.T. Press, 1962.

Film as Art by Rudolf Arnheim. Berkeley: University of California Press, 1957.

Focus on D.W. Griffith by Harry M. Geduld. Englewood Cliffs, N.J.: Prentice-Hall, 1971.

For Everyone a Garden by Moshe Safdie. Cambridge, Mass.: M.I.T. Press, 1974.

Hokusai Sketches and Paintings by Muneshige Narazake. Palo Alto, Calif.: Kodansha International, 1969.

House Form and Culture by Amos Rapoport. Englewood Cliffs, N.J.: Prentice-Hall, 1969.

How to Talk Back to Your Television Set by Nicholas Johnson. New York: Bantam Books, 1970.

How to Wrap Five Eggs by Hideyuki Oka and Michikazu Saki. New York: Harper & Row, Publishers, 1967.

Ise: Prototype of Japanese Architecture by Kenzo Tange and Noboro Kawazoe. Cambridge, Mass.: M.I.T. Press, 1965.

It's Only a Movie by Clark McKowen and Mel Byars. Englewood Cliffs, N.J.: Prentice-Hall, 1970.

Kindergarten Chats by Louis H. Sullivan. Washington, D.C.: Scarab Fraternity Press, 1934.

Kiss Kiss Bang Bang by Pauline Kael. New York: Bantam Books, 1969.

Masters of the Japanese Print by Richard Lane. Garden City, N.Y.: Doubleday & Co., 1962.

Modern Prints and Drawings by Paul J. Sachs. New York: Alfred A. Knopf, 1954.

Painting: Some Basic Principles by Frederick Gore. New York: Reinhold Publishing Corp., 1965.

Painting with Synthetic Media by Russell O. Woody, Jr. New York: Van Nostrand Reinhold Co., 1965.

Photographers on Photography edited by Nathan Lyons. Englewood Cliffs, N.J.: Prentice-Hall, 1966.

Photographs by Henri Cartier-Bresson by Henri Cartier-Bresson. New York: Grossman Publishers, 1963.

Pioneers of Modern Design by Nikolaus Pevsner. Baltimore: Penguin Books, 1964.

Printmaking by Gabor Peterdi. New York: The Macmillan Co., 1961.

Prints and Visual Communication by William M. Ivins, Jr. New York: Plenum Publishing Corp., 1969.

Problems of Design by George Nelson. New York: Whitney Publications, 1965.

Sacred Dance: Encounter with the Gods by Maria Gabriele Wosien. London: Thames and Hudson, 1974.

Sculpture (Appreciation of the Arts Series 2) by L. R. Rogers. New York: Oxford University Press, 1969.

Space, Time and Architecture by Siegfried Giedion. 5th ed. Cambridge, Mass.: Harvard University Press, 1967.

Synthetic Painting Media by Lawrence N. Jensen. Englewood Cliffs, N.J.: Prentice-Hall, 1964.

The Artist's Guide to His Market by Betty Chamberlain. New York: Watson-Guptill Publications, 1970.

The Artist's Handbook of Materials and Techniques by Ralph Mayer. New York: Viking Press, 1968.

The Art of Drawing by Bernard Chaet. New York: Holt, Rinehart & Winston, 1970.

The Arts and Man by UNESCO. Englewood Cliffs, N.J.: Prentice-Hall, 1969.

The Behavioral Basis of Design by Robert Sommer. Englewood Cliffs, N.J.: Prentice-Hall, 1969.

The City in History by Lewis Mumford. New York: Harcourt Brace Jovanovich, 1972.

The Concerned Photographer by Robert Capa et al. New York: Grossman Publishers, 1969.

The Decisive Moment by Henri Cartier-Bresson. New York: Simon & Schuster, 1952.

The Design of Cities by Edmund N.

Bacon. Rev. ed. New York: Penguin Books, 1976.

The Emergence of Film Art by Lewis Jacobs. New York: Hopkinson & Blake Publishing Co., 1969.

The Language of Architecture by Niels L. Prak. New York: Humanities Press, 1968.

The Liveliest Art by Arthur Knight. New York: New American Library, 1957.

The Natural Way to Draw by Kimon Nicolaides. Boston: Houghton Mifflin Co., 1941.

The Unfashionable Human Body by Bernard Rudofsky. New York: Anchor Press/Doubleday & Co., Inc., 1974.

The Way of Chinese Painting, Its Ideas and Techniques by Mai-Mai Sze. New York: Random House, 1959.

Time-Life Library of Photography by editors of Time-Life Books. 17 vols. New York: Time, Inc., 1970–1972.

Watercolor: Materials and Techniques by George Dibble. New York: Holt, Rinehart & Winston, 1966.

Who Designs America edited by Lawrence B. Holland. Garden City, N.Y.: Doubleday & Co., 1966.

Young Designs in Living by Barbara Plumb. New York: Viking Press, 1969.

**Chapters 4 and 5
WHAT IS THE ART OF THE PAST?
WHAT IS THE ART OF OUR TIME?**

A Concise History of Modern Painting by Herbert Read. New York: Praeger, Publishers, 1959.

A Concise History of Modern Sculpture by Herbert Read. New York: Praeger, Publishers, 1964.

A Documentary History of Art 1: The Middle Ages and the Renaissance edited by Elizabeth Gilmore Holt. Garden City, N.Y.: Doubleday & Co., 1957–58.

A Documentary History of Art 2: Michelangelo and the Mannerists: The Baroque, and the Eighteenth Century edited by Elizabeth Gilmore Holt. Garden City, N.Y.: Doubleday & Co., 1957–58.

African Art by Frank Willett. New York: Praeger, Publishers, 1971.

A History of Far Eastern Art by Sherman Lee. New York: Harry N. Abrams, 1964.

American Art Since 1900 by Barbara Rose. Rev. New York: Praeger, Publishers, 1975.

Ancient Chinese Bronzes by William Watson. Rutland, Vt.: Charles E. Tuttle Co., 1962.

Artists on Art edited by Robert Goldwater and Marco Treves. New York: Pantheon Books, 1958.

Art, Music and Ideas by William Fleming. New York: Holt, Rinehart & Winston, 1970.

Assemblage, Environments and Happenings by Allan Kaprow. New York: Harry N. Abrams, 1966.

Chinese Painting by James Cahill. Switzerland: Skira Art Books, 1960.

Concerning the Spiritual in Art and Painting in Particular by Wassily Kandinsky. New York: George Wittenborn, 1966.

Dada: Art and Anti-Art by Hans Richter. New York: Harry N. Abrams, 1970.

Foundations of Modern Art by Amédée Ozenfant, translated by John Rodker. New York: Dover Publications, 1952.

Four Essays on Kinetic Art by Stephen Bann, Reg Gadney, Frank Popper, and Philip Steadman. St. Albans, Eng.: Motion Books, 1966.

From the Classicists to the Impressionists: A Documentary History of Art and Architecture in the Nineteenth Century edited by Elizabeth Gilmore Holt. Garden City, N.Y.: Doubleday & Co., 1966.

Gardner's Art Through the Ages by Horst de la Croix and Richard Tansey. 6th ed. New York: Harcourt Brace Jovanovich, 1975.

Gauguin by Ronald Alley. Middlesex, Eng.: Hamlyn Publishing Group, 1968.

History of Art by H. W. Janson. 2nd edition. New York: Harry N. Abrams, 1977.

History of Modern Art: Painting, Sculpture and Architecture by H. H. Arnason. New York: Harry N. Abrams, 1968.

Japanese Prints from the Early Masters to the Modern by James A. Michener. Rutland, Vt.: Charles E. Tuttle Co., 1960.

Kinetic Art by Guy Brett. New York: Reinhold Publishing Corp., 1968.

Masters of Modern Art edited by Alfred H. Barr, Jr. New York: Museum of Modern Art, 1955.

Modern Artists on Art edited by Robert L. Herbert. Englewood Cliffs, N.J.: Prentice-Hall, 1964.

Museum without Walls by André Malraux, translated by Stuart Gilbert and Francis Price. Garden City, N.Y.: Doubleday & Co., 1967.

Myths and Symbols in Indian Art and Civilization by Heinrich Zimmer. New York: Harper & Row, Publishers, 1946.

Painting and Reality by Etienne Gilson. Princeton, N.J.: Princeton University Press, 1957.

Painting in the Twentieth Century by Werner Haftmann. New York: Praeger, Publishers, 1965.

Picasso's Guernica by Anthony Blunt. New York: Oxford University Press, 1969.

Primitive Art by Paul S. Wingert. New York: World Publishing Co., 1965.

The Ascent of Man by J. Bronowski. Boston: Little, Brown and Co., 1974.

The Art of the South Sea Islands by Alfred Buehler, Terry Barrow, and Charles P. Mountford. New York: Crown Publishers, 1962.

The Dance of Shiva by Ananda Coomaraswamy. New York: Farrar, Straus & Co., 1937.

The Eternal Present: The Beginnings of Architecture by Siegfried Giedion. Princeton, N.J.: Princeton University Press, 1964.

The History of Photography by Beaumont Newhall. New York: Museum of Modern Art, 1964.

The Painter and the Photographer by Van Deren Coke. Albuquerque: University of New Mexico Press, 1964.

The Social History of Art by Arnold Hauser. 4 vols. New York: Alfred A. Knopf, 1951.

The Story of Art by E. H. Gombrich. 12th ed. New York: Praeger, Publishers, 1972.

Total Art: Environments, Happenings and Performance by Adrian Henri. New York: Praeger, Publishers, 1974.

Women Artists: Recognition and Reappraisal from Early Middle Ages to the Twentieth Century by Karen Peterson and J. J. Wilson. New York: Harper & Row, Publishers, 1976.

Chapter 6
WHAT CAN ART DO FOR THE PRESENT AND THE FUTURE?

As We Live and Breathe: The Challenge of Our Environment by Gilbert M. Grosvenor. Washington, D.C.: National Geographic Society, 1971.

City and Country in America edited by David R. Weimer. New York: Appleton-Century-Crofts, 1962.

Design with Nature by Ian L. McHarg. Garden City, N.Y.: Doubleday & Co., 1971.

God's Own Junkyard: The Planned Deterioration of America's Landscape by P. Blake. New York: Holt, Rinehart & Winston, 1964.

In Wildness Is the Preservation of the World by Eliot Porter. San Francisco: Sierra Club Books, 1967.

Man-Made America: Chaos or Control: An Inquiry into Selected Problems of Design in the Urbanized Landscape by Christopher Tunnard and Boris Pushkarev. New Haven: Yale University Press, 1963.

Man's Struggle for Shelter in an Urbanizing World by Charles Abrams. Cambridge, Mass.: M.I.T. Press, 1964.

Matrix of Man: An Illustrated History of Urban Environment by Sibyl Moholy-Nagy. New York: Praeger, Publishers, 1968.

Street Art by Robert Sommer. New York: Links Books, 1975.

Survival through Design by Richard Neutra. New York: Oxford University Press, 1969.

The American Environment: Readings in the History of Conservation edited by Roderick Nash. Reading, Mass.: Addison-Wesley Publishing Co., 1968.

The American Landscape by Ian Nairn. New York: Random House, 1968.

The End of Affluence by Paul R. Ehrlich and Anne H. Ehrlich. New York: Ballantine Books, 1974.

The Hidden Order of Art by Anton Ehrenzweig. Berkeley: University of California Press, 1971.

The Image of the City by Kevin Lynch. Cambridge, Mass.: M.I.T. Press, 1960.

The Language of Cities by Franziska P. Hosken. New York: The Macmillan Co., 1968.

The Last Landscape by William H. Whyte. New York: Doubleday & Co., 1968.

The Last Whole Earth Catalog. Menlo Park, Calif.: Portola Institute, 1971.

The Limits of Growth by Donella H. Meadows et al. New York: Universe Books, 1972.

The Way of Silence: The Prose and Poetry of Basho edited by Richard Lewis. New York: Dial Press, 1970.

This Is the American Earth by Ansel Adams and Nancy Newhall. San Francisco: Sierra Club Books, 1970.

INDEX

About the Author

Duane Preble is a man who practices what he teaches. Heading his list of special interests are painting and photography, and he and his wife Sarah have recently formed a partnership called Treetop Artworks, to produce everything from ceramics and sculpture to design, photography and paintings. He illustrates his belief that life is art through his active involvement with citizens' groups concerned with urban planning, community design and beautification, historic preservation, conservation, and other environmental issues.

After completing his B.A. in painting, graphics, and sculpture at UCLA, Duane took his Master of Fine Arts degree in Visual Design at the University of Hawaii. He liked Hawaii so well he stayed, and since that time has advanced to Professor, teaching many phases of art, art history, and art appreciation at the University of Hawaii. In 1975, Duane was selected for listing in that year's edition of *Outstanding Educators in America*.

Duane and Sarah live with their two children in a "treehouse" at the edge of a tropical rain forest overlooking Honolulu, the mountains, and the ocean. The perfect spot, they say, for their favorite sports, hiking and skin-diving. Delving into *all* the arts, Duane spends leisure hours as part of a local jug band.